W9-DIG-734

DATE DUE

MAY 3 2002	

DEMCO, INC. 38-2931

The Letters of
AUBREY BEARDSLEY

ST. JOSEPH'S UNIVERSITY

3 9353 00224 8787

The Letters of
AUBREY
BEARDSLEY

Edited by
Henry Maas, J. L. Duncan
and W. G. Good

RUTHERFORD • MADISON • TEANECK
FAIRLEIGH DICKINSON UNIVERSITY PRESS

NC
242
.B3
M28

© Henry Maas, J. L. Duncan and W. G. Good 1970

Library of Congress Catalogue Card Number: 68–11571

Associated University Presses, Inc.
Cranbury, New Jersey 08512

SBN
8386–6884–4
Printed in the United States of America

Contents

Illustrations

Principal Editions of Drawings and Letters of Aubrey Beardsley and Abbreviations used in the Footnotes

A Book of Fifty Drawings (1897)	**Fifty Drawings**
A Second Book of Fifty Drawings (1899)	**Second Book**
The Early Work of Aubrey Beardsley (1899)	**Early Work**
The Later Work of Aubrey Beardsley (1901)	**Later Work**
Some Unknown Drawings of Aubrey Beardsley collected and annotated by R. A. Walker (1923)	**Unknown Drawings**
The Uncollected Work of Aubrey Beardsley (1925)	**Uncollected Work**
An Aubrey Beardsley Miscellany edited by R. A. Walker (1950)	**Miscellany**
Beardsley by Brian Reade (1967)	
Last Letters of Aubrey Beardsley edited by John Gray (1904)	**Last Letters**
Briefe Kalendernotizen und die Vier Zeichnungen zu E. A. Poe (Munich, 1908)	**Briefe Kalendernotizen**
Letters from Aubrey Beardsley to Leonard Smithers edited by R. A. Walker (1937)	**Walker**
Aubrey Beardsley. Catalogue of Drawings and Bibliography by A. E. Gallatin (New York, 1945)	**Gallatin**

Introduction

AUBREY Beardsley is one of the few men who have given their names to a whole period of art and letters. 'I belong to the Beardsley period,' wrote Max Beerbohm in 1895. The phrase was taken by Osbert Burdett for his study of the eighteen-nineties, *The Beardsley Period* (1925), and has remained in use since. Beardsley's art is an epitome of the *fin de siècle*, its fascination with the curious, the grotesque, the perverse and the exquisitely wrought. Although it was his skill in recording the preoccupations of the age that won him his first notoriety, his reputation since then has rested on more purely artistic qualities, the power of his imagination and the mastery of composition and line shown in all his mature work.

Despite Beardsley's fame there was until the appearance of Mr Stanley Weintraub's *Beardsley* (1967) no full biography of him, and this book is the first to offer a complete collection of his letters. The following have already been published: those to André Raffalovich (*Last Letters of Aubrey Beardsley*, edited by John Gray, 1904), to A. W. King (in *An Aubrey Beardsley Lecture*, edited by R. A. Walker, 1924) and to Leonard Smithers (*Briefe Kalendernotizen*, Munich, 1908, and *Letters to Smithers*, edited by R. A. Walker, 1937). In 1955 a set of fifty-five miscellaneous letters from the Gallatin Collection in Princeton University Library was edited by R. A. Walker and was printed in *The Princeton University Library Chronicle* (Volume XVI, number 1). William Rothenstein included extracts from Beardsley's letters to him in *Men and Memories*, Volume 1 (1931), and some of those to Robert Ross were included in *Robert Ross: Friend of Friends,* edited by Margery Ross (1952). Had these books been in print it would have been enough now to publish only those letters which are completely new. But as few of them are available, and as their text (especially that of *Last Letters*) is often both incomplete and inaccurate, we have decided to print every letter we could trace, even those of which we could find only brief extracts. A few which are known to have reached the saleroom have eluded our search. Otherwise we believe that the letters here printed include all whose survival has been recorded.

Our predecessors had far less material at their disposal and many of their judgements have had to be revised. We have therefore

chosen to start *de novo*, particularly in questions of dating and the identification of drawings; but this is not to underestimate the value of their work, without which our task would have been much harder. In *Last Letters* John Gray explained several references from his personal knowledge, and wherever we have followed him we have indicated the fact by adding 'Gray's note' in brackets. The debt that all students of Beardsley owe to the late R. A. Walker is incalculable. He, more than any other man, was the custodian of Beardsley's fame. He edited three collections of his letters, wrote eloquently about him, was the first to publish a number of drawings and assembled the materials for a catalogue which, when completed, will be the definitive work of reference. Not long before he died in 1960, he set to work on a new edition of Beardsley's letters. His intention was to publish the full text of the letters to Raffalovich together with the most important of Beardsley's unpublished letters to other correspondents. For this purpose he collected much of the material which is new in this book. Had he lived, he would certainly have produced a notable edition. His death before he could complete and annotate the text is a loss that his successors as well as his friends must mourn. We have from the start of our work had the use of his papers, and while the faults of this book are ours alone, any merit it may have must be attributed in large part to him.

One other name will be constantly found in the footnotes, that of the late A. E. Gallatin. Like Walker, Gallatin gave the devotion of a lifetime to Beardsley's work. In a period of fifty years he assembled a notable collection both of letters and of drawings, which, through his foresight, remains intact and is one of the glories of Princeton University Library. His patient searches brought to light much that might otherwise have been lost, and his *Catalogue of Drawings and Bibliography* (New York, 1945) is a detailed and often admirable compilation which has held the field for over twenty years. In the notes, we have used it for identification of drawings, and, with the few exceptions which we have indicated, any drawing not recorded by Gallatin, can be assumed not to have survived.

Beardsley's letters, like those of many of his contemporaries, are usually written in haste and without thought of literary form. Slips of the pen abound, and these we have corrected except where they seemed to be of interest, as in the letters written when he was a boy. We have also felt free to arrange the text into paragraphs, to spell out abbreviations and to supply punctuation. Titles of drawings, books and plays are printed in italics, those of poems and

articles in inverted commas. Addresses, after the first appearance of each, are abbreviated and dates are put into standard form. Square brackets indicate editorial interpolations. We have made no excisions, but where only part of a letter has been available to us we have repeated the dots used in the printed source to show omissions. Unless we have said otherwise, the text is taken direct from the original or a photographic copy.

Throughout our work we have received much generous help, particularly from the collectors and libraries that own the original letters. They have unfailingly given their ready permission to us to use their materials, and have shown a constant willingness to help with additional information. They are listed in the table of manuscript locations, but we wish here to record our sense of obligation and gratitude for all the assistance they have so freely given us. Many other friends and correspondents have come to our aid in countless ways, tracing letters, explaining references and allusions, supplying specialized information, and correcting our mistakes. We are particularly indebted to Mr L. Quincy Mumford of the Library of Congress; the late Dr John D. Gordan of the Berg Collection, New York Public Library; Dr Alexander P. Clark and Mr Howard C. Rice, Jr., of Princeton University Library; Dr Lawrence Clark Powell and Mrs Edna C. Davis of the William Andrews Clark Library, University of California; Mr H. N. P. Pepin of Bournemouth Central Library; Mr Alan Anderson; Don Pablo Azcona; Mr T. C. Barnard; Mr Robert Booth; Mr John Burns; Monsieur F. Casanova; Mr R. L. Coutts; Mr Andrew Dempsey; Mr Anthony d'Offay; Dr Carl Dolmetsch; Dr Malcolm Easton; Professor Ian Fletcher; Don Patricio Gannon; Fr. R. C. Gorman, S.J.; Sir Rupert Hart-Davis; Miss Susan Hodges; Mr Ernest Mehew; Mrs Katherine Lyon Mix; Mr C. W. Musgrave; Mr Brian Reade; Mr Michal Rhodes; Mr J.-P. B. Ross; Mr Stanley Scott; Fr. Brocard Sewell, O. Carm.; Mr John Smithies; Mr Dominick Spencer and Mr Alan G. Thomas. The proofs have been read, and many important corrections made in them, by Sir Rupert Hart-Davis and Mr Brian Reade. To all these, and to the many others who have patiently answered our inquiries, we here offer our warmest thanks.

Part I
1878-1892

AUBREY Vincent Beardsley was born in Brighton on 21 August 1872. His father, Vincent Paul Beardsley (1839-1909), belonged to a family that had been in trade and, though he inherited a little money, the family of his wife, Ellen Agnus Pitt (1846-1932), whom he married in 1870, would have felt justified in thinking that she had married beneath her. Her father, Surgeon-Major William Pitt (1816-1887), a distant relative of the two Prime Ministers, had served with distinction in the Indian Army. Her two children were born in rapid succession, Mabel in 1871 and Aubrey in the following year. At about this time her husband lost his small fortune and the family was reduced to bare respectability. Vincent Beardsley had little capacity for gainful employment. He drifted from one job to another, usually clerking for wine merchants, and was often away from his family. It was chiefly Ellen Beardsley who supported herself and the children by working as a governess and teaching the piano.

Aubrey began his education at a kindergarten, but at the age of seven he showed the first symptoms of weakness in the lungs and was sent to a small boarding school, Hamilton Lodge, at Hurstpierpoint near Brighton. In 1881 it was judged that Epsom would provide a healthier climate and for the next two years he lived there, though how and with whom is not known. The family moved to London in 1883, and at about this time the two children, who were both excellent musicians, began to play at concerts. It was probably poor health more than anything else which kept Aubrey from a musical career and turned his attention increasingly to drawing.

In 1884 he and his sister were again sent to Brighton, where they lived with an elderly great-aunt, a Miss Lamb, a rather forbidding figure who allowed little cheerfulness to break into the children's lives. They were lonely and took to reading. Aubrey's chief interest was history, and he himself began to write an account of the Armada. In January 1885 he became a boarder at Brighton Grammar School and there his qualities were soon recognized. His housemaster, A. W.

King, encouraged him to draw and gave him the use of his sitting-room and library. He started acting and took part in all school theatricals. He also wrote a farce, *A Brown Study*, which was performed, and reviewed in the local papers. During the holidays he and Mabel gave a regular series of home entertainments, performing scenes from the Elizabethan dramatists as well as sketches of which he was the author.

It is clear that he was a highly gifted and imaginative child and that his early years were unusually bookish, but in other respects he seems to have been a normal enough boy, well liked at school and admired for his talent.

Beardsley left school at the end of 1888 at the age of sixteen and on 1 January 1889 became a clerk in the District Surveyor's Office in Clerkenwell. Later in the year he moved to a similar job in the Guardian Life and Fire Insurance Office in the City, and it was while working there that he made the acquaintance of F. H. Evans, a bookseller off Cheapside, who was probably the first man to be aware that Beardsley's gifts were quite out of the ordinary. Evans accepted several of his drawings in exchange for books and used his skill in photography and blockmaking to make platinotype reproductions which he showed and perhaps sold to other customers, among whom there were several in a position to help the young artist.

In the same year however Beardsley suffered the first of his haemorrhages from the lung and for eighteen months he was too weak to do any serious drawing. In 1891 however, as his health improved, he returned to it with renewed energy. For a time he considered enrolling in the Herkomer School of Art at Bushey; prevented by lack of funds, he resigned himself to continuing his humdrum existence as a clerk, but a meeting with Burne-Jones, who pressed him to study seriously, led to his joining the Westminster School of Art, where for about a year he attended evening classes. This was the only formal training Beardsley ever received. The Professor, Frederick Brown, was a prominent member of the New English Art Club and was able to arrange for the Club to exhibit Beardsley's work, now maturing with remarkable speed. In May 1892 Beardsley was in Paris and there met Puvis de Chavannes who treated him as a prodigy. In England too there was recognition. Joseph Pennell wrote an enthusiastic article in the first number of *The Studio*, which was sold in thousands; J. M. Dent commissioned him to illustrate an elaborate new edition of Malory's *Le Morte Darthur* and other publishers showed themselves eager to use his

work. By the autumn of 1892 Beardsley was able to leave his office job to earn his living by drawing. He was only twenty and his ambition for fame needed only a few months to be fulfilled.

MS PRINCETON

To Vincent Beardsley
[*Christmas 1878*]

[*Brighton*]

My dear Dad,

I wish you a happy Christmas. I have made you a marker; it is affection, because I love you. We enjoy Cook's travels very much.

Your loving son AUBREY

MS PRINCETON

To Ellen Beardsley
1 October [*1879*]

Hamilton Lodge, Hurstpierpoint

My dear Mother,

I hope you are quite well. I am getting on quite well. The boys do not tease me. I like Hurst very much. I met Mrs C. Cook one day. I do not do very many lessons. I go lots of times in to the playground. I hope Mabel is quite well. How do you like Margate? My knee is better. I am quite well. I received your letter this morning; thank you for it. I am very happy. I hope Mabel is quite well. I think the old man who had two umbrellas must have taken Mrs Cook's. Good-bye.

Your loving AUBREY

MS PRINCETON

To Ellen Beardsley
Wednesday [*? 8 October 1879*]

Hamilton Lodge

Dear Mother,

I hope you are quite well. Miss Wise took us to some Pretty Gardens. I like the little views of Margate very much. Thank you for the letter. We had tea at the Gardens: we had cake and some eggs. We played about all the afternoon. With love to yourself and Mabel.

Your loving AUBREY

MS PRINCETON

To Mabel Beardsley
15 October [*1879*]

Hamilton Lodge

My dear Mabel,

Thank you for your letter. We have pudding every day. The drilling master [comes] every Thursday. I like the lessons very much. We drill on a lawn. We have a dog named Fido, he comes out with us every day. I like the walks very much. I am quite well. Give my love to Mother and to Father. I will write to Mother next week. I hope you feel better for your trip to Margate. I like some of the boys very much.

Miss Wise reads out of a book about French and English ships.
Good-bye.

Your loving brother AUBREY

MS Princeton

To Ellen Beardsley
Thursday [6 November 1879]

Hamilton Lodge

My dear Mother,

Thank you for sending my shirts. Last Saturday we all went to see the wedding of one of the boys' sisters. We had a large cake sent us. The Saturday before we went to a Circus.[1] I liked it very much. There were two large Elephants who did all kinds of funny things. Last night Miss Wise let us make a bonfire in the playground, and then the boys let off some fireworks. We had great fun and stayed up a little later than usual. I am quite well and happy. Please send me some more money, mine is nearly gone, and all the boys give one or two shillings towards the expenses of the play, which they act at the break-up party. When is my engine going to be mended? Give my love to father and Mabel and yourself.

Your loving son AUBREY

1. Myers' Great American Circus at the Polo Grounds, in Preston Park, Brighton.

MS Princeton

To Vincent and Ellen Beardsley
27 November 1879

Hamilton Lodge

My dear Parents,

Miss Wise wishes me to tell you that the holidays will begin on Saturday the 20th instant, when I shall be very glad to see you all again and hope you will be pleased with the progress I have made in my studies during the past term.

With love to you and all at home
I remain
my dear Parents
your affectionate Son AUBREY V. BEARDSLEY

P.S. Send me the money for my journey.

MS PRINCETON

To Ellen Beardsley
Friday [*January-February 1880*]

Hamilton Lodge

My dear Mother,

Thank you for the nice letter. I was going to write before but Miss Barnett thought I had better wait to tell you about the Exhibition. Miss Wise took us all [on] Tuesday afternoon. It was so pretty, just like a bazaar. Nearly every one in Hurst exhibited work of some sort. There were some beautiful cakes and pies there. Some of the elder boys went again in the evening, and Miss Barnett and several others played the piano. I have begun Music but I do not do much yet. I am quite well. Miss Barnett sends her love, she will write to you soon but she has been so busy this week.

Please give my love to Father and Mabel.

Your loving little boy AUBREY

MS PRINCETON

To Ellen Beardsley
Friday [*20 February 1880*]

Hamilton Lodge

My dear Mother,

I hope you are quite well. I had three valentines on Valentine's day. I think one was from Papa. There were such a lot for the boys. Miss Wise let us have them after dinner and we had great fun in opening them. I sent Mabel one. Please thank her for her letter. I will write to her next time. I am quite well. It has been so wet lately we have not been able to go out very much.

Please give my love to dear Papa and Mabel and with many kisses. I am dear Mother your loving little boy

AUBREY

MS Princeton

To Mabel Beardsley
Friday [*? 27 February 1880*]

Hamilton Lodge

My dear Mabel,

I thank you for your nice letter.

I hope you are quite well. Please tell Mother I did have four Valentines; I made a mistake. Miss Barnett sends her love and will write next week. She will take care of the prescription but I am quite well, and don't want any medicine yet. I am getting on much better with my music now. At first Miss Barnett was nearly bald with teaching me. I hope I shall begin a tune soon; if I am good perhaps I shall on Monday. We had a half holiday yesterday and had such nice games in Danny Park.[1] Give my love to Father and Mother.

Your loving brother AUBREY

1. The Elizabethan manor house of Hurstpierpoint.

MS Princeton

To Ellen Beardsley
Thursday [*circa March 1880*]

Hamilton Lodge

My dear Mama,

I am quite well and happy.

We go out for nice walks every day and to the Chinese Gardens very often; we went there yesterday as there was a Temperance Fete. Mr Hannington our Clergyman[1] was there and came and played with us in the Gymnasium. Please give my love to Father and Mabel.

I remain,

Your affectionate Son AUBREY BEARDSLEY

I was very much pleased and amused with your nice long letter and thank you very much for it.

1. The Rev. James Hannington (1847–85), at this time curate of St. George's, Hurstpierpoint. In 1884 he became Bishop of Eastern Equatorial Africa, and in the following year was captured and put to death by the King of Uganda.

MS PRINCETON

To Ellen Beardsley
Wednesday [*24 March 1880*]

Hamilton Lodge

My dear Mother,

I thank you for your letter. I am sorry Mabel has not been well.

Last Thursday Mr Hannington asked for a half-holiday as it was such a fine day and we all went to Wolstonbury hill,[1] and enjoyed ourselves very much.

Yesterday we went again to gather moss to decorate the Church for Easter.[2]

Our holidays begin on 22nd of April but many of the Brighton boys go home for Easter Sunday. There is going to be a Review at Brighton.[3] Miss Barnett sends her love and will write in a day or two. I am quite well.

With love to Father and Mabel.

Your loving little boy AUBREY

1. A steep hill to the south of Hurstpierpoint.
2. Easter Sunday fell on 28 March.
3. A parade of 20,000 men led by Prince Edward of Saxe-Weimar on 29 March.

MS PRINCETON

To Ellen Beardsley
Thursday [*1 April 1880*]

Hamilton Lodge

My dear Mother,

I am quite well. We had a whole holiday Monday and Tuesday because the weather was so beautiful. As the Review was in Brighton

there were no exurtionists [?] over here, so we went to the Chinese Gardens all the afternoon; on Tuesday we went to the hill and Miss Wise took buns for us all. On Good Friday we had hot cross buns for breakfast. On Easter Sunday both the churches were beautifully decorated with flowers and inscriptions.

Some of the boys went to Brighton but they are all returned, and we are settled in to lessons again for the three weeks.

With love to all, I remain, My dear Mother,

<div align="right">Your affectionate Son AUBREY BEARDSLEY</div>

MS PRINCETON

To Ellen Beardsley
Thursday [*circa July 1880*]

<div align="right">Hamilton Lodge</div>

My dear Mother,

Thank you for your letter. Miss Barnett says I may put a letter in hers. I thank you for the piece of music which I received this morning. I am learning *Fading Away* and then I shall begin the Sonata.

We have not had so much rain as you have I expect, for we go out every day, except last Saturday, when it rained all the afternoon, so we had some games in the school room. I am going to learn a Duet to play with Hugh Saunders at the Breaking-up party. Miss Barnett is going to choose it soon. I am quite well and happy.

Please give my love to Mabel and tell her I will write to her next time.

With love to father and yourself,

<div align="right">Your loving son AUBREY V. BEARDSLEY</div>

MS PRINCETON

To Ellen Beardsley
Friday [*October 1880*]

Hamilton Lodge

My dear Mother,

Thank you for your letter and for the transfers.

I have been quite well since I came back, and we are able to get out every day. We are now quite settled in school again.

Last Wednesday week we went to the Harvest Festival and afterwards to the fête at the Gardens.

Last Sunday it was the Harvest Home at St. George's.[1] There were lots of vegetables and fruit besides flowers which were sent to the Hospitals in London the next day. We saw some apples, and some very big cabbages, vegetable marrows, carrots, and several large bunches of grapes.

Thank you for the stamp. I shall be very glad to have five shillings to spend in the holidays, it is very kind of Grandpapa.

With love to Father and Mabel.

I remain,

Your loving son AUBREY V. BEARDSLEY

P.S. Miss Barnett sends her love to you.

1. The private chapel in the grounds of St George's House.

MS ROSENWALD

To Lady Henrietta Pelham[1]
1 February [*? 1883*]

2 Ashley Villas [*London*]

Dear Madam,

The drawings which I sent you were all copies from different books. The little figures on the bench and *Secrets* were out of the book you sent me, the former I thought so very sweet that I was in a great hurry to draw it. I often do little drawings from my own imagination but in doing figures the limbs are apt to be stiff and

out of proportion and I can only get them right by copying. I forgot to put the names on the two buildings. One is the Maypole Inn and the other is the Boot Inn, both from Dickens' *Barnaby Rudge*. It is all about the Gordon Riots and the Rioters used to meet at the Boot Inn. I also copied the flowers from the other book you sent me, but they were failures as I was not very patient over them, or I should have sent them to you. I find it very difficult to be persevering, but I think I am a little more so than I used to be. I am very fond of drawing and should very much like to make you anything for a bazaar. Thank you for your kind letter. I am looking forward to coming to see you. Mabel and I both send our love.

I remain,

Yours truly AUBREY V. BEARDSLEY

1. Lady Henrietta Juliana Pelham (1813–1905) befriended the Beardsley family at this time and gave help in the form of payment for Aubrey's drawings.

MS REVINGTON

To Miss Felton
[*circa 1887*]

Brighton Grammar School

My dear Miss Felton,

Imagine my delight, rapture, joy, DELIGHT, pleasure and happiness on opening and reading your letter.

How could it have entered your head to think such loving thoughts of me. I adore the very ground you walk on.

I will give the letter to Bessie Ashdown tomorrow at half-past five. How can I express my feelings towards you? Words are too poor, alas. I couldn't get pens enough to write all that is contained in the inmost depths of my love-stricken heart.

I hear that you are anxiously expecting a letter from me. Will you be going to church next Sunday? If your answer is favourable hold a handkerchief in your right hand as a token that you love me. Dare I expect this token? Oh rapture! ! ! You will be *always* in my thoughts, dreams and reveries, day and night. My heart is too full. I can write no more. Farewell, farewell, and once again farewell.

> For thee I am dying,
> For thee I am sighing
> For thee I am bursting, like fine ginger pop.
> Whilst this letter is flying
> With rapture I'm crying;
> Don't show this, I beg you, to dear Betsy Topp.[1]

I remain your loving and devoted lover, AUBREY V. BEARDSLEY

1. Headmistress of the school in which Miss Felton was a boarder.

MS REVINGTON

To Miss Felton
[*circa 1887*]

Brighton Grammar School

My own Love,
 How can I excuse myself for not having written before? But to tell the truth I have been unable to think of sweet enough things to say. I think of you still; I will for ever. I cannot thank you enough for your last letter, over which I have been pondering ever since. I was too modest and bashful to come to the window the other day, as all the girls were there.
 My soul is too full to write any more, so I remain, for ever and for ever,
 Your own devoted slave and admirer, AUBREY V. BEARDSLEY

MS PRINCETON

To A. W. King[1]
[*January 1889*]

32 Cambridge Street, S.W.

My dear Mr King,
 Thank you very much for your postcard. I called for the book (Scott's *Poems*) and got it all right. It is a beautiful edition. I went to *Macbeth* last week.[2] I was delighted with it. I was very frightened

for some time that I shouldn't see Irving and was truly thankful he recovered in time. He was splendid in it, I thought; I didn't much care for Ellen Terry in some scenes. Sullivan's music was a great disappointment; what did you think of it?

You should have seen Irving in the murder scene, it was tremendous. I am very sorry you saw Vezin,[3] though I dare say he was very good.

I have been to a good many theatres this holidays.

I am very glad the new matron is pleasant. I suppose that means some respectable suppers for you. Who is in your room this term?

I have been 'In Business' since New Year's day. I don't exactly dislike [it] but am not (as yet) frantically attached. My work however is not hard.

Here am I looking wise over an empty Ledger.

Is the football kept up this term? And have we any chance for the cup? I suppose a good many of the first eleven have left.

I wonder if you are able to have any entertainments this term. I wish I was back to help with some.

I hope you are quite well.

Please remember me to Mr Lampson and Mr Sam.[4]

<div align="center">

With all affectionate wishes,

I remain

Yours very affectionately A. V. BEARDSLEY

</div>

P.S. Your prologue[5] was much admired here.

1. 1855–1922. Beardsley's housemaster at Brighton Grammar School.
2. Revived by Irving at the Lyceum on 29 December 1888 with Ellen Terry as Lady Macbeth.
3. Herman Vezin (1829–1910), an American actor who worked mostly in London and had appeared as Macbeth in a previous production by Irving.
4. S. Marshall (so called to distinguish him from E. J. Marshall, the Headmaster).
5. Prologue to *The Pay of the Pied Piper,* the Brighton Grammar School Christmas entertainment, 1888. Beardsley illustrated the programme and played a leading part. Also in the cast was C. B. Cochran (1872–1951), the elebrated impresario.

I am very glad the new Matron
is pleasant I suppose that means
some respectable suppers for you

who is in your room this term?

I have been "In Business" since new
years day I don't exactly dislike but
am not (as yet) frantically attached
to it. My work however is not hard.

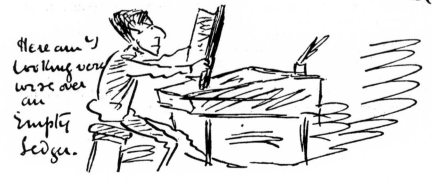

Here am I
looking very
wise over
an
empty
Ledger.

MS PRINCETON

To A. W. King
4 January 1890

32 Cambridge Street

My dear Mr King,

I should like to get a line from you. Would have written before myself but have been so dreadfully ill. Some weeks ago I had a bad attack of blood spitting. I went to see Dr Symes Thompson[1] who said I was in a shocking state of health and wondered how I had existed in such a worn-out condition. My lungs luckily are not diseased but my heart is so weak that the least exertion brings on bad haemorrhage.

My Christmas has been kept on slops and over basins. Of course I had to leave the Insurance Office. I read all day. I have just been enjoying Daudet's books immensely, I can read French now almost as easily as English.

I have been doing a little writing. My first attempt has been successful, vide 'The Story of a Confession Album' in *Tit Bits*.[2] They sent me £1.10.0 for it.

You were quite right about Willard.[3] *The Middleman*[4] was the last thing I saw. No theatres for me now for a long while.

How do you like the Technical Schools?[5] I hope you are quite well.

I remain,

Yours very affectionately A. V. BEARDSLEY

1. Edmund Symes Thompson (1837–1906), eminent specialist in the treatment of tuberculosis.
2. In *Tit-Bits*, 4 January 1890.
3. E. S. Willard (1853–1915), melodramatic actor.
4. By Henry Arthur Jones, first produced at the Shaftesbury Theatre, 27 August 1889.
5. King had recently become Secretary to Blackburn Technical Institute. He remained there until his retirement in 1904.

MS Princeton

To G. F. Scotson-Clark[1]
[July 1891]

59 Charlwood Street, S.W.

My dear Clark,

Thanks very much for your letter and hint as to charcoal. My interview with Marshall[2] was not wholly unproductive. If I want help he is willing to give it. Mr Gurney[3] is at present ungetatable, he liked my drawings much, especially *Notre Dame de la Lune*.[4]

He has just got hold of some very capital Rossetti sketches, pen and pencil. *Death of Lady Macbeth, Fiammetta* etc.

Yesterday I went to Mr Leyland's[5] house. His collection is GLORIOUS.

Rossetti *La Pia* *Blessed Damozel!*
 Salutation! *Loving cup*
 Sea Spell *Lady Lilith*
 Proserpine! *Mnemosyne!*
 Veronica Veronese!
 Ghirlandata
 Dis Manibus

Burne-Jones *Merlin and Vivien!*
 Night
 Morning!
 4 Seasons
 Venus' Mirror!
 Cupid reviving Psyche!
 Circe's Wine
 Phyllis and Demophoon!

Watts *Portrait of Rossetti*

Ford Madox Brown *Burial of Christ!*
 Chaucer at Court!

Millais *Eve of St Agnes*

[?] Botticelli *Madonna!*
 4 pictures for Mastagio [?]

Lippo Lippi *Madonna*
 Adoration of Magi

and

a Giorgione, Memling, Luini, Vinci, Vecchio, Costa, Rubens
etc.

Went to Academy last Saturday.[6] Terrible and wearying. Just too late for New English Art Club.[7]

My latest productions are *Ladye Hero, Litany of Mary Magdalen, La Belle Dame, Mercure de Molière, Griselda.*[8]

I am going to Burne-Jones next week.

 Yours for ever AUBREY BEARDSLEY

Sorry not to have written before.

I return Herkomer papers.[9] The Secretary sent me mine about a week ago, also a long and courteous letter re my candidature. He wrote again yesterday saying that vacancies were filled up for *this* term but that I had better send my drawings as soon as possible for the following one.

 Amen.

Photo (a frightfority) enclosed.

1. 1872–1927. Beardsley's contemporary at Brighton Grammar School, now also living in London and working in the City. In 1892 he emigrated to the United States, where he prospered in business and pursued his interest in gastronomy, of which he left a record in *Eating Without Fears* (1924).
2. Probably E. J. Marshall, his old Headmaster.
3. The Rev. Alfred Gurney (1845–98), poet and miscellaneous writer, who had known Beardsley's family in Brighton. He was at this time Vicar of St Barnabas, Pimlico.
4. Not recorded in Gallatin.
5. Wealthy art collector and patron of Whistler, who decorated the dining-room of his house in Prince's Gate as the Peacock Room.
6. The Summer Exhibition, which opened at Burlington House on 4 May.
7. At the Dudley Gallery, Egyptian Hall, Piccadilly.
8. *The Litany of Mary Magdalen* (Gallatin 202) was first published in *Second Book*. The other drawings are unrecorded.
9. Entry forms to the Herkomer School of Art at Bushey, Hertfordshire, founded by Hubert Herkomer R.A. (1849–1914). Lack of funds prevented both Beardsley and Scotson-Clark from studying there.

To G. F. Scotson-Clark[1]
Sunday midnight [*July 1891*]

 59 Charlwood Street

[Discussion of the Pre-Raphaelites. The Rev. Alfred Gurney is enthusiastic over his drawings of *Dante*[2] and *Cephalus and Procris.*[3]]

. . . Whistler has a large painting in his Peacock Room. I suppose this is what you mean by the *Jap Girl painting a vase*. The figure is very beautiful and gorgeously painted, the colour being principally old gold.

I advise you to get *Atalanta* for this month. It contains an article by Miss Zimern on 'A Tapestry Gallery at Florence'; full of glorious designs. I enthuse somewhat over the same.[4]

Voilà tout.

I have just got hold of a gem in the shape of an etching by Whistler dated 1859. The subject is Billingsgate in the last century.[5]

I've just seen a wonderful little boy in the street (10½ years) who draws in chalks on a large board. Subject, a castle and sea surrounding it—done in grand style I can tell you.

Ta Ta. I am ever yours AUBREY BEARDSLEY

I enclose Jap sketches. Official performances.

1. Text from *Uncollected Work* supplemented by Sale Catalogue, Anderson Auction Galleries, New York, 18 December 1928.
2. Probably *Dante at the Court of Don Grande della Scala* (Gallatin 198), not published.
3. Gallatin 243, not published.
4. *Atalanta,* July 1891.
5. No. 130 in Wedmore's catalogue of Whistler's etchings (1886).

MS PRINCETON

To A. W. King
[*13 July 1891*]

59 Charlwood Street

My dear Mr King,

I do not believe I can have written to you since I left school. The truth is I have had next to no news. A short time back I had a playlet[1] performed at the Brighton Pavilion, with some success, also a monologue. Yesterday (Sunday) I and my sister went to see the Studio of Burne-Jones,[2] as I had heard that admittance might be gained to see the pictures by sending in one's visiting card. When we arrived however we were told that the Studio had not been open for some years and that we could not see Mr Burne-Jones without a special appointment. So we left somewhat disconsolately.

I had hardly turned the corner when I heard a quick step behind me, and a voice which said, 'Pray come back, I couldn't think of letting you go away without seeing the pictures, after a journey on a hot day like this.' The voice was that of Burne-Jones, who escorted us back to his house and took us into the studio, showing and explaining everything. His kindness was wonderful as we were perfect strangers, he not even knowing our names.

By the merest chance I happened to have some of my best drawings with me, and I asked him to look at them and give me his opinion.

I can tell you it was an exciting moment when he first opened my portfolio and looked at the first drawings: *Saint Veronica on the Evening of Good Friday,*[3] *Dante at the Court of Don Grande della Scala.*

After he had examined them for a few minutes he exclaimed, 'There is *no* doubt about your gift, one day you will most assuredly paint very great and beautiful pictures.'

Then as he continued looking through the rest of them (*Notre dame de la lune, Dante designing an angel, Insomnia, Post Mortem, Ladye Hero* etc etc), he said, 'All are *full* of thought, poetry and imagination. Nature has given you every gift which is necessary to become a great artist. I *seldom* or *never* advise anyone to take up art as a profession, but in *your* case *I can do nothing else.*' And all this from the greatest living artist in Europe.

Afterwards we returned to the lawn and had afternoon tea. Mrs Burne-Jones is very charming. The Oscar Wildes[4] and several others were there. All congratulated me on my success, as 'Mr Burne-Jones is a very severe critic.'

During tea B.J. spoke to me about art training. 'I will,' he said, 'immediately find out the very best school for you, where two hours' daily study would be quite sufficient for *you.* Study hard, you have plenty of time before you. I myself did not begin to study till I was twenty-three. You must come and see me often and bring your drawings with you. Design as much as you can; your early sketches will be of immense service to you later on. Every one of the drawings you have shown me would make beautiful paintings.'

After some more praise and criticism I left feeling, in the words of Rossetti, 'a different crit'ter'. We came home with the Oscar Wildes—charming people.

I feel now doubly how helpful and beneficent your kindness to me at school has proved. If I ever succeed I feel that it is very very much owing to you. At a time when everybody snubbed me you

kept me in some sort of conceit with myself. I shall *never* forget our evenings together in the old room. One day they may bear real good fruit.

A line from you would be a very great pleasure. I am so anxious to hear all about you and your doings, so please write.

I am now eighteen years old, with a vile constitution, a sallow face and sunken eyes, long red hair, a shuffling gait and a stoop.

The drawings I showed Burne-Jones were those done within the last few weeks, as prior to that I don't think I put pencil to paper for a good year. In vain I tried to crush it out of me but that drawing faculty would come uppermost. So I submit to the inevitable.

I am sure you will wish me all success in years to come.

Nash[5] I met the other day—he draws no longer.

Clark (do you remember him?) will I think step to the part one day; he is a good sort.

I am your very affectionate pupil AUBREY VINCENT BEARDSLEY
Please excuse this long wordy letter.

1. *A Brown Study*, produced by C. B. Cochran.
2. Sir Edward Burne-Jones (1833–98), Pre-Raphaelite painter, the strongest single influence on Beardsley's early work. From page 20 it seems that Beardsley's meeting with Burne-Jones was less fortuitous than he pretends.
3. Not recorded.
4. Oscar Wilde (1854–1900) had recently scored his first great success with *The Picture of Dorian Gray*. Beardsley's illustrations to his *Salomé* were published in 1894.
5. Not identified.

To G. F. Scotson-Clark[1]
[*July 1891*]

11 Lombard Street, E.C.

. . . My latest productions show a great improvement, *The Flower and the Leaf* from Chaucer,[2] and two pictures from Aeschylus' *Libation Bearers . . . Orestes and Electra Meeting over the Grave of Agamemnon* and *Orestes Driven from City Argos by the Three Furies.*[2] I am about to illustrate the life of the great wonder-worker Merlin.[3]

I have just had a charming epistle, four pages, from Burne-Jones. He advises two schools: first, Mr Brown's Academy at Westminster

(impressionist),⁴ second, South Kensington.⁵ . . . Two hours' daily
work is quite sufficient for me, so, as you suggest, I mean to attend
night classes.

[*Advice from Burne-Jones*]

'I should like,' he says, 'to see your work from time to time, at
intervals, say, of three or six months. I know you will not fear work,
nor let disheartenment languor you because the necessary discipline
of the school seems to lie so far away from your natural interest and
sympathy. You must learn the grammar of your art, and its exercises
are all the better for being rigidly prosaic.'

1. Text from Sale Catalogue of Anderson Auction Galleries, New York,
 18 December 1928, and J. Lewis May, *John Lane and the Nineties*
 (1936).
2. Not recorded.
3. An early reference to his work on *Le Morte Darthur* by Sir Thomas
 Malory, for which he made over three hundred illustrations between
 1892–4. Beardsley did not receive Dent's commission for this work
 until 1892, so that at this stage the idea must have been his own.
 There is no evidence that he made any drawings on this subject be-
 fore 1892.
4. Frederick Brown (1851–1941) was head of the Westminster School
 of Art 1877–93. In 1886 he was one of the founders of the New
 English Art Club.
5. The Royal College of Art.

*To G. F. Scotson-Clark*¹
9 August 1891

59 Charlwood Street

My dear Clark,

I am very anxious to hear about the Cantata. I hope you've settled
on Merlin.² I am most horribly dull and look forward muchly to a
sight of you in a short time. Give me warning of your approach,
however, so that the two embryonic genii mayn't miss each other.
My mother and sister are at Woking now for a couple of months,
so I and my pater are alone in London and not having a particularly
lively time of it. Behold thy dear friend swearing and cursing because
he was idiot enough to miss the Walter Crane show of pictures.³
I only saw the advertisement thereof on the last day of Exhibition.

I am getting up a grand show of drawings for my visit to Burne-

Jones on his return from holidays. My last chef d'oeuvre being
Hamlet following the ghost of his father or, as I have it in Latin,
Hamlet patris manem sequitur (a stunning design, I can tell you) .⁴

I turned into the National Gallery yesterday where I saw for the
first time the new acquisition, Holbein's *Ambassadors,* a damned
ugly picture I assure you.

Can you measure the distance yet between our present position
and Herkomer's Glory Hole? Don't I wish I could get there!

I am reading Morris' *Earthly Paradise* which is simply enchant-
ing.⁵ If you have not read it you must take it away with you when
you come.

Bring a copy of your song with you if it is out by that time.⁶
Who knows but that I may honour you by singing it.

I herewith enclose a *Real Art* TREASURE for you. 'Tis a hasty im-
pression of Whistler's *Miss Alexander* which I saw a week or so back;
a truly glorious, indescribable, mysterious and evasive picture. My
impression almost amounts to an exact reproduction in black and
white of Whistler's *Study in Grey and Green.*⁷

By the side of it was W's portrait of his mother, the curtain
marvellously painted, the border shining with wonderful silver notes.
The accompanying sketch is a *vile* libel. By the way, have you seen
Whistler's letters to the papers about that picture of his at Dowdes-
wells?⁸ (somewhat amusing) .

Farewell. Je suis pour toujours,

Votre ami A B

I

The lights are shining dimly round about,
The Path is dark, I cannot see ahead;
And so I go as one perplexed with doubt,
Nor guessing where my footsteps may be led.

II

The wind is high, the rain falls heavily,
The strongest heart might well admit a fear,
For there are wrecks on land as well as sea
E'en though the haven may be very near.

III

The night is dark and strength seems failing fast
Though on my journey I but late set out.
And who can tell where the way leads at last?
Would that the lights shone clearer round about!

1. Facsimile in *Uncollected Work.*
2. Possibly a composition by Scotson-Clark's father, the Rev. Frederick Scotson-Clark (1840–83), well known as an organist and composer.
3. Painter and illustrator (1845–1915). The exhibition, held at the Fine Art Society, opened on 1 July 1891.
4. Gallatin 195, first published by King in *The Bee,* November 1891.
5. First published 1868–70.
6. This appears not to have been published.
7. In the exhibition of the Society of English Portrait Painters; now in the Tate Gallery.
8. In *The Pall Mall Gazette,* 28 July and 4 August, 1891; reprinted in the enlarged edition of *The Gentle Art of Making Enemies,* 1892.

MS PRINCETON

To A. W. King
[*Postmark 10 August 1891*]

59 Charlwood Street

My dear Mr King,

Have just got your postcard. It will alas be impossible for me to see you tomorrow morning as I am due in the City at 9.30. I am still in the Fire Office, my art study being nocturnal. You may guess from this that I have some real hard work in front of me, for the next three or four years at least.

When I leave the Office tomorrow, say about 5.30, I will call at the Covent Garden Hotel on the spec of finding you there, but *don't* put *anything* off on my account. Of course I am always at home every evening but I don't want to drag you out to these outlandish parts, when you are in London for so short a time and probably very busy.

I'm afraid I shan't be able to bring you many of my drawings as the bulk of them are in the possession of Mrs Russell Gurney,[1] from whom I may expect some substantial help.

I was delighted to get a letter from you, and to hear of your visit to London.

I am,
Your very affectionate AUBREY V. BEARDSLEY

1. Emelia (née Batten), widow of Russell Gurney (*d.*1878), Recorder of the City of London and M.P. for Southampton.

MS PRINCETON

To G. F. Scotson-Clark
[August 1891]

59 Charlwood Street

My dear Clark,

Much thanks for your letters. (1st) I must congratulate you vastly on your new friend and envy your luck in getting those Autotyped Rossettis. (2nd) I must express my abhorrence of your gross Philistinism in respect to Whistler's *Miss Alexander,* but you have by this time, perchance, discovered its beauties and merits—if not you are one of England's Unworthies.

I am anxious to hear anything about the Cantata. Are you thinking of taking the tenor part? If you intend doing so I must beg you to reconsider the matter.

I have just been into the most lovely church imaginable—Holy Trinity, Chelsea, one of Sedding's productions. The style is a sort of Tudor Gothic. *The Architect* calls it 'debased Sedding'.[1] But it is church furniture inside that is the real treat. One of the altars has a picture by Reynolds Stephens as a frontal. It is entitled *All Men Seek Thee* and represents the Infant Saviour being worshipped by all sorts and conditions of men, in modern costume.

The lectern is a perfect wonder. It consists of a glorious Rosettiish angel stepping forward and holding above her head the olive branch.

The quire stalls are grandly decorated in gold reliefs representing the days of creation. The chancel rails are also A 1.

I may possibly be able to send you some platinotypes from some of my latest pictures.[2]

The Triumph of Joan of Arc[3] which I am now engaged on is A 1.
In haste from the office.

Je reste pour tojours,
Votre ami BÉALE[4]

1. Holy Trinity, Chelsea, left unfinished at his death by John Dando Sedding (1838–91), was discussed at length in an article in *The Architect,* August 1891.
2. Reproductions made by F. H. Evans. See p. 5.
3. Gallatin 200, first reproduced in *Second Book.* A smaller version appeared in *The Studio,* May 1893.
4. Beardsley's nickname at school.

MS PRINCETON

To A. W. King
[*Postmark 25 August 1891*]

59 Charlwood Street

My dear Mr King,

I have just received your letter and enclosure. It is really awfully good of you to take so much trouble over my sketches. By all means accept 10/- for the *Hamlet* if it is offered. By the way please imitate my signature at the bottom of it—AB.

I have two fairish designs by me, *The Triumph of Joan of Arc* and *The Litany of Mary Magdalen,* I will send if you think you could dispose of them. I will also try and get the Gurney drawings.

Burne-Jones' letter I enclose herewith. It doesn't prove much, except that I know him and that he has taken an interest in my work.

I am looking forward very much to a sight of the *Bee,* which you say you are sending me.

In haste,

From your very affectionate AUBREY V. BEARDSLEY

MS PRINCETON

To G. F. Scotson-Clark
[*circa September 1891*]

59 Charlwood Street

My dear Clark,

I am very glad that you've had a sight of the immortal EBJ. Is he not gentle and charming? I also found him very different to what I expected—older, as you say. Your portrait of him is *very* A 1 indeed, though I think you miss the extraordinary look he has about the eyes. I enclose a sketch, made a few days after I saw him. To me—at least—it is very like.[1] (I suppose you know what that means.) I am just now enthused to the highest degree about pictures, and am studying the life and works of Mantegna, who, as you know, has inspired Burne-Jones all along.

If you can come up to London we must try and manage to get down to Hampton Court together, and see one of the grandest

collections of paintings in England—small, but everything in the first order of merit. Mantegna's tremendous *Triumphs of Caesar* are there—an art training in themselves.

I am beginning to feel somewhat ashamed of what I said about Holbein's *Ambassadors*. I have seen it several times since.

A few days back I met Nash in the Strand. He is about to bring out a new paper, *Modern Life* and is in high feather about it.[2] I suppose he must have his head on his shoulders after all, for according to (his own) accounts he is making a good thing of journalism.

By the bye, how does Cochran[3] get on? Swimmingly eh?

My sister has just passed the exam I told you of, very brilliantly.

I shall never be able to get down to Brighton I'm afraid. I wish I could manage it though. In your next letter please let me know your private address, I have mislaid it.

Last night I went to see Grace Hawthorn in *Theodora,* the famous Byzantine prostitute.[4] She was truly splendid in the part, the only actress on the English stage who comes anything near to Sarah Bernhardt's style.

[End of letter missing]

1. Gallatin 183 (there incorrectly dated. The date on the drawing is 12 July 1891). Eight copies were printed in 1899, and a reproduction was published in *The Critic* (New York), December 1902.
2. This seems never to have appeared.
3. See p. 298.
4. By Robert Buchanan (from the French), first produced in 1890, revived at the Olympic Theatre, 1 August 1891.

MS PRINCETON

To A. W. King
13 October [*1891*]

59 Charlwood Street

My dear Mr King,

Thanks very much indeed for the Bees. I admire the general get-up immensely. Your hand is noticeable distinctly throughout. You must excuse me writing a long letter this time as my eyes are

very weak and inflamed just now, and I am anxious not to overtire
them. I eventually selected the Impressionist Academy as my
school of art. I certainly make decided headway, and it will not
be so very long before I get into the life class. However if my
eyes are going to give me any serious trouble I may have to give
up the pencil for some time.

I went to see Watts[1] the other day. He is a disagreeable old
man, however very nice to me. He strongly dissuaded South
Kensington for art training, and spoke emphatically on the subject
of *self*-culture.

Our art master, Mr Fred Brown, is tremendously clever with
the brush, and exhibits A 1 work at the Academy. He seems to
have great hopes of me. By the way I shall be going to see Burne-
Jones soon, and am anxious of course to show him as much new
sketching as I can so when you can spare the time you might let
me have my pencillings. I haven't forgotten the Brighton souvenirs
I promised. I will polish them off as soon as my eyes think fit to
improve.

I have just said farewell to Ambler[2] who sails for India imme-
diately. The best place for him I imagine, as he strenuously refused
to turn his hand to anything over here.

I have been reading that book of G. Moore's you spoke of, *A
Mere Accident.*[3] I was not wholly pleased with the same. Realism—
so-called—does not seem to flourish on British soil.

> With much love,
> I am,
> Yours very affectionately AUBREY V. BEARDSLEY

1. G. F. Watts R.A. (1817–1904).
2. Not identified.
3. Published in 1887.

MS PRINCETON

To A. W. King
[*Postmark 7 December 1891*]

59 Charlwood Street

My dear Mr King,

I have received the drawings all right. Thanks very much. It's
awfully good of you to have the *Hamlet* in the *Bee*. Should you

ever want any designs for the B. of course I should always be more than delighted to send you any.

The old drawings gave me great hope, as there is a world of difference between them and my present pictures, and only two months' difference in point of time.

I am anxious to see how the *Hamlet* turns out. As it is in very distinct and well-defined black and white it should reproduce fairly well.[1]

Have you E. B. Jones' letter?

In haste.

 I am your

 Very affectionate AUBREY V. BEARDSLEY

1. It was reproduced by lithography and printed in sanguine as the frontispiece.

MS PRINCETON

To A. W. King
Christmas [*25 December 1891*]

 59 Charlwood Street

My dear Mr King,

Of all things received on Christmas morn, none more pleasant than the *Bee*. On reading your 'notice on the illustration',[1] I scarcely knew whether I should purchase to myself a laurel wreath and order a statue to be erected immediately in Westminster Abbey; or whether I should bust myself.

Hamlet has certainly been splendidly reproduced, by someone or other, and splendidly introduced by yourself; and for all this I must indeed thank you very much.

The November number of the *Bee* is in every respect *A 1*, I can truthfully say that I never see any 'monthly' so *well written;* certainly *a good style*—clear and unornate—is the rarest of things, not to be met with even in some of the best newspaper articles.

I shall be glad of a few more copies of the November *Bee,* so enclosed PO for 1/-.

I should very much like to be able to contribute to the *Bee* from time to time if I may be allowed.

I am anxious to say something somewhere, on the subject of *lines* and line drawing. How little the importance of outline is understood even by some of the best *painters*. It is this feeling for harmony in *line* that sets the old masters at such an advantage to the moderns, who seem to think that harmony in *colour* is the only thing worth attaining.

Could you reproduce a drawing purely in line?

To wish anyone a happy Christmas is to me very foolish, but I will wish you something which is exactly 365 times better, viz a happy new year.

In this respect the French are wiser than us, and they feast and present and wish well on the first of January.

By the way what *is* your private address? I have quite forgotten.

Hoping that good health etc. is yours

 I am,

 Yours very affectionately AUBREY V. BEARDSLEY

P.S. Only send two 'Bees' for November, the other 8d. for next four numbers.

The old aunt I used to pay so many visits to when at school died about three weeks ago—only left me £500.[2]

1. Under the heading 'Our Illustration' King had written of Beardsley: '. . . He is destined to fill a large space in the domain of art when the twentieth century dawns.'
2. Probably Beardsley's great-aunt, Miss Lamb, with whom he had lived for some years in Brighton.

MS PRINCETON

Postcard to A. W. King
[Postmark 5 January 1892]

 [59 Charlwood Street]

Dear Mr King,

After making several designs in transfer ink, lithographic ink and lithographic chalk, I think it would be better to *etch* the picture and will let you have plate in a few days.

The article had better stand over, as I have just discovered one on line drawing by Walter Crane in an Art Magazine too much like my own.

 AVB

MS Ross

To Robert Ross[1]
[*? 14 May 1892*]

59 Charlwood Street

My dear Mr Ross,

I have just received your letter and cheque.[2] Thank you so much for arranging the purchase. I was out when your telegram came.

I shall be going to Paris for a short time in about a week. Can you tell me of a good place to stay at?

Yours very sincerely AUBREY BEARDSLEY

1. Canadian-born journalist and art critic (1869–1918), one of Beards-ley's first admirers and later Wilde's most trusted friend. His *Aubrey Beardsley* (1909) gives much valuable biographical information. He recorded the date of his first meeting with Beardsley as 14 February 1892, at Aymer Vallance's rooms.
2. Among the Ross papers there is a cheque made out by Ross to Beards-ley dated 13 May 1892, in payment for a replica of *The Procession of Joan of Arc*. It is likely that this is the cheque Beardsley acknowledges.

MS BRIGHTON

To E. J. Marshall[1]
[*Autumn 1892*]

59 Charlwood Street

My dear Mr Marshall,

I cannot forgive myself for being so tardy a letter writer. May hard work and lack of anything to write about be my excuse. I do hope Mrs Marshall and yourself are well.

I cannot quite recall my last letter to you, but I think it must have been written as far back as the early spring, and was full of laments and grumbling. I was very ill at the time, and nearly lost my post at the Fire Office. All my drawing too was stopped for the time. However I soon got much stronger and was able to forge ahead with the drawing with renewed vigour. I struck out a new

style and method of work which was founded on Japanese art but quite original in the main. In certain points of technique I achieved something like perfection at once and produced about twenty drawings in the new style in about a couple of months. They were extremely fantastic in conception but perfectly severe in execution. I took them to Paris with me in June (my holiday time) and received the very greatest encouragement from the President of the Salon des Beaux-Arts, who introduced me to one of his brother painters as 'un jeune artiste anglais qui fait des choses étonnantes!'

On my return to England I continued working in the same groove and made some nice additions to my portfolio. I then took my drawings to Cassell's who gave me work at once;[2] and soon afterwards I was introduced by chance (?) to a very good publisher, Dent and Co., who has practically appropriated me and my works. He has given me so much to do and pays me so well that I have at last been compelled to leave the Guardian.

At present I am working on no less than four books for him, to say nothing of little odds and ends such as title pages and book covers etc. which all mount up nicely in the account.

The best and biggest thing I am working on at present is Malory's *Morte Darthur* (a splendid *édition de luxe*) for which I am getting £200. (Not bad for a beginning, is it?) I have everything to do for the book, which will be coming out at first in parts. There will be twenty full-page drawings (eight on copper and twelve on zinc), about a hundred small drawings in the text, nearly 350 initial letters and the cover to design. The drawings I have already done have met with great approval from all who have seen them. The first part will be coming out early next year.

Just now I am finishing a set of sixty grotesques for three volumes of *Bon-Mots* soon to appear. They are very tiny little things, some not more than an inch high, and the pen strokes to be counted on the fingers. I have been ten days over them, and have just got a cheque for £15 for the work—my first art earnings. Then I have drawings to do for Hawthorne's *Classic Tales*, Miss Burney's *Evelina* and Mackenzie's *Man of Feeling*. Altogether my hands are very full of nice things, and I don't forget to be thankful.

My dear mother's health is very bad now, and amongst other ills she is suffering from chronic sciatica. What she suffers must at times be really terrible, and it seems there is nothing to be done for her. Only perfect rest will be of avail. Very soon my sister and myself will have the 'family' on our hands, so the money view of my art work has to be kept keenly in view. My sister is teaching

now at the Polytechnic High School and ought to have a head-mistress-ship offered her sooner or later. I think you heard how successful she was the last two years in the Higher Women's examination, taking the highest honours in all subjects. I have no doubt she will be able to get literary work through the influence of my publisher, who is the kindest of men.

How often my thoughts go back to the old school I can hardly tell you. The finest inspiration for a young man is the remembrance of a pure childhood and a good school time. That time should always remain as the standard for the later life. It was indeed a privilege to have come under your influence and tuition, a privilege perhaps not fully understood *then* but warmly and keenly appreciated *now*.

I join with my mother and my sister in kindest remembrances to Mrs Marshall and yourself, and am,

Yours very affectionately AUBREY V. BEARDSLEY

P.S. Please remember me most kindly to Mr Carr.

1. Headmaster of Brighton Grammar School.
2. This commission came to nothing.

To Aymer Vallance[1][2]
[*1892*]

[*London*]

. . . Here is the zinc process picture—a much better pull than the one I showed you on Thursday. I couldn't get anything else to bring. It's awfully good of you to show it to Mr Morris. . . .

AUBREY V. BEARDSLEY

1. Text from sale catalogue of the American Art Association, 5–6 November 1923.
2. Art critic (1862–1943) who had introduced Beardsley to Ross. He was at this time associated with William Morris in the Kelmscott Press, and tried to interest Morris in Beardsley's work.

MS Ross

To Robert Ross
1 December [*1892*]

[*London*]

Dear Ross,
I am so sorry I shan't see you at Vallance's next Sunday. Of course I shall be delighted to do any drawing for your friend. I should prefer designing something new rather than parting with any Japonesques I have got in my portfolio already. I have been invited by the New English Art Club to exhibit some of them at their spring exhibition[1] and am much exercised in my mind as to frames (the all-important item).
By the bye I should ask 30/- for a Japonesque similar to the one Stenbock[2] has got, and considering that my drawings look quite as beautiful upside down as the right way up I don't think I could ask less.

Yours most sincerely AUBREY V. BEARDSLEY

1. Among Beardsley's drawings in this exhibition were *Salomé with the Head of John the Baptist* and *La Femme Incomprise* (Gallatin 232 and 213).
2. Count Eric Stanislaus Stenbock, Scots-Russo-Swedish writer (1860–95), author of *Shadows of Death* (1893) and *Studies of Death* (1894).

MS PRINCETON

Postcard to Otto Kyllmann[1]
[*Postmark ? 2 December 1892*]

[*London*]

Am so awfully sorry but a bad cold (influenza ?) keeps me within doors so will not be able to be with you this evening.

Yours AUBREY BEARDSLEY

1. Publisher, later director, in the firm of Constable, where he managed the publication of Shaw's work.

MS PRINCETON

To A. W. King
Midnight 9 December [*1892*]

59 Charlwood Street

My dear Mr King,

So glad to get your postcard and see your writing again. I've heaps of news for you, so prepare for a budget. I've been horribly ill this year, and for the first few months of it I had to stop my drawing altogether. In the spring however I set to work again and struck out an entirely new method of drawing: Fantastic impressions treated in the finest possible outline with patches of 'black blot'. A little later on I went to Paris for about three weeks. The new work was regarded with no little surprise and enthusiasm by the French artists.

[Extract from *Past and Present* pasted in]

There are not a few who will rejoice to hear of Aubrey V. Beardsley. As illustrator of *The Pied Piper* his name will be remembered by some to whom he is not known. In the summer some of his work received the very greatest encouragement from the *President of the Salon des Beaux-Arts* in Paris, who introduced Beardsley to one of his brother painters as '*Un jeune artiste anglais qui fait des choses étonnantes*'. He is at present chiefly engaged on illustrations for an *édition de luxe* of Malory's *Morte Darthur*, but has also in hand drawings for new editions of Hawthorne's *Tales*, Miss Burney's *Evelina* and Mackenzie's *Man of Feeling*. Our readers will join us in congratulations to Beardsley on his successes. May they be the precursors of a long line of brothers!

The President as you know is the immortal Puvis de Chavannes.[1] I never saw anyone so encouraging as he was.

On coming back to London I knocked off a lot more of the grotesque pictures and went round to the publishers. Dent and Co. were the first to give me work. The *Morte Darthur* means a year's hard work.[2] I've everything to do for it. Cover, initial letters, head-pieces, tailpieces, in fact every stroke in the book will be from my pen. I anticipate having to do at least 400 designs all told, and I shall get £200 for them.

I've also got a good many other books in hand for the same publisher in addition to those mentioned in enclosed cutting. I'm now practically on the staff of a new art magazine *The Studio*

about to be published by Lawrence and Bullen. I've four of my weird pictures in the first number and four or five in the second. No. 1 appears February.[3] There is quite an excitement in the art world here about my 'new method' and I shall be getting some grand notices. Only today Lawrence and Bullen have given me a delightful book to illustrate: Lucian's *Comic Voyage*,[4] the original of *Gulliver* and all such books.

The Lucian will be the third of a very exquisite set of classics they are bringing out. I dare say you have seen them. The work will consist of about thirty full page illustrations.

I've also had very good offers from Elkin Mathews and Lane and R. and R. Clark of Edinburgh, but I don't know how I'm to find time for them all.

Elkin Mathews was very anxious to put me on to *The Shaving of Shagpat,* and will do so if they can secure rights from Chapman and Hall. I'd give anything to get the job, in fact I've always set my heart on doing *Shagpat—*the most glorious of books.[5]

I left the fire office about two months ago to the great satisfaction of said office and myself. If there ever was a case of the □ boy in the ○ hole, it was mine. I left the office and informed my people of the move afterwards. There were ructions at first but of course now I have achieved something like success and getting talked about they are beginning to hedge and swear they take the greatest interest in my work. This applies however principally to my revered father.

I'm going to have a grand show of my works at the New English Art Club in the Spring, having been invited to exhibit by Fred Brown, the new Slade Professor, a great admirer of mine.

By the way *The Studio* is going to publish a series of articles by those who have special experience in art training. Fred Brown and a lot of others will be contributing, and I have asked my Editor to beg you to send something about the Blackburn Technical schools and their scheme of training. I do wish you could manage it.

The Studio will be a monthly affair and price 6d. Sir Frederick Leighton[6] has a picture in No. 1.

Pray forgive this outrageously egotistical letter, but I thought you would like to know all about my doings. I should like to hear from you at equal length about yours. Are you likely to be in London this Christmas? Do come and see me at your earliest opportunity.

Ever yours AUBREY V. BEARDSLEY

1. French painter (1824–98), famous for his frescoes in the Paris Hôtel de Ville.
2. Beardsley's first major commission. The book appeared in parts, 1893–1894.
3. The first number appeared in April 1893. Beardsley's drawings were introduced in an enthusiastic article "A New Illustrator" by Joseph Pennell.
4. Beardsley produced five illustrations to Lucian. Two were reproduced in Lawrence and Bullen's edition (1894) and a third inserted into the large-paper copies. The remaining two were first published in a portfolio of Beardsley's drawings illustrating Juvenal and Lucian issued in 1906.
5. By George Meredith (1856). Beardsley never illustrated this book but in 1893 he undertook extensive work for Mathews and Lane and remained the principal illustrator for their firm, The Bodley Head, until 1895.
6. 1830–96. Painter and sculptor, President of the Royal Academy since 1878 and an early admirer of Beardsley's work.

Part II
1893-1895

THE Beardsley boom started early in 1893. The beginnings were modest—a series of sketches in *The Pall Mall Budget*, a handful of drawings exhibited by the New English Art Club and a laudatory article in *The Studio*—enough for a small reputation, but no more. But with the publication of the first part of *Le Morte Darthur* in June he reached a wider public and before the end of the year he was engaged not only on Malory but had also begun work on Wilde's *Salomé,* had produced the grotesques for Dent's *Bon-Mots* series and designed title-pages, frontispieces or ornaments for at least a dozen other books and periodicals.

By then his success had enabled the family to buy a house in Pimlico, 114 Cambridge Street, a place with no pretensions but large enough to enable them to entertain. Mabel Beardsley's Thursday afternoon tea parties became popular among a growing number of friends including Robert Ross, William Rothenstein, Max Beerbohm, Aymer Vallance, Joseph Pennell, Henry Harland and John Lane.

The last two have the honour of giving Beardsley his first great opportunity. On 1 January 1894 Beardsley was with Henry and Aline Harland at their house in Cromwell Road. During the afternoon the talk returned to a topic that had been discussed the previous summer when they were on holiday together in Normandy, the creation of a new kind of magazine in book form, to be published quarterly, containing short stories and poems, making no attempt at topicality, and with pictures chosen for their own sake and not as illustrations to the text. This was *The Yellow Book*, the most successful and in many ways the most characteristic of the literary and artistic periodicals of the time. The arrangements were completed over luncheon with John Lane the next day. Harland was to be the editor, Beardsley (still only twenty-one) the art editor and chief illustrator, and the Bodley Head was to publish the first number on 16 April.

The preparations, added to all his other work (he was still oc-

cupied with Malory) kept Beardsley busy throughout the first quarter of the year, but the effort proved rewarding. Lane put out heavy advance publicity, and by the time the first number filled the booksellers' windows with a vivid splash of yellow, the public knew that the proper reaction was outraged incredulity. This it duly provided. Disapproving critics once again failed to remember that the only way to kill a fashion is to ignore it. Instead *The Yellow Book* was attacked on all sides with satire and abuse in turn, and swiftly gained a wide circulation. A few enterprising advertisers had already invited Beardsley to design posters, and other artists, quick to catch on to a new fad, began imitating Beardsley's mannerisms— the bold lines, the masses of black contrasting sharply with the large areas left blank, the women with thin elongated bodies, pouting mouths and hooded eyes. Soon Beardsley women were ogling the man in the street from every hoarding and the Beardsley craze had begun its hectic year's run.

Its inventor doubtless had faults—most of them apparent in these letters—but his sudden notoriety had not the slightest effect of making him conceited. All the testimony of his friends agrees that in private he remained modest, good-natured and unpretentious. He knew that his fame would pay only so long as he continued to produce new drawings, and he threw himself all the harder into his work, launching out meanwhile into a fresh scheme, the composition and illustration of a novel on the theme of Tannhäuser.

The strain on his constitution brought on the warnings of another breakdown, and an unsatisfactory holiday in August 1894 was followed by a period of enforced rest in a nursing-home at Malvern. There is very little record of his doings in the early months of 1895, and it is likely that his illness kept him from seeing many people or doing more than the minimum of work for *The Yellow Book*.

Meanwhile a crisis that proved decisive in the artistic history of the 1890s was approaching. On 28 February 1895, a fortnight after the opening of his last and most brilliant comedy, *The Importance of Being Earnest*, Oscar Wilde received the card bearing Lord Queensberry's accusation of 'posing as a sodomite'. Prompted chiefly by Ross, Wilde began his prosecution of Queensberry for criminal libel. On April 5 he lost the case and was arrested. The Press immediately burst into a campaign of abuse aimed not only at Wilde but at the so-called decadence of the whole artistic movement of which he was taken as the representative. For years the cry of *épatez les bourgeois* had drowned all serious protest; now *les bourgeois* came back with an irresistible *écrasez l'infâme*. It was a time of

suspicion and intolerance, and anyone even remotely associated with Wilde faced ostracism.

Beardsley, whose position in art was comparable with Wilde's in letters, was particularly vulnerable. In the general *crise de moralité* his work in *The Yellow Book* and, even more, his illustrations to *Salomé*, were easily convicted of degeneracy. Although the April issue of *The Yellow Book* was already in the press, Lane yielded to pressure from some of his writers, lost his head, dismissed Beardsley from his post as art editor and eliminated all his drawings from the new number. Although he soon regretted his moment of panic and gave Beardsley occasional small commissions, his action nearly proved disastrous to the artist. With his health in constant danger and his livelihood dependent on the quick publication of his new work, Beardsley found himself abandoned by the publisher for whom he had drawn almost exclusively for the past year at the very moment when no established firm would risk its reputation by employing him. Though he put a brave face on it, he was badly shaken by the innuendoes of the newspapers, which by using words like 'sexless' and 'unclean' about his work made it clear that, but for the libel laws, they would gladly have applied far more explicit terms to the artist personally.[1]

At this time good fortune brought him the friendship of a man whose generosity saved him more than once from destitution. This was André Raffalovich, a wealthy Russian Jew from Paris who, in Wilde's cruel phrase, had come to London to found a salon and had succeeded in opening a saloon. Raffalovich enabled Beardsley to continue his work free from pressing financial anxiety. It was his vanity to let Beardsley address him as Mentor, but otherwise he was a tactful and undemanding patron. The value of his later influence on Beardsley in persuading him to become a Roman Catholic is a matter which the reader must judge for himself; the only comment needed here is that he probably carried less weight with Beardsley than he thought.

1. There is in fact nothing in Beardsley's work, apart from an unimportant episode in *Venus and Tannhäuser,* or in what is known of his life, to suggest any dominant homosexual interest.

MS BERG

To Mr Purchas[1]
[circa February 1893]

Pall Mall Budget, 2 Northumberland Street, Strand

Dear Mr Purchas,

I am so sorry that I shall not be able to come to dine with you on Sunday as we arranged. I have got to get off some drawings for the *P.M. Budget* by Monday morning the first thing; so I shall have to be hard at it all to-morrow. I do hope I shall not be inconveniencing you, but you see how I am placed. Would you allow me to come on Sunday week?

Yours sincerely
AUBREY BEARDSLEY

1. Not identified.

MS PRINCETON

To G. F. Scotson-Clark
[circa 15 February 1893]

59 Charlwood Street
In bed

Dear Old Friend,

I'm ashamed of not having written to you before but I have gone through so much of late and had such a terrific lot of news to tell you that I have always fought shy of the ordeal.

Behold me, then, the coming man, the rage of artistic London, the admired of all schools, the besought of publishers, the subject of articles! Last summer I struck for myself an entirely new method of drawing and composition, something suggestive of Japan, but not really japonesque. Words fail to describe the quality of the workmanship. The subjects were quite mad and a little indecent. Strange hermaphroditic creatures wandering about in Pierrot costumes or modern dress; quite a new world of my own creation. I took them over to Paris with me and got great encouragement from

Puvis de Chavannes, who introduced me to a brother painter as 'un jeune artiste anglais qui a fait des choses étonnantes.' I was not a little pleased, I can tell you, with my success.

On returning to England, I continued working in the same method, only making developments. The style culminated in a large picture of *Siegfried* (which today hangs in Burne-Jones's drawing-room.) [1]

My next step was to besiege the publishers, all of whom opened their great stupid eyes pretty wide. They were frightened, however, of anything so new and so daringly original. One of them (Dent— lucky dog!) saw his chance and put me on to a large *édition de luxe* of Malory's *Morte Darthur*. The drawings were to be done in medieval manner and there were to be many of them. The work I have already done for Dent has simply made my name. Subscribers crowd from all parts. William Morris has sworn a terrible oath against me for daring to bring out a book in his manner. The truth is that, while *his* work is a mere imitation of the old stuff, mine is fresh and original. Anyhow all the good critics are on my side, but I expect there will be more rows when the book appears (in June).

Better than the *Morte Darthur* is the book that Lawrence and Bullen have given me, the *Vera Historia* of Lucian. I am illustrating this entirely in my new manner, or, rather, a development of it. The drawings are most certainly the most extraordinary things that have ever appeared in a book both in respect to technique and conception. They are also the most indecent. I have thirty little drawings to do for it 6 inches by 4. L and B give me £100 for the work. Dent is giving me £250 for the *Morte*.

Joseph Pennell[2] has just written a grand article on me in the forthcoming number of *The Studio*, the new art magazine which has by the way a grand cover by me. I should blush to quote the article! but will so far overcome my modesty as to send you a copy on publication. It will be profusely illustrated with my work. My weekly work in the *Pall Mall Budget* has created some astonishment as nobody gave me credit for caricature and wash-work, but I have blossomed out into both styles and already far distanced the old men at that sort of thing. Of course the wash drawings are most impressionist, and the caricatures in wiry outline. This last week I did the new Lyceum performance, *Becket*.[3]

My portrait of Irving made the old black-and-white duffers sit up; and my portrait of Verdi,[4] this week, will make them sit up even more. I get about £10 a week from the *Pall Mall* and can get off all the work they require on Sunday. Clark, my dear boy, I have

fortune at my foot. Daily I wax greater in facility of execution. I have seven distinct styles and have won success in all of them. I have really more work on my hands than I can possibly get through and have to refuse all sorts of nice things.

I still cling to the best principles of the P.R.B.[5] and am still the beloved of Burne-Jones, who as I told you at the beginning, has given my *Siegfried* a place of honour in his drawing-room. The *Siegfried* will be reproduced (badly) in Pennell's article.

I fear you are going to be a fixture in the land of the Philistines.[6] O Clark, come out from among them if you can manage it. England after all is the place for oof and fame.

Ever yours AUBREY BEARDSLEY

Here is my trade mark [7]

P.S. Needless to add long left the office. I'm to have a grand show of my work at the New English Art Club in the spring.

Have just got your letter as I finish this. My best congratulations on your splendid success!

1. Gallatin 229, first published in *The Studio* April 1893.
2. 1860–1926. American-born painter, etcher and art critic; friend and biographer of Whistler.
3. *Pall Mall Budget,* 9 February 1893.
4. 16 February 1893.
5. Pre-Raphaelite Brotherhood.
6. Scotson-Clark was now living in the United States.
7. Device often used by Beardsley in the next year in place of a signature on his drawings.

MS Ross

Postcard to Robert Ross
[Postmark 14 March 1893]

[London]

Sorry to have missed you when you called. Will you come and have tea with me Wednesday 4.30? I expect Julian Sampson.[1]

Ever yours AUBREY BEARDSLEY

1. Julian Gilbert Sampson (1870–1942) was a collector and man of leisure. His brother, the Rev. Gerald Sampson, was curate to the Rev. Alfred Gurney at St. Barnabas, Pimlico.

MS Ross

Postcard to Robert Ross
[Postmark 14 March 1893]

[*London*]

I find Sampson is coming Thursday. Will that day suit you equally well? If not, come Wednesday as arranged.

Ever yours AUBREY BEARDSLEY

MS PRINCETON

To T. Dove Keighley[1]
[circa March 1893]

59 Charlwood Street

Dear Mr Keighley,
 I should be so much obliged if you could let me have the black and white drawing I left with you. The title is *La femme incomprise*[2] and is worked in semi-japonesque style. I am sending a good deal of work to the New English Art Club and Monday next is the sending-day. I am anxious that this particular drawing should be shown. I am so sorry to trouble you.

Sincerely yours AUBREY BEARDSLEY

1. Editor of *The Pall Mall Magazine*.
2. Gallatin, 213, first published in *To-Day*, 1895.

MS PRINCETON

Postcard to A. W. King
[*Postmark 20 April 1893*]

[*London*]

Dear Mr King,

Thanks so much for your letter. Let me have a longer one. I am so glad I have satisfied you. I will write you soon a regular egotistical letter. I've such lots to tell you about. I'm off to Paris soon with Oscar Wilde.[1]

Ever yours AUBREY BEARDSLEY

1. Beardsley was in Paris in May 1893, but with Joseph Pennell and his wife.

To F. H. Evans[1] [2]
[*circa May 1893*]

59 Charlwood Street

Dear Mr Evans,

There is *no doubt* that I shall get the *Shaving* to do. Chapman and Hall are much taken with my work and are willing to wait till the autumn to make a start. All now depends upon the Immortal George. I am collecting my Persianesques etc. to show him, I feel quite sure myself that he will like my work. This evening I dashed off a fine head of Shagpat[3]—a most mysterious and Blake-like affair which simply ought to fetch the master.

C and H will be willing to pay a good figure I can see. I'm returning the *Morte* drawings you so kindly lent me.

Thanks so much for giving me the tip.

Ever yours AUBREY BEARDSLEY

Unless Meredith sticks to the head of Shagpat (as I fancy he will) the drawing shall be yours if you care for it.

1. Facsimile in *Uncollected Work*.
2. Bookseller in Cheapside, whose acquaintance Beardsley had made while working in the City. Evans sometimes accepted drawings from

Beardsley in payment of bills. He was a friend of J. M. Dent, whom he persuaded to commission Beardsley as illustrator of *Le Morte Darthur.*

3. Possibly Gallatin 977, reproduced in *Unknown Drawings.*

MS Princeton

To T. Dove Keighley
[*circa May 1893*]

59 Charlwood Street

Dear Mr Keighley,

I am returning you the *Kiss of Judas*[1] and must apologize for having kept it so long; but I was stopping down at Brighton when you sent it and there was a little delay in the forwarding. The subject of the legend seems to me to fit in well with pictorial treatment.

I suggest that my drawing should contain in one decorative scheme—the strange form kissing its victim (as the centre), with the other incidents (such as the diabolical commission, the suicide and victim after death) worked round it. I will let you have it soon. It certainly is an awfully striking legend.

Sincerely yours AUBREY BEARDSLEY

1. Story by 'X.L.' published in *The Pall Mall Magazine,* July 1893, with full-page illustration by Beardsley.

MS Texas

Postcard to T. Dove Keighley
[*Postmark 18 May 1893*]

[*Paris*]

I am sending by this post the *Kiss of Judas* which I hope you will like. I should like the broken effect of the judas flowers to be kept as much as possible. I didn't know whether you would print *all over* the page or with margins, however the proportions of my drawing will fall in with either method.[1]

It is really *lovely* over here; my address is
Hôtel de Portugal et L'Univers
Rue Croix des Petits Champs
 near the Louvre.

 AUBREY BEARDSLEY

1. The drawing was printed without border.

MS TEXAS

To T. Dove Keighley
[*Postmark 25 May 1893*]

 [*Paris*]

Dear Mr Keighley,
 I indeed hope that no mishap has occurred to my picture in the
post. I sent it off last Thursday. Did you get my postcard? I'm rather
nervous about it all. Could you let me have a line?

 A. BEARDSLEY

My address is
 Hôtel de Portugal et L'Univers
 Rue Croix des Petits Champs
 Paris.

MS ROSS

To Robert Ross
[*circa June 1893*]

 [*London*]

Dear Ross,
 So sorry to find you out again. I want to have a talk with you
about the *Procession of the Magi* which I am about to do for a new
paper.[1] I've a sort of recollection that you had some ideas on the
subject.
 Come and have lunch with me tomorrow Wednesday. If you

happen to be near Elkin Mathews *today* they have a drawing (*Salomé*) [2] to show you.

AUBREY

1. *St Paul's,* which ran from 1894 to 1900. Beardsley contributed a number of drawings to its early numbers. *The Procession of the Magi* is not recorded.
2. The first reference to his work on Wilde's *Salomé,* published by Mathews and Lane in 1894.

MS PRINCETON

To F. H. Evans
[*circa June 1893*]

114 Cambridge Street, Warwick Square, S.W.[1]

Dear Evans,

Thanks for your letter. I should be *charmed* to do something for Jeffries.[2] Of course you know how horribly busy I am just now, and without affectation may say that just now I could hardly spare the time to go over the paper printing works. Could you put me in communication with Jeffries and I could arrange a day of meeting say in about a fortnight from now. Anyhow let them know that I'm anxious to do something for them.

Have just been asked to contribute to a forthcoming magazine *St. Paul's.* I am going to do a full page illustration of the wonderful and gorgeous *Song of Songs,*[3] in mystico-Oriental style. They pay well.

Ever yours AUBREY BEARDSLEY

1. This house in Pimlico remained the home of Beardsley and his family for the next two years.
2. Not identified.
3. This drawing was apparently not made.

MS PRINCETON

To Robert Ross
[circa August 1893]

114 Cambridge Street

Dear Bobby,

So sorry to hear you're not well. Of course Hampton Court would be foolish without Mantegna.[1] I'm afraid the pilgrimage must stand over for some time now, as next week I shall be hard at work working off arrears for Dent. *Salomé* goes famously. I have done two more since I saw you; one of them, the *Studio* picture[2] redrawn and immensely improved.

Ever yours AUBREY

1. Mantegna's series of paintings *The Triumph of Caesar.*
2. *Salomé with the Head of John the Baptist,* published in *The Studio,* April 1893. This drawing led to Beardsley's commission to illustrate Wilde's play. The new version, stronger and less ornate, is called *The Climax* (Gallatin 888).

MS ROSS

To Robert Ross
[August 1893]

Chez vous

Dear Bobbie,

I wandered this way thinking I might find you carrying round tables etc. from 54.[1] The notice in *Livre et L'Image* is really awfully good. (August number).[2] This morning I went round to see *Pick-me-up*[3] and *St. Paul's* people, as they wrote to me again.

They are in a great hurry to sign all sorts of contracts with me for both papers. However I have settled to do *Masques*[4] for *Pick-me-up*; on condition they publish it in book form afterwards.

I shall certainly want some occasional verse for it. Would you do it for me? Especially I want a prologue to be spoken by Pierrot (myself). The new volume of *Artistes Célèbres, Les Moreau*[5] is simply ravishing.

Don't forget Saturday.

Yours Aubrey

1. Ross was moving from 54 Church Street to 11 Upper Phillimore Gardens, Kensington.
2. Brief account of Beardsley's work in *The Studio, Le Morte Darthur* and *Salomé*.
3. A humorous magazine which ran 1882–1909. Beardsley did not contribute.
4. A projected series of drawings and poems. Beardsley later invited Max Beerbohm to contribute the verses and at one stage proposed to write them himself, but the scheme was given up before the end of the year.
5. i.e. the eighteenth-century engravers Louis Gabriel and Jean Michel Moreau, by Adrien Moureau.

MS Ross

To Robert Ross
[*late August 1893*]

114 Cambridge Street

Dear Bobbie,

Of course I should have acknowledged the Postal Order ages ago. I got it all right, thanks. I think the title page I drew for *Salomé* was after all 'impossible'.[1] You see booksellers couldn't stick it up in their windows.

I have done another with rose patterns and *Salomé* and a little grotesque Eros, to my mind a great improvement on the first.

If you have got a portrait of *Whibley*[2] I should be glad if you could let me have it. I am just beginning the Magi picture.

Did you see the 'life' and *atrocious portrait* of myself that came out in the *Morning Leader* last week?[3]

The Brutes gave my real age too!

Ever yours AUBREY B.

1. The drawing was used in an expurgated form.
2. Charles Whibley (1860–1930), journalist and literary critic, at this time working with W. E. Henley on *The National Observer*.
3. Short article on Beardsley published on 25 August 1893.

To John Lane[1] [2]
[*Postmark 12 September 1893*]

114 Cambridge Street

Dear and Reverend Sir,

I went round to Goupils[3] this morning. It seems that Pennell is no longer in Paris, and from my sister's accounts this seems to be the case, so we shall not just yet have the pleasure and privilege of his criticisms.

I hope that William Rothenstein[4] has done no more than take you to the Chat Noir in the daytime and shown you the outside of the Moulin Rouge.

I am going to Jimmie's[5] on Thursday night dressed up as a tart and mean to have a regular spree.

I suppose you will be back at the 'Tête de Bodley' next week looking a gay and garish Parisian.

Love and best wishes to the future P.R.A.

Ever yours AUBREY BEARDSLEY

1. Facsimile in J. Lewis May, *John Lane and the Nineties* (1936).
2. 1854–1925. The leading publisher of the early Nineties. He went into partnership with Elkin Mathews in 1892, and their firm, The Bodley Head, in Vigo Street, was soon the outstanding publishing house for poetry and belles lettres. Besides the work on *Salomé* Lane also commissioned Beardsley to design numerous title-pages, particularly for his *Keynotes* series, and in 1894 appointed him art editor of *The Yellow Book*.
3. Art gallery in Waterloo Place, exhibiting paintings by Charles Conder.
4. 1872–1945. English artist living in Paris since 1890. He had been commissioned by Lane to produce a series of *Oxford Portraits,* the first instalment of which had just been published. Lane was visiting him in Paris.
5. The St. James's Restaurant, Piccadilly.

MS Ross

To Robert Ross
[*September 1893*]

114 Cambridge Street

Dear Bobbie,

Come and lunch with me tomorrow Wednesday 1.30. Come as early as you can as I have much to say to you, and will expect of you

counsel, advice and resolution.

Rothenstein's address is

 23 Rue Fontaine

 Paris

 France.

Livre et L'Image can be got at *Hachettes,* or *could* be a few months ago.

Did you see the article on my works in *The Artist?*[1]

 Sincerely yours AUBREY B. PIMLICONIENSIS

1. *Some Drawings of Aubrey Beardsley* by 'Pastel' (i.e. Theodore Wratislaw) in *The Artist,* September 1893.

MS HARVARD

To William Rothenstein
[September 1893]

 114 Cambridge Street

Dear Rothenstein,

Thanks so much for letter. I am sure you must have had a very funny time with Jean Lane (who by the way is behaving (I think) very treacherously both to you and to myself) .[1]

Am so glad you have got such a charming model. I have been very ill since you left—rather severe attacks of blood spitting and an abominable bilious attack to finish me off. This is my first day up for some time. The *Salomé* drawings have created a veritable fronde,[2] with George Moore[3] at the head of the frondeurs. I have made definite arrangements about *Masques.* Max Beerbohm[4] is going to write the occasional verse. Will you be stopping in London at all before you go on to Oxford? Hope I shall see something of you soon. Impossible for me to come over to Paris so soon. For one thing I should be funky of the sea in my present condition. I would like a dressing-gown if you could get a nice one. Let me have a line if you see one. Don't trouble about anything else. I should like a nice long one, full and ample. I have just found a shop where very jolly *contemporary* engravings from Watteau can be got quite cheaply. Cochin etc.

Pennell has just returned but is off again to Chicago. He is very enthusiastic about your Oxford lithographs.

Ever yours AUBREY BEARDSLEY

1. Lane had commissioned Max Beerbohm to produce a series of caricatures called *Oxford Celebrities* to appear at the same time as Rothenstein's *Oxford Portraits,* but the project came to nothing.
2. Some of Beardsley's drawings were slightly expurgated before publication.
3. Irish novelist (1852–1933). In 1895 he made a similar protest about Beardsley's design for the prospectus of *The Savoy*.
4. Essayist and caricaturist (1872–1956), at this time still an undergraduate at Merton College, Oxford. Rothenstein had met him there in May 1893 and later introduced him to Beardsley. He was a half-brother of Herbert Beerbohm Tree.

MS PRINCETON

To A. W. King
[Postmark 27 September 1893]

114 Cambridge Street

Dear Mr King,

Forgive my long silence. But really I find writing letters a terrible strain on me now, as my health is very feeble and my work very exacting. Even now I cannot write you the nice long letter I should. Certainly for the moment I have fortune at my foot, but I can tell [you] I have worked hard for it. I have simply loads of news for you, and mean to run down to Blackburn for a day or two ere long. I have had no rest this summer at all and indeed fear I shall get none this side of Christmas. My drawings for *Salomé* have aroused great excitement and plenty of abuse. However I will tell you all about these things when we meet.

If you are thinking of getting a copy of *Salomé* order a large-paper one or none at all. The difference in the printing of the plates will I think be very great.

Anxiously looking forward to seeing you once more.

Ever yours AUBREY BEARDSLEY

To John Lane[1]
4 November [*1893*]

114 Cambridge Street

Dear Lane,

I have been considering the matter of *Salomé* and I think the only feasible plan is to let the drawings remain in your hands. I quite recognise that they are legally your property as long as you consent to make them public, and that their transference to another publisher would only lead to trouble. I hope you may settle satisfactorily with Wilde.[2]

Yours AUBREY BEARDSLEY

1. Copy in another hand at Princeton.
2. Publication of *Salomé* was delayed by a dispute between Wilde and Lord Alfred Douglas, who had translated it from the original French. Wilde was dissatisfied with the translation and rewrote it.

MS HARVARD

To William Rothenstein
[*circa 20 November 1893*]

114 Cambridge Street

Dear Rothenstein,

Very many thanks for the beautiful *Book of Love*.[1] It was so charming of you to remember it. I am looking forward to seeing your Verlaine in the *Pall Mall Budget*.[2] I hope they will reproduce it properly. I have a hellish amount of work to get through during the next twenty days or so and am wretchedly ill at the same time. However I intend a visit to you and Oxford—unless these two words have already become synonymous.

Have you had a satisfactory explication with Jean de Bodley? Or are you ready to join the newly formed anti-Lane society?

I suppose you saw Max's latest caricatures. The George Moore I thought simply incomparable. It is some time since I was at Vigo Street so have not had an opportunity of seeing his sketches of ourselves or your own Verlaine.[3]

Ever yours AUBREY BEARDSLEY

1. A book of Japanese erotic prints. Beardsley hung them in his bedroom.
2. Published on 23 November on the occasion of Verlaine's visit to London.
3. Max Beerbohm frequently drew George Moore, Beardsley and Rothenstein and these particular drawings cannot be identified.

MS PRINCETON

To William Rothenstein
[circa 23 November 1893]

114 Cambridge Street

Dear Rothenstein,

Here is the photo I promised you. Not a very satisfactory one, I think. I have just done a rather amusing portrait of Réjane.[1] No news. Hope to see you soon. I hear the Verlaine lecture was rot.[2]

Ever yours AUBREY BEARDSLEY

1. Probably Gallatin 941, first published in *Second Book*.
2. Verlaine lectured at Barnards Inn on 21 November 1893 on French poetry. The visit was arranged by Rothenstein and Arthur Symons. Verlaine's account of it, together with the text of the lecture, was published in *The Savoy*, January 1896.

MS PRINCETON

Postcard to A. W. King
[Postmark 27 November 1893]

114 Cambridge Street

So sorry to hear of your illness; and do hope you are quite recovered. I fear I shan't have time to come and see you this side of Christmas. If you are in London at that festive season *do* come and see me. I hardly know which way to turn for work. Will write you a good long letter as I have lots of news. In the meantime hoping to get a few lines about yourself.

Ever yours AUBREY BEARDSLEY

MS Ross

To Robert Ross
[*late*] November [*1893*]

114 Cambridge Street

Dear Bobbie,

Many thanks for your letter. I haven't found a moment to answer it sooner. How beastly dull you must be on the top of Mont Blanc or wherever you are.[1] I do wish I could have managed to get over to see you.

I suppose you've heard all about the *Salomé* row. I can tell you I had a warm time of it between Lane and Oscar and Co. For one week the numbers of telegraph and messenger boys who came to the door was simply scandalous. I really don't quite know how matters really stand now. Anyhow Bozie's name is not to turn up on the Title.[2] The book will be out soon after Christmas. I have withdrawn three of the illustrations and supplied their places with three new ones (simply beautiful and quite irrelevant). *Masques* is going to be A 1.

I have just turned out a very amusing frontispiece to *Vergilius the Sorcerer*[3] (Nutt), also a really wonderful picture for *Scaramouch in Naxos*.[4]

This morning Pennell has been giving me lessons in etching. Verlaine is over here,[5] I met him at the Harlands'.[6] He is a dear old thing. Moore's article about him was a downright libel.[7]

My *Girl and a Book Shop* at the N.E.A.C.[8] has received very amusing notices; *Public Opinion*[9] sets me down as belonging to the Libidinous and Asexual School.

Whibley is meditating a violent attack on the Birmingham School. I do hope it will come off, idiots are beginning to say nice things about Gaskin, Batten and all those hopeless people.[10] Wratislaw has just published rather a clever volume of verse.[11] I think he's really not a bad sort.

By the way Bozie is going to Egypt, in what capacity I don't quite gather; something diplomatic I fancy.[12] Have you heard from either him or Oscar? Both of them are really very dreadful people.

I long for your return.

In January I shall be over in Paris for a short time. There is a very jolly exhibition of French work at the Grafton now.[13] Affiches, lithographs, and all that sort of thing. Let me have a line and tell

me something about your vegetable life. I suppose you see papers, can I send you any books?

Ever yours AUBREY BEARDSLEY

Kindest remembrances from my mother and sister.

1. Ross was at Davos. He had been obliged to leave London on account of a scandal which also involved Douglas and a schoolboy. See Max Beerbohm's *Letters to Reggie Turner* (edited by Rupert Hart-Davis, 1964) p. 84.
2. The dispute over Douglas's translation of *Salomé* was ended by an agreement that his name should not appear on the title-page but that Wilde should dedicate the book 'To my friend, Lord Alfred Bruce Douglas, the translator of my play'. Bosie (not Bozie) was Douglas's nickname.
3. Published by David Nutt in 1893 (Gallatin 858).
4. Frontispiece to *Plays* by John Davidson, published by The Bodley Head, 1894 (Gallatin 936).
5. Paul Verlaine (1844–96) arrived in London on 21 November and lectured at Barnard's Inn, High Holborn, that evening. He also visited Oxford and Salford and returned to Paris in December.
6. Henry Harland, American-born novelist (1861–1905), had been living in London since 1889. Beardsley first met him in Dr Symes Thompson's waiting-room, and had stayed with him in Normandy in the summer of 1893.
7. 'A Great Poet' in *The Hawk*, 25 February 1890.
8. Gallatin 789. The design was later used as a poster advertising Fisher Unwin's Pseudonym Library.
9. Issue for 24 November 1893: 'The whole has a charm, but it is undoubtedly the charm of degeneration and decay. These things do not belong to the sane in body or mind, and they do not find their out-and-out admirers in men of robust intellect, or of a wholly healthy moral tone . . .' [Of Mark Fisher's *In the Garden*] 'In any painter who can do this without *arrière pensée* we are safe from the abnormalities of the libidinous, and of the equally objectionable asexual schools.'
10. Whibley's article did not appear.
11. *Caprices* by Theodore Wratislaw (1871–1933). He had published anonymously two earlier volumes, *Love's Memorial* and *Some Verses*.
12. Douglas was sent to Egypt by his family to remove him from Wilde's influence. Early in 1894 he was made honorary attaché to the Ambassador in Constantinople but failed to take up the appointment and returned to England in March.
13. Opened on 18 November.

MS Ross

To Robert Ross
[December 1893]

114 Cambridge Street

Dear Bobbie,

I am indeed rejoiced to hear of your return which I learnt of first from Sickert.[1] So sorry I was out when you and Adey[2] called. Will you both come and have tea with us tomorrow, Sunday?

Ever yours AUBREY BEARDSLEY

1. Walter Richard Sickert (1860–1942), the most eminent English painter of his generation.
2. William More Adey (1858–1942), art critic and close friend of Ross. They were together responsible for the first comprehensive exhibition of Beardsley's work at the Carfax Gallery in 1904.

MS PRINCETON

To Messrs Stone and Kimball
2 January *[1894]*

114 Cambridge Street

Dear Sirs,

I must thank you for your letter of the 22nd December. I feel that Poe's tales would give me an admirable chance for picture making and I am sure I could do something that would satisfy us both.[1] I should be quite willing to undertake the work and begin it in February (that is to say, to make four drawings for Volume I and four drawings for Volume 2 of Edgar Allan Poe's works) under the following conditions: that I shall receive five pounds for each of the drawings and that half of the total amount shall be paid in advance. Thanking you for your suggestion,

Yours very truly AUBREY BEARDSLEY

1. Beardsley made four illustrations to Poe's *Tales of Mystery and Imagination* (Gallatin 983–986). They were issued with the large-paper edition published by Stone and Kimball, Chicago, in 1895.

MS Ross

To Robert Ross
[circa 3 January 1894]

114 Cambridge Street

Dear Bobbie,

If superfluous fresh air, tobogganing and snow-capped mountains have not completely killed your love of the fine arts, I am sure you will be vastly interested to hear that Harland and myself are about to start a new literary and artistic Quarterly. The title has already been registered at Stationers' Hall and on the scroll of fame. It is *THE YELLOW BOOK*.

In general get-up it will look like the ordinary French novel. Each number will contain about ten contributions in the way of short stories and discursive essays from the pens say of Henry Harland, Henry James, Crackanthorpe, George Egerton, and Max Beerbohm. The drawings will be independent and supplied by Aubrey Beardsley, Walter Sickert, Wilson Steer, and Will Rothenstein and other past-masters. The publication will be undertaken by John Lane, and the price will be five shillings.

(No. 1 appears on April 15th.)

We all want to have something charming from you for the first number. Say an essay or a short story in which the heroine is not a beautiful boy. Now *do* send us something soon in your most brilliant style; and make up your mind to be a regular contributor.[1]

Our idea is that many brilliant story painters and picture writers cannot get their best stuff accepted in the conventional magazine, either because they are not topical or perhaps a little risqué. Let me have a line by return as we want to get No. 1 ready as soon as possible.

Ever yours AUBREY BEARDSLEY

Best wishes for New Year from all.

1. Ross did not contribute to *The Yellow Book*.

MS PRINCETON

To Ada Leverson[1]
Thursday [? *4 January 1894*]

144 Cromwell Road[2]

Dear Mrs Leverson,
 May Mr Harland and myself come to lunch with you tomorrow—1.30 or about there? The maid will bring answer. I am spending the night at Cromwell Road.

 Yours very sincerely AUBREY BEARDSLEY

1. 1862–1933. Novelist and author of several witty contributions to *Punch* and other papers; the intimate friend of Wilde, who called her The Sphinx. Two stories by her appeared in *The Yellow Book*, in the numbers for April 1895 and January 1896.
2. Harland's house in South Kensington.

MS ROSS

To Robert Ross
[*January 1894*]

114 Cambridge Street

Dear Bobbie,
 Five to six thousand words is about our mark; a little longer wouldn't matter. So delighted that we can count on you for No. 1. I have designed a wondrous cover which has received universal admiration.[1]

 AUBREY B.

1. Six words illegible before the signature.

MS CLARK

To Florence Farr[1]
[*circa February 1894*]

[*London*]

Dear Miss Farr,

I think you will find dark green on light the most satisfactory scheme of colour, though it has often been used before for magazine covers etc. Of course I should make my design in black and white, so that a zinc block can be made, and from that you can print in any colour you like. By the way, if my design is going to be used as a poster had I not better draw it large size and have it reduced for programme?[2]

I saw Mrs Todhunter yesterday who told me that you hadn't yet definitely settled on a theatre. I shall be able to start my picture whenever you like.

Yours sincerely AUBREY BEARDSLEY

1. English actress (?1860–1917), author of *The Dancing Faun* (1894), close friend of W. B. Yeats and associated with him in the founding of The Irish Literary Theatre.
2. Florence Farr had commissioned Beardsley to design the programme for *A Comedy of Sighs* by John Todhunter which she produced at the Avenue Theatre on 29 March 1894 with W. B. Yeats's *The Land of Heart's Desire* as curtain-raiser. The design (Gallatin 788) was printed in blue and green on programme and poster.

MS DAVIS

To Mrs Patrick Campbell[1]
Wednesday [*circa February 1894*]

114 Cambridge Street

Dear Mrs Patrick Campbell,

I have written to Mr Alexander[2] asking permission to come to the Theatre next Friday evening. It is so good of you to give me a sitting. I will write to you directly I hear from Mr Alexander.

Yours very truly AUBREY BEARDSLEY

1. Actress (1865–1940), at this time appearing in *The Second Mrs Tanqueray* by A. W. Pinero at the St James's Theatre. Beardsley had been introduced to her shortly before the date of this letter by Wilde.
2. George Alexander, eminent actor; manager of the St James's Theatre, 1891–1918.

MS LEEDS

To Edmund Gosse[1]
20 February 1894 [?][2]

114 Cambridge Street

Dear Mr Gosse,

I am so sorry you should have been in doubt about the book; of course I mean to picture *The Secret of Narcisse*. I thought both you and Heinemann understood that I had definitely settled to do so.

Heinemann I suppose is waiting to hear about terms. It is now only a question of guineas and I hope it will be settled without difficulty. I look forward much to beginning the work.

Yours very sincerely AUBREY BEARDSLEY

1. 1849–1928. Poet, essayist and critic.
2. The last figure in Beardsley's date is unclear but is almost certainly either 0 or 2. Eighteen ninety-two would be the likelier reading, since Gosse's *Secret of Narcisse* was published by William Heinemann in that year, but Beardsley, so far as can be discovered, did not live at this address until the summer of 1893. If the date we have adopted is correct an illustrated edition of the book must have been contemplated.

MS PRINCETON

To Mr Purchas
27 February [*1894*]

114 Cambridge Street

Dear Purchas,

It was very good of you to recollect young Wratislaw. However he is now reconciled with his father and settled in his office. I hope I may have the pleasure of seeing Mrs Purchas and yourself ere long. We are always at home on Thursday afternoons.

Yours AUBREY BEARDSLEY

To the Editor of The Daily Chronicle
1 March 1894

114 Cambridge Street

Sir,

In your review of Mr Davidson's plays,[1] I find myself convicted of an error of taste, for having introduced portraits into my frontispiece to that book. I cannot help feeling that your reviewer is unduly severe. One of the gentlemen who form part of my decoration is surely beautiful enough to stand the test even of portraiture, the other owes me half a crown.[2]

I am, yours truly AUBREY BEARDSLEY

1. *The Daily Chronicle* reviewed Davidson's *Plays* on 1 March. This letter appeared on the following day. Text from *The Daily Chronicle*.
2. The drawing contained caricatures of Wilde and Sir Augustus Harris, the Manager of Covent Garden where Beardsley had some time previously paid 2/6d for a seat without getting one.

MS BODLEY

To John Lane
[*circa March 1894*]

114 Cambridge Street

Dear Lane,

Shall be delighted.

Yours A.B.

Singer's Sewing machines!! have just commissioned a poster.[1] What next?

1. Gallatin 793.

To John Lane[1]
[*March 1894*]

114 Cambridge Street

Yes, my dear Lane, I shall most assuredly commit suicide if the *Fat Woman*[2] does not appear in No. 1 of *The Yellow Book*.

I have shown it to all sorts and conditions of men—and women. All agree that it is one of my very best efforts and extremely witty. Really I am sure you have nothing to fear. I shouldn't press the matter a second if I thought it would give offence. The block is such a capital one too, and looks so distinguished. The picture shall be called *A Study in Major Lines*.

It cannot possibly hurt anybody's sensibilities. Do say yes.

I shall hold demonstrations in Trafalgar Square if you don't and brandish a banner bearing the device 'England expects every publisher to do his duty.'

Now don't drive me into the depths of despair. Really I am quite serious. *The Second Mrs T*[3] has come off splendidly. Annan and Swan[4] will finish it in two or three days.

The Furse[5] portrait looks A 1.

Yours AUBREY BEARDSLEY

1. Text from J. Lewis May, *John Lane and the Nineties* (1936).
2. Caricature of Mrs Whistler (Gallatin 933). It was not included in *The Yellow Book* but was published in *To-Day*, 12 May 1894.
3. Drawing of Mrs. Patrick Campbell in *The Second Mrs Tanqueray* (Gallatin 899) published in *The Yellow Book*, April 1894.
4. Blockmakers responsible for most of the illustrations in *The Yellow Book*.
5. *Portrait of a Lady* by Charles Furse, published in *The Yellow Book*, April 1894.

MS ROSS

To Robert Ross
[? 1894]

114 Cambridge Street

Dear Bobbie,

I shall be enchanted to lunch with you tomorrow. It seems ages since I have seen you. You have quite deserted me of late.

Yours AUBREY B.

MS CLARK

To Maurice Baring[1]
[*April 1894*]

114 Cambridge Street

Dear Sir,

I should have much pleasure in designing a cover for your magazine.[2]

My terms would be £10: 10: 0.

Of course you would let me know the particular 'attitude' your magazine is going to adopt.

Yours truly AUBREY BEARDSLEY

1. 1874–1945. Novelist and essayist, at this time an undergraduate at Trinity College, Cambridge.
2. *The Cambridge ABC,* produced in June 1894 by Baring and two other undergraduates, R. Austen Leigh and H. Warre Cornish, with cover design by Beardsley (Gallatin 866).

To the Editor of the Daily Chronicle[1]
16 April [*1894*]

Hogarth Club, 36 Dover Street, W.

Sir,

It is a matter of sincere regret to me that your reviewer's copy of *The Yellow Book* did not contain the portrait of Mrs Patrick Campbell.[2] For the benefit of your readers I may add that every other copy *did.*

Yours obediently AUBREY BEARDSLEY

1. Text from *The Daily Chronicle,* 17 April 1894.
2. The reviewer had complained of the portrait's absence. An editorial note printed below Beardsley's letter reads in part: 'Our own copy, it is true, contained a female figure in the space thus described, but we rated Mrs Patrick Campbell's appearance and Mr Beardsley's talent far too high to suppose that they were united on this occasion.'

To The Editor of **The Pall Mall Budget**[1]
27 April [*1894*]

The Bodley Head, Vigo Street, W.

Sir,

So much exception has been taken, both by the Press and by private persons, to my title-page of *The Yellow Book,* that I must plead for space in your valuable paper to enlighten those who profess to find my picture unintelligible. It represents a lady playing the piano in the middle of a field. Unpardonable affectation! cry the critics. But let us listen to Bomvet.[2] 'Christopher Willibald Ritter von Gluck, in order to warm his imagination and to transport himself to Aulis or Sparta, was accustomed to place himself in the middle of a field. In this situation, with his piano before him, and a bottle of champagne on each side, he wrote in the open air his two *Iphigenias,* his *Orpheus,* and some other works.' I tremble to think what critics would say had I introduced those bottles of champagne. And yet we do not call Gluck a *décadent.*

Yours obediently AUBREY BEARDSLEY

1. Text from *The Pall Mall Budget,* 3 May 1894.
2. Almost certainly a fictitious authority.

MS HARVARD

To Henry James[1]
30 April [*1894*]

114 Cambridge Street

Dear Mr James,

Harland tells me that you very kindly promised to lend your portrait by Sargent to *The Yellow Book.* Will you give me authority to go to your rooms and take it away as I am now making up No. 2. Of course I will have it carefully returned as soon as the block is made.[2]

Have you heard of the storm that raged over No. 1? Most of the thunderbolts fell on my head. However I enjoyed the excitement immensely.

I am very anxious to pick up an old copy of Goldoni. Is the thing to be got in Venice?

If you should come across the plays on any bookstall by chance it would be very kind of you to remember me.

The portrait of Réjane has at last been returned me from exhibition. I am afraid you must have thought me very forgetful—or worse—but now she shall be duly installed at De Vere Gardens if you still find it a pretty picture.[3] By the way did you see my portrait of Mrs Patrick Campbell. She has alas failed sadly in her new part.[4]

Will you forgive me if I tell you how delighted I was with your wonderful story!

Yours very sincerely AUBREY BEARDSLEY

1. The great American novelist (1843–1916) had contributed a story, 'The Death of the Lion', to *The Yellow Book*, April 1894.
2. Sargent's drawing of James duly appeared in the second number of *The Yellow Book*.
3. Beardsley made at least six drawings of the famous French actress Madame Réjane (Gallatin 908 and 938–942) and it is not possible to identify this particular one.
4. In *The Masqueraders* by Henry Arthur Jones at the St James's Theatre.

MS CLARK

To Maurice Baring
[*circa May 1894*]

114 Cambridge Street

Dear Mr Baring,

I certainly should prefer the cover to be white.[1]

The design was made with that idea in view.

I think you would find that such a stuffy red would rather spoil the picture.

Yours sincerely AUBREY BEARDSLEY

1. Beardsley's cover design for *The Cambridge ABC* was printed in black and white.

MS Princeton

To A. W. King
[*Postmark 15 May 1894*]

114 Cambridge Street

Dear King,

I was at Empire[1] last night in 3/- lounge but saw you not. Do come and dine with us Wednesday evening, 7.30. Let me have a line to say if you can come.

Yours ever AUBREY B.

1. The famous music-hall in Leicester Square.

MS Harvard

To William Rothenstein
[*? circa May 1894*]

114 Cambridge Street

Dear Billy,

I was very sorry not to have you with me last Sunday. Will you dine with me next Sunday at the same hour?

I'm afraid I'm engaged on Wednesday or would have been delighted to lunch with you. I don't know anything about the Pink Domino; the farce *Pink Dominos* was written (adapted) by Albery.[1]

Yours AUBREY B.

I have just got some rather jolly photos from Goya.

1. First produced in 1877, revived at the Criterion Theatre, 10 October 1892.

MS WILSON

To F. H. Evans
[*? 18 June 1894*][1]

114 Cambridge Street

Dear Evans,

Did I by any chance leave £5.0.0 at your place, either in gold or note? Have you any means of finding out? You know I gave you a cheque for £20.0.0. But when I came home I had alas only £15 minus the books. Such a nuisance, all this stupid coin.

The books have been a rare treat, and I play see-saw between Meredith and Browning. Both splendid and mean more than much to me just now.

The doctor has just left me—with rather a grave face. I suppose I shall be compelled to take a rest soon.

Yours AUBREY BEARDSLEY

1. This is the postmark date of the envelope preserved with the following letter, to which it cannot belong.

MS WILSON

To F. H. Evans
[*27 June 1894*]

114 Cambridge Street

Dear Evans,

The *Sidonia*[1] is impossible and thereby hangs a tale. I shall be paying you for it myself in a few days.

The German opera[2] is indeed exciting. Klafsky!!! beyond all praise.

Tannhäuser went very well I thought after the first act. Alvary is scarcely a singer. I go to *Tristan* on Saturday when you will see your devoted friend reclining in the unmusical stalls.

Have you seen the Réjane[3] yet. She is ravissante. I have just done a new portrait of her for *The Yellow Book*.[4] By the way it is going to be a glorious number after all. The *Comedy Ballet of*

Marionettes performed by the troupe of the Théâtre Impossible is now finished and looks superb.[5]

Then I have an astounding piece of decorative realism which I call *Les Garçons du Café Royal*[6] and a thing called *The Slippers of Cinderella.*[7] Then there are three amazing Sickerts, quite his best stuff, three admirable Steers, a divine Walter Crane (his only great thing) and about a dozen more pictures—some very amusing. The concert must stand over for a month or so till I can finish a big long thing of the revels in act I of *Tannhäuser*[8]—it will simply astonish everyone I think.

Ever yours AUBREY BEARDSLEY

P.S. They would [not] let me descend to have a chat with you last night.

1. *Sidonia the Sorceress* by Wilhelm Meinhold, issued by the Kelmscott Press in Lady Wilde's translation, 1893. At Vallance's suggestion Beardsley had drawn a frontispiece, but Morris rejected the design and Beardsley failed to redraw it. He destroyed the original.
2. A season of German opera at Drury Lane with Max Alvary and Katharina Klafsky in the leading roles. *Tannhäuser* was given on 26 June and *Tristan und Isolde* on 30 June.
3. In *Madame Sans-Gêne,* which opened at the Gaiety Theatre on 23 June 1894.
4. Gallatin 908.
5. A series of three drawings (Gallatin 903–905).
6. Gallatin 906.
7. Gallatin 907.
8. The first reference to Beardsley's projected 'romantic novel' *The Story of Venus and Tannhäuser,* which he began writing and illustrating at this time. The drawing mentioned here seems not to have been completed.

MS WILSON

To F. H. Evans
[August 1894]

114 Cambridge Street

Dear Evans,
My address is

Valewood Farm
Haslemere
Surrey.

Hentschel[1] is sending you the Réjane.

Ever yours AUBREY BEARDSLEY

Hurrah am let off the Craigie.[2]

1. Carl Hentschel (1869–1930) whose firm specialized in zinc process reproduction. He was the original of 'Harris' in Jerome K. Jerome's *Three Men in a Boat* (1889).
2. Mrs Craigie (1867–1906) published several successful novels under the name John Oliver Hobbes. Lane had evidently asked Beardsley to draw her for the series of 'Bodley Heads'—portraits of his better-known authors—appearing in *The Yellow Book*.

MS WILSON

To F. H. Evans
[Postmark 20 August 1894]

Valewood Farm, Haslemere, Surrey

Dear Evans,

I think the photos are splendid; couldn't be better.[1] I am looking forward to getting my copies. I should like them on cabinet boards if that's not too much trouble. Down here all is too peaceful for my restless brain. I shan't stop so long as I intended. However 'tis the pick of scenery and full of backgrounds for *Tannhäuser*.

The Book is a great pleasure to me and gets on well, but as slowly as any of my drawings.

I shall bring it round to you one fine evening and give you a reading.

I have just had a charming note from Sir Frederick Leighton expressing his admiration for my little efforts, and the interest with which he looks forward to a sight of my *Tannhäuser*.

I simply long for London again, the only place where you can live, or work (which comes to the same thing).

I hope your holiday trip will be a success.

Ever yours AUBREY BEARDSLEY

1. Evans was an enthusiastic amateur photographer. One of his studies of Beardsley was shown at the Salon Exhibition in October 1894 and used as the frontispiece to *Later Work*.

MS WILSON

Postcard to F. H. Evans
[*Postmark 21 August 1894*]

Haslemere

Dear Evans,
 This place gives me the blues. I'm back to Town tomorrow.[1]
 Yours AUBREY BEARDSLEY

1. On 5 September Ellen Beardsley wrote to Robert Ross: 'Haslemere
 was a failure. Aubrey took a dislike to the place directly he got there
 and wanted to rush back to town at once. I didn't quite see the sense
 of this so I persuaded him to stay on from day to day, but his depres-
 sion was so great and the life he led me so dreadful that at the end
 of a fortnight I gave it up and let him come home.'

MS PRINCETON

To A. L. Teixeira de Mattos[1]
[*1894*]

114 Cambridge Street

Dear Teixeira de Mattos,
 Do come and see me next Wednesday afternoon about 4.30
o'clock, if that time will suit you.
 Yours sincerely AUBREY BEARDSLEY

1. 1865–1921. Journalist and translator engaged at this time in editing
 the Lutetian Society translation of the works of Zola.

MS PRINCETON

To A. L. Teixeira de Mattos
[*1894*]

114 Cambridge Street

Dear de Mattos,
 Gleeson White[1] no longer edits *The Studio*, it is run entirely by
the proprietor Charles Holme.[2] If you care to see *him* here is what

you asked for. The book[3] looks capital.

Yours sincerely AUBREY BEARDSLEY

1. 1851–98. Poet and writer on art and first editor of *The Studio*.
2. Retired East India merchant (1848–1923) who devoted himself to writing and lecturing on art. He continued to edit *The Studio* for twenty-five years.
3. Probably the translation of Zola's *Les Héritiers de Rabourdin* (1894).

MS WILSON

To F. H. Evans
[*early October 1894*]

114 Cambridge Street

Dear Evans,

I will rake together that £5 from the four quarters of the publishing world, and hope to let you know of the rake's progress soon. I am so glad your photo of me was a success at the Salon. It did indeed deserve to be.

The *Tannhäuser* gets on tortoise fashion but admirably for all that. I hope to show you a specimen of the pictures ere long.

Look out for No 3 of the *Y.B.* By general consent my best things are in it, particularly one called

The Wagnerites[1]

Lane and Mathews are at last divorced.[2]

Your bookplate is designed as far as pencil is concerned. A Pierrot standing on a field plentifully sown with flowers. He raises with one hand a curtain that hangs just over his head and holds out with the other a pyx.[3]

Explanation needless.

Apropos of the Chaucer I think I will be content with Skeat as I find (contrary to a distressing rumour) that Vol IV is unexpurgated.

Yours AUBREY BEARDSLEY

1. Gallatin 915.
2. The partnership was dissolved on 29 September 1894 and *The Yellow Book* was thereafter published by Lane alone.
3. This bookplate was never completed.

MS HUNTINGTON

To W. Palmer[1]
2–3 October [*1894*]

114 Cambridge Street

My dear Palmer,

How charming of you to put my little life into *Hazell!* I enclose what you want, and have asked Lane to send you on a *Yellow Book.*

Next year you will I am sure be able to announce my death in addition to other events in my life. I am suffering from acute haemorrhage of the lungs but am not able to get away to warmer parts on account of my work which is abominably heavy. I had hoped to be at the Old Boys' dinner next month[2] but I fear it is out of the question as I have to take ridiculous care of my little self. Please remember me to the few fellows who might recollect me at Brighton.

Yours AUBREY BEARDSLEY

Born 1873[3] at Brighton. Came to London in the next year. Took up music first as a profession and gave small concerts when I was about seven or eight; afterwards went to school at B.G.S. Left when I was fifteen or sixteen. Entered architect's office and then a Fire Insurance office, but studied art at the same time by myself and at Fred Brown's (now Professor) art school. Took up art professionally on the advice of Burne-Jones and Puvis de Chavannes. First drawings appeared in No. 1 of *The Studio* with an article on them by Joseph Pennell. Also made over 300 illustrations for Malory's *Morte Darthur,* and illustrated Oscar Wilde's *Salomé* in 1893-4. The last produced a very strong and disagreeable impression upon the critics. At the beginning of this year was made art editor of *The Yellow Book* to which I contributed many drawings each number; particularly noticed were the portraits of Mrs Patrick Campbell and Réjane and of myself, also the picture *L'Education Sentimentale* and the *Wagnerites* and *Lady Gold's Escort.*

At present engaged in making a large number of illustrations for *The Story of Venus & Tannhäuser,* written by myself and to appear early in 1895.

You might just mention my posters that made rather a sensation. Avenue Theatre and Pseudonym Library also one for *To-day*[4] to appear shortly.

1. An Old Boy of Brighton Grammar School, and since 1892 editor of *Hazell's Annual,* the 1895 edition of which contains an article on Beardsley reproducing the information given in this letter.
2. At the Holborn Restaurant on 3 November 1894.
3. Beardsley was vain about his age and habitually gave misleading information about it.
4. There is no record of this poster.

MS BERG

To T. Fisher Unwin[1]
[circa October 1894]

114 Cambridge Street

Dear Mr Fisher Unwin,
 I shall be very pleased to have lunch with you next Wednesday and to discuss the book.[2]
 Yours very sincerely AUBREY BEARDSLEY

1. English publisher (1848–1935), who founded his firm in 1882.
2. Probably *Good Reading about Many Books, Mostly by Their Authors,* published by Unwin in 1894 with another version (Gallatin 790) of Beardsley's Pseudonym Library poster used as an illustration.

MS BERG

To T. Fisher Unwin
[early November 1894]

114 Cambridge Street

Dear Mr Fisher Unwin,
 Enclosed is the receipt you kindly sent me.
 Let me have a look at the proofs.
 Yours very sincerely AUBREY BEARDSLEY

MS BERG

To T. Fisher Unwin
[Date of receipt 12 November 1894]

114 Cambridge Street

Dear Mr Fisher Unwin,

By all means of course use the poster you like best.[1] *Please* tell the lithographer to ignore and obliterate my signature, I always think it looks abominable on the hoarding. I have been in the thick of doctors' consultations the last few days so please forgive the delay in answering your note. I am off in a few days to Malvern.[2]

Yours very truly AUBREY BEARDSLEY

1. Beardsley designed a second poster for Unwin. It was used to advertise his Children's Books Library (Gallatin 791).
2. Beardsley left for Malvern on 14 November to stay at a clinic recommended by Dr Symes Thompson.

MS BERG

To T. Fisher Unwin
[circa 12 November 1894]

114 Cambridge Street

Dear Mr Fisher Unwin,

Many thanks for the proof of poster which I think looks enormously fine. Are you going to use it then after all? I cannot help feeling it is the best of the two. I'm off on Wednesday.

Yours very truly AUBREY BEARDSLEY

MS WILSON

To F. H. Evans
[November 1894]

c/o Dr Grindrod, Wyche Side, Malvern

Dear Evans,

A thousand thanks for your note, the sort I like to receive. As you see I am buried in the country getting back a little of my usual

nerve. I have been suffering terribly from haemorrhage of the lung which of course left me horribly weak. For the time all work has stopped and I sit about all day moping and worrying about my beloved Venusberg. I can think of nothing else. I am just doing a picture of Venus feeding her pet unicorns which have garlands of roses round their necks.[1] (By the way don't tell anyone of this subject.)

The book *really* will be fine.

I certainly don't mean to hurry.

Please forgive me for all the monstrous delay over the Pierrot. Still the thing shall be yours ere long. I don't know when I shall get back to town.

By the way how is Thurnam?[2] I suppose he's in the same boat as I, only further out at sea.

Yours ever AUBREY BEARDSLEY

1. This drawing is not recorded.
2. William Rowland Thurnam, author of *Parsifal. The Story of Wagner's Opera,* 1914.

MS PRINCETON

To Elkin Mathews[1]
[December 1894]

St Mary's Abbey, Windermere[2]

Dear Mr Mathews,

Could you get for me one copy of the first or some early edition of Gifford's *translation of Juvenal.*[3] I don't think it is rare or expensive.

With best wishes for the season.

Yours very sincerely AUBREY BEARDSLEY

1. Lane's former partner, now in business on his own. His shop was opposite Lane's in Vigo Street.
2. Beardsley spent part of the Christmas holiday 1894 at this house which was rented by Lane. The other guests were Max Beerbohm and William Watson.
3. Beardsley's *Frontispiece to Juvenal* (Gallatin 923) was reproduced as a double-page supplement to *The Yellow Book,* January 1895.

MS PRINCETON

To Ada Leverson
[*? 2 January 1895*]

114 Cambridge Street

Dear Mrs Leverson,

It is so sweet of you to give me a place in your box tomorrow night.[1] I was so sorry you weren't able to come to see you [us] yesterday.

How exciting about Oscar and wonderful. By the way the most amazing biographies are being published of me in American papers just now.[2]

Yours AUBREY BEARDSLEY

1. Possibly for the first night of Wilde's *An Ideal Husband,* which opened at the Haymarket Theatre on 3 January 1895. Ada Leverson contributed a short anonymous skit of the play to *Punch,* 12 January 1895.
2. In connection with his abortive plan for visiting the United States with John Lane in March 1895.

MS HARVARD

To Ada Leverson[1]
[*? 14 February 1895*]

114 Cambridge Street

Dear Mrs Leverson,

I shall be enchanted to come to the play this evening![2] I will certainly make a little picture with that title[3] only you must give me some suggestions for it.

Yours most sincerely AUBREY BEARDSLEY

1. Added above: 'I shall be delighted to come on and shall get to you soon after 9. Yrs. Mabel.'
2. Possibly the first night of Wilde's *The Importance of Being Earnest* on 14 February 1895, when Beardsley and his sister were among the guests in Ada Leverson's box.
3. Perhaps for Ada Leverson's parody of Wilde's play *The Advisability of not being Brought up in a Handbag,* published in *Punch,* 2 March 1895.

MS Princeton

To Miss Milman[1]
16 February [*1895*]

114 Cambridge Street

Dear Miss Milman,

I shall look forward very much to meeting Father Williamson.[2] Would Tuesday or Wednesday afternoons suit you? We shall be free both those days and Friday also if that would be more convenient.

Yours sincerely AUBREY BEARDSLEY

1. Probably Lena Milman, translator of Dostoevsky's *Poor Folk,* for which Beardsley had designed the title-page in 1894 (Gallatin 798).
2. Probably the Rev. C. D. R. Williamson (*b*. 1853) of the London Oratory.

MS Princeton

To Father Williamson
Monday [*circa March 1895*]

114 Cambridge Street

Dear Father Williamson,

I wonder if you would care to use this? I think some of the pictures would amuse you.[1] (There will be some of mine.) If you think of coming you might meet us there about 12 o'clock (Saturday week).

Yours sincerely AUBREY BEARDSLEY

If you have nothing better to do would you come and take tea with me tomorrow afternoon?

1. Probably a ticket of admission to the New English Art Club exhibition in April which included Beardsley's *Black Coffee* (Gallatin 976).

MS LAMBART

To Ada Leverson
[*April 1895*]

114 Cambridge Street

Dear Mrs Leverson,

If I can possibly manage it I will turn up at taper time[1] or rather earlier this afternoon.

I should love to see Oscar's letter. Poor dear old thing, I am writing to him this morning. I suppose letters reach him all right.[2]

We stayed on at Brandon's[3] till past three.

Very sincerely yours AUBREY BEARDSLEY

1. The phrase is borrowed from *The Story of Venus and Tannhäuser,* Chapter 1.
2. Wilde had been arrested on 5 April. He remained in prison until he was granted bail on 7 May. There is no record of his receiving a letter from Beardsley.
3. Brandon Thomas (1856–1914), the author of *Charley's Aunt.* His wife was a cousin of Ernest Leverson, Ada Leverson's husband.

MS HARVARD

To Ada Leverson
Tuesday [*April–May 1895*]

114 Cambridge Street

Dear Mrs Leverson,

I am alas! engaged tomorrow evening or should have been charmed to come and dine with you. I look forward eagerly to the first act of Oscar's new Tragedy.[1] But surely the title *Douglas* has been used before.

Yours most sincerely AUBREY BEARDSLEY

1. Wilde had entrusted the manuscript of his unfinished play *La Sainte Courtisane* to Ada Leverson for safe keeping during his imprisonment, but the reference here is more probably a joke about his forthcoming trial, in which Lord Alfred Douglas's name was repeatedly mentioned.

MS PRINCETON

To William Heinemann[1]
[*? circa April 1895*]

114 Cambridge Street

Dear Heinemann,
Should be so pleased if you would come and take tea with us tomorrow (Thursday) afternoon. I can't tell you how much I liked your play.[2]

Yours very sincerely AUBREY BEARDSLEY

1. English publisher (1863–1920) who founded his firm in 1890.
2. *The First Step,* Heinemann's first play. It was published in 1895 but not publicly performed. We have not traced the private performance which Beardsley apparently saw.

MS McGILL

To Frederic Chapman[1]
[*April–May 1895*]

114 Cambridge Street

Here is the W. C. Dawe Key[2]—Mr Kent's drawings[3] are, of course, quite admirable and must be used.[4]

1. Manager of Lane's office and in charge of The Bodley Head during Lane's absence in the United States.
2. Ornamental key embodying the author's monogram for the contents page, back cover and spine of *Yellow and White* by W. Carlton Dawe, published by Lane in his Keynotes Series, 1895 (Gallatin 833).
3. Projected illustrations for *Yellow and White,* not used.
4. Also at McGill is a postcard from France postmarked 2 May 1895 with another ornamental key and note: 'Here it is. A.B.'

MS OXFORD

To André Raffalovich[1]
[*circa 8 May 1895*]

114 Cambridge Street

My dear Mentor,[2]
 Very many thanks for your book of verses[3] which I am just dipping into.
 I have been writing most of the day and found the chocolate a great support in my quest of epithets. On Friday I shall be pleased to lunch with you.
 Thank you for the note.

Yours TÉLÉMAQUE

1. Marc-André Raffalovich (1864–1934), a friend of Ada Leverson's, had settled in England about 1882. He had published four books of poems and a novel and was now living at 72 South Audley Street. In February 1896 he became a Roman Catholic and was largely responsible for Beardsley's conversion a year later.
2. The allusions are to *The Odyssey,* where Telemachus is advised by Mentor, an old comrade of Odysseus.
3. Raffalovich's forthcoming *The Thread and the Path.*

MS OXFORD

To André Raffalovich
[*circa 11 May 1895*]

114 Cambridge Street

My dear Mentor,
 I shall be enchanted to assist at the performance of *Mefistofele*[1] on Thursday. I have never heard it.
 As to the passage[2] you send me I don't think it could possibly do me any harm; besides I in no way regret my pictures to *Salomé.* Crashaw is perfectly delicious.[3] I shall be with you tomorrow.

Yours AUBREY BEARDSLEY

1. By Boito, given at Covent Garden once only in the 1895 season on Tuesday (not Thursday) 14 May.

2. Probably a footnote on *Salomé* in Raffalovich's *L'Affaire Oscar Wilde,* published in France later in the year: 'M. Aubrey Beardsley, un jeune artiste du plus grand talent, eut la malcontreuse chance d'illustrer cette *Salomé* médiocre de douze dessins que je déplore en les admirant. Mais il n'a pas été dupe de cette publication.'
3. Presumably Richard Crashaw (*c.* 1613–49).

MS OXFORD

To André Raffalovich
[*? 13 May 1895*]

114 Cambridge Street

My dear Mentor,
I have noted your charming invitations upon my tablets.
Last night was a perfect success.[1] I can't tell you how much I enjoyed myself.

Yours TÉLÉMAQUE

1. Probably the first performance, given at Raffalovich's house, of two short plays, *A Northern Aspect* and *The Ambush of Young Days,* written by him in collaboration with John Gray. The title-page of the printed text is dated 12 May 1895.

MS OXFORD

To André Raffalovich
[*15 May 1895*]

114 Cambridge Street

Dear Mentor,
The little sticks are quite 'adorable'.[1] I never wear an overcoat after the first of May.
Your study of inversion[2] is I think quite brilliant. Thanks so much for giving me a copy. Till this evening.

Yours AUBREY BEARDSLEY

I enjoyed *Mefistofele* enormously.

1. Walking sticks (Gray's note). The inverted commas round 'adorable' suggest that Raffalovich had teased Beardsley for his affected use of the word.
2. *L'Uranisme. Inversion Sexuelle Congénitale,* published in France, 1895.

MS OXFORD

To André Raffalovich
[*circa 16 May 1895*]

114 Cambridge Street

My dear Mentor,

First for your sonnet[1] a thousand thanks. You shall have one in return when my thoughts can find 'a shape in which to wander forth', meantime your verses lie amongst my treasures. How charming of you to send me these letters of Meredith,[2] they are full of his splendid manner. Of course I shall value them enormously—but I feel I am robbing you.

I am delighted with the idea of making your portrait;[3] it must be in pastel on brown paper—full length. I shan't plague you with long sittings as I draw very quickly.

Monday evening I am free and will be very pleased to spend it with you.

Yours till Saturday morning TÉLÉMAQUE

I am beginning the frontispiece[4]—a literal rendering of the first line—.

1. Not traced.
2. Raffalovich started to correspond with Meredith in 1881. Meredith's letters, published in 1912, contain seven to Raffalovich.
3. Beardsley never made this drawing.
4. To *The Thread and the Path,* published by David Nutt in 1895. Beardsley's drawing, *The Mirror of Love* (Gallatin 1051), was not used, and was first published in *Aubrey Beardsley* by Arthur Symons, 1898. The first line is: Set in the heart as in a frame Love liveth.

MS OXFORD

To André Raffalovich
Saturday [*25 May 1895*]

114 Cambridge Street

My dear Mentor,

Very many thanks for your letters.

It was so charming of you to like the frontispiece. I am going to Nutt's with it the first thing next week and will try to explain to him how the book is to be made up.

I hope your journeying by sea and land has not tired you too much.[1]

London is adorably bright and busy today. I don't quite know what's happening but St James's Palace parapets are lined with pretty frocks.[2]

Looking forward to a letter from you—and the columbines.

Yours TÉLÉMAQUE

Please give my kindest regards to Miss Gribbell.[3]

1. Raffalovich was on holiday in Germany.
2. Official celebrations of the Queen's birthday.
3. Florence Truscott Gribbell, Raffalovich's former governess, now in charge of his household and his travelling companion. She remained with him until her death in 1930.

MS READING

To John Gray[1]
Saturday [? *25 May 1895*]

114 Cambridge Street

My dear Gray,

Thanks awfully for the little bundle of verses—they are quite delicious—particularly the charming interludes from the *Lovers' Manual*. Nutt will be a little surprised and shocked I think when he hears that some French novels are bound in yellow paper—however I will break all that gently to him.

Yours AUBREY BEARDSLEY

1. Poet and translator (1866–1934) famous for his first volume of poems, *Silverpoints,* published in 1893. At this time he was a librarian in the Foreign Office, but in 1898 he gave up his career to study for the Roman Catholic priesthood. He was ordained in 1901 and spent the rest of his life in Edinburgh. His friendship with Raffalovich dated from 1892. Their play *The Blackmailers* had been produced in 1894.

MS Oxford

To André Raffalovich
[28 May 1895]

114 Cambridge Street

My dear Mentor,

Thank you for your letter and the photograph which interests me very much.

The frontispiece is quite finished and looks pretty.

Sarah's first night[1] was a huge success. I have never seen such a reception as she got. She played superbly. What a pity though she did not start with *Fedora*. It would have been such a splendid reply to Mrs Patrick Campbell who really turns out to be the most incompetent creature.[2] How I should love to come to Berlin, but I'm afraid it will be impossible with all the work I have to get through. By the way, some lovely flowers came to me yesterday from Goodyear's[3]—thanks so much. I saw the prospectus for *Pan*[4] when I was in Paris, of course it interested me enormously; it would be quite delightful to do anything for it.

Your advice as to work, food and sleep is not wasted on me. I have plenty of each. I suppose the result of the Oscar trial is in the German papers—two years' hard.[5] I imagine it will kill him.

On Friday I am going to hear *Tannhäuser*.[6] I look forward to it with mixed pleasure for it puts me most terribly out of conceit with my own little variations on the same theme.

Best remembrances to John Gray.

Yours TÉLÉMAQUE

Please give my kindest regards to Miss Gribbell.

1. Sarah Bernhardt began her season at Daly's Theatre with Sardou's *Gismonda* on 27 May.

2. Mrs Patrick Campbell opened in Sardou's *Fedora* at the Haymarket Theatre on 25 May.
3. Florist in Bond Street.
4. German literary and artistic magazine first published in 1895.
5. Wilde was retried after the jury had failed to agree at his first trial earlier in the month. On 25 May he was convicted and sentenced to two years' hard labour.
6. The performance at Covent Garden was announced for 31 May.

MS OXFORD

To André Raffalovich
[*circa 29 May 1895*]

114 Cambridge Street

Dear Mentor,

A deadlock. Nutt refuses to print my frontispiece because it contains a nude Amor. What's to be done?

Yours TÉLÉMAQUE

MS OXFORD

To André Raffalovich
Sunday [*2 June 1895*]

114 Cambridge Street

My dear Mentor,

I am most distressed at Nutt's behaviour. Have you really withdrawn the book? Surely it would have been better simply to have dropped the frontispiece and let me make another.[1] It was delightful of you to think of me in Goethe's rose garden.[2] What a great treat it must have been to see his collection of treasures; the drawings especially must have been interesting. I am almost surprised when you tell me that there is a Watteau amongst them. The cult for him is so entirely modern; and when Goethe probably acquired the drawing Watteau's reputation had been smothered everywhere—except in England—and the new classical school in Germany—Winckelmann and all the rest, must have had him in abhorrence.

It will be impossible for me to join you!

Our house is on the eve of sale and I can't leave my sister single-handed. The new tenant can take possession almost at once so a grand move would be imminent.

Goodyear has sent me the most delicious flowers. Thank you so much. At the opera on Friday *Tannhäuser* was suddenly changed for *Lohengrin* which never touches me outside the concert room. The most impossible parts of the *Ring* are more suitable for the operatic stage, I don't believe the tenor lives who could play *Lohengrin*. Albani was the Elsa and too vile for words. I shall be enormously interested to see those ten new pages of your *Procès Oscar*. I hear he has been put into the infirmary.[3] So glad the weather is behaving itself during your tour. Cassel must have been adorable.

Yours TÉLÉMAQUE

Please give my kindest regards to Miss Gribbell and best remembrances to John Gray.

1. *The Thread and the Path* was printed without frontispiece.
2. Raffalovich's letter had probably referred to Beardsley's drawing *The Mysterious Rose Garden* (Gallatin 920) first published in *The Yellow Book* January 1895.
3. Wilde was serving the first part of his sentence in Wandsworth Prison.

MS OXFORD

Telegram to André Raffalovich
5 June 1895

Received your letter should so much like to come and will if I possibly can. Berlin must be splendid. Some columbines have just come and are quite adorable. Télémaque.

MS OXFORD

Telegram to André Raffalovich
8 June 1895

Thanks for sonnets. Quite delightful. Perhaps you had better not take rooms till I wire again. Have many business engagements. Télémaque.

MS Oxford

Telegram to André Raffalovich
14 June 1895

Thanks for letters. Could not answer. Been through rather a trying time. So glad you return. Télémaque.

MS Oxford

Telegram to André Raffalovich
16 June 1895

So sorry to hear of your illness. Shall be delighted to lunch Wednesday. Look forward to seeing your treasures. Télémaque.

MS Oxford

To André Raffalovich
[circa 17 June 1895]

114 Cambridge Street

Dear Mentor,
 I don't know whether you left Berlin before my last wire arrived to say I should be delighted to lunch with you Wednesday.
 I do hope your sufferings are at an end.

Yours TÉLÉMAQUE

MS Oxford

To André Raffalovich
[circa 26 June 1895]

[London]

Dear Mentor,
 I shall be delighted of course to go with you to the colour music.[1] Thanks so much for the magazine. Mabel and myself most pleased to dine with you next Sunday.

Yours TÉLÉMAQUE

1. A 'colour organ' which projected coloured patterns onto a screen to accompany piano music was demonstrated by its inventor, A. Wallace Rimington, at St James's Hall on 27 June.

To the Editor of St. Paul's[1]
28 June [*1895*]

114 Cambridge Street

Sir,

No one more than myself welcomes frank, nay hostile, criticism, or enjoys more thoroughly a personal remark. But your art critic[2] surely goes a little too far in last week's issue of *St. Paul's,* and I may be forgiven if I take up the pen of resentment. He says that I am 'sexless and unclean'.

As to my uncleanliness, I do the best for it in my morning bath, and if he has really any doubts as to my sex, he may come and see me take it.

Yours etc. AUBREY BEARDSLEY

1. Text from *Aubrey Beardsley* by Haldane Macfall (1928).
2. Haldane Macfall (1860–1928), novelist and art historian writing as Hal Dane. Beardsley was persuaded to withdraw this letter.

MS OXFORD

To André Raffalovich
[*July 1895*]

114 Cambridge Street

I am most grieved not to be able to go with you to the play last night, and I fear I shall be unable to see you this evening.

I can't answer your letter this morning. What afternoon will you be alone? I want to see you about something.

Yours A.B.

MS OXFORD

To André Raffalovich
[*July 1895*]

114 Cambridge Street

My dear Mentor,

I really haven't the faintest idea what you mean by a declaration of war. Of course I'm dreadfully ashamed of having forgotten your prior invitation. You ought to know by this time how very unimpressionable my memory is. However it retains today at 2 o'clock.

Yours A———.

MS PRINCETON

To Clara Savile Clarke[1]
Tuesday [*circa July 1895*]

57 Chester Terrace. S.W.[2]

Dear Mrs Savile Clarke,

It was quite delightful of you to send me that art muslin. It suits me so well and will be so nice and cool in the hot weather. If my tailor finds that there is any over I shall get some curtains made.

Yours very sincerely AUBREY BEARDSLEY

1. Author of *The Poet's Audience* (1891) and *The World's Pleasures* (1893), wife of H. Savile Clarke, a well-known playwright. Her daughter Kitty, who later married Cyril Martineau, was a celebrated beauty and a friend of Ada Leverson, who used her as the model for the heroines of her novels.
2. Beardsley took a lease on this house in June 1895 but lived there for only a few weeks.

MS HARVARD

To William Rothenstein
Sunday [*circa July 1895*]

Casino de Dieppe[1]

Dear Billy,

Do forgive me for behaving so rudely. I had meant to get back

to Town on Sunday but missed the boat and so stopped on here indefinitely.

Really Dieppe is quite sweet—it's the first time I have ever enjoyed a holiday—Petits Chevaux and everything most pretty and amusing. I shall leave at the end of the week. What about Gyp?[2] Symons[3] has written to Meredith to ask if he would sit to you for a portrait. Personally I think Gyp is much more desirable. Do bother Smithers about it. He comes over here on Friday en route for Paris I fancy. How is the furnishing progressing?

<div align="right">Yours AUBREY</div>

1. Beardsley paid several visits to Dieppe in the summer of 1895, often travelling with Rothenstein, Leonard Smithers and Arthur Symons. It was chiefly on these trips that the plans were made for the forthcoming magazine *The Savoy*.
2. Pseudonym of the French authoress Comtesse de Martel de Janville (1849–1932). Rothenstein was looking for sitters for a series of portraits to appear in *The Savoy*.
3. Arthur Symons (1865–1945), poet, essayist and critic, at this time editor-designate of *The Savoy*.

To John Lane[1]
[*circa July 1895*]

<div align="right">Dieppe</div>

. . . I think £15 is what I should want as the Pierrot Library[2] will mean a good deal of work.

1. Text obtained by R. A. Walker.
2. A series of books of short stories named after the first volume, *Pierrot* by H. de Vere Stacpoole. Beardsley designed the covers, title-page, spine and end-papers (Gallatin 1044–1049).

1895-1896

SOON after his first meeting with Raffalovich Beardsley made the acquaintance of a man who was to have a decisive effect on his work for the remainder of his life. This was the publisher Leonard Smithers, a man of audacious originality, an utterly unbusinesslike enthusiasm for literature and art, and no morals. Chance and opportunism together brought him on the scene at the moment when he could play his part to the greatest effect. Early in 1895, on the dissolution of his partnership with H. S. Nichols, he opened his own firm, starting as a bookseller but prepared to spend his substantial initial capital to establish himself as a publisher.

Beardsley's dismissal from *The Yellow Book* had shocked many of his fellow-contributors into severing their links with the Bodley Head, and one of them, Arthur Symons, was the first to see that Smithers could be used as the ideal substitute for Lane as publisher to the new writers and artists. He persuaded Smithers to seize the moment and engage Beardsley and himself to edit a new magazine to rival and replace *The Yellow Book* as the showcase of the latest ideas. This was *The Savoy*. Its arrival came most opportunely for Beardsley. He once again had regular employment and a publisher who was not only eager to take all his drawings but was also full of ideas for new projects.

Despite his continued poor health Beardsley flung himself into the work. Eager to resume *The Story of Venus and Tannhäuser* for *The Savoy*, he travelled to Belgium, Germany and France, writing as he went. On his return to London he took rooms in St. James's Place, presumably to be near to Smithers's office in Arundel Street off the Strand. 114 Cambridge Street had been sold and his mother and sister, faithful to Pimlico, returned to Charlwood Street, where they lived at No. 48.

The first issue of *The Savoy* was published on 11 January 1896. Although its impact was not comparable with that of *The Yellow Book* it was in many ways a better magazine. It was more original, less dependent on established names; Symons was a more incisive

and discriminating editor than Harland, and Beardsley was now at the height of his powers. The conceit of placing the story of Tannhäuser in an eighteenth-century setting had turned his style from the Japanese influence, which had dominated his *Salomé* drawings and some of his work for *The Yellow Book,* to a classical manner perfectly suited to his next major undertaking, the illustration of *The Rape of the Lock,* which Smithers was to publish in a *de luxe* edition.

Beardsley did most of the work in Paris. Others staying there in the early part of 1896 included two of Smithers's authors, Ernest Dowson and Vincent O'Sullivan. Beardsley went to the first performance of *Salomé* on 11 February with Dowson, and through him he met two of the younger French critics, Henry Davray and Gabriel de Lautrec, who played a large part in making his work known in France.

In March Smithers came over and on an impulse Beardsley decided to go on with him to Brussels. A few days after his arrival there he suffered a complete breakdown. From this time on he remained an invalid, weakened by repeated haemorrhages and in constant need of care. His life became a succession of journeys in search of health. As soon as he could travel he returned to London. After a few weeks in bed he was advised by the doctors to try Crowborough. Life in an English country boarding house was utterly wearying and in a fortnight he was back in London, this time to be sent to Epsom, where he spent six restless weeks before moving to Boscombe. There Ellen Beardsley came to live with him and he settled down for the winter.

Throughout the year he continued to work feverishly; indeed 1896, as R. A. Walker pointed out, was Beardsley's *annus mirabilis.* In the course of it he produced some thirty major drawings for *The Savoy,* illustrated *The Rape of the Lock,* the *Lysistrata* and Dowson's play *The Pierrot of the Minute.* Three other projects, eagerly begun but soon abandoned, *Ali Baba,* a volume of his own *Table Talk* and a translation of the *Sixth Satire* of Juvenal, elicited further drawings. At intervals he continued to write *Venus and Tannhäuser,* composed two memorable poems and at least toyed with the text of *Table Talk,* the Juvenal translation and a narrative version of *Das Rheingold.*

His letters in these months show unusual courage. He does not conceal the fact of his illness, but all the time he plays it down, and even when things are at their worst he spares the feelings of his correspondents by adding touches of wry humour that take the

edge off the tragedy of his situation, just as the constant vivacity of his work hides the appalling effort which it must have cost him.

To Leonard Smithers[1] [2]
30 July 1895

2 Bennett Street,[3] St. James's Street, S.W.

Dear Mr Smithers,

My doctor has just sent me to bed for two days on account of a haemorrhage of the lungs. It will therefore be impossible for me to come to you tomorrow as promised. Could you perhaps visit me at 57 Chester Terrace, Eaton Square? About 5 o'clock—or later if you like?

Your truly devoted A B

1. Leonard Charles Smithers (1861–1907) had practised as a solicitor in Sheffield before settling in London about 1890. He opened his own bookshop in Arundel Street, off the Strand, in 1895. The first book to appear under his imprint was Symons's *London Nights*, published in June that year. Through Symons he met W. B. Yeats, Ernest Dowson, Rothenstein and Beardsley, who had been dismissed from *The Yellow Book* in April and welcomed the opportunity of working for Smithers's new venture *The Savoy*.
2. Translated from *Briefe Kalendernotizen*.
3. Probably a doctor's consulting room.

MS HUNTINGTON

To Leonard Smithers
[Postmark 19 August 1895][1]

57 Chester Terrace

Dear Mr Smithers,
Might not my little book[2] be called
The Queen in Exile?

You see if we gave it that name Lane would not suspect it was his book when your prospectus or announcement appears.

Yours sincerely AUBREY BEARDSLEY

1. Most of Beardsley's letters to Smithers are preserved with envelopes, but it is clear that they have frequently been matched with envelopes that cannot belong to them. We have therefore used the postmark dates very sparingly and only where there is some corroboration. Otherwise we have ignored them and dated the letters as accurately as possible from internal evidence.
2. *The Story of Venus and Tannhäuser*, still being advertised by Lane but now transferred to Smithers, who published the first four chapters in *The Savoy* January-April 1896. The version there printed was called *Under the Hill.*

MS HUNTINGTON

To Leonard Smithers
[? late August 1895]

57 Chester Terrace

Dear Smithers,
 Many thanks for cheque.
Here is the initial for poem.[1]
On and after Saturday my address is
 10 St James's Place[2]
 St James's Street
 S.W.
All the books I have left behind are at your disposal. Also a set of erotic Japanese prints.

Yours sincerely AUBREY BEARDSLEY

1. Probably intended for Beardsley's poem *The Three Musicians* in *The Savoy,* but used instead for the prospectus of *The Savoy* (Gallatin 1031).
2. Beardsley rented a set of rooms at this address until early in 1896. A previous tenant was Oscar Wilde.

MS HARVARD

To William Rothenstein
[late August 1895]

57 Chester Terrace

Dear Billy,
 What of John Oliver Hobbes as a portrait.[1] Do you know her?
She is a dear pretty little lady. By the way this is one of the last letters
I shall write from here. On and after Sunday my address is
 10 St James's Place
 SW.
If you care to cart off a few books I have some that might amuse you.
Not rare or valuable though, I'm afraid.
 Yours AUBREY BEARDSLEY

1. Rothenstein's portrait of John Oliver Hobbes was published in the
 Illustrated Supplement to *The Saturday Review*, Christmas 1896.

MS HUNTINGTON

To Leonard Smithers
[late September 1895]

Café des Tribunaux, Dieppe[1]

Dear Smithers,
 My clothes have arrived and Richard is himself again.[2] Weather
quite perfect so I shall linger a little here. *For Satan's sake send me*
de quoi vivre and quickly. This I ask as charity and not by right.
 I want to urge you to get the block of the cover[3] made as soon
as possible; it is so much easier to make a good block from a fresh
drawing.
 Yours ever AUBREY BEARDSLEY

1. Beardsley had been travelling in Belgium and Germany.
2. *Richard III*, Act V, scene iii.
3. For *The Savoy*, January 1896.

MS HARVARD

To William Rothenstein
[*late September 1895*]

Chalet du Bas-Fort-Blanc, Dieppe

Dear Billy,

J. E. Blanche[1] is sending two pictures to the forthcoming exhibi-
tion of portraits at the New Gallery.[2] He has no time to get frames
made in *Dieppe* so would you order Chapman to make frame AT
ONCE for the following measurements. I enclose pieces of string for
the largest which is this shape

The two smaller lengths of strings are for my own portrait—

The canvases will be at the New Gallery and ready for framing.

You will be doing Blanche such a favour if you will arrange this
immediately.

Yours AUBREY BEARDSLEY

Best love etc.

The frame for the large picture should be plain oak gilded something after this fashion.

The frame for my portrait an ordinary Watts frame—gilded (and glazed).
4 October I think is last day for sending in. AB

1. Jacques-Emile Blanche (1862–1942), French portrait painter. His portrait of Beardsley, painted at Dieppe in the summer of 1895, is now in the National Portrait Gallery.
2. Exhibition of the Society of Portrait Painters, October 1895.

MS PRINCETON

To Leonard Smithers
[*late September 1895*]

Sandwich Hotel, Dieppe

Dear Smithers,
 Very many thanks for your cheque. I'm afraid though it won't be enough to secure my returning ticket. I leave here *on Sunday next midday. Could you let me have something before then.*
 Tannhäuser goes on well. I have also the *Savoy* drawing in hand.[1]
AUBREY BEARDSLEY

1. Probably *Siegfried* (Gallatin 1032), used on the prospectus of *The Savoy* and adopted by Smithers as a trademark.

MS PRINCETON

To H. C. J. Pollitt[1]
Thursday [*October 1895*]

10 & 11 St. James's Place, S.W.

My dear Friend,
 I found your charming letter awaiting me on my return to this desolate city. I have been touring all over the world and ended in Dieppe and lost my little all at the "Little Horses." Your book plate shall be my first care. I wish by the way you would give me my wages now for it. The *Venus* (first three chapters) will appear in No. 1 of the *Savoy*. With pictures of course. What has your summer holiday been like?

AUBREY BEARDSLEY

1. Herbert Charles Pollitt (1871–1942), who assumed the Christian name Jerome, collector and connoisseur, at this time still at Trinity College, Cambridge. In 1898 he began to correspond with Wilde and at about the same time became an associate of Aleister Crowley in the study of Black Magic. It is not certain that this letter is addressed to Pollitt, but its tone resembles that of Beardsley's later letters to him and Beardsley designed a bookplate for his use.

MS PRINCETON

To John Lane
[*October 1895*]

10 & 11 St. James's Place

My dear Lane,
 The block is not bad. Only the Pierrot's eye (to your left) seems to miss an eyeball and the whole effect in the proof is a little thin.[1] However this may be just as well as it will be printed on cloth. On the whole the result is quite good.

Yours AB

1. Design for the reverse cover of Pierrot's Library (Gallatin 1045).

MS Princeton

To John Lane
[*circa October 1895*]

10 & 11 St. James's Place

My dear Lane,

Your note has come too late for me to get the Grant Allen T. P.[1] ready by tomorrow morning early but you shall have it in the early afternoon. I am engaged alas next Friday for lunch or should have been charmed to be with you.

Sincerely yours AUBREY BEARDSLEY

1. Title-page for *The British Barbarians* by Grant Allen, 1895, (Gallatin 816).

MS Huntington

To Leonard Smithers
[*Postmark 7 November 1895*]

10 & 11 St. James's Place

My dear Smithers,

The letter from Billy which I took as an answer to my own was written and sent before he got my refusal to publish the Cunninghame Graham.[1]

He has sent me a very charming drawing instead; (to be called *Chloe*). I should advise you very strongly to publish the *Pucelle* etching[2] as well, it will give distinction to the number. I do wish you could send for W. R.'s picture; my drawings keep me prisoner here, I can tell you.

The *Toilet* scene[3] goes splendidly though I'm afraid it can't possibly be got through with till Saturday night.

The third picture will take much less time.

Yours A. B.

1. Robert Bontine Cunninghame-Graham (1852–1936), Scottish author, socialist and horseman. Rothenstein's portrait of him is now in New Zealand.

2. Both these appeared in *The Savoy,* January 1896.
3. *The Toilet of Helen* (Gallatin 997), the second of Beardsley's illustrations to *Under the Hill* in *The Savoy,* January 1896.

MS HUNTINGTON

To Leonard Smithers
[*circa 10 November 1895*]

10 & 11 St. James's Place

Dear Smithers,

The dreadful thing was a blaze up with Lane-cum-Mathews, and a drawing to be produced at the sword's point.[1] The *Toilet* is going really grandly but there is such a heap of work in it. It will be finished tomorrow and that will include a night's work. Did you see the *National Observer*?[2]

Yours A B

Pennell's drawing[3] will be sent to you tomorrow.

1. The dispute concerned Beardsley's frontispiece to *An Evil Motherhood* by Walt Ruding which Mathews published in 1896. Beardsley had intended to use his drawing *Black Coffee* (Gallatin 976) which had been destined for *The Yellow Book,* April 1895. At the last moment an objection was raised, probably by Lane refusing to relinquish his rights in the drawing, and Beardsley was obliged to produce another design (Gallatin 975).
2. Article and satirical poem on *The Savoy* in the issue for 9 November.
3. *Regent Street,* published in *The Savoy,* January 1896.

MS HUNTINGTON

To J. H. Ashworth[1]
[*November 1895*]

10 & 11 St. James's Place

Dear Mr Ashworth,

I wish you would let me have back the last picture (Cardinal's

portrait and arms) .² I want to convert it into an initial letter for the dedication of my book.

<div align="right">Sincerely yours AUBREY BEARDSLEY</div>

I have nearly finished a new and superior drawing for the prospectus so don't use the old one.³

1. John Henry Ashworth, bookseller and collector, and Smithers's chief assistant.
2. *Under the Hill* begins with a mock dedication to Cardinal Giulio Poldo Pezzoli, 'Bishop of Ostia and Velletri, Nuncio to the Holy See in Nicaragua and Patagonia'. The drawing mentioned here was not used and is unrecorded.
3. Beardsley made two versions of his drawing for the cover of the prospectus of *The Savoy*. The one here withdrawn (Gallatin 1030), a winged Pierrot with pencil and quill, was replaced by a drawing of John Bull (Gallatin 1029).

MS HUNTINGTON

To Leonard Smithers
[November 1895]

<div align="right">10 & 11 St. James's Place</div>

My dear Smithers,

Very many thanks for the cheque. I wish you would instruct Naumann¹ to take my signature off the prospectus drawing. I think for many reasons it should not be there. Please and particularly do this.²

<div align="right">Yours A B.</div>

Fanfreluche shall be the abbé's name,³ and the play now will be called *The Bacchanals of Sporion*.⁴ I don't want the dedication to be pictured after all. It would be underlining the joke too much. To say nothing of the fact that I am not very successful with cardinals' hats.

1. Paul Naumann, the blockmaker responsible for reproducing the illustrations in *The Savoy*.
2. The drawing of John Bull contained a slight impropriety, but despite protests from George Moore it was printed unexpurgated. Beardsley's signature was omitted.
3. The hero of *Under the Hill*. In this version he had previously been

called the Abbé Aubrey; in the full text he is the Chevalier Tann-
häuser.
4. Described in Chapter IV. In the other version it is simply *The Ballet
Danced by the Servants of Venus.*

MS HUNTINGTON

To Leonard Smithers
[November 1895]

10 & 11 St. James's Place

Dear Smithers,
 I will let you have a fair list[1] first thing tomorrow morning. The
prospectus looks A 1. Thanks for cheque. A B

1. Probably of the art contents of the first number of *The Savoy.*

MS HUNTINGTON

To Leonard Smithers
[Postmark 21 November 1895]

10 & 11 St. James's Place

Dear Smithers,
 Thanks for letters and I say 'yes' to all the suggestions. The
third of the illustrations to *Under the Hill*[1] will be finished quite
in time to send out the dummy copy. In the ordinary course of
things you shall have the picture late tomorrow morning.
 Yours sincerely AUBREY BEARDSLEY

1. *The Fruit Bearers* (Gallatin 998).

MS Oxford

To André Raffalovich
Thursday [*28 November 1895*]

10 & 11 St. James's Place

I wish I had illustrated a book recently! but all my essays in art and letters have been kept for a new magazine I am bringing out. *That* will contain a Christmas card; and the beginning of a fairy tale (illustrated) by myself and also some verse.[1] Did not Frau Ida Doxat sing quite splendidly at the last Mottl concert?[2]

Yours AUBREY BEARDSLEY

1. Besides the opening chapters of *Under the Hill, The Savoy,* January 1896, contained Beardsley's poem 'The Three Musicians' and his large Christmas card (Gallatin 999).
2. At St James's Hall on 26 November.

To Leonard Smithers[1]
[*circa December 1895*]

10 & 11 St. James's Place

Here are a few more useful addresses.[2]

1. Translated from *Briefe Kalendernotizen.*
2. Presumably recipients of the prospectus of *The Savoy.*

MS Princeton

To A. W. King
Monday [*Postmark 9 December 1895*]

10 & 11 St. James's Place

My dear old friend,
 It will be impossible for me to come and see you in the evening as I have a bothering dinner which I cannot throw over. Will you

be at your hotel from 6 to 7 by any chance? I could come then. Or would you be in this part of the world (St. James's Street) in the late afternoon, and be able to take a little tea with me? Of course I would turn up the first thing Wednesday morning if you should be stopping as long as that in town.

The Savoy is quite ready but will not appear till January 4th.[1] I think you will be pleased with it.

With kindest regards,

Yours affectionately AUBREY BEARDSLEY

What a year it's been!

1. It finally appeared on 11 January 1896.

MS OXFORD

To André Raffalovich
[circa December 1895]

10 & 11 St. James's Place

My dear **Mentor,**
 I shall be most delighted to sup with you tomorrow.

Yours AUBREY BEARDSLEY

MS OXFORD

To André Raffalovich
[December 1895]

10 and 11 St. James's Place

My dear Mentor,
 I am indeed pleased at the prospect of beginning the long talked-of portrait. I hope it is going to be a great success.

Let me know directly you can give me a sitting.

I may be in Paris at the opening of the New Year, but only for a few days.

Yours AUBREY BEARDSLEY

MS OXFORD

To André Raffalovich
[December 1895]

The Savoy, Effingham House, Arundel Street, London, W.C.

My dear Mentor,
 I saw the Michelet in a second-hand bookshop in Hampstead Road (near Robert Street). It was in about twenty volumes.
 I am beginning the sketch presently.
 Please forgive this commercial paper.
 Yours AUBREY BEARDSLEY
10 St James's Place.

MS OXFORD

To André Raffalovich
[? 21 December 1895]

 10 & 11 St. James's Place

My dear Mentor,
 I shall be delighted to dine with you on the 8th. Last night I went to one of Dolmetsch's old instrument concerts.[1] It was quite the most delicious and delicate entertainment. With kindest regards to Miss Gribbell.
 Yours AUBREY BEARDSLEY

1. Probably the Purcell concert at the Portman Rooms, Baker Street, on 20 December.

MS OXFORD

To André Raffalovich
[December 1895-January 1896]

 10 & 11 St. James's Place

My dear Mentor,
 Very many thanks for your review of Oscar Wilde's career.[1] I told you how much I admired it when you read it to me; and upon

reading myself I think it even more admirable.

I am just beginning some pictures for an edition of the *Rape of the Lock*.[2]

<div align="right">Yours AUBREY BEARDSLEY</div>

1. *L'Affaire Oscar Wilde* now published in France.
2. Beardsley made ten illustrations to Pope's poem (Gallatin 1033–1042). The book was published by Smithers in May 1896.

MS OXFORD

To André Raffalovich
[*December 1895–January 1896*]

<div align="right">10 & 11 St. James's Place</div>

My dear Mentor,

So good of you to call for me. I will be ready at ten minutes past eleven.

<div align="right">Yours AUBREY BEARDSLEY</div>

MS OXFORD

To André Raffalovich
Tuesday [*circa January 1896*]

<div align="right">10 & 11 St. James's Place</div>

My dear André,

I shall be most pleased to come to lunch today.

<div align="right">Yours AUBREY BEARDSLEY</div>

MS PRINCETON

To Elkin Mathews
[*circa January 1896*]

<div align="right">10 & 11 St. James's Place</div>

Dear Mr Mathews,

I should be so much obliged if you would let me have the unpublished frontispiece back.[1] Would you also let me have a copy of Mr

Ruding's book? I should like to possess one.

Yours very sincerely AUBREY BEARDSLEY

1. See p. 104, note 1.

MS PRINCETON

To William Heinemann
Friday [*January 1896*]

10 & 11 St. James's Place

My dear Heinemann,

My Cinderella[1] month by month will be pieced out this way:

I *Cinderella attires her sisters for the dance.*
*II *Cinderella is left disconsolate in the kitchen.*
III *Appearance of the Fairy Godmother.*
IV *The pumpkin.*
V *The rat trap.*
VI *Cinderella's equipage.*
VII *The ball.*
VIII *The flight.*
IX *Cinderella—once more in poor clothes—contemplates her coming good fortune.*
X *The fitting of the slipper.*
XI *The marriage of Cinderella and Prince xxxxxx.*
XII *They lived very happily ever afterwards.*

Will this scheme suit? I shall follow Perrault[2] for the historical details.

I was imagining the size and proportions of the almanack to be something the same as *The Savoy*'s.

Very sincerely yours AUBREY BEARDSLEY
* Why not ask George Moore to write the February number?

1. This project was not carried out.
2. 1628–1703. French writer of fairy tales.

MS HUNTINGTON

To Leonard Smithers
[*circa 15 January 1896*]

10 & 11 St. James's Place

Dear Smithers,

So sorry to miss you. If you have not already sent a copy of *The Savoy* to the *Sunday Times*, do send one round at once by hand. They are so very friendly to me, and have rather important book articles.[1]

Pennell etc. rave about the Mag. Have got a Whistler for No. 2.[2]

A.B.

1. The *Sunday Times* reported receiving *The Savoy* on 19 January and reviewed it favourably the following week.
2. No picture by Whistler appeared in *The Savoy* apart from a drawing dating from 1861, printed in the first number.

MS OXFORD

To André Raffalovich
Saturday 2 o'clock [? *18 January 1896*]

10 & 11 St. James's Place

My dear André,

I shall be so pleased to come to lunch on Monday. I am ashamed of myself not to have begun the sketch but there shall be no more delay.

Yours AUBREY BEARDSLEY

MS BOOTH

To Ada Leverson
Tuesday [*21 January 1896*]

10 & 11 St. James's Place

Dear Mrs Leverson,

I shall be delighted to dine with you on Wednesday. Did you

see our delicious review in *The Star*?[1] Am longing to see your bur-
lesque.[2]

<div align="right">Yours very affectionately AUBREY BEARDSLEY</div>

1. Unfavourable review of *The Savoy*, 20 January 1896.
2. *Dickens Up to Date,* a brief parody of *Under the Hill,* published
anonymously in *Punch,* 25 January 1896.

MS PRINCETON

To André Raffalovich
Tuesday [*? 21 January 1896*]

<div align="right">10 & 11 St. James's Place</div>

My dear André,
 I shall love to meet Letty Lind[1] next Monday. She is such a dear.
I am so sorry you won't be at lunch with us on Thursday.

<div align="right">Yours AUBREY BEARDSLEY</div>

1. English actress (1862–1923) appearing at this time in *An Artist's
Model* by Owen Hall. Beardsley's drawing of her in the title-part
was first published in *Early Work.*

MS OXFORD

To André Raffalovich
Thursday [*? 23 January 1896*]

<div align="right">10 & 11 St. James's Place</div>

My dear André,
 I have not yet heard from Raymond Roze[1] if [he] can come
with me on Monday or no. I will write to you immediately I get
his answer.
 I am longing to see the Aphra Behn you have just got and the
Quinault.[2] *Oroonoko*[3] is the only thing I have read of Astrea's: her
comedies must be delightfully careless.

<div align="right">Yours AUBREY BEARDSLEY</div>

1. Pseudonym of J. H. Raymond Rose-Perkins (1875–1920), theatrical conductor and composer of light music.
2. Philippe Quinault (1635–88), French poet and playright, librettist to Lully.
3. Novel first published 1688.

MS Oxford

To André Raffalovich
Sunday [? *26 January 1896*]

10 & 11 St James's Place

My dear André,
 I have just heard from Raymond Roze. He will be most delighted to be brought to lunch with you tomorrow.
 I am quite well again. Mrs Webster[1] called soon after you left me on Friday. So sweet of her I thought.
 Yours AUBREY BEARDSLEY

1. Not identified.

MS Princeton

To André Raffalovich
Friday [? *31 January 1896*]

10 & 11 St James's Place

My dear André,
 I shall be delighted to dine with you on the 9th. I will *not* fail on Wednesday.
 By the way you never showed me your Behn and Quinault.
 Yours AUBREY BEARDSLEY

To Leonard Smithers[1]
[February–March 1896]

Hôtel St Romain, 7 Rue St Roch, Paris

Mon cher Leonard,

The meticulous precision and almost indecent speed with which I have produced the drawing[2] I send you by this post will prove to you that I have been nowhere near the Rue Monge.[3] I remain the same old hardworking solitaire you know and love so well. The drawing is one of the best I have done for the *Rape*. I am longing to get the Balzac. It was so good of you to look out for one for me.

Paris suits me very well. I believe I shall stay here a deuce of a time.

Scrope Davies[4] was only on approval. Horton's[5] drawings had better go in; he has a sort of a kind of talent. I will do the Dubarry[6] next.

Yours AUBREY BEARDSLEY

1. Text from Walker.
2. Probably the sixth illustration (Gallatin 1039) to *The Rape of the Lock*.
3. A *quartier louche* on the Left Bank.
4. Reference untraced.
5. W. T. Horton, black and white artist (1864–1919). Five of his drawings were published in *The Savoy*, April 1896.
6. Cover design for *The Life and Times of Madame du Barry* by R. B. Douglas, published by Smithers in April 1896.

MS O'CONNELL

To Leonard Smithers
[February–March 1896]

7 Rue St Roch

My dear Smithers,

Very many thanks for the cheque que j'ai reçu ce matin. When are you coming over? I see no one here at all and am just writing a lying note to Blanche to escape a lunch party at his place. It is so blessed to be away from all the boresome people. I would gladly

avoid (if it is possible) calling on Clara Savile Clarke. I know she will expect me to wander all over Paris with her. Can't Symons let me know something about the story?[1] I'm very pleased her contribution is being put in. Why the (?) after Baron.[2] If you compare the faces in the two pictures you will find them surprisingly similar.

Yours AUBREY BEARDSLEY

1. Clara Savile Clarke's story 'A Mere Man' was published in *The Savoy,* April 1896, over the signature 'A New Writer'.
2. Smithers seems to have questioned the identity of the Baron in the sixth illustration.

MS HUNTINGTON

To Leonard Smithers
Saturday [? *7 March 1896*]

7 Rue St Roch

My dear Smithers,

I sent you yesterday the *Cave of Spleen*[1] drawing which was completed amid the distraction of toothache and diarrhoea. Still!

The Balzac has arrived and is quite charming. I have already re-read two of the evergreen and comforting novels. So glad you are coming over soon, but so sorry to hear of your illness. I hope you are quite well now. I shall leave these rooms when my month is up as I am being hideously overcharged. Of course I'm not capable of remonstrating.

I read in the papers here that Stead has established an agency for the adoption of children.[2] Is it true? If so I certainly mean to adopt some nice little girl who would at once satisfy my maternal, amatory and educational instincts. This quite seriously.

Yours AUBREY BEARDSLEY

1. The seventh illustration to *The Rape of the Lock* (Gallatin 1040).
2. William Thomas Stead (1849–1912), editor of *The Review of Reviews,* had already won notoriety with his campaign against child prostitution ten years earlier.

MS Princeton

To Leonard Smithers
[*circa 9 March 1896*]

Café Anglais

My dear Smithers,

Many thanks for cheque. So glad you liked the last *Rape*. I am sending you the last 'full page' in a day or so (*The Battle of the Beaux and Belles*).[1]

I think the sylphs and the cul de lampe had better be thrown into one, and form the terminal decoration to the book. In all, that will be nine drawings, plus the cover.[2] What of the *Savoy*??????????

I began by trying to save money here and *did* save 200 francs the first week. However I can't keep it up. Duvals[3] end by becoming loathsome and impossible.

Regular March weather here. Most anxious to have your advice about some new rooms. With tender enquiries after your health.

Yours AUBREY BEARDSLEY

	Drawings for the Rape	
1	(Frontispiece)	*Dream*
2	(Headpiece)	*Billet doux*
3		*Toilet*
4		*Baron burning offering*
5		*Barge*
6		*Rape*
7		*Cave of Spleen*
8		*Battle*
9		*Sylphs* (cul de lampe)

A B

P.S. I hear that Le Gallienne[4] is anxious to collaborate with me in some literary way or other!!!!!

1. Gallatin 1041.
2. Beardsley did not make a drawing of the Sylphs for *The Rape of the Lock*. The cul-de-lampe (Gallatin 1042) is called *The New Star*. Otherwise Beardsley's list is correct.
3. A chain of cheap restaurants.
4. Richard le Gallienne, poet and miscellaneous writer (1866–1947), at this time principal reviewer on *The Star* and literary adviser to John Lane. Beardsley never collaborated with him.

MS Huntington

To Leonard Smithers
[*circa 10 March 1896*]

7 Rue St Roch

My dear Smithers,

Here is the last full page (rather a success) the cul de lampe follows tomorrow.

Pennell has the Whistler which I am not absolutely certain will be allowed us. Pennell himself promised us a drawing and I should like the Greiffenhagen[1] to be asked.

The title-page of the *Rape* is quite charming. I don't quite understand about the publisher's design for title-page of *Savoy*. Do you want some little drawing for insertion in the lower blank space of the present full page design?[2]

Yours A. B.

1. *The Savoy*, April 1896, contained nothing by Whistler or Maurice Greiffenhagen (1862–1931). Pennell contributed a drawing called *Classic London*.
2. Beardsley's title-page design (Gallatin 990) was repeated from the first number. In the April number the blank space was filled with the words 'Edited by Arthur Symons'—information which had not previously been given. In later numbers the title-page was illustrated with Beardsley's *Puck on Pegasus* (Gallatin 1005).

MS Princeton

To Mabel Beardsley
[*circa 12 March 1896*]

[*Paris*]

Dear Mabel,

I have written to Geneux[1] giving up the rooms and asking for the account. I don't know when I shall return to London—filthy hole where I get nothing but snubs and the cold shoulder.

The *Rape of the Lock* is finished and I think with great success. No. 2 of *The Savoy* will keep me dreadfully hard at work.

So sorry you are not in the new piece but a thousand congratulations on your success at the Royalty.[2]

With lots of love for yourself and dear Ma.

Yours AUBREY

I am sending you a little paroissien[3] which I hope is the right thing.

1. The proprietor of the Hôtel St Romain.
2. Mabel Beardsley had begun her professional career on the stage under Beerbohm Tree at the Haymarket in 1894. She then toured in Wilde's *A Woman of No Importance* and joined Arthur Bourchier's company in *A Chili Widow* by Bourchier and Alfred Sutro which had opened at the Royalty Theatre on 7 September 1895.
3. A prayer book to mark her reception into the Roman Catholic Church.

To Leonard Smithers[1]
[*circa 24 March 1896*]

Hôtel de Saxe,[2] Brussels

Dear Smithers,

I am sending you the cover and contents page by this post.[3] The latter should be, I think, slightly reduced. The weather is simply too celestial, but quite wasted on me as I never cross the Hotel door. By the way they presented me with my bill this morning. Just as well, I suppose.

Morgand[4] swindled me abominably over *Le Neveu de Rameau*. On reading it I find it is only a faked version from *Goethe's* translation made three years before the first real French edition appeared.[5] Still!

How is Symons? And what colossal sum have you given for the remainder of Aubrey Beardsley's library?

Yours AB

1. Text from Catalogue 343, Maggs and Co.
2. The date of Beardsley's move to Brussels is not known though it was probably about 17 March. In a letter of *circa* 24 April 1896 Ernest Dowson wrote to Henry Davray: 'Beardsley, as perhaps you have heard, has been very seriously ill at Bruxelles. He went to see Smithers off at the Gare du Nord and quite in the spirit with which we used to retire to Dieppe last summer decided *at the station* to go with him. There he was attacked with congestion of the lungs and has been nursed by his sister and the good Smithers.'

3. For *The Savoy*, April 1896. The cover design is Gallatin 1000, but there is no illustration to the contents page.
4. Paris bookseller and publisher.
5. By Diderot. Goethe's translation from the unpublished manuscript appeared in 1805. A French retranslation was published in 1821; the first authentic text was included in Vol. xxi of Diderot's *Works*, 1823.

MS HUNTINGTON

To Leonard Smithers
[*26 March 1896*]

Hôtel de Saxe, Brussels

Dear Smithers,

I'm as nervous as a cat, and am torn in a thousand directions so don't be surprised if you get a mixed collection of drawings from me. My prose contribution will probably take the form of a letter to Symons.

Hope the trial went off well, most excited to hear the result.[1] You are quite right—the drawings I sent you are extremely fine. Sorry the clock was wrong. The little creature handing hats is *not* an infant but an unstrangled abortion.[2] Rayon[3] sent me a funny little note yesterday. Photograph to follow.

Yours AUBREY BEARDSLEY

By all means let me do a picture for Clara's story.[4]

1. Proceedings brought at Westminster County Court by Rothenstein on 26 March to recover payment for his etching *La Pucelle* published in *The Savoy*, January 1896. Smithers defended the action on the ground that Rothenstein was in breach of contract in refusing to deliver a second etching but Rothenstein was given judgment and costs.
2. In the cover design for *The Savoy*, April 1896.
3. A girl friend.
4. Beardsley did not illustrate 'A Mere Man'.

To Leonard Smithers[1]
[*circa 27 March 1896*]

[*Brussels*]

Herewith Chapter 9th of *Under the Hill*.[2] Chapter 10 will consist of pictures.[3] Is not the verse polished . . . I am sending you

the *Tombeau* by this post . . . The *Musée Salent*[4] etc. I am sending later.

1. Text from Walker.
2. The manuscript of Beardsley's poem 'The Ballad of a Barber' (facsimile in *Miscellany*) shows that it was originally intended to stand as Chapter 9 of *Under the Hill.* It was first published in *The Savoy,* July 1896.
3. Possibly illustrations to the poem. Only two were completed (Gallatin 1006–7).
4. Projected illustrations to *Under the Hill,* not published and unrecorded.

To Leonard Smithers[1]
[*circa 1 April 1896*]

Brussels

Dear Smithers,
 Here is drawing No. 2.[2] If you are not coming in the swift future to Brussels you would be doing me a great favour in sending me a suit or so as the weather grows summery.

Your A B

1. Translated from *Briefe Kalendernotizen.*
2. *The Ascension of Saint Rose of Lima* (Gallatin 1002) illustrating Chapter IV of *Under the Hill* in *The Savoy,* April 1896.

To Leonard Smithers[1]
[*circa 3 April 1896*]

[*Brussels*]

 I shall look forward to the clothes and feel a beastly toff when I find myself once more with two suits . . . I am sending with this the illustration to the 'Ballad'.[2]

1. Text from Walker.
2. *The Coiffing* (Gallatin 1006).

MS HUNTINGTON

To Leonard Smithers
[*circa 6 April 1896*]

Hôtel de Saxe, Brussels

Dear Smithers,

I am horrified at what you tell me about 'The Ballad'. I had no idea it was 'poor'. For goodness' sake print the poem under a *pseudonym* and *separately* from *Under the Hill*.

What do you think of 'Symons' as a nom de plume? Seriously the thing must *not* be printed under my name. Any signature will do. Make it *Arthur Malyon.**

I am furious at Holme's refusal.[1] The beast. Has Prangé written about the Hawkins?[2]

If you can give me time at the last moment I should like to attack a picture for the Chopin Ballade.[3]

Yours AUBREY BEARDSLEY

* However I reserve my private judgment and think my poem is rather interesting.

No news from Bruxelles.

Bruxelles! C'est moi!

1. Of permission to reproduce Beardsley's *Frontispiece to Chopin's Third Ballade* (Gallatin 969), drawn in 1895 and sold to *The Studio* but not published there till 1898.
2. Prangé seems to have been an agent. Hawkins is probably Louis Welden Hawkins (*d.* 1910), naturalized French painter and water colourist.
3. Beardsley made two attempts to redraw this picture but failed each time.

MS HUNTINGTON

To Leonard Smithers
[*Postmark 8 April 1896*]

Hôtel de Saxe, Brussels

Dear Smithers,

All the work will be finished on *Friday*. I am very disappointed at what you tell me about the 'Ballad' and its illustration. The

picture is such a good one and its withdrawal leaves me rather thinly represented in the number. You see the writing of the poem and the illustration took nearly five days out of my time for the preparation of work for *The Savoy* and I could have been doing other things if I had known that Symons would have made arrangements to keep things of mine out of the magazine. Surely as literary editor he could have written to me earlier saying that the last verses must be re-written; you know how willing I am always to make alterations and listen to suggestions. Of course it is too late now to revise the poem.[1] I will never get work ready for *The Savoy* again away from London. I am so glad you liked the *St Rose*. I think it has a sort of charm in it that I have never given to any other drawing. *The Rheingold*[2] (coming next) is an elaborate piece of nonsense, and *The Bacchanals*[3] the last century once more.

I hope you will be coming over soon. My sister is here, the weather better and my spirits daily improving.

Yours A B

1. In fact he continued to alter the text for another two months.
2. *For the Third Tableau of the Rheingold* (Gallatin 1003), the second illustration to Chapter 4 of *Under the Hill*.
3. This drawing was not completed and is unrecorded. A Publisher's Note in *The Savoy*, April 1896, explained that Beardsley had been prevented from finishing it by illness and promised its appearance in the next number.

MS HUNTINGTON

To Leonard Smithers
[Postmark 8 April 1896]

Café Riche, Brussels

Dear Smithers,

Here is the Rheingold drawing which I hope you will like. I have just had a most delicious wine here—Latour Blanche 1874— the most insidious and satisfactory thing imaginable. Rather a nice lunch with it too.

Yours AUBREY BEARDSLEY

Kindest regards from my sister.

MS PRINCETON

To Leonard Smithers
[*circa 10 April 1896*]¹

Hôtel de Saxe, Brussels

Dear Smithers,

Here (by this post) is Chapter 17. Don't let the footnotes get printed as anything *but* footnotes. As the *Bacchanals* purport to be nothing but a quotation from another book the asterisks can be left in without any offence.² The illustration will be good.

The unsuccess of my beastly poem has depressed me very much. There is only one excuse for the existence of a poem—that it should be good. Arthur Malyon however will have to be excused by my superb illustration.

Brussels really is an impossible place on the whole; if it wasn't for my work I shouldn't know how to kill my time.

My *most affectionate love* to Symons!!!!!!!!!!!!

Yours AB

Just got your letter with list of drawings. It is a good idea to print the *Rape* drawing. Which one are you printing—the last and best? I hope you have chosen that one.³

I made a slight mistake when I ascribed the third picture to *Under the Hill*. The title should read *For the Third Tableau of Das Rheingold*. This is important.

Thanks very much for the Dubarry.⁴ It looks very nice indeed, the portrait a great success.

Rayon looks quite charming in her photo, but my daily increasing nervousness and general cerebral activity have put her utterly out of my mind. I haven't even thanked her for it. I should have liked Yvonne last night.

Yours AB

The hotel is filling up. Eighty Polytechnic tourists have arrived. Such a crew.

I am dining with the Demans⁵ tonight—beastly nuisance. I shall have to give a return meal. Damn it all. O'Sullivan⁶ has turned up. He is stopping at the Emperor. Nichols' young man stays on eternally.

1. This letter is preserved with an envelope postmarked 4 May 1896; that date has been written on the letter in another hand, but is

impossible. *The Savoy,* April 1896, which was published by the 25th of the month, is here still in preparation.

2. *The Bacchanals of Sporion,* an imaginary ballet described in a long footnote, professedly quoted from the *Mémoires* of the Marquis de Vandésir, in *Under the Hill,* Chapter IV.

3. Smithers selected the sixth drawing (Gallatin 1039) —the one entitled *The Rape of the Lock.*

4. See p. 115, note 6.

5. Not identified. Beardsley appears to have borrowed money from Mr Deman. See p. 172.

6. Vincent O'Sullivan, American-born poet and novelist (?1868–1940), for whose *A Book of Bargains* Beardsley drew the frontispiece (Gallatin 1052) in September 1896. His recollections of Beardsley are included in his *Aspects of Wilde,* 1936.

MS HUNTINGTON

To Leonard Smithers
[circa 20 April 1896]

Hôtel de Saxe, Brussels

Dear Smithers,

Very many thanks for the 200 frs. The kind and thoughtful 10 did not arrive or they would have been duly acknowledged. I shall begin the *Lysistrata*[1] in a day or so but of course shall not post any of the results. I think of spending a few days in London soon!

You see I still have the letch for wandering from Paris to St Petersburg, Vienna and St James's Hall.[2]

How *is* London?

Yours A.B.

1. Smithers had commissioned a set of eight illustrations to Aristophanes' comedy, which he issued privately later in the year in an anonymous translation.

2. An allusion to Beardsley's poem 'The Three Musicians'.

MS HUNTINGTON

To Leonard Smithers
[*Postmark 26 April 1896*]

Hôtel de Saxe, Brussels

My dear Smithers,

Very many thanks for the 200 frs. I think you had better not send me any copies of the *Savoy* or *Rape* here as my return to town will be speedy. I am utterly furious at my treatment here. The last blister has done nothing but give me dreadful pain in the spine so that the least sudden change in position gives me beans. I must get out of this as soon as possible. I walk now quite strongly without a stick, but my trouble with the breath is as bad as the day I got up. Of course I am damned civil to the doctor as else he will stick it on to his bill.

I have nearly finished the *Bacchanal* picture and only want a copy of Hazlitt's essays to complete it (for some lettering). I have also written a little of the 'Chronicles'[1] and have a good idea for a story to be told by Mrs Marsuple,[2] in which Hop-o'-my-thumb is the hero.

With best wishes,

Yours AUBREY BEARDSLEY

1. Presumably a further instalment of *Under the Hill*.
2. Helen's 'fat manicure and fardeuse' in *Under the Hill*.

MS PRINCETON

To Mabel Beardsley
[*circa 28 April 1896*]

Hôtel de Saxe, Brussels

Dearest Ma,

Many thanks for letter. I am *much* better and the doctor allows me to come to London early in May. Yesterday I took quite a long walk—although I was told not to. It did me a lot of good. My spirits have gone up at the prospect of wiping Brussels dust off my shoes.

I saw the advertisement of the concert you went to in *The Times*. I was so interested to see that Sophie Menter[1] (the heroine of the 'Three Musicians') was playing again in London. I should so much have liked to have heard her. The C minor is a sweet and beautiful thing.[2] It seems ages since I heard any nice music. In great haste and with lots of love,

Your loving AUBREY

1. German pianist (1846–1918). In 'The Three Musicians' she is represented as a soprano.
2. Piano Concerto in C minor by Saint-Saëns at the Philharmonic Society's concert on 22 February 1896.

MS HUNTINGTON

To Leonard Smithers
[Postmark 28 April 1896]

Hôtel de Saxe, Brusssels

My dear Smithers,

Very many thanks for the 200 francs received this dewy morn. After all there will [be] no question of flight as the doctor gives me full permission to come to *London on the 2nd or 3rd of May*. I am decidedly better and went out yesterday (against doctor's orders). I walked as far as the Place Royale and then drove back.

The cul de lampe shall be done with all speed, and prettily.[1] I long to be in the cockney city again.

I'm afraid I shall have some little difficulty as to logement. Stairs are an impossibility for me, the few short flights to my room here finish me off. A high up room in an hotel with a lift is my mark. Can you suggest anything?

Yours AUBREY BEARDSLEY

1. To 'The Ballad of a Barber' (Gallatin 1007).

MS HUNTINGTON

To Leonard Smithers
[*circa 30 April 1896*]

Hôtel de Saxe, Brusssels

My dear Smithers,
 The Hotel Cecil will be the very place for me, such a good idea of yours. The Arundel will do capitally till it opens. I will wire you the moment of my arrival.
 So glad *The Savoy* has been well ordered.
 Of the Y.B. I know nothing.[1]

Yours AUBREY BEARDSLEY

1. *The Yellow Book,* April 1896, did not appear till 2 May.

MS PRINCETON

To Leonard Smithers
[*circa 1 May 1896*]

Hôtel de Saxe, Brusssels

My dear Smithers,
 I hope you liked the cul de lampe. I thought it rather pretty. I suppose you are up to your eyes in work so don't bother to write. I saw the announcement of Miall's book in *The Times.*[1] The Hôtel is of an abysmal dullness just now. I am about the only person stopping on. Weather filthy. I am taking creosote pills and am not allowed to eat fish and no wine yet. I have tried to amuse myself by writing limericks on my troubles but have got no further than

> There once was a young invalid
> Whose lung would do nothing but bleed.

Symons shall finish it *if* he is a good boy. I am just going to take a daring step and have my hair cut. Not without however offering up a little prayer first beginning 'Oh Lord who art never unmindful of the prayers of thy faithful people, and whose loving kindness is so particular that thou hast not disdained to number the hairs of

our heads, grant I beseech thee that in the difficult ordeal (through which it hath pleased thee I shall presently pass), some *few* hairs may be left me to be numbered, and to be an everlasting annoyance unto thy people Philistia.'

Yours A.B.

1. *Nocturnes and Pastorals* by A. Bernard Miall, announced by Smithers in *The Times*, 29 April 1896.

MS HUNTINGTON

To Leonard Smithers
[2 May, Postmark 3 May 1896]

Hôtel de Saxe, Brussels

Dear Smithers,

Many thanks for the 150 frs. I would have left tomorrow but Raffalovich pressed me to a lunch; and I should not have got any one to pack for me this evening as the whole hotel is occupied with the Grader[1] marriage which has fluttered the bourgeoisie here tremendously. A perfectly gargantuan function. The hair was cut quite decently, my prayer was heard. Your continuation of the limerick is superb and quite in the spirit of the first sublime couplet.

My blood by the way has long since ceased to show the slightest inclination to spout. I have wired to my sister to pilot me over on Monday or to send somebody who is at liberty.[2] At the last moment I funk the travelling; Dent's bill arrives to-morrow. It can't be anything very dreadful.

My work has been a little desultory but I have not been idle. My idea for the cover[3] will be quite complete and matured when I have finished the drawing. The story of Hop-o'-my-thumb gets on. The *Bacchanals* have been spoilt, begun again and carried up to the point where the will alone is wanting. I drink uninteresting health to the *Rape* and *Savoy* at every meal.

Yours A.B.

In the next room I hear laughter and a strange clapping of hands. Flemish lewdness is going forward, I doubt not, Belgian lubricity.

1. Proprietor of the Hôtel de Saxe.

2. Mabel Beardsley was unable to go. Her mother asked Robert Ross to make the trip, but he could not, and she was forced to go herself, though unwell at the time.
3. Probably for *Under the Hill* in book form. The drawing was not made.

To Leonard Smithers[1]
[*3 May 1896*]

Hôtel de Saxe, Brusssels

My mother arrived in answer to my telegram, but was so knocked up when she got there, that a return journey today was out of the question. Deep-felt grief at my departure is noticeable all over the hotel. What a thing it is to be loved! I hear that Symons has written an extraordinarily witty and brilliant Editorial note to this number of *The Savoy*.[2]

A.B.

1. Text from Catalogue No. 59, Frank Hollings.
2. Symons thanked the critics for their flatteringly unfavourable notices of the first number. 'It is always possible to learn from any vigorously expressed denunciation, not, perhaps, what the utterer of that denunciation intended should be learnt.'

MS OXFORD

To André Raffalovich
5 June [*actually 5 May 1896*]

17 Campden Grove,[1] Kensington

My dear André,
 I know you will be very sorry to hear Dr Symes Thompson has pronounced very unfavourably on my condition today. He enjoins absolute quiet and if possible immediate change. Yet I despair of ever getting away, there are so many difficulties in the way! I am so sorry but I shall have to give up the pleasure of lunching with you on Thursday.

I am beginning to be really depressed and frightened about myself.

Yours AUBREY BEARDSLEY

1. Beardsley took rooms at this address and kept them until he went to live in Epsom late in June.

MS PRINCETON

To Edmund Gosse
[*circa 5 May 1896*]

17 Campden Grove

Mon cher Maître,

It was not without hesitation that I allowed myself the pleasure of placing this little edition of *The Rape of the Lock* under your protection,[1] for I feared you would find it a very poor offering. Please accept it as a friend rather than a critic, and forgive if you can some of its shortcomings.

I have only just returned from Brussels where I was laid up with severe congestion of the lungs. I am better now but still a dreadful wreck.

With kindest regards to Mrs Gosse and to yourself.

Yours very sincerely AUBREY BEARDSLEY

1. The edition was dedicated to Gosse.

MS ROSS

To Robert Ross
[*6 May 1896*]

[*17 Campden Grove*]

Dear Robbie,

It was so good of you to take the rooms for me yesterday, and to send in such a nice sofa. I can't thank you enough. I do hope you are better now.

Will you take tea with me tomorrow, the only meal at which I am at all possible now. I like these rooms very well.

Thanks for the Hardy.

Yours AUBREY

MS HUNTINGTON

To Leonard Smithers
[*Postmark 8 May 1896*]

[*17 Campden Grove*]

My dear Smithers,

I suppose another copy or so of the *Rape* is my undeservéd due. Would you send a copy to Yvette G[1] with the accompanying card.

Yours A.B.

If you think this quite unnecessary and foolish don't trouble to pack and post.

1. Yvette Guilbert, the celebrated French *diseuse* (1865–1944), who appeared at the Empire Theatre on 6 May.

MS ROSS

To Robert Ross
[*May 1896*]

17 Campden Grove

Dear Robbie,

Do forgive me for troubling you. Could you spare me the Calvert[1] for a few days, it would be of the greatest use to me just now? If you can, will you send it to me by bearer, and I will be your unwearying beadsman.

AUBREY

1. *Early Engravings of Edward Calvert* (1799–1883), a series of eleven proofs issued in 1829 (Margery Ross's note).

MS READING

To John Gray
[*May 1896*]

17 Campden Grove

My dear Gray,

I think the *Northern Aspect*[1] would prompt me to make some nice pictures. I like the idea of illustrating it very much, and will talk it over with André and yourself when you are back in town. I shall await anxiously your account of the performance of *Tasso*.[2]

I am only well enough to write you a short note. With the minimum of strength I have to grapple with a tremendous amount of work just now, as *The Savoy* is being turned into a monthly magazine.[3]

With kindest regards to all.

Ever yours AUBREY BEARDSLEY

1. Beardsley did not illustrate this play.
2. By Goethe, first published in 1790. Gray's article is untraced.
3. In the number for July 1896 Smithers announced that *The Savoy* would thereafter appear monthly.

MS HUNTINGTON

To Leonard Smithers
[*late May 1896*]

Twyford, Crowborough, Sussex

Dear Smithers,

I hope you weren't bothered with two telegrams giving my address, but I only just recollected after I had sent my wire that I had asked my sister to telegraph for me. I don't know whether she did or not. Crowborough isn't bad but not thrilling. This establishment is rather a grand sort of place and comfortable as well. By the way in addressing letters you need not put c/o Mrs Dashwood.

The Juanesque continuation of *Under the Hill* begins to take form bootifully.[1] As to my health I think it will improve very

quickly here and perhaps I may yet be strong enough to kick Symons'
little [sketch of behind]

Yours A.B.

1. Beardsley still intended to continue the novel for *The Savoy* but in
the issue for July 1896 Smithers announced that serialization was dis-
continued, but that it would be published in book form with numer-
ous illustrations as soon as Beardsley was well enough to complete it.

MS Ross

To Robert Ross (Letter card)
[*Postmark 1 June 1896*]

Crowborough

Dear Robbie,
I'm so glad you can come down to see me. Let me know what
train you arrive by as I will send the fly to meet you. Mabel turns
up here on Sunday.

Yours AUBREY

MS Ross

To Robert Ross (Letter card)
[*Postmark 7 June 1896*]

Crowborough

Dear Robbie,
Crowborough isn't exciting, but the air is fresh, there being
a strong wind from the east.
When can you come down and spend a few days with me? Let
me know in time to arrange about a room for you.
I shall not stop here for any serious length of time.

Yours AUBREY

MS PRINCETON

To H. C. J. Pollitt [*Letter card*]
[*Postmark 7 June 1896*]

Crowborough

My dear friend,
 I should have been so pleased to have accepted your charming invitation, but I am a sad invalid now and unable to indulge in any worldliness. My drawing has been stopped by Doctor's orders and here in the depths of country stillness I am taking an entire rest. The bookplate is not forgotten but I may as well once for all confess to being a lazy fellow.
 With best wishes,

Yours AUBREY BEARDSLEY

MS HUNTINGTON

To Leonard Smithers
[*Postmark 10 June 1896*]

Crowborough

My dear Smithers,
 I wish you would send me 1 and 2 of that chaste publication *The Savoy*. They would be a great help to me. I cannot order them here. I get on very well at Crowborough. What of No. 3? Is the Philistine yearning for it?

Yours A.B.

MS HUNTINGTON

To Leonard Smithers
[*Postmark 16 June 1896*]

[*17 Campden Grove*]

My dear Smithers,
 I think the last verse of 'Ballad' must have yet another alteration. The line

'One thing alone remains to tell'

will read as if something in the room was left behind that could convict him of the crime.
Let the verse go thus:

> He left the room on pointed feet,
> Smiling that things had gone so well.
> They hanged him etc.[1]

I hope this is not too late.

Yours A.B.

1. This is the version printed.

To Leonard Smithers[1]
[*circa 20 June 1896*]

[*17 Campden Grove*]

Dear Smithers,
 Just a line to say that my return to Crowborough has been put off till next Wednesday—perfectly exasperating. Will be round soon.

Yours A.B.

1. Text from Walker.

MS PRINCETON

To Leonard Smithers
[*circa 24 June 1986*]

17 Campden Grove

Dear Smithers,
 Another delay in returning to Crowborough. Result is I shan't return at all now, but am off to Brighton or somewhere immediately. Will let you know my whereabouts as soon as I do.

Yours A.B.

MS Huntington

To Leonard Smithers[1]
[*circa 26 June 1896*]

The Spread Eagle Hotel, Epsom

My dear Smithers,
 I have fallen on my feet here. Two palatial rooms and the additional comfort of being able to feed in a pretty little restaurantish dining-room. Expenses about the same as at Campden Grove. The air is lovely and view from my sitting-room quite sweet. When can you trot down to have a look at me?

Yours A.B.

1. Text from Walker.

MS Huntington

To Leonard Smithers
[*circa 27 June 1896*]

Epsom

My dear Smithers,
 Epsom turns out to be a capital place for work and play. I have taken a half-holiday today as the haranguing picture is completed beautifully,[1] and the pencil work for the obstreperous Athenians[2] as well. What of the *Savoy*?

Yours A.B.

1. *Lysistrata Haranguing the Athenian Women* (Gallatin 1068), the third illustration.
2. Probably *Cinesias Soliciting Myrrhina* (Gallatin 1071), the sixth picture.

MS HUNTINGTON

To Leonard Smithers
[circa 29 June 1896]

Epsom

My dear Smithers,

Sequel to 'Barber' nearly finished.[1] The first ten verses give a very spirited description of the post mortem examination of the princess. Thanks for the boards, I am sending you a *Lysistrata* drawing between two of them.

Yours A.B.

1. This was not published and is unrecorded.

MS HUNTINGTON

To Leonard Smithers
[circa 30 June 1896]

Epsom

Dear Smithers,

Proof enclosed. The rampant Athenians are finished finely; and if there are no cunts in the picture, Aristophanes is to blame and not your humble servant.

A.B.

I have begun the rampant women,[1] also the first picture for *Table Talk*[2] (for same reduction as you gave the little horse).[3]

1. *Two Athenian Women in Distress* (Gallatin 1070), the fifth picture.
2. *The Table Talk of Aubrey Beardsley*, a projected small volume of aphorisms and illustrations. The first picture, *Tristan and Isolde* (Gallatin 1015), appeared in *The Savoy*, November 1896. Eleven of the aphorisms were included in Lane's edition of *Under the Hill*, 1904.
3. *Puck on Pegasus.*

MS HUNTINGTON

To Leonard Smithers
[*Postmark 2 July 1896*]

Epsom

My dear Smithers,
 Here is the first picture for the *Table Talk*. You had better have a block made of it to see if such drawings will bear the necessary reduction. I am taking your Sunday's idea of size of the book as final and have designed the cover.[1] Very many thanks for the £5.
 Yours ever AUBREY B.
I am feeling a little stronger. Did you go to *Tristan*?[2] The picture by the way is of Tristan and Isolde. The two other pictures for *Lysistrata* are (1) *Herald* (2) *Pisspots* etc.[3]

[on back of envelope]
Let me see a proof of the *Tristan* if you have one to spare.

1. This drawing is not recorded.
2. *Tristan und Isolde* was given at Covent Garden on 26 and 30 June and 4 and 14 July 1896.
3. *The Examination of the Herald* (Gallatin 1072) and *Lysistrata Defending the Acropolis* (Gallatin 1069), the seventh and third illustrations.

MS HUNTINGTON

To Leonard Smithers
[*Postmark 3 July 1896*]

Epsom

My dear Smithers,
 Here is another for the *Table Talk*, a portrait or what you will of Weber.[1] I mean to do three or four in the same manner of some other musicians. The next *Lysistrata* is just in hand. There doesn't seem to be any time to lose over work; will you let me know how long you can give me to complete drawings and MS of the T. Talk in order to bring it out in good time next season. By the by I should

be awfully obliged if you would let me have proofs of each and all of the drawings. They will be so useful to have by me when I am writing my immortal opinions.

I shall have finished the *Lysistrata* in a week from now. The *Savoy* work (5 and 6) will take about a fortnight. Do you want the catalogue cover[2] immediately?

What about the Christmas book. Is it to be *Amlet* or the *40 thieves*? The latter I think judging from your account would give me plenty of chance.[3]

A huge iron rod fell on my head this morning and did not kill me! Wonderful was it not?

Yours A B.

Cough about the same.
Very many thanks for the £3.

1. Gallatin 1025, published in *The Savoy,* December 1896.
2. Cover design for Smithers's Catalogue of Rare Books No. 5 (Gallatin 950), reprinted in *Second Book.*
3. This project came to nothing. Beardsley made only two illustrations to *Ali Baba.*

MS READING

To John Gray
6 July [*1896*]

Epsom

My dear Gray,

It was most charming of you to send me a copy of your new book of verses.[1] It has only just reached me this morning (by the way of Crowborough), and I have been dipping into it furiously all through breakfast.

What I have read has fairly delighted me.

Your muse always seems to me to be the most successful creature and the most satisfactory. Please accept my warmest congratulations on the achievement of the *Spiritual Poems.*

YOURS AUBREY BEARDSLEY

1. *Spiritual Poems,* published by the Vale Press, 1896.

MS PRINCETON

To Leonard Smithers
[Postmark 6 July 1896]

Epsom

My dear Smithers,

I shall be enchanté de vous voir any afternoon and any time this week. My engagement tablets show a virgin face so make the day what you will. I shall be awfully glad to have a chat with you. The *Pisspots* is turning out a pretty thing.

How goes *The Savoy*, and what are the wild reviews saying?

I think the *forty thieves* will be my best choice. I fancy I shall do the pictures in a very superior *Morte Darthurian* manner.

Gray has just sent me a copy of his new book of verses. They are *really admirable* and might be reviewed (I should have thought) in our monthly.[1] I wish Gray was asked more frequently to contribute for us, he is one of the few younger men worth printing. Symonds'[2] dislike of his work is perfectly ridiculous.

Yours chastely A B.

1. i.e. *The Savoy*. This suggestion was not adopted.
2. A wilful confusion of Arthur Symons with John Addington Symonds (1840–93), poet and critic.

MS HUNTINGTON

To Leonard Smithers
[Postmark 7 July 1896]

Epsom

My dear Smithers,

I am so glad you are coming down tomorrow. I send you with *this* the *pisspots*. Three more of the *Table Talk* are ready for ink.

The reviews of *The Savoy* are not unpleasant I think. Don't bother about the money but let me have a few pounds on Wednesday as my bill arrives that day and I'm not quite sure if I've enough to square it with. In haste.

A B.

Yes, I should like the *40 thieves* to read.

MS O'CONNELL

To Leonard Smithers
[*circa 10 July 1896*]

Epsom

My dear Smithers,
 Many thanks for the *Nights*.[1] I will take great care of the tome. *Ali Baba* will make a scrumptious book.

Yours A. B.

Doctor just been down. He says my left lung is breaking down altogether and that the right is becoming affected.

1. *The Arabian Nights*. Smithers had edited Sir Richard Burton's translation in 1894, but this is probably Lawrence and Bullen's edition of *Sinbad and Ali Baba*, 1896.

MS HUNTINGTON

To Leonard Smithers
[*circa 11 July 1896*]

[*Epsom*]

My dear Smithers,
 My *study of two ladies in distress* is going very well. I am seriously distressed myself about the drawing of mine that is to appear in the next *Savoy*.[1] I don't mind it appearing so much if you will let me do another to go in the same number. Do say *yes* and you shall have the thing immediately. My wretched head is full of the *40 thieves*, pray heaven it continues so.

Yours ever A B

It would be best if possible to cancel the *Death of Pierrot* in this number and bring it out in the September.

1. *The Death of Pierrot* (Gallatin 1012), published in *The Savoy*, October 1896. The August number contained nothing by Beardsley except the cover and title-page designs.

MS HUNTINGTON

To Leonard Smithers
[*circa 13 July 1896*]

Epsom

My dear Smithers,

So glad the *Pierrot* goes into September. The distressed ladies are complete and look lovely. I will not send it as you are coming down on Monday. (2.15 as usual I suppose).

My pen shall be dug into the *40 thieves* immediately. The book I take it will be the same size as the *Rape*.

The doctor has given me a wondrous medicine which makes my shit black and head ache. Ammonia, potassium, belladonna and chloroform are among its simplest ingredients.

Yours A B.

MS OXFORD

To André Raffalovich
[*circa 15 July 1896*]

Epsom

My dear André,

I was so glad to have a letter of you. I should be delighted to come over to Weybridge[1] any day. Some afternoon this week I fancy Leonard Smithers is coming down to see me, so I am not quite certain if I am free for the moment. I will write again tomorrow.

I heard of Money-Coutts'[2] dinner from a friend who was just going on to it. Were you at any of the performances of *Tristan*? I read the announcements of it with jealous eyes.

The *Forty Thieves* will be my Christmas book. It's great fun illustrating it, but it is hard work, and will take me some time to finish. Only very evilly disposed persons would grumble at the hot weather. My only trouble now is my entire inability to walk or exert myself in the least.

With kindest regards to Miss Gribbell and John Gray.

Yours AUBREY BEARDSLEY

1. Where Raffalovich had taken a house for the summer.
2. F. B. Money-Coutts, later Lord Latymer (1852–1923), banker and poet. His *Poems* had recently been published by Lane.

To Leonard Smithers[1]
[*circa 15 July 1896*]

[Epsom]

. . . Very many thanks for the £10. I am feeling wonderfully well, considering my little setback. The last of the *Lysistrata* is finished. Surely it is the occasion for a little prayer and praise.

1. Text from Walker.

MS HUNTINGTON

To Leonard Smithers
[*circa 19 July 1896*]

Epsom

My dear Smithers,

Many thanks for £10. The first of the *Ali Baba* pictures[1] is finished and very successfully too. I am sending the definitive cover for *The Savoy*.[2] I think you dropped your pin catch here the other day. I send it by this post.

I think I am feeling a little stronger.

Hope you won't be too busy to come down some time next week.

Yours A B.

I hear George Moore enthuses over my poem.[3]

1. *Ali Baba in the Wood* (Gallatin 1058), first published in *Fifty Drawings.*
2. For August 1896 (Gallatin 1008).
3. *The Ballad of a Barber.*

MS HUNTINGTON

To Leonard Smithers
[Postmark 21 July 1896]

Epsom

My dear Smithers,
 Very many thanks for the Liszt.[1] So glad you are coming down this week. I am keeping the pin catch like a sacred thing.
 Yours A B

1. Probably a biography, to provide material for *Table Talk*.

MS HUNTINGTON

To Leonard Smithers
[Postmark 24 July 1896]

[Epsom]

My dear Smithers,
 Had a return of haemorrhage this morning and have been slightly troubled with it all day. The Doctor came to see me this afternoon and says that in spite of the return of blood I am making great progress.
 Did you see the silly mistake made by the *Morning Post* in its list of royal wedding presents:
 'Lady Alston—*The Rape of the Lock* by Mrs. Beardsley, illustrated by herself'![1]
You see how widely spread is the doubt as to my sex.
 Yours A B.

[On back of envelope]
Thanks for notice in *Manchester Guardian*.[2]

1. The paragraph, printed on 21 July, reads: 'Mrs Aubrey Beardsley, *The Rape of the Lock,* illustrated by herself.'
2. Review of *The Rape of the Lock,* 23 July 1896.

MS HUNTINGTON

To Leonard Smithers
Tuesday [*Postmark 28 July 1896*]

Epsom

My dear Smithers,

So sorry to hear of your touch of rheumatics. My little trouble has dried up; the cause of it, by the way, was *not* venereal. Thanks for *The Savoy*,[1] Yeats again provides the most interesting item.[2] His studies on Dante will, when completed, make a most desirable little book. *Ali Baba* progresses.

Yours A B.

Can you get me a copy of *The Earthly Paradise?*

1. The issue for August.
2. The second of three articles on Blake's illustrations to Dante.

MS HUNTINGTON

To Leonard Smithers
Wednesday [*Postmark 29 July 1896*]

[Epsom]

My dear Smithers,

I am sorry to hear that your pains have waxed and not waned. I should like to see you some day this week.

My wretched self is rapidly becoming buried in the fogs of depression, or approaching idiocy. I rather funk going to Dieppe, as I have alarming notions of the perfection of the French police system. I don't believe there's a gendarme in France who hasn't either my photograph or a model of my prick somewhere about him.[1]

Really as long as there is the faintest risk of my getting into trouble I had better not find myself on French soil. I *like* this number of the *Savoy* vastly, but should have *loved* it had there been an Aubrey or so within its covers. (The cover, by the way, looks very well at a distance). I am beginning to feel very proud of the *Lysistrata*. I shall ask you for a copy of it after all.

Yours A B.

1. Beardsley had left Paris in March without paying his bill at the Hôtel St Romain.

MS HUNTINGTON

To Leonard Smithers
Thursday [*Postmark 30 July 1896*]

[Epsom]

My dear Smithers,
 So glad you are feeling better and that you are coming down to-morrow. I am perfectly enchanted with the idea of a shop in the Royal Arcade.[1] I have always loved the place. Would you mind bringing me down a copy of the *Savoy* Vol. 1 and the original of the full page drawing for 'The Three Musicians'.[2] The latter I shall only want for a few minutes.
 Why not call your new premises 'The Sodley Bed'?
 Yours A B.

1. Smithers moved his shop from Arundel Street to Royal Arcade, Old Bond Street, in August.
2. i.e. Gallatin 992, published in *The Savoy*, January 1896.

MS HUNTINGTON

To Leonard Smithers
[*Postmark 6 August 1896*]

Bed [Epsom]

My dear Smithers,
 Quite an exciting overflow of blood on Tuesday night, I thought I was in for another bad illness. Luckily we had a splendid haemorrhage prescription at hand; and the bleeding was stopped in an hour. There has been no return, and I feel wonderfully well considering all things and in good spirits. This afternoon I get up.
 Bournemouth will see me some time on Tuesday if all goes well. Your place in the Royal Arcade is perfectly A 1. I will do a really

beautiful cover for the first catalogue you send out from the new address.[1]

Yours A B

1. Beardsley planned an architectural drawing of Royal Arcade but did not succeed in making it.

To Leonard Smithers[1]
Sunday [*9 August 1896*]

Epsom

My dear Smithers,
Very many thanks for the £15.
I fancy we shall go to Boscombe, Bournemouth, to-morrow.[2]
I am up and about once more.
Doctors say that Boscombe is the very place for me.
Don't forget Juvenal.[3]

Yours a b

1. Text from Walker.
2. In fact he went on Wednesday 12 August.
3. Another abortive project. Beardsley planned to translate the Sixth Satire and make a set of drawings. He completed only six—the frontispiece and two of Bathyllus (Gallatin 1074–6), two of Messalina (Gallatin 951 and 972) and *The Adulterer* which is unpublished. He seems to have begun the translation but nothing of it survives.

MS OxFORD

To André Raffalovich
Tuesday [*11 August 1896*]

Epsom

My dear André,
I am so sorry my stay here has come to an end before I have been well enough to drive over to Weybridge. I should like so much to have seen you. Mabel has gone down to Boscombe to find some

little home for me, and has just wired to say that 'Pier View' will be my address.

I had the pleasure of meeting Fr MacDaniel[1] two or three years ago when I was staying at Weybridge, he is a dear old thing, I'm sure you must find him vastly entertaining.

So interested in what you tell me about your book and the Italian brigandage.[2] I have just completed a set of illustrations to *Lysistrata*, I think they are in a way the best things I have ever done. They will be printed in pale purple. Juvenal number six is my next book, and I am making the translation as well as the pictures.

The attacks of haemorrhage have been a dreadful nuisance, last week I had a severe one and I have been an invalid ever since.

I look forward very much to *Self-Seekers*.[3] I hear that proofs are all corrected so I imagine that the novel will be out in October.

Very many thanks for your letter.

Please give my kindest regards to Miss Gribbell and to John Gray and thank them for their good wishes.

Yours AUBREY BEARDSLEY

I go down to Boscombe tomorrow morning.

1. The Rev. Simon MacDaniel, the Roman Catholic priest at Weybridge.
2. *Uranisme et Unisexualité*, published in France, 1896.
3. Raffalovich's second novel, published by Smithers, 1897.

MS HUNTINGTON

To Leonard Smithers
[*11 August 1896*]

Epsom

My dear Smithers,

My last letter from Epsom. Tomorrow I retire to the secrecy of Boscombe. My address will be:

Pier View

In a letter to Raffalovich to-day I told him that I had completed a set of illustrations to *Lysistrata*. I wonder if he will take any notice of it. The frontispiece to Juvenal 6[1] is scrumptious, likewise some smaller pictures.[2]

I was nearly going to Brighton but both my doctors forbade me.

Yours A B.

1. *Juvenal Scourging Woman* (Gallatin 1076).
2. Probably studies for *Bathyllus in the Swan Dance* (Gallatin 1074).

MS PRINCETON

To Leonard Smithers
[Postmark 14 August 1896]

Pier View, Boscombe

My dear Smithers,

What a time you must have had moving! The picture for your catalogue should now be permanent—a drawing of the Arcade from some point of view that would admit the introduction of figures. Shall be so glad to have the Madan, Bohn is all I have with me.[1] I did a pretty sketch for Bathyllus as Leda last night.

Boscombe is a strange place! Pier View is quite the best place to put up at in it. The Chine Hotel was too expensive for anything, and they say that it is not as good as it used to be.

How many pictures may I do for the Juvenal?

With best wishes for 4 and 5 Royal Arcade.

Yours ever A B.

Kindest regards from my sister.

Whose Latin Dictionary is worth having? I shall have to get one.

1. Translations of Juvenal. The Rev. M. Madan's appeared in 1789; that in Bohn's Classical Library, by L. Evans, in 1852.

MS PRINCETON

To Leonard Smithers
[Postmark 18 August 1896]

Pier View, Boscombe

My dear Smithers,

I hope you are much better now, and that the move is not proving too exasperating; also that you found a Pullman on your train back. I am doing a Bathyllus No 2 as I feel that I cannot say all I

should like to about him in one picture.[1] We wrote to all the publishers, private persons etc., etc. we could think of this morning for right to reproduce work.[2] My sister is going to call on Lane personally (also on Dent). I will let you know results as soon as possible. Some new original work will I think be wanted to complete the album, say two or three drawings. I am so anxious for it to be an entirely pretty monument of my work and to contain my latest work especially. I am going to get Aymer Vallance to write a complete iconography of my drawings for it.[3] The Hollyer photo[4] in possession of the Harlands will make the best frontispiece, and I think that Sickert's,[5] Blanche's and Will R's[6] portraits of me should also appear.

There will be no difficulty in getting all my posters. The shape and size of the book had better be settled soon as I shall want to make a showy cover.

Juvenal continues to flourish beneath my pen and I have given him a handsome spout in the flagellation picture. I am feeling about the same, myself.

Yours ever A B.

My sister sends kindest regards and inquires as to the neuralgia.

1. *Bathyllus Posturing* (Gallatin 1075).
2. For *A Book of Fifty Drawings,* published by Smithers in 1897, the only substantial collection of Beardsley's drawings to appear in his lifetime.
3. This was duly included.
4. Reproduced in Gallatin. For *Fifty Drawings* H. H. Cameron's photograph of Beardsley was used as the frontispiece. None of the other portraits here suggested was used.
5. Published in *The Yellow Book,* July 1894.
6. Rothenstein had made two drawings of Beardsley in 1893. One of them, which seems not to have been reproduced, belonged at this time to Smithers. The other, which later belonged to A. E. Gallatin, is reproduced in *The Portrait Drawings of William Rothenstein* (1928).

MS HUNTINGTON

To Leonard Smithers
[Postmark 19 August 1896]

Pier View, Boscombe

My dear Smithers,

Just a line to report progress. I am feeling a little better to-day,

and in more perky spirits than usual, owing I think to a certain complacent view I have taken of my latest efforts for the Juvenal. How goes the new shop? Raffalovich writes me this morning that he is all agog to see the *Lyistrata,* and asks if the pictures are for Aristophanes or Maurice Donnay.[1] The weather has broken up here, I'm afraid. Still! I await your classic packet of books anxiously. Mother was delighted with the copy of Morris, so I have presented it to her.

There are Fêtes and a Battle of Flowers going forward outside,[2] but I am assisting at none of their revelry.

Yours ever A B.

Kindest regards from my mother and sister.

1. French poet (1859–1945). His *Lysistrata* was first performed in 1892 and published the following year.
2. In Shelley Park, Boscombe; this was the first of an annual series of Boscombe Carnivals.

MS OXFORD

To André Raffalovich
Wednesday [*19 August 1896*]

Pier View, Boscombe

My dear André,

I was so glad to get your letter. The child who only parts his hair when a stranger comes to lunch must be very charming.

My breathing is a little better here but the cough distresses me a good deal, and the doctor has just given me rather a bad account of myself. He is afraid he cannot stop the mischief. To compensate, my little scribblings go on well and I think the Juvenal will be an interesting book.

My pictures in pale purple are for Aristophanes and not Donnay.

How I envy anyone who is able to spend the summer on the Thames, and be within punting distance of the ever gracious Hampton Court. I am beginning to feel that I shall be an exile from all nice places for the rest of my days. Boscombe is only tolerable, I am so disappointed with it.

By the way our publisher has now a new address, 4 and 5 Royal Arcade, next door but one to the admirable Goodyear.

With many thanks for your good wishes.

Yours AUBREY BEARDSLEY

Please give my kindest regards to Miss Gribbell and to John Gray and thank them for their kind messages. Mother and Mabel, who are both with me now, join me.

MS HUNTINGTON

To Leonard Smithers
[Postmark 21 August 1896]

Pier View, Boscombe

My dear Smithers,

Life drags on here wearily, Juvenal at a better pace. I shall come up to town for a few days as soon as we have any material in hand for the Album. Dent has written quite gushingly so we shall get all we want from *him*. Lane I fear will not be so polite. Mabel will be seeing him in a few days. I suppose you mean to bring the thing out this side of Christmas. I hope we shan't find too many difficulties in our way. I am going to redraw the *Lady on Horseback* for the collection.[1] I should like the bulk of the volume to contain my latest work; the early stuff will have to be used very sparingly. Listen not to the counsels of Symons and such persons as to the respective merits of my drawings.

Forgive such a long screed about myself. Let me have a line, if you can find time to write it, with news of yourself and doings.

So sorry the Holyday will not be amongst the other Juvenals.[2] Please give my kindest regards to Mrs Smithers, we hope she had a pleasant journey back to town.

With kindest regards from all.

Yours ever AUBREY BEARDSLEY

1. See p. 122, note 1.
2. Verse translation with notes and illustrations by Barten Holyday (1673).

MS HUNTINGTON

To Leonard Smithers
[Postmark 23 August 1896]

Pier View, Boscombe

My dear Smithers,

Juvenals have just arrived; thanks so very much. I shall be in town for a day or so ere long and will bring the pictures with me.
In haste for the post.

Yours A B.

[On back of envelope]
Vol. 2 of Herodotus did not arrive.[1]

1. William Beloe's translation in four volumes, first published 1791.

MS HUNTINGTON

To Leonard Smithers
[Postmark 25 August 1896]

Pier View, Boscombe

My dear Smithers,

I am so awfully sorry the neuralgia has clung to you. It has been such beastly weather for the last week that I'm afraid you haven't had a chance to get better. I do hope, though, that you will soon pull round. Please forgive my bothering letters.

I have enjoyed the little *prose* translations of Juvenal very much. The title page of the book doesn't say who they are by. The Messalina picture which I have just finished for the VIth will do quite well for the Album.[1] I am doing the adulterer fiddling with his foreskin in impatient expectation—rather a nice picture. I shan't be many days finishing the whole lot. We have been having floods and sand storms and God knows what here lately. Do you mind the *Lysistrata* and *Juvenal* drawings being mentioned in the Iconography? They need not be spoken of as published.[2]

I was amused by your small p and little b's on the envelope.[3]

Yours a.b.

Kindest regards from my mother.

1. Neither of Beardsley's drawings of Messalina (Gallatin 951 and 972) was included in *Fifty Drawings*.
2. They were duly recorded as unpublished, although *Lysistrata* was issued before *Fifty Drawings*.
3. In imitation of Beardsley's occasional use of small letters in signing his initials, as in this letter.

MS HUNTINGTON

To Leonard Smithers
[*circa 27 August 1896*]

Pier View, Boscombe

My dear Smithers,

I have quite got over my fatigue and tantrums. Blessed weather down here, it ought to do you good. When do you come? The cover[1] goes beautifully. I have written to Dent for a copy of the *Morte,* so we can go through it together. Aymer Vallance has got the Iconography in hand. I had better put him in communication with you.

Yours ever A B
In haste

1. Of *Fifty Drawings* (Gallatin 1063) .

MS HUNTINGTON

To Leonard Smithers
[*circa 28 August 1896*]

Pier View, Boscombe

My dear Smithers,

I have written to Fisher Unwin asking him to send the posters[1] to me at the Royal Arcade. Have you got the Savile Clarke[2] and

Max[3] pictures? Have a filthy lot of letters to write, the day isn't half long enough. I suppose I shall *have* to read a sentence or so of O'Sullivan![4]

Yours AB.

1. The Children's Books and Pseudonym Library posters, for reproduction in *Fifty Drawings*.
2. Kitty Savile Clarke owned *The Fat Woman* (see p. 65) and *La Dame aux Camélias* (Gallatin 916, published in *The Yellow Book*, October 1894).
3. Max Beerbohm owned *Child Standing by its Mother's Bed* (Gallatin 870), published in *The Sketch*, 10 April 1895. See p. 164, note 3.
4. *A Book of Bargains*, a volume of short stories by Vincent O'Sullivan, published by Smithers later in the year with frontispiece by Beardsley (Gallatin 1052).

MS HUNTINGTON

To Leonard Smithers
[*circa 31 August 1896*]

Bed of Sickness [Pier View, Boscombe]

My dear Smithers,

By *all means* reproduce *both* of the Savile Clarke pictures. I have sent you yesterday the two Fisher Unwin posters. *The cover* is finished and is a great success; the *Frontispiece to Chopin's 3rd Ballade*, and *The Atalanta in Calydon*[*1] are both in hand and are going to be very nice. A little vignette of some sort will be imperative for the title-page.[2] I will get one done at once.

I think Swan[3] had better be entrusted with the more important half-tone. Anyhow they should do the Sangreal picture.[4] It is *so* important. Don't forget that Max's picture is half-tone; also the Savile Clarkes.

As soon as *you* have a final list of the pictures, let me have a ditto. Then the order of putting in can be settled. I am so sorry to hear of your cold. On Friday afternoon I broke down again and have stained many a fair handkerchief red with blood. Perfectly beastly. I don't believe I shall pull through the winter. I long for the album to take shape and get out. Am always delighted to get a scrawl from

you about it. With kindest regards from my mother.

<div align="right">Yours AB.</div>

* Line blocks.

1. Gallatin 946, first published in *Fifty Drawings*.
2. Beardsley failed with this drawing and Smithers used *Puck on Pegasus*.
3. The Swan Electric Engraving Company.
4. The frontispiece to Volume 2 of *Le Morte Darthur* (Gallatin 295).
 It was reproduced in photogravure there and in *Fifty Drawings*.

MS HUNTINGTON

To Leonard Smithers
[Postmark 1 September 1896]

<div align="right">Pier View, Boscombe</div>

My dear Smithers,

Very many thanks for the books.

I will take great care of your *Gamiani*[1] and *Priapeia*.[2] So stupid of me to have left my superb translation of Juvenal's *Satires* behind me.[3] Aymer Vallance's address is

<div align="center">6 Wells Street</div>
<div align="center">Oxford Street</div>

I wish you would ask him to come round to the Arcade one day, to let you see how the list has progressed. Mabel tells me she has sent you the Poster.[4] I think you will be pleased with the cover. How are the complications, and when are you coming to sunny Boscombe?

<div align="right">Yours ever A B.</div>

1. *Gamiani ou Deux Nuits d'Excès* by 'Alcide Baron de M____' (thought to be Alfred de Musset), 1833.
2. Translated by Sir Richard Burton and Smithers and issued by the Erotika Biblion Society, 1890.
3. On his visit to London a few days earlier.
4. The Avenue Theatre poster.

MS PRINCETON

To Leonard Smithers
Wednesday [*Postmark 2 September 1896*]

Pier View, Boscombe

My dear Smithers,

So sorry you have been bad; and so glad you are better. I have sent Dent a ditto to enclosed list for his approval and consent.[1] Most of the small chapter headings are very small indeed, will go any number to the page. Some of them will brighten up the iconography nicely. *The Savoy* looks very pretty, I haven't had time to read it yet. Shall I send you the album cover, or keep it till your arrival? It's A 1; but must not be reproduced inside in *Black*.[2]

The doctor says I am no better and no worse.

Yours A B

1. List of illustrations to *Le Morte Darthur* to be included in *Fifty Drawings*.
2. The cover was printed in gold on red cloth. It was not reproduced inside.

MS HUNTINGTON

To Leonard Smithers
[*circa 4 September 1896*]

Pier View, Boscombe

My dear Smithers,

I enclose a copy of Dent's letter giving full permission for the reproduction of the drawings. What about the large *Réjane* that appeared in Pennell's book?[1] Macmillan have the *block*. The Swan Co. who made it will of course have the *negative*; had they not better be applied to directly, as no permission is needed for reproduction? It is such an important drawing and mustn't get left out for anything.

Have you approached *The Studio* about the *Isolde?*[2]

I do hope you are keeping well; but what weather.

Yours ever A B.

1. Gallatin 940, reproduced in Pennell's *Pen Drawing and Pen Draughts-men,* published by Macmillan, 1894.
2. Gallatin 987, a pen-and-ink and water-colour drawing reproduced in colour in *The Studio,* October 1895.

MS PRINCETON

To Leonard Smithers
[circa 5 September 1896]

Pier View, Boscombe

My dear Smithers,

It seems to me you have an embarras de richesses in the way of drawings. Don't hesitate to overstep the number of fifty, as titles, half-titles and iconography will be all the better for occasional pictures. I have set apart with a wrapper the drawings of Evans[1] that should be used. But what of the list I sent you of *Morte* drawings? Do not discard it I beg of you. I am sending you my copy of the *Morte.* When will you be able to let me have a final list of things to go in? We settled that the *Slippers of Cinderella*[2] should not go in, if you recollect. Brandon Thomas has the original, and it's not worth while bothering him for it.

La dame aux camélias must of course be done from the original (half-tone) and by *no* means from the Y. B.

You may as well ask the *Studio* for the Chopin drawing whilst you are about it. I will do them another colour picture *gratis* if they will lend it. I am doing the cover for *Savoy*[3] at once; you will see that the *picture* part of it can be cut out of it and used by itself as a contribution to the album. So I kill two birds with one stone.

Yes by all means ask Dent for permission to use the *Bon-Mots* picture.[4] I have not said anything to him about it myself. It will I am afraid make a very bad block as the line is so thin and broken.

Let me know later what you think of doing with the quite small pictures, some are not good or important enough to print on a page by themselves.

The *Caricature of Mendelssohn*[5] I should like to have all the glory of a vast margin.

Lane has not replied yet about the *Salomé* drawings. They had better be reproduced from the book as I have practically destroyed

all the originals (for purposes of block making) by soaking them in hot water. Besides they have got very dirty and rubbed.[6]

If you will give the cover *plenty* of reduction I don't see, after all, why it should not appear inside, and in black and white.[7]

The haemorrhage has stopped, but has left my lung in a vile state. I filled up Douglas Sladen's paper,[8] and sent it him.

How is the health?

Kindest regards from my mother.

Yours ever A B.

1. Evans owned many of Beardsley's early designs, but the only one used in *Fifty Drawings* is *The Woman in White* (Gallatin 1010) first published in *The Savoy*, September 1896.
2. Gallatin 907, first published in *The Yellow Book*, July 1894.
3. *The Fourth Tableau of the Rhinegold* (Gallatin 1011), the cover of the issue for October.
4. Beardsley had produced 130 drawings for Dent's *Bon-Mots* Series published 1893–4 (Gallatin 642–771). These were mostly small grotesques and vignettes. None was used in *Fifty Drawings*.
5. A small drawing (Gallatin 1024) first published in *The Savoy*, December 1896, not included in *Fifty Drawings*.
6. Beardsley's statement is baffling. Most of the *Salomé* drawings were still in Lane's hands some years later and nine of them are now in the Fogg Museum of Art, Harvard University.
7. This was not done, but the design was used to advertise *Fifty Drawings* in *The Savoy*, December 1896.
8. Poet, anthologist and miscellaneous writer (1856–1947); editor of the new series of *Who's Who*, begun in 1897. The paper mentioned is no doubt the form for Beardsley's biographical particulars. He gave the date of his birth as 1874.

MS HUNTINGTON

To Leonard Smithers
[*circa 8 September 1896*]

Pier View, Boscombe

My dear Smithers,

This and *here* is the Réjane I wish to appear in the album. Please *do get* a half-tone made from it. There will be no need to get any permission.

Yours ever A B

To Leonard Smithers[1]
[*Postmark 11 September 1896*]

Pier View, Boscombe

My dear Smithers,

You will live to love that dog in Atalanta, yet.[2] Of course the drawing is only a caricature. Didn't you enjoy the coronet on the bow-wow's coat. I didn't sign it because I don't always sign my drawings. I send you by this post the *Savoy* Album drawing.[3] It ought not to need any reduction for the Album. You will see at once how easily the drawing can be detached to make the larger block. I am very satisfied with it, but fully recognize its divine unsuitability for a magazine cover. Still, I am doing the catalogue[4] and Léonard[5] covers next.

My wretched health is about the same; my spirits though have been in fine form lately, quite an exalted state.

Thanks for O'Sullivan proofs. I will look into them.

I have not forgotten the pencil sketch,[6] it will be in sanguine and bloody slight.

I am doing a little writing nowadays.[7]

Weather perfectly monstrous here.

If you haven't the Wagner prose works, will you sweetly get me such volumes of them as have already been published. (Kegan Paul, Trubner, Charing Cross Road).

I rather like the scroll Henry is using for the Parade.[8] Hope your hump has gone down.

Yours A.B.

Kindest regards from my revered parent.

What about the iconography? Don't let Vallance give the public the idea that I am forty-five and have been working for fifteen years; but give people the impression that I am two and have been working for three weeks.

Youth and beauty are my only boasts! My beauty will of course be demonstrated by Cameron;[9] be it Vallance's duty to certify my youth.

[On back of envelope]
Cameron photo is superb; pray God it is not the only good thing in the book. A.B.

1. Text from Walker.
2. In this drawing the dog's heavy coat emphasizes the scantiness of Atalanta's tunic.
3. Cover design for the bound volumes of *The Savoy*. It is not clear what drawing is sent here but the design used was the title-page drawing from the first two issues (Gallatin 990).
4. The Royal Arcade drawing, which he never produced.
5. Cover design to *The Souvenirs of Léonard, Coiffeur to Marie Antoinette*, published by Smithers in 1897 (Gallatin 1055).
6. Possibly *Silhouette of the Artist* (Gallatin 1064), used as a tailpiece in *Fifty Drawings*.
7. His version of *Das Rheingold*. See p. 164.
8. Beardsley's title-page for *The Parade*, 1897, recently published by H. Henry and Co. (Gallatin 953).
9. The photographer.

To Leonard Smithers[1]
[Postmark 15 September 1896]

Pier View, Boscombe

My dear Smithers,

I send you by this, the *Léonard* binding block which I hope you will like, and which I think rather pretty. Thanks very much for the Wagner.[2] I am glad and sorry that the pure works are sold. I returned Cameron his proof at once as I did not wish there to be any delay, photographers do take such ages over everything, but of course I should have sent it to you first. So sorry.

What on earth does Max mean by saying his drawings were never reproduced? The one on page 561 (of *Sketch*) will also be utterly useless. You can't imagine how utterly different it is from the original.[3]

I think you are right about the art paper, for though of course it will not be the most suitable in all cases, it will be the best for the majority. The description must certainly not be underneath the block.[4]

I am horrified about Vallance; he mustn't be allowed to leave us in the lurch. Would it bother you too much to write to him again, giving him some date by which the iconography must be ready for us to revise.

I am much struck by O'Sullivan's stories, I believe they will be a success. My frontispiece is for the story of Mde. Jahn, and will be done tomorrow. I should use it I think for the album as it is rather

unlike my usual work. It will make a good note. By the way in your letter you speak of V. O'Sullivan's 'cover'. Do you want a binding block as well as frontispiece?[5] So glad the cold is better. I continue to be perky.

<div align="right">I am A.B.</div>

1. Text from Walker.
2. Wagner's *Prose Works,* translated by W. A. Ellis and published 1892–9.
3. It is not known which drawings Max Beerbohm owned apart from *Child Standing by its Mother's Bed,* which he believed lost, though it remained in the possession of Hentschel after he had made the block.
4. *Fifty Drawings* was printed on imitation Japanese vellum. Each drawing was preceded by its description on a separate sheet.
5. *A Book of Bargains* was bound in plain covers.

<div align="center">MS PRINCETON</div>

To Leonard Smithers
[Postmark 16 September 1896]

<div align="right">Pier View, Boscombe</div>

My dear Smithers,

Thanks for your letter. I send by this the O'Sullivan frontispiece which I hope will please both you and the immortal author. The immortal artist is quite delighted with it. Put it in the book of 50. 'Tis for the *'Business of Madame Jahn'*. The photograph of me is being printed now. Cameron wrote me a charming letter about it this morning.

From John Gray I received another charming letter containing a pretty copy of verses; may I ask him if we may use them in the *Savoy*?[1]

So glad you like the Rheingold drawing, it *is* A 1.

Thank you very much for procuring me the Wagner prose works.

I am writing an elaborate version of *Das Rheingold,* called *The Comedy of the Rhinegold*. I will send you the MS directly it is finished. It will make a little teeny book. I wonder if you will think it worth illustrating.[2]

The weather is clearing up here, and I am painting my chest with iodine.

<div align="right">Yours AB</div>

The names of the characters in my *Rhinegold* picture are

Loge (the fire god)

Wotan

In the depths of the valley below, the Rhine maidens are singing un-
seen and are bewailing the loss of their gold. Loge turns round and
speaks to them jeeringly, whilst the gods, with Wotan at their tail,
pour into the new palace which they have built with the wealth they
have robbed from the daughters of the Rhine.

God blast everything—I have been and gone and spoilt the O'S.
frontispiece (the second). I could cry with vexation. *Curse* O'Sul-
livan and his bloody book.

1. Gray's only contribution to *The Savoy* was a poem 'The Forge' in
 the issue for April 1896.
2. Another project which he did not carry through. His four further
 illustrations to *Das Rheingold* (Gallatin 1020–3) were published in
 The Savoy, December 1896.

MS HUNTINGTON

To Leonard Smithers
[*circa 17 September 1896*]

Pier View, Boscombe

My dear Smithers,

Very many thanks for the £12.

Here at last is the O'Sullivan picture. Radiant and compelling
is it not? Beg Naumann to be careful with the dots in the face. You
will see by the enclosed what passage I have dignified by my draw-
ing. So sorry O'Sullivan has come to grief, give him my sympathies.[1]

So Symons is still a virgin back and front; well it's cheap; saves
the washing bill if nothing else. I am doing the pencil or crayon
sketch immediately. What about 'Queen Eleanor and Fair Rosa-
mund?'[2] It has never occurred to me to make use of the subject, still,
it might make a good picture.

I don't feel equal to repeating the *Chopin Ballade.* It's like put-
ting old wine into new bottles. I failed utterly with the second ver-
sion. Pray heaven the *Studio* will show us some clemency.

Are you suffering with a south-west wind in London? It prevails
here utterly and has given me the pip.

Vastly pleased to hear that you are better.
Kindest regards from my Mama.

Yours A B.

I have written to Cameron to tell him to send you on a photo directly
one is ready.

1. O'Sullivan was consumptive and had already been ill in May, but he
 recovered and lived to over seventy.
2. Beardsley made no drawing of this subject.

MS PRINCETON

To Leonard Smithers
Thursday night [*17 and Friday 18 September 1896*]

Pier View, Boscombe

My dear Smithers,

Here is another page for the album. This drawing is, by the way,
a very good example of the improvement in my drawing of late. It's
all nonsense what they say about my early work. Just compare the
drawing of the nude with the nudes in the *Morte*; and the drawing
of the trees and general handling of line. It will also make you a
fine and eternal catalogue cover.[1] (Puzzle; find the arcade). Please
let me have a proof of the O'Sullivan picture before it is passed.
When do you think the album will be ready? I am worrying myself
into an early grave, can't rest for a single minute. I don't know which
is beastlier, to be in London, or to be out of it. It is simply exasperat-
ing to have to carry on all one's conversations by penny post. Let me
know your plans about Juvenal. I suppose you won't bring it out till
Lysistrata has run its little life. By the way what about *Lysistrata*?
When may I hug to my withered bosom a copy of it?

Friday

Many thanks for your letter. Hope the adventure was amusing.
I look forward much to the Wagners.
The album had better be declared *closed* when I have sent you
the little pencil sketch (I shall do it tomorrow). I feel sure that the
iconography will want a lot of 'shaping' when we get it from Val-
lance.

The *Rhinegold* will not take long to finish. May I do the pictures next? Don't forget it is quite a tiny brochure; and might be the first of a *'Play book'* series? What do you think?

I'm so glad your blisters are leaving you.

I enclose Gray's verses (please return the letter as I want to answer it) .

I am suffering from nervousness most horribly and can't make up my mind to get to bed at night.

By *'Play book'* series I mean a series of little booklets giving versions of famous or curious plays in story form. Something like Lamb's *Tales from Shakespeare.* I believe they would go; and the idea is quite a novel one. They might be done by several hands. Symons could take up one; and Yeats for some mystical plays such as Calderon wrote, and John Gray. Really I think the series would be amusing, and would be something to start the new year with.

Let me have your profound and extensive views on the subject.

Yours ever A B.

N.B. I want you *particularly not* to put my name on the title-page of Sullivan's book.[2]

1. Apparently the bookplate made for Pollitt; published in *Fifty Drawings* as *Bookplate of the Artist* (Gallatin 1065) .
2. Beardsley's name appeared nonetheless.

MS HUNTINGTON

To Leonard Smithers
[*circa 20 September 1896*]

Pier View, Boscombe

My dear Smithers,

Very many thanks for your letters. Nothing else could I fear be done with the *Savoy.*[1] Your joke is charming[2] and I shall do you some scorching drawings for No. 8.[3] The Rheingold drawings are going *most capitally.* You might use one of the more important ones in the final No. There will be four fairly elaborate full page and about eight or ten smaller pictures. I will send you a fine batch of drawings at the week's end. Cameron *quite* understands about the photo being reproduced so you can fire away with the block.

I would certainly use the No. 1 Title Page for *Savoy* binding block; it will immortalize the drawing.

I have stuck a pin in the cloth which I far and away prefer for my *album*. It's the only one of the lot you sent me that would print the cover really nicely, and in point of colour it is best; in fact just what I expected you would use. My genius for work possesses me in an extraordinary degree just now. Pray God it continue to do so. It is so important to turn out stuff. Down here there is nothing else to do; the heavens be praised.

Lane sends his written permission for *Salomé* drawings to appear,[4] with apologies for delay in writing.

Yours ever A B

I enclose Gray's poems. Please put them in No. 7. They are good.

1. Smithers had decided to cease publication of *The Savoy* with the issue for December 1896.
2. Probably a suggestion that Beardsley should make his drawing *Et in Arcadia Ego* (Gallatin 1027) as the final illustration to *The Savoy*— the pun being on Smithers's address in Royal Arcade.
3. *The Savoy*, December 1896, consisted entirely of work by Symons and Beardsley, who contributed twelve drawings.
4. Three of these were included in *Fifty Drawings*.

MS READING

To John Gray
[*circa 20 September 1896*]

Pier View, Boscombe

My dear Gray,

A thousand thanks for your letter and copy of verses. I wonder if you would let us print the piece in our next *Savoy*. It would be so good of you to let us have it.

There is a perfect return of sunny weather here, for which I am devoutly grateful, though only strong enough to enjoy from my open window.

I look to you for a fine essay on archery after your summer exploits with the bow and shaft, for it will seem quite fit that a member of the Société des Enfants d'Apollon[1] is also an archer.

I have just been re-reading the charming account of *Tasso* you sent me some weeks ago. I wish you would enlarge it.

Yours very sincerely AUBREY BEARDSLEY

1. Probably a French literary society. Gray took a lifelong interest in archery.

MS OXFORD

To André Raffalovich
[*circa 22 September 1896*]

Pier View, Boscombe

My dear André,

You must forgive me for leaving at least two delightful letters unanswered for so long. Nearly a month ago I had to go up to town on urgent business, and the trip brought on a most serious attack of haemorrhage. I am only just recovering and am not allowed to leave my room. I shall spend the winter here for I shall not be strong enough to travel further South. It seems I shall never be out of the wood.

John Gray writes to me that you will be back in town next week. I am beginning to think of London like some untravelled yokel.

Could you let me have the address of your French publishers?[1] I have utterly mislaid my copy of your book.

Smithers tells me that he has prepared an album of 50 of my drawings, to appear this autumn. I look forward to seeing it very much. It is I believe to contain an iconography.[2]

Do let me hear from you sometimes and have some accounts of your winter gaieties.

My mother joins me in kindest regards to Miss Gribbell and yourself.

Yours AUBREY BEARDSLEY

1. A. Storck of Lyon, publisher of *Uranisme et Unisexualité*.
2. This seems to be a hint that he is too ill to work and needs renewed financial support, but if so it is contradicted by his next letter to Raffalovich (see p. 172).

MS HUNTINGTON

To Leonard Smithers
[*Postmark 23 September 1896*]

Pier View, Boscombe

My dear Smithers,

Many thanks for note. May Dover do you good![1] I am distressed at what you tell me about Vallance. The iconography will be very bad if it is not good. We must not spare our tongues in licking it ship-shape. All right, I will fire away with 7th and 8th *Savoys*. One of the last is already done and looks beautiful. By the way, how many drawings make a number? I am working hard nowadays.

Yours ever A B.

My mother joins me in kindest regards to Mrs Smithers and yourself.

1. This letter is addressed to Smithers at 43 Castle Street, Dover.

MS O'CONNELL

To Leonard Smithers
[*circa 24 September 1896*]

Pier View, Boscombe

My dear Smithers,

Many thanks for your note. I am getting on with the *Savoy* work.

Yes the *Rheingold* is an interesting idea. I shall want to use for it the picture in *Savoy* No 2 and the last on the subject that I have done for the album, as it would be waste of time to redraw them. The pictures will be of all shapes and sizes. Hope to let you have the MS soon. What is Dover like? I hope you are feeling nineteen now and not ninety.

Six inches in height will do well I think for the photo.[1]

For *goodness sake* put Gray in No 7 or else I shall (all unwary) have put my foot in it.

Just received a charming letter from Pennell. Raffalovich expresses after his manner a deep interest in the album.

Mother joins me in kindest regards to Mrs Smithers and your-

self, and it would be awfully nice if you could come over to Bos-
combe.

<div align="right">Yours ever A B</div>

1. Cameron's portrait of Beardsley in *Fifty Drawings*.

<div align="center">MS HUNTINGTON</div>

To Leonard Smithers
Saturday [*26 September 1896*]

<div align="right">Pier View, Boscombe</div>

My dear Smithers,

Tonics, milk, retirement, and Boscombe air, seem to avail nothing
in keeping back the blood, which like murder *will* out. Yesterday I
was laid out like a corpse with haemorrhage. For me and my lung
there seems to be little hope. You must have had a bright time at
Dover with the gala. How has it left you? Cameron has just sent
me my photos. How good they are. Have you a nice copy *yourself*
with a mount? I suppose the one he sent you was the same as those
I have just received. I am doing fine work for the final *Savoy*. Any
news of the album will of course come to me like balm. How furious
I should be if I went away without ever having seen it. Everyone
here is very kind, flowers and fruit galore which give me not the
slightest satisfaction. It is a month now since I have left my room
and I fear it will be some time yet before I can even get down to
meals. I suppose it is a special providence that has sent this spell
of damp and damnable weather. I write sitting clammy from head
to foot.

Wagner alone consoles me somewhat.

I shall look forward much to seeing what Symons and myself
will turn out for No. 8.

Ugh! That's what I feel like.

<div align="right">Yours A B.</div>

What about America and the *Book of 50*?

I am literally crying with vexation. One of the best drawings I
have ever done and the most elaborate has been *entirely* ruined with
this awful damp. All that part of the paper on which I was drawing
the head and shoulders of Loge has been reduced to the state of

blotting paper. That is three days' hard work wasted utterly.[1] It's too cruel. I send you the first drawing for No. 8.[2] *All* the drawings I send now will be for No. 8. All attempts at redrawing the aforesaid picture have proved fruitless. I send you a portion of it which I was able to save.

Do not send me on any letters from *Lloyds Bank, Tunbridge Wells.* They are only communications from Deman.

1. This drawing has not survived.
2. Probably *Alberich* (Gallatin 1023).

MS Oxford

To André Raffalovich
[*circa 27 September 1896*]

Pier View, Boscombe

My dear André,

Thank you a thousand times for your book, a precious volume. It was so good of you to send it to me.

Yet another attack of haemorrhage, a slight one, but severe enough to put me in bed for two days. My agony of mind is great even at the slightest appearance of blood, for one never knows if the first few streaks are going to lead to something serious or no. It is nearly six weeks now since I have left my room. I am very busy with drawing and should like to be with writing, but cannot manage both in my weak state. I am sure you will feel it is quite pardonable for me to speak bitterly of this weather. My room faces south-west, and all my books, papers, etc., have been saturated with the damp. So I have fallen into a depressed state.

I am sending you a photograph that Cameron took of me when I was in town. I thought you might like a copy.

With my kindest regards to Miss Gribbell and yourself and John Gray in which my mother joins me.

Yours AUBREY BEARDSLEY

MS HUNTINGTON

To Leonard Smithers
Tuesday [*Postmark 29 September 1896*]

Pier View, Boscombe

My dear Smithers,

Am hugely pleased at the idea of your coming down. I am so glad Dover bucked you up a little. *Erda*[1] outspoken?!! Ye gods methought t'was a mere whisper of a drawing. However. Yes I think the Christmas card[2] should be printed from a half-tone. Still you had better take Naumann's advice. I shouldn't like the design on the skirt to clog at all. But all the rest of the drawing has come out so hardly and coldly in the line block. Witness the shading in the neck.

Certainly I think you will get a superior result in HT.[3] I am a bit tight in the purse myself just now, though of course I shall never allow myself to forget that money is the root of all evil.

Confound Naumann for being so slow with things, and *has* Vallance finished with that accursed iconography? At most it was only three or four days' work for the stupidest of iconographers.

By the way if you frame my photo I should get Cameron to do it for you. Ask him to put it in a similar frame to the one he has sent me. I am glad you like the photo.

Shall be so amused to see the *Savoy* bound into three volumes. How is Symons? What does he think of my translation of Catullus?[4] I am sending a photo to V. O'Sullivan, you said I think that he wanted one.

Am sending divine things by imminent post.

Yours A B

I enclose un petit rien pour la comédie de *L'or du Rhin*.[5]

1. Another of the *Rheingold* drawings, published in *The Savoy*, December 1896.
2. Gallatin 999, first published in *The Savoy*, January 1896.
3. Half-tone.
4. 'Carmen CI', published in *The Savoy*, November 1896.
5. Probably *Flosshilde*, published in *The Savoy*, December 1896.

MS Huntington

To Leonard Smithers
[*circa 1 October 1896*]

Pier View, Boscombe

My dear Smithers,

Very many thanks for the cheques. They shall remain in durance vile in my cash box till you say the word.[1] I quite understand what you say about *Erda*. *The comedy of the Rheingold* which I have sent is of course for the *Savoy*.[2] It will hardly need reduction. Rather pretty I think.

The *Savoy* No. 6 pleases me greatly. After all poor Pierrot[3] cuts a fairly decent figure on rougher paper.

Symons' note on Millais is all right; Wratislaw is also all right,[4] Ellis, as usual, most readable.[5]

The cover est tout à fait charmante.[6]

Flesh tints! He will die without having ever seen anything worse than a baby's bottom.[7]

I will finish MS of *Rheingold* before I make any new drawings for it.

Yes I will make another shot at the catalogue if you like, but I fear the idea of the architecture will not come into it easily.

I am working comme un petit brick.

Hope you are quite well.

Ever your A. B.

1. Smithers gave it out that his agreement with Beardsley was to pay him £20 a week in return for all his work. It was generally believed that however short he was he always paid Beardsley in full, but it is clear from this letter and others that the weekly payment was usually £12 and that even so he had to post-date the cheques.
2. Gallatin 1020, published in *The Savoy*, December 1896.
3. *The Death of Pierrot.*
4. Translation of Villon's 'Epitaph'.
5. 'Concerning *Jude the Obscure*' by Havelock Ellis.
6. Beardsley's *Fourth Tableau of Das Rheingold.*
7. An allusion to 'Notes on Stained Glass Windows' by Olivier Georges Destrée in *The Savoy*, October 1896. The article contains some enthusiastic references to the flesh colour of the nude figures of Adam and Eve in the windows of St Martin's, Scarborough.

To Leonard Smithers[1]
[*? 1 October 1896*]

[*Pier View, Boscombe*]

Dear Smithers,

The enclosed has come into my hands.[2] Would you advise me to take no notice whatever of it? In case you take the view that I *ought* it would be simply sweet of you if you would write as my solicitor to Doré's solicitor and say that I will pay him at the rate of £5 a month.

In haste,

Ever yours A B

If you think that I ought to pay, telegraph 'yes'. I will then send you a cheque for £5 for Doré.

Could you post me the *Liaisons Dangereuses*?[3] I should be very grateful.

1. Translated from *Briefe Kalendernotizen*.
2. A threatening letter from Doré, his tailor, demanding payment.
3. By Choderlos de Laclos, 1782.

To Leonard Smithers[1]
[*circa 2 October 1896*]

[*Pier View, Boscombe*]

My dear Leonardo,

Would you be so very kind as to get me everything Henry & Co have published of Nietzsche[2]—send it here and earn the thanks of

Your A B.

1. Translated from *Briefe Kalendernotizen*.
2. An eleven-volume edition in which Gray was translating the poems. Three volumes had so far appeared.

MS O'CONNELL

To Leonard Smithers
[*Postmark 3 October 1896*]

Pier View, Boscombe

My dear Smithers,

I am sending you by this Molière's *Don Juan* (Act III Sc. 2). It is the scene where Don Juan and Sganarelle meet the beggar in the wood. Don J. offers him a Louis d'or if he will curse and blaspheme. The beggar refuses to do so and at last Don Juan gives him the money 'pour l'amour de l'humanité'.[1]

Thanks for the new cheque.

The proof of O'Sullivan's frontispiece is not bad. The hair is of course too open. I suppose you will not print it on shiny paper. Something similar to that on which *St Rose of Lima* is printed will be best.[2] It is a pretty picture.

Yes I think *Saint Rose* should *most decidedly go in*. It is quite one of the best of my later drawings. *The* best according to many opinions.

Am glad you like the *Rheingold* drawing. I think it is rather smart.

As to the Christmas card. What does Naumann mean by it being spoilt? He most probably thinks that I am anxious to preserve its hardness and tightness.

It is a silly pseudo thing and the more it loses of its original technique the better.

I am doing a picture of Count Valmont (*Liaisons Dangereuses*) for my 'next.'[3]

Blow Sickert! You had better tell him that the *Savoy* only pays for the right of reproduction (mention some small sum) and that we do not buy originals. Let him have the picture back. No agreement was made as to price.[4]

Phil May certainly looks very out of place in the magazine.[5]

Yours ever A B.

1. Gallatin 1018, published in *The Savoy*, December 1896.
2. *The Ascension of St Rose of Lima* had hitherto been printed only in *The Savoy*, April 1896, where it is on the ordinary paper of the magazine. Beardsley must be referring to trial proofs for *Fifty Drawings*.
3. Gallatin 1026, published in *The Savoy*, December 1896.

4. Sickert's pen-and-ink drawing of the Rialto, Venice, was reproduced in *The Savoy*, April 1896.
5. *Holiday Joys*, a satirical water-colour, published in *The Savoy*, October 1896.

MS PRINCETON

To Leonard Smithers
[Postmark 4 October 1896]

Pier View, Boscombe

My dear Smithers,
 You have now for the final *Savoy*
1 A reproduction of Album cover
2 *The Comedy of the Rhinegold*
3 *Alberich*
4 Figures from Molière's *Don Juan* (Act III Sc 2)
And on the way is *5 (Count Valmont)*.
 About a fortnight ago I did a small pen and ink and wash drawing for Dent, as a sort of recognition of his generosity in lending drawings for the album, and in payment of a long-standing debt. I took for my subject *The Return of Tannhäuser to the Venusberg*.[1] It was a very beautiful drawing and Dent gushed over it hugely. I didn't like to ask for permission to bring it out in the album as I did not want him to think I had any *arrière pensée* in doing it for him. Evans' letter however urges me to ask for it and I imagine he has spoken to Dent about it. I am writing by return to Evans asking him to move Dent to a permission,[2] and I should like you to use all your influence to get it for the Album. There is time to get block (a half-tone) made. I am vastly cheered to learn that things are in full swing.
 Yes the *Morte* frontispiece had best go first. If the Tannhäuser can be got it will make a strong *last* page.
 I shall look forward to your coming down tremendously. I wish you could have come this week as rather a nice fellow is spending it with us.[3]
 I am feeling fairly bright nowadays.
 Another filthy gale is raging around the house. Perfectly abominable.

Yours AB.

1. Gallatin 864, first published as an illustration to an article by Max Beerbohm in *The Idler*, May 1898.
2. Evans did so, but Dent wrote to him on 5 October refusing permission.
3. Not identified.

MS WILSON

To F. H. Evans
[Postmark 4 October 1896]

Pier View, Boscombe

My dear Evans,

Very many thanks for your charming letter. Please use *all your influence* to get the *Tannhäuser* put into the forthcoming album. I don't like to ask Dent myself, or he will think I had an interested motive in doing the drawing for him. Which I had not.

Of course I should like it to go in enormously. I am so glad you liked it. Yes I have had rather a shaky time with my lungs, but somehow or other I don't get any worse.

I was so sorry to miss you when I came up to town.

Thanks very much indeed for helping us with the loan of drawings for the album.

Yours ever sincerely AUBREY BEARDSLEY

N.B. Please don't inform anyone of my address and whereabouts.

MS OXFORD

To André Raffalovich
[circa 4 October 1896]

Pier View, Boscombe

My dear André,

The chocolates were delicious. How nice of you to think of them.

Florence St John must be perfectly charming in the *Little Genius*.[1] She is always 'adorable'.

I was interested to hear that the allegorical photograph was attributed to Dürer. The picture has, I believe, in its time been attributed to every painter except Dürer. It is a beautiful thing, so

clear and mysterious. I have just begun a narrative version of Wag-
ner's *Das Rheingold* (the most amusing thing he ever wrote). Most
of the pictures for it are already finished. Smithers has just sent me
a *Savoy*. I rather like this number. No. 7 will contain a translation
of mine from the 'Hail and Farewell' poem of Catullus. I have also
made a picture for it.[2]

 We are having such a soothing spell of still, warm weather here,
troubled only by the wasps, that bring however with them a sort of
memory of orchards.

 I am glad that January will bring me a new brochure of yours.[3]

 What sort of book has Ellis made and whom has he found to pub-
lish?[4] I am amused at what you tell me about the way he treats our
Lord and all the Saints. How treacherous is the illative sense!

<div align="right">Always yours AUBREY BEARDSLEY</div>

 Please give my kindest regards to Miss Gribbell and John Gray
and give them many thanks for their kind wishes.

1. A comic opera, first produced at the Shaftesbury Theatre 9 July 1896.
2. *Ave atque Vale* (Gallatin 1014).
3. 'Annales de l'Unisexualité', published in *Archives de l'Anthropologie
Criminelle* and later reprinted.
4. *Sexual Inversion,* the first volume of *Studies in the Psychology of Sex*
by Havelock Ellis, was published in 1897 and in the following year
successfully prosecuted as an obscene libel.

<div align="center">MS OXFORD</div>

To André Raffalovich
[Postmark 5 October 1896]

<div align="right">Pier View, Boscombe</div>

My dear André,

 Thank you again for the books. The Diderot in two volumes—
that gives me so much more than I asked for—is especially nice. *Le
Rouge et le Noir* is an adorable book, and I am going to re-read it at
once. No I don't think that the little French bookseller has any sort
of claim against me, so my address will be quite unfruitful in his
hands. Considering that his shop is so small he really has a wonderful
number of books 'in stock'. I don't remember ever having had to
order anything from him.

Thanks very much for your account of the Comedy first night. I should love to see Nina Boucicault in the piece.[1]

What with your green and yellow-backed books, your informing letter, a new screen in my room, the first fire I have lit this autumn, some nice drawings I have made, and the collected works of Friedrich Nietzsche, I am feeling quite gay this morning. The weather too is perfectly lovely, and jolly winds are driving white clouds over the bluest sky.

Mother joins me in kindest regards to Miss Gribbell and yourself and John Gray.

I am always yours AUBREY BEARDSLEY

1. *Mr Martin,* first performed at the Comedy Theatre on 3 October 1896.

MS OXFORD

To André Raffalovich
Wednesday [*7 October 1896*]

Pier View, Boscombe

My dear André,

You sent me some most delicious chocolates. It was so good of you. Eida[1] must have been most entertaining. How charming of the Japanese to risk a lacquered warship in a real battle.

I can't tell you how much I have been enjoying the Diderot. He is an extraordinarily attractive writer. I was particularly interested in the 'Salons'.

Very many thanks for your stagey news. First nights are, I suppose, the order of the day just now. I shall be most curious to hear what Gilbert Parker's play is like. The book was so clever.[2]

Please tell me more of your controversy[3] with M. Féré.[4]

A certain publisher has been begging me to illustrate *Pilgrim's Progress* for him. He says that my lately acquired knowledge of suffering has fitted me perfectly for the task! All this was suggested to him by a little picture I sent him of *Tannhäuser returning to the Horselberg.*[5]

It is really too kind of you to invite me to more books. However, I cannot resist the temptation. If there *is* such a thing as an illustrated account of the Brighton Pavilion I should love to have it. And has

any history been written of Napoleon's early life and first Italian campaigns? I ask for the book on the Brighton Pavilion in order to get help for some architectural backgrounds I have been thinking of.

But you mustn't allow me to trouble you so recklessly.

Mother joins me in the very kindest regards to Miss Gribbell and yourself and John Gray.

<div align="right">I am always yours AUBREY BEARDSLEY</div>

1. A note in the German edition of *Last Letters* identifies (presumably on Gray's authority) Eida as a Japanese dealer but gives no further information.
2. *Seats of the Mighty* (1896). The stage adaptation was chosen by Beerbohm Tree as the first play to be presented at Her Majesty's Theatre on its opening in April 1897.
3. Probably on homosexuality. Raffalovich contributed a short article, 'Unisexualité Anglaise', to the *Archives de l'Anthropologie Criminelle*, July 1896.
4. Charles Samson Féré (1852–1907) was the author of *La Famille Névropathique* (1894).
5. On 21 September Dent wrote to Beardsley: 'There is one great book which you should turn your attention to if your strength comes back—that is *The Pilgrim's Progress*, don't laugh! Just take it up and read it. If you could do it I believe it would be your monument for ever—and you know what real suffering is.'

MS HUNTINGTON

To Leonard Smithers
[Postmark 7 October 1896]

<div align="right">Pier View, Boscombe</div>

My dear Smithers,

Here is *Count Valmont* and a beaded border to go round him. I look to Naumann to marry the picture and its frame aright. How are you? I hope you will be down on Saturday.

<div align="right">Yours A B</div>

MS HUNTINGTON

To Leonard Smithers
[Postmark 8 October 1896]

Pier View, Boscombe

Thanks, my dear Smithers, for the proof which I return. Three *was* the number my sister bargained for.[1] Yes Sganarelle is the figure in black.[2] Hope you liked the *Liaisons Dangereuses*.[3] *Do* send me a copy of the *L. D.* if you love me! Very well, leave Christmas card as it is. It certainly might come out woolly. When will you want Cover for No. 7? And how long may I go on working for No. 8?

Glad you are feeling better.

Yours A B

My next picture (well in hand) is *La Dispute de Chopin*.[4]

1. The number of *Salomé* drawings Lane would allow to appear in *Fifty Drawings*.
2. See p. 176.
3. i.e. *Count Valmont*.
4. This drawing seems not to have been made.

MS WILSON

To F. H. Evans
[circa 8 October 1896]

Pier View, Boscombe

My dear Evans,

Very many thanks for the picture. It's a wonderful proof I must say, and my drawing quite unworthy of it.[1]

I won't forget the Pierrot[2] for I feel in the mood to do it quite soon. London seems to be horrid just now, here all is sunshine and south winds.

Is there such a thing as a *complete* reprint of Gibbon's *Rome*?

Yours ever AUBREY BEARDSLEY

1. A platinotype reproduction of *Tannhäuser Returning to the Venusberg*.
2. Evans's bookplate (see p. 75) .

MS HUNTINGTON

To Leonard Smithers
[*Postmark 12 October 1896*]

Pier View, Boscombe

My dear Smithers,

Hope you had a comfortable Pullman up to Town. I send the *Répétition of Tristan und Isolde*[1] and have begun cover No. 7.
With kindest regards from all.

Your A B

1. Gallatin 1017, published in *The Savoy*, December 1896.

MS BERG

To T. Fisher Unwin
[*Date of receipt 16 October 1896*]

Pier View, Boscombe

Dear Mr Fisher Unwin,

I shall be most pleased to make the poster for Crockett's forthcoming book.[1] I shall begin it directly the volume reaches me, for as yet I do not know whether it is a modern or costume book.

Thank you very much for allowing us to reproduce your *Pseudonym* and *Christmas Books*.[2] My album will I think look rather nice.

Sincerely yours AUBREY BEARDSLEY

1. *The Grey Man* by S. R. Crockett, published in 1896 with twenty-six illustrations by Seymour Lucas. Beardsley did not design the poster.
2. i.e. Children's Books.

MS HUNTINGTON

To Leonard Smithers
16 October 1896

Pier View, Boscombe

My dear Smithers,

Many thanks for *Lysistrata*,[1] the *adorable Ingoldsby*,[2] and Dryden.

I should like to have a really *swagger Ingoldsby*. Mallarmé's poem is hideously depressing. Symons' translation of it is A 1, but I don't think I can manage a picture for it.[3] I am sending you soon the two concluding pictures for the 8th *Savoy:*

The hand of Glory
The black Mousquetaire.[4]

Fisher Unwin has asked me to do a poster for Crockett's new book *The Grey Man.*

I enclose the little ornament you wanted.[5]

Am glad you are not entirely disappointed with the *Répétition of Tristan.* What did you think of the cover for No 7?[6] I liked it very much myself.

God speed the album.

Kindest regards from all.

Yours A.B.

When am I to get Juvenal frontispiece for alteration?

1. Smithers's edition, now ready for distribution.
2. R. H. Barham's *Ingoldsby Legends,* published 1840–7 and often reprinted.
3. 'Hérodiade'. Symons's translation was printed without illustration in *The Savoy,* December 1896.
4. Projected illustrations to *The Ingoldsby Legends,* not made.
5. The candle-stick design for the spine of the bound volumes of *The Savoy* (Gallatin 1028).
6. Gallatin 1013.

To Leonard Smithers[1]
[*circa 17 October 1896*]

Pier View, Boscombe

My dear Smithers,

Thank you for the Dryden (volume 5), and the Thorpe[2] which is very entertaining. I am just recovering from a beastly bilious attack. I hope to goodness Dent will hurry up with the blocks. They ought not to take long as they are all in line except one. Yes the fairly cheap *Ingoldsby* would be nice (something about 15/— to 20/—). You have taken a great weight off my mind about Fisher Unwin's poster. . . . Pierrot's death should go in the album, certainly,

and if you are wanting a fiftieth drawing, *The Woman in White*[3] will do quite well.

Am glad the *Savoy* cover looks well. My candle sketch is, as you suppose to be used thus

The frontispiece to Juvenal is not (after the necessary altera-tion) at all indecent, but it will always be unpleasant, so do as you think fit about it. *Messalina* is going in the 8th *Savoy*, I presume.[4]

Mother has seen *three* more little dogs since you were here and sends you her kindest regards.

Yours AUBREY BEARDSLEY

1. Text from catalogue No. 295, Maggs and Co.
2. Possibly *The Hive of the Bee Hunter*, 1854, by Thomas Bangs Thorpe, American humorist and illustrator (1815–78).
3. *The Death of Pierrot* was not included, *The Woman in White* was.
4. First published in *Second Book*. Smithers was evidently holding all the Juvenal drawings for publication in the projected edition.

MS BERG

To T. Fisher Unwin
18 October [*1896*]

Pier View, Boscombe

Dear Mr Fisher Unwin,

I am afraid I shall not be able to make you the poster for Crockett's book. This morning my publisher writes me that the agreement I made with him does not leave me free to do any work for another firm and he is unwilling to make an exception of the present case. I hope I have not caused you a too serious delay in failing you so late as this.

With many apologies.

Yours most sincerely AUBREY BEARDSLEY

Thank you very much for the copy of *The Grey Man*, though I feel I have not now the least right to possess it.

To Leonard Smithers[1]
[*circa 18 October 1896*]

Pier View, Boscombe

Many thanks for your cheerful notelet. Am glad you liked *Mrs Pinchwife*.[2] Yes, she is from Wycherley's *Country Wife*, and you may as well say so in naming the picture.

All right about Yeats, you know I admire his work.[3] By the way I hope Symons is not offended about the Herodias.

1. Text from Walker.
2. Gallatin 1019, published in *The Savoy*, December 1896.
3. *The Shadowy Waters,* a verse play on which Yeats had been working for several years. Smithers had now arranged to publish it with illustrations by Beardsley and was paying Yeats £2 a week to complete it. The play was eventually published by Hodder and Stoughton in 1900. See also p. 215, note 3.

MS PRINCETON

To Leonard Smithers
[*circa 19 October 1896*]

Pier View, Boscombe

My dear Smithers,
The iconography turns out very nicely.[1] I have made a few additions etc in purple pencil. I hope intelligibly. Thanks.

Yours A B

1. The manuscript.

To Leonard Smithers[1]
[*circa 20 October 1896*]

[*Pier View, Boscombe*]

Holme really is too horrid.[2] Put in *The Woman in White* by all means, if you affect it. As to the *Bon-Mot,* it is such a trifle. I

thought the iconography was rather good. I sent the immortal author a congratulatory telegram. Shall long to see proofs of it, and hope it will look imposing. Have nearly completed the next drawing for *The Savoy*.[3]

1. Text from Walker.
2. A second refusal of permission to use the two drawings sold to *The Studio*.
3. Probably *Et in Arcadia Ego*.

MS BERG

To T. Fisher Unwin
[*circa 22 October 1896*]

Pier View, Boscombe

Dear Mr Fisher Unwin,

I am sorry I have been unable to make any arrangement favourable to the production of a new poster; even in the way you suggested.

The loss of *The Yellow Girl* was most vexing,[1] I hope I shall be able to make up for it at some later time.

Yours very sincerely AUBREY BEARDSLEY

1. Gallatin 794. The poster was accidentally destroyed in New York, where it was sent for reproduction. No copy survives.

To Leonard Smithers[1]
[*Postmark 23 October 1896*]

Pier View, Boscombe

My dear Smithers,

Many thanks for letter. So glad you have made a good stroke of biz with America.[2] I had a dreadful day of it yesterday, vomiting a bucketful of previous dinners etc. This morning I feel wonderfully better; and will have the last *Savoy* drawing fini by this evening. After all I need only write 'The Savoy' on the poster cover.[3] You had better let me have two or three pulls on water colourable paper, it will

be better not to paint on the original. See that the pulls have *full lettering* on them.

The Dryden metamorphoses are all very short, and each story has no proper beginning. Could we take a complete book?[4]

Or what say you to an elaborate version of *The Bacchanals of Sporion*?[5] Anyhow we must fix up the 3/6 volume as soon as possible.

Some kind person who has sent me a copy of Pater's *Gaston de Latour* has sent it me through Hatchards.[6]

Have you received the lucky pig my sister sent you a day or so back?[7]

Yours A.B.

[On back of envelope.] Can you get me a complete and cheap Ronsard?

1. Text from Walker.
2. Probably arrangements for the distribution of *Fifty Drawings*.
3. Beardsley's design for a small placard to advertise the bound volumes of *The Savoy* now adapted as the cover design for the issue for December 1896 (Gallatin 1016).
4. Verse paraphrases of stories from Ovid's *Metamorphoses*. Beardsley's suggestion seems to be a complete book of the original, with illustrations by himself.
5. An expanded version of the ballet described in *Under the Hill*.
6. Published in 1896. The book was sent by Raffalovich via Hatchard's bookshop in Piccadilly.
7. Smithers collected ornamental brass pigs.

MS PRINCETON

To Leonard Smithers
[*Postmark 25 October 1896*]

Pier View, Boscombe

My dear Smithers,

Words cannot describe the simple agony of depression into which I seem to have fallen chronically. Here is the last of No 8.[1] Cover nearly done.

Have begun *Bacchanals*.[2]

Ugh A B

Enclosed Sig.[3]

Dent must be simply maddening.

1. *Et in Arcadia Ego.*
2. The cover design. A few days later (see p. 192) it was nearly finished, but the drawing has not survived.
3. Specimen signature for reproduction under the photograph of Beardsley in *Fifty Drawings.*

MS OXFORD

To André Raffalovich
Monday [*26 October 1896*]

Pier View, Boscombe

My dear André,

Very many thanks for your charming letter. I did not know who had sent me the *Gaston de Latour.* Thank you so much for it. I knew no more of the book than its title, and was deeply interested to read it. All that part about Ronsard delighted me.

The 1853 reminiscence of Augustus Hare is instructive and amusing.[1]

No I have not read *The Island of Dr Moreau.*[2] Is it a romance? So good of you to say you will send it me.

I have never been to the church in Spanish Place, what is it like? Monsignor Croke Robinson preached on a strangely suggestive subject.[3] I wish I had heard him. There is down here a beautiful little church served by the Fathers of Jesus.[4] I hope, when I am able to go out, to assist at their services.

I do hope you have not troubled about the Brighton Pavilion; such a foolish idea of mine to want it. I look forward much to the book on Napoleon and his early conquests. I can never bring myself to read far into his life—for sentimental reasons.

Diderot continues to rejoice me. *So* serious and *so* amusing.

It is really *too good* of you to allow me to tell you of my bookish wants. I will send you a list, but it's *too good* of you to ask me for it. My only immediate want is some illustrated account of Claude Lorraine; though perhaps what would be best would be four or five photographs of his seaport and Arcadian pieces.

Now I don't want this to bother you.

Mother joins me in most kind regards to Miss Gribbell and yourself and John Gray.

Yours AUBREY BEARDSLEY

Thank you so much for your kind Paters,[5] I fear I am a sorry beadsman.

1. Brief account of a period of intense religious feeling in the first volume of Hare's *The Story of My Life,* just published.

2. By H. G. Wells, published in 1896.
3. Walter Croke Robinson (1839–1914), Preacher and Lecturer of the Archdiocese of Westminster since 1892 and from 1900 Domestic Prelate to the Pope.
4. Church of the Sacred Heart.
5. Pater Nosters (Gray's note). Raffalovich was now mounting his campaign to secure Beardsley's conversion to Roman Catholicism. The combination of pious advice, generous presents, visits from priests sent at his instigation, and the promise of regular supplies of money achieved success in five months, but produced a sanctimonious unction in Beardsley's letters to him which is perhaps less insincere than it sometimes sounds.

MS PRINCETON

To Leonard Smithers
[26 October 1896]

Pier View, Boscombe

Dear Smithers,

Quite forgot to say anything about the Conder cover.¹ Shall of course be charmed to do one. What is the size of the book? I should hardly imagine that the frontispiece would make a cover block.

Here is the *Savoy* cover. Such a job to manage anything that would be sufficiently elaborate to print in its first state, and sufficiently simple to colour.

Will the 3/6 book be [*drawing of a crown*] *quarto*? The *Liaisons*² had best be begun in preference to any other book.

Hope you are well.

With kindest—for all A B.

In filthy haste.

1. Balzac's *La Fille aux Yeux d'Or,* translated by Ernest Dowson with six woodcuts by Charles Conder (1868–1910). Smithers had asked Beardsley to design the cover.
2. *Les Liaisons Dangereuses.* Beardsley began work on a series of illustrations a month later but completed none.

MS HUNTINGTON

To Leonard Smithers
[*circa 29 October 1896*]

Pier View, Boscombe

My dear Smithers,

Many thanks for letter. I have been thinking over the cover for Conder's book and I feel that the relations that exist between us (humanly and artistically) stand very much in the way of any collaboration in *La Fille aux Yeux d'Or*. Whatever may be my private feelings against him, my artistic conscience forbids me to add any decoration to a book which he has illustrated. Do not smile or frown too much at this sudden outburst of a view of the matter.

I should have felt monstrously upset if you had asked him to do a cover for the *Rape*.

Meanwhile expect hourly to have your eyes feasted with another cover, i.e. cover to *Bachannals*—a *chef d'oeuvre* may I say en passant.

My old friend the blood has turned up again! But I am keeping it at bay with gallic acid.

I am longing to hear details about the *big* big house in Bedford Square.[1] Odd or even? How many rooms? Bath room? And when do you take possession?

I'll take on Yeats's play as soon as you like, am in working form. Am so glad you are pleased with No 8 *Savoy*. I look forward to Ronsard.

Yours ever A B.

1. Smithers was about to move to 6A Bedford Square.

MS OXFORD

To André Raffalovich
Thursday [*29 October 1896*]

Pier View, Boscombe

My dear André,

Thanks for your letter.

I should be indeed grateful for an introduction to any of the

Jesuit Fathers here. It is kind of you to think of asking Father Bampton[1] to write to them and it will be most kind of Fr B. to do so on my behalf.

I recollect reading *Erewhon*[2] at school and enjoying it immensely. I remember so well it being lent me as a very precious book and with grave doubts on the part of the lender as to whether it was not altogether too deep for me.

My little trouble continues, but is somewhat abated.

Sunshine has been with us too; such a blessing.

All sorts of delays seem to have beset the path of my album, but it will appear before Christmas, I am longing to see it.

And what of *Self-Seekers*? With it I begin the list of books I am without and should like.

Pater's *Renaissance*. [1873]

Meinhold's *Sidonia the Sorceress* (Reeves & Turner). [Translated by Lady Duff, 1894]

Laclos' *Liaisons Dangereuses*.

Evelina. [by Fanny Burney, 1786][3]

Gray's Poems. [*Silverpoints*, 1893]

The Shaving of Shagpat. [by Meredith, 1856]

Morley's *Voltaire*. [1872]

 Diderot and the Encyclopedists. [1878]

Voltaire's *Mélanges Littéraires*.

Théâtre (any volume containing *Mérope, Zaïre, Mahomet*).

I have been reading lately some of George Sand's earlier novels, *Mauprat, Indiana, Horace*, etc. How abominably she has been plundered by everyone since.

What was the Gaiety piece like?[4]

Mother joins me in kindest remembrances to Miss Gribbell and yourself and John Gray.

I am yours very affectionately AUBREY BEARDSLEY

1. The Reverend Joseph M. Bampton (*b*. 1854), Superior of the Jesuit Church, Farm Street, 1894–8, and later Rector of Beaumont College.
2. By Samuel Butler, published in 1872.
3. Beardsley had designed the title-page (Gallatin 855) and a small cover ornament (not recorded) for Dent's edition of 1893.
4. *My Girl* by J. T. Tanner with music by F. Osmond Carr, which opened on 13 July 1896.

MS OXFORD

To André Raffalovich
[*circa 30 October 1896*]

Pier View, Boscombe

My dear André,

Thank you for the Claude Lorraine and *The Island of Dr Moreau*. The latter is certainly a horrible affair and very well set forth. I can't tell you how ill I am today. Another outbreak of blood; and the medicine I have to take to keep the blood at bay has also the effect of producing an atrocious headache.

I am quite paralysed with fear. I have told no one of it. It's dreadful to be so weak as I am becoming. Today I had hoped to pilfer ships and sea-shores from Claude, but work is out of the question.

The *Gaston de Latour* has given me great pleasure.

With kindest remembrances to Miss Gribbell and John Gray (who has I hope quite recovered from his cold) and with all best wishes for yourself.

Yours very affectionately AUBREY BEARDSLEY

MS HUNTINGTON

To Leonard Smithers
[*Postmark 1 November 1896*]

Pier View, Boscombe

Dear Smithers,

Thanks for cheque £6 which I have duly cashed. I am so sorry about the Conder cover. Still!

Here is the posterette. Do not be troubled about the unevenness of colour (not intentional). Lithographer must not of course attempt to reproduce brush marks which are inevitable. The green is *emerald green* and a little *black*; the red, *pure vermilion*, the yellow—*chrome orange*, the grey simple black and white mixture.

So interested to hear about the house.

The blood continues, no keeping it off. I dread a violent outburst. God only knows what condition my lung is in with this continual leaking.

Thanks for ordering Ronsard.

How I wish I could be in town to watch the papers and curtains and things going up in Bedford Square. Mother sends kindest regards to Mrs Smithers and yourself in which I join.

<div align="right">Your A B.</div>

<div align="center">MS OXFORD</div>

To André Raffalovich
[circa 2 November 1896]

<div align="right">Pier View, Boscombe</div>

My dear André,

This morning's post brought me Stendhal's fragments on Napoleon,[1] and two magistral volumes, edited by Masson and Biagi, of Napoleon's student writings, and notes upon his early life.[2] I need not tell you how grateful I am for them, and how delighted with the prospect of reading.

The haemorrhage has stopped today for the first time for nearly a fortnight. I am most relieved.

I was tremendously interested to hear about your correspondence with the beautiful Rachilde,[3] and will look forward to her new novel, documented from your book.

No, you never told me anything about a blind man with a romantic history; still I am sorry he has taken to drink.

Sudermann's play must be charming in *Cosmopolis.*[4]

It is most kind of Father Bampton to write to the Fathers down here about me. A Fr. Charles de Laposture called, and was most charming and sympathetic.

I am indeed interested to hear all news of your controversy on nonconformity.[5] I hope you will resume all that is being said for and against in some future edition of your book.

I have just been lent a study of moeurs antiques entitled *Aphrodite*. It is by Pierre Louÿs.[6] You have I expect read it.

Thank you for Father Bampton's utterance on the Papal Bull.[7]

Such weather here! This afternoon is like an afternoon in a radiant September.

Please give my kindest remembrances to Miss Gribbell and to John Gray.

<div align="right">Yours very affectionately AUBREY BEARDSLEY</div>

1. *Vie de Napoléon,* 1876.
2. *Napoléon Inconnu,* 1895.
3. Pseudonym of Marguerite Eymery (1860–1953), French novelist and wife of the publisher Alfred Vallette. Her new novel *Les Factices* was serialized in *Le Mercure de France* beginning with the issue for December 1896. It was the second of her books to treat the theme of homosexuality.
4. Hermann Sudermann's *Das Ewig-Männliche* was printed in German in Fisher Unwin's international monthly *Cosmopolis,* October 1896.
5. See pp. 180–1.
6. *Aphrodite* by Pierre Louÿs (1870–1925), a novel about prostitution in Hellenistic Alexandria, had appeared in April 1896 and achieved a *succès de scandale.*
7. 'The Papal Bull on Anglican Orders', sermon preached at Farm Street on 13 September 1896.

MS Huntington

To Leonard Smithers
[Postmark 5 November 1896]

Pier View, Boscombe

My dear Smithers,
 V. O'Sullivan's book[1] looks very nice. He (the immortal author) is staying at Bournemouth just now and has paid me sundry calls. I hope the book will go well. Words fail to describe the horrid state I have been in. Today is my first of any respite from blood spouting. But then I put on such a bloody great blister last night. Is it possible to get volume 2 of Beloe's Herodotus? Je le veux.
 Beastly life, simply beastly.

Yours A B.

1. *A Book of Bargains.*

MS Reading

To John Gray
[circa 5 November 1896]

Pier View, Boscombe

My dear Gray,
 I should have written to you before, had I been well enough—

to thank you for the parcel of books you sent. *Sidonia* is such an enchanting book. I have had such a trying time with my untractable lung. Neither rest nor fine weather seems to avail anything. How delightful is what you tell me about the Melanesian and his string;[1] perfectly delicious.

<div align="right">Yours ever AUBREY BEARDSLEY</div>

1. A short story, not traced.

MS OXFORD

To André Raffalovich
[circa 6 November 1896]

<div align="right">Pier View, Boscombe</div>

My dear André,

Such a nice little packet of French books has reached me. How kind of you to send them. Catulle Mendès[1] is a great favourite of mine. The conversational pieces of Maurice Donnay[2] are most entertaining; I knew nothing of his before, except *Lysistrata*, which you have of course read and seen acted.

I am a little better today, but not yet quite out of the wood.

With kindest remembrances to all.

<div align="right">Yours very affectionately AUBREY BEARDSLEY</div>

1. French poet and novelist (1841–1909).
2. *Dialogues des Courtisanes* by 'Lucienne' (Donnay and J. Marni), 1892.

MS PRINCETON

To H. C. J. Pollitt
[Postmark 6 November 1896]

<div align="right">Pier View, Boscombe</div>

My dear friend,

I must indeed thank you for the photographs; they are really magnificent; *chefs d'oeuvre!* If you have any others *do* send them

me. Your photographer is, by the way, no mean artist. I would have written to you long before this but have been in such a shocking state. So interested to hear that you are being added to the gallery of the Butterfly.[1]

I should be delighted to see you down here. Will write on the photographs as soon as I can.

Yours AUBREY BEARDSLEY

1. i.e. Whistler, who was painting Pollitt. The portrait is not recorded.

MS HUNTINGTON

To Leonard Smithers
[*circa 6 November 1896*]

Pier View, Boscombe

My dear Smithers,

Thanks for letter. The blood *has* ceased. I am doing the Dowson frontispiece,[1] it will set my hand going again at work. I am planning out the *Way of the World*;[2] it must be a delicate affair. What a bother about the type. *So* sorry about your leg.[3] Hope it will soon be rid of the trouble. I hear there is some article or other on me in the November *Magazine of Art*.[4] Have you seen it?

Yours ever A B

1. *The Pierrot of the Minute,* a verse play by Ernest Dowson published by Smithers in 1897; Beardsley's last completed commission. He contributed five designs (Gallatin 1079–1083).
2. Beardsley made no drawings for Congreve's *The Way of the World.*
3. Smithers was ill with gout.
4. 'Aubrey Beardsley and the Decadents' by Margaret Armour.

MS Oxford

To André Raffalovich
Sunday [*8 November 1896*]

Pier View, Boscombe

My dear André,

You have sent me such a delightful green-covered volume of Voltaire's plays. I have been so cheered with it. Thank you many times.

My dear mother must have been very surprised to hear of my haemorrhage, for I had told her nothing of it.[1] Every one in town seems to have greeted her with the news of it. There has been no return, so I suppose I may consider myself out of the wood for the time being.

Three very interesting photographs have just been sent to me. I should like you to see them.

Mother joins me in kindest regards to Miss Gribbell and to yourself and John Gray.

I am yours very affectionately AUBREY BEARDSLEY

1. Ellen Beardsley was in London to see Mabel, who was leaving for the United States.

MS Huntington

To Leonard Smithers
Sunday [*Postmark 8 November 1896*]

Pier View, Boscombe

My dear Smithers,

I am *enchanté* with the idea of occupying some part of the Bedford Square mansion should I come to town, and pray that that may not be too utterly remote a possibility.

I send you by next post the Dowson frontispiece which I think is pretty.[1]

How vexatious are all the delays about the album.

Very many thanks for the cheques for £12 and £6. I have cashed

the earliest cheque I hold. How goes the world with you, and how is the leg?

I am going to try and get out a little next week, D.V.

<div align="right">Yours toujours A B.</div>

Many thanks for the Ronsard—just what I wanted.

My ma must have been surprised to hear of the bleeding!

1. Gallatin 1080.

MS HUNTINGTON

To Leonard Smithers
[Postmark 10 November 1896]

<div align="right">Pier View, Boscombe</div>

My dear Smithers,

Many thanks for the iconography[1] which I return by this. I grieve to think of you with no fire and hope the gas stove has arrived.

All right about Dowson's play. I am doing a cul de lampe and I will add headpiece and initial letter. P I think is the one wanted.

So glad the leg is getting better even if slowly.

Weather continues to be glorious here. When will you be sufficiently unbusy to come down again? Today is my first out of doors. I feel this afternoon strangely matrimonial. Still! The winter people have begun to arrive. Rather dull and uninteresting.

You might add the Dowson productions to the iconography:
Frontispiece
Headpiece
Initial
Tailpiece.[2]
How goes on the house?

<div align="right">Yours aye B.</div>

Magazine of Art not arrived.

1. The proof.
2. These were duly added. Beardsley also designed the cover.

MS HUNTINGTON

To Leonard Smithers
[*Postmark 11 November 1896*]

Pier View, Boscombe

My dear Smithers,

Thanks for proof.[1] By all means leave the broken red as it is. It looks quite well. Am glad you like the Dowson frontispiece. I have all but finished the initial P and the headpiece.

Some kind person has sent me Browning's *Poems* from Sotheran[2] and Sotheran has sent me his bill. I feel like some helpless target stuck down here to be shot at. Can't you find out something compromising about Sotheran?

Yours A B.

1. Of the placard for *The Savoy*.
2. Bookseller in Sackville Street, Piccadilly.

MS HUNTINGTON

To Leonard Smithers
[*circa 12 November 1896*]

Pier View, Boscombe

My dear Smithers,

Thanks for letter. Dowson initial and headpiece are completed and the cul de lampe[1] nearly so. Will send them in a batch. Bless the *Daily Mail*.[2]

No I don't mind having an *Atalanta* (ordinary edition).[3]

London must be 'orrid just now. I thank my wretched stars that I am here.

The smoking room is downstairs now, and has the addition of a bagatelle board!

Everyone here by the way—adores me.

Yours A B.

1. Gallatin 1083.
2. Unfavourable review of *A Book of Bargains*, 11 November 1896.
3. Probably Swinburne's *Atalanta in Calydon,* first published in 1865.

<center>MS HUNTINGTON</center>

To Leonard Smithers
[*circa 14 November 1896*]

<div align="right">Pier View, Boscombe</div>

My dear Smithers,

Herewith the initial and headpiece, the cul de lampe turned out a cul de sac, so must be redone.

Here too is a list of cheques with amounts and dates

26 September	£12
3 October	£12
9 "	£12
17 "	£12
7 November	£12
30 November	£6
	£66 ?

These are the cheques I now hold.

I can't put my hand on the book bills. But here is I think a fairly correct list of them and their prices.

Racine	£3– 3–	
Ingoldsby	9	Perhaps you know more
Ronsard	3–	about this than I do
Binding of *Savoy*	10– 6	
Acajou etc.	£2– 2–	
Delacroix *Journal*	£1–10–	
Dryden	12s ?	
Earthly Paradise	£1–15s	
	£9–16– 3 ?	

Stunning weather down here. So glad you are thinking of coming down. When will the final *Savoy* be out?

<div align="right">Yours ever A B.</div>

MS Huntington

To Leonard Smithers
[*circa 15 November 1896*]

[*Pier View, Boscombe*]

My dear Smithers,

Very many thanks for letters and cuttings which latter I return. The cul de lampe has not reached you because its precious life is not yet quite complete and therefore not yet confided to the post. I have shed bitter tears over it and love none too well the one I am sending you. All I say about it is *reduce*.

I note what you say about the drawing paper, and I will try some new stuff. I also mean to make all my drawings now for considerable reduction.

Thanks for Vol. 2 of *Savoy*,[1] I shall look forward to 1 and 3.

The smallest female canary 'came' when I gave her your love. Such a mess.

Glad the house goes on, though slowly.

Gray writes me great congratulations on my translation of Catullus. What is it he wants to publish with you?[2]

Yours ayever A B.

1. Of the bound set.
2. Smithers published no book by Gray.

MS Oxford

To André Raffalovich
Sunday [*15 November 1896*]

Pier View, Boscombe

My dear André,

I am all gratitude for the Browning, a perfectly delightful present! My time is being laid out royally amongst the pages. I had only one volume out of the old seventeen-volume edition with me, and am quite bewildered with the sudden blaze of *all* the poems.

I cannot tell you how deeply solaced I have been with this your

latest kind of thought for my bookshelves. If *Cecilia*[1] is a tenth part as good as *Evelina* it must be a very capital book. How good of you to think of sending her in company with her elder sister.

The winter season is settling here rather pleasantly. Yesterday I was able to take quite a long walk, and was scarcely tired at all afterwards. So my fortnight's bleeding does not seem to have done me much injury.

It is sad not to see Mabel before she starts for America.[2] I envy her passage, boat life is so delightful.

Many thanks for all your amusing gossip. Mrs Martyn[3] I seem to have come across in some novel or other. Edward Martyn[4] I fancy I have met in the flesh.

Mother joins me in kindest regards to Miss Gribbell and to yourself and John Gray.

I am yours most affectionately AUBREY BEARDSLEY

1. By Fanny Burney, 1782.
2. Mabel Beardsley toured the United States and Canada in a company led by Arthur Bourchier.
3. Not identified.
4. Irish author (1859–1924), one of the founders of the Irish Literary Theatre and a close friend of George Moore. W. B. Yeats recalled in *Dramatis Personae,* 1936, that Martyn at one time asked Beardsley to design a stained-glass window for the hall of his Irish castle.

MS HUNTINGTON

To Leonard Smithers
[*circa 16 November 1896*]

[*Pier View, Boscombe*]

My dear Smithers,

Herewith the cul de lampe. Many thanks for cheque. I have cashed the earliest I hold.

Thanks for *Atalanta!* Presented to me originally by a fellow at the office. So glad to hear of the iconography, that all goes well with it.

The pigs must be charming. What a joke if all your pigs (like the statue of Pygmalion) came to life one day.

Mother cherishes canaries just now and sends her kindest re-

gards. I continue to get better. Had a brisk walk for an hour yesterday morning.

Yours ever A B.

What's the matter with the new landlord?

MS OXFORD

To André Raffalovich
Tuesday [*17 November 1896*]

Pier View, Boscombe

My dear André,

Thank you so much for the volumes of Miss Burney. I was so amused to find that they had covers and title-pages of my own early designing.[1] *Cecilia* I have begun, and believe I shall like even better than *Evelina*.

In the bay here, the sea is as smooth as a shirt front, so I wish Mabel could have started from Southampton. I do hope her crossing may be quiet and resting after all her hard work. Boats are such blessed things, one loses all sense of responsibility upon them.

I am bothered beyond words to find some little book to do pictures for. Can you think of anything for me?

I have just made rather a pretty set of drawings for a foolish playlet of Ernest Dowson's.

I wondered if *La Dame aux Camélias*[2] or *Diane de Lys*[3] would serve my purpose?

The Lamoureux festival must be a real feast.[4] I don't believe I shall ever hear the sound of a fiddle again.

Boscombe is ignominiously dull.

Mother joins me in kindest regards to Miss Gribbell and to yourself and John Gray.

I am always yours very affectionately AUBREY BEARDSLEY

1. Dent repeated Beardsley's designs for *Evelina* in his edition of *Cecilia*.
2. By Dumas *fils*, 1852.
3. By Dumas *fils*, 1851.
4. Held in the Queen's Hall, 16–21 November 1896.

MS HUNTINGTON

To Leonard Smithers
[*circa 18 November 1896*]

Pier View, Boscombe

My dear Smithers,

Enfin! I like it much better now it is done.[1] Rather pretty
I think. When will Yeats be ready? In the meantime I will do what-
ever you like. There is absolutely nothing in the *Liaisons Dan-
gereuses* to prevent it being published in the ordinary way. Shall
I begin it?

Thanks very much for the *Savoy* No 1.[2] I like the candlestick
design very much.

Yours A B.

1. Evidently still the cul-de-lampe for *The Pierrot of the Minute.*
2. Volume 1 of the bound set, containing the two first issues.

MS HUNTINGTON

To Leonard Smithers
[*Postmark 19 November 1896*]

Pier View, Boscombe

My dear Smithers,

Thanks for letter. I am reading the *Liaisons.* Certainly I think a
good translation of it and pictures would make a saleable book. I
think the pictures must be in line and tint as the decorative element
will have to take a back seat. I have a lot of new ideas for drawing
and am anxious to trot them out in some good series of pictures.

By the way if you are in Paris I should like to get the bound copy
of *La Dame aux Camélias* from Daniel. What is Symons doing for
you now? Would he not be best to make the translation of *Les
Liaisons*? He likes the book and is a quick worker. The *Savoy* covers
I like much.

I look forward to seeing the house in Bedford Square.

Yours A B

All right about the canary. I have procured an abortion. Good old Collins[1] managed it for me.

1. See p. 210.

MS OXFORD

To André Raffalovich
Friday [20 *November 1896*]

Pier View, Boscombe

My dear André,

Thank you so much for your kind suggestions for books to illustrate. Any one of them would make a charming volume; *L'Histoire d'une Grècque moderne*[1] will I think be my choice. Stendhal's *Armance*[2] I do not know. I wonder if an English version has been made of *Adolphe*.[3] Where ought I to look to find out something about Choderlos de Laclos? I am anxious to acquaint myself with his life.

I have just had a letter of Mabel from Queenstown. Her first day at sea passed off most successfully, and she seems quite enamoured of the life on board. I must confess I envy her and should like nothing better than a sea voyage myself. I fear though a real rest is not amongst the possibilities for me.

However, from my window, on Saturdays, I can see the boats leaving Southampton.

I was so sorry to hear you had been unwell; but I hope the trouble is over now.

I was so interested in what you tell me about Thursby.[4]

Yes, I have made a friend here, a Mrs Towle, daughter of Sir Henry Taylor's.[5] She is quite charming, and full of accounts of all the Victorian great people. She is taking me up one day to visit Lady Shelley,[6] who has I believe a delightful collection of the poet's portraits, letters, etc. How good of you to think of friends for me here.

Mother joins me in kindest regards to Miss Gribbell and to yourself and John Gray.

Yours very affectionately, AUBREY BEARDSLEY

Fr. Laposture came to see me on Sunday. He is leaving Boscombe for a short time. He was so glad that I had Fr Bampton's sermon with me. He corrected me most charmingly for mispronouncing Fénelon. I had said Fénélon.

What a delicious subject for a historical essay would be the Gallic Church in the seventeenth century. Though it would be difficult to say much more than is sung in *Le Lutrin*.[7]

By the way I hope you have not seen an atrocious portrait of me in the *Magazine of Art* for this month. I feel I owe an apology to all my friends for it.

1. By the Abbé Prévost, 1740.
2. His first novel, published in 1827.
3. By Benjamin Constant, published in 1816.
4. An actor.
5. Civil Servant, poet and playwright (1800–86).
6. Daughter of the 5th Earl of Courtown and wife of Sir Charles Shelley, nephew of the poet.
7. Mock-epic poem by Boileau, published 1674–83.

MS Huntington

To Leonard Smithers
[*Postmark 20 November 1896*]

Pier View, Boscombe

My dear Smithers,

So glad you liked the cul de lampe. I am firing away at the *Liaisons*.

My copy is by the way incomplete, still good enough to get off the first two or three pictures from.

Sorry the Japanese paper doesn't print half-tone as it should. I am anxious to hear who is to be the honoured translator of the *Liaisons*.

Room papers is of course a contentious question.

Certes a new house is a mixed blessing.

How is Symons?

Have cashed the earliest cheque—a beautiful primeval thing.

Yours A B.

Thanks for cheque.

MS PRINCETON

To Leonard Smithers
[*circa 22 November 1896*]

Pier View, Boscombe

My dear Smithers,
 I much would like to have a talk with you about the *Liaisons* and
its general get-up. It is so important to have a perfectly clear idea of
what the book will be before one begins the pictures. The distance
between London and Bournemouth is driving me crazy. We shall
have to establish a half-way house on the line. Size of page and sort
of paper and such questions are beginning to worry me dreadfully.
With a slight book such as Dowson's play one troubles less, but in
doing a considerable number of drawings such as will be wanted
for Laclos some definite scheme should be settled on first. My mind
and pen still waver between half-tone and line, art paper and other-
wise. Can all this be settled?

Yours ever A B.

MS O'CONNELL

To Leonard Smithers
22 [*actually 23*] November [*1896*]

Pier View, Boscombe

My dear Smithers,
 The 'beautiful primeval thing' was returned me this morning
owing to a slight omission on my part to endorse it. So it will now
be presented at the bank today, Monday. Will that be all right? So
sorry to have made the mistake.
 I sympathize with you entirely in your admiration of the Dowson
drawings. Does the authorette approve?
 Can you send me as soon as possible a *complete Liaisons*, so nec-
essary to have one.
 I am sending you quite soon the first picture for the book. It
will be the frontispiece, a kind of allegorical affair.[1] If you don't care
for the method it can easily be changed for the other pictures. I am
rather wavering in my own mind how the thing should be done.

Another shocking story about Symons? Ye Gods! Are you quite sure he is a safe companion for you?

By the way Collins is the doctor the 'pure English girl' goes to when she has got into trouble.

Florizella[2] flourishes.

Hurry Dowson up over the translation.[3] Can you procure me a portrait of Laclos?

Yours ever A B.

1. This drawing was not completed.
2. Probably one of the canaries.
3. Smithers had commissioned Dowson to translate *Les Liaisons Dangereuses*.

MS OXFORD

To André Raffalovich
Tuesday [*24 November 1896*]

Pier View, Boscombe

My dear André,

It was most charming of you to have copied out for me that little life of Laclos. I never meant you to set yourself such a task, still I am delighted to have the biographical note. I did not know that he had played so important a role in the revolutionary drama, and I am surprised that the wonderful *Liaisons* was written early rather than late in his career. I have long set my heart on making some pictures for the book, not 'galants' in any way but severe and reticent. Prud'hon[1] would have done them to perfection.

I was delighted to find the other day, in Delacroix's *Journal*,[2] an enthusiastic appreciation of a picture of Prud'hon's, the portrait of the Empress Josephine. Do you know it? It is quite one of the most beautiful portraits in the world.

The idea of *Adolphe*, translated by John Gray and illustrated with something of mine, smiles on me very much.

Here is, in order, the list of places Mabel's tour takes her to in America:

New York	25	November
Brooklyn	14	December
Montreal	21	”
Toronto	24	”
Baltimore	28	”
Washington	4	January
Pittsburgh	11	”
Boston	18	”
Chicago	1	February
Philadelphia	8	”
Harlem	15	”

Rest of the tour return visits.

I have been dreadfully upset the last few days with toothache and neuralgia. So depressing.

The lung gives me little or no trouble, I suffer from Boscombe more than anything else.

Mother joins me in kindest regards to Miss Gribbell and to yourself and John Gray.

I am yours always affectionately AUBREY BEARDSLEY

1. French portrait painter and illustrator (1758–1823).
2. First published 1893–5.

MS READING

To John Gray
Tuesday [*24 November 1896*]

Pier View, Boscombe

My dear Gray,

I cannot thank you enough for your delicious volume of Drayton.[1] Ricketts' frontispiece is very elegance, and the cover is enchanting. I am so pleased with the book. I must thank you too for your diverting Melanesian ghost story.

I shall look forward to seeing the Watteau. No painter has ever been more successfully engraved than he.

André tells me that you would not be utterly averse to making a translation of *Adolphe*, that should be illustrated by me.

I need hardly say that it would be an added pleasure to my labour, if I knew that the English version was to be yours.

Signs of winter are beginning to show themselves here, to my anguish.

Yours very sincerely AUBREY BEARDSLEY

1. Drayton's *Nymphidia,* edited by Gray, published by the Vale Press, 1896.

MS HUNTINGTON

To Leonard Smithers
Toosday [*Postmark 24 November 1896*]

Pier View, Boscombe

My dear Smithers,

I shall look forward to getting the *Liaisons.* Raffalovich copied out for me, from the *Biographie Universelle,* a life of Laclos; he seems to have been rather a distinguished sort of person. Shall be so glad if you can get me a portrait.

The frontispiece, I have nearly done, is a picture of Cupidon, a full-sized young man adjusting his bow.

How dare Symons go to Paris and Rome? Et moi!

I have been troubled the last few days with toothache, an utterly disheartening pain.

How annoying of Dent to keep things waiting. C'est trop fort.

So in the spring Symons goes to Spain and Portugal?! I'm blessed.

Yours A B.

MS ROSS

To Robert Ross
[*November 1896*]

[*Pier View, Boscombe*]

Dear Robbie,

It is charming of you to think of coming down here. I shall be so delighted to see you again. I have thought of you so much.

I have become an agonized wreck of depression, a poor shadow of the gay rococo thing I was.

Yours AUBREY

MS Oxford

To André Raffalovich
Wednesday [*25 November 1896*]

Pier View, Boscombe

My dear André,

Thank you so much for the packet of primrose-covered books. *Naïs Micoulin*[1] is a Zola I have never read. Yeats has just sent me the synopsis of a Wagnerian drama he has written and wishes me to illustrate. It is rather fine.

How strangely competent and unnervous one feels with a new and unpublished work. Have you noticed that no book ever gets well illustrated once it becomes a classic? Contemporary illustrations are the only ones of any value or interest.

My neuralgic pains have found a little relief from phenacetin, so I am less of a wreck today.

Yours ever affectionately AUBREY BEARDSLEY

1. Published in 1884.

MS Huntington

To Leonard Smithers
[*circa 26 November 1896*]

[*Pier View, Boscombe*]

My dear Smithers,

Thanks for the catalogue. The title-page looks first rate, just as it should be. There are some pretty things in the catalogue.

Just off to the dentist. Got to have a gigantic tooth out that has spread huge roots and come through the gums in bits.

A.

MS OXFORD

To André Raffalovich
Thursday [*26 November 1896*]

Pier View, Boscombe

My dear André,
 Thank you so much for the copy of *Adolphe*. I am delighted at the prospect of my pictures accompanying Gray's letterpress. At Boscombe it is weather royal, sunshine and south winds. I wish I could hear it was the same with you in London, I should be sorely tempted to run up for a few days.
 We have not yet heard from Mabel since her arrival, it seems the Bourchiers' first night was a great success.
 I am surprised to find that I like almost everybody who comes to Pier View, I can't explain it to myself; even more strange is the fact that they seem to like me. This is quite a new thing in my life.
 I shall feel very lonely in a new church on Christmas day. I am so accustomed to the Brompton Oratory on the great festival. The Oratory is such a lovable church.
 Yours affectionately AUBREY BEARDSLEY
Mother joins me in kindest regards to Miss Gribbell and to yourself and John Gray.

MS READING

To John Gray
[*circa 26 November 1896*]

Pier View, Boscombe

My dear Gray,
 I had thought of attacking *Adolphe* in the early spring, I mean about the beginning of March, as I hope to have finished by then the pictures for the *Liaisons Dangereuses*. But you must choose any time to make the translation. *My* weather *has* come back. Today it is as mild as milk.
 I have not yet seen Beerbohm's album.[1]
 The Bourchiers seem to have started grandly in New York.
 Yours ever AUBREY BEARDSLEY

1. *Caricatures of Twenty-Five Gentlemen,* Max Beerbohm's first collection of caricatures, just published by Smithers.

MS HUNTINGTON

To Leonard Smithers
27 November [1896]

Pier View, Boscombe

My dear Smithers,

Thanks for the letter. I have cashed the £6 cheque. I look forward to the Prud'hon album; and final *Savoy*. My stupidity in making those initials for the *Liaisons* consists in the fact that I have not yet had a sight of Dowson's version, and that I can hardly expect him to begin each epistle of the book with the same letter as is used in the original. Voilà tout.[1]

What's the matter with phenacetin?

For the Dowson play cover I should suggest grey papered boards with a little white label on the back side.[2] Would you care about a design? Yeats's play will well stand six pictures. I am now doing a double page drawing for it of the young man on horseback following the young woman on horseback.[3]

The dentist would not take out the teeth, but is going to do all sorts of things to them daily for the next few months.

I hope your holiday-making will be chaste.

I know well those labouring ruffians, you will never see the last of them.

Your A B.

1. The initials were only sketched, and Beardsley had abandoned *Les Liaisons Dangereuses* before the translation was ready.
2. *The Pierrot of the Minute* was in the event bound in green cloth with Beardsley's cover design printed in gold.
3. There is no evidence in Beardsley's letters that this drawing was completed and there is no record of it, but Yeats stated to Walker forty years later that he had seen it, presumably in its final form, at Smithers's office. The scene described by Beardsley is from a cancelled section of the play.

MS HUNTINGTON

To Leonard Smithers
[*circa 28 November 1896*]

Pier View, Boscombe

My dear Smithers,
 I will do at once a something for Dowson's back.[1] The *Prud'hon* is simply *ravishing*.[2] He is a *great* erotic, and I shall find him hugely useful for the *Liaisons. Do* hurry Dowson up over the translation. The Letters I have sketched are for the 1st five epistles in my edition. T R V S and I. I look forward to a complete copy. May I have No 1180 and 1332[3] out of your last catalogue, if you care to let me have them out of any moneys you may pay me. The Yeats pictures will be amusing. The young man on horseback is vastly beau, and the young woman vastly belle. I am drinking Beaune.
 Hope your adventure was entertaining. Good old balls!
 Yours A B.
May I not come with you to Paris? R.S.V.P.

1. He must mean the cover design for *The Pierrot of the Minute* (Gallatin 1079).
2. The illustration is probably *Le Premier Baiser de l'Amour.*
3. The letters of Alciphron and Procopius' *Secret History,* both published by the Athenian Society, 1896.

MS OXFORD

To André Raffalovich
Saturday [*28 November 1896*]

Pier View, Boscombe

My dear André,
 Thanking you so much for your letter.
 Le frisson de Paris[1] seemed almost too good a title to be true.
 I wonder what a picture of mine to *Esther Waters* would be like?[2] How charming of George Moore to say that I should do it well.
 I wish I could have been at the children's dinner party. I recollect the one I came to.

With a piercing wind from the north-east, the question of hot water bottles becomes important, and I will think of Cotsford Dick's advice.[3] We had our first snow here today.

The Russell case certainly makes horrid reading,[4] still I shall look forward to your précis and study of it.

I am now in the hands of a very charming and skilful dentist here who promises to do great things for my teeth, six of which are under his care. I don't know when the operations will come to an end. It seems I am only just in time to save great trouble with my mouth.

I shall be interested to hear of your visit to Wormwood Scrubs. Will it include a sight of the prisoners? What a painful experience.

I have just seen a most wonderful illustration of Prud'hon's for the episode of the bosquet de Clarens in *La Nouvelle Héloïse*. I fairly melted over it. The défaillance of passion is marvellously rendered in the figure of Julie, which is a perfect triumph of expressive drawing. It recalls strangely the Madonna in our Lady of the Rose Garden of Francia.[5]

Prud'hon's picture is simply ravishing, and has made me happy for a moment.

Yours very affectionately AUBREY BEARDSLEY

Mother joins me in kindest regards to Miss Gribbell and to yourself and John Gray.

1. Novel (1895) by Abel Hermant (1862–1950).
2. Published in 1894. Beardsley made no illustrations for it.
3. Author and composer (1846–1911) and most of his life an invalid.
4. The second Earl Russell's criminal libel action against his mother-in-law, Selina Lady Scott, and three male defendants. In the course of a long and bitter dispute she had circulated a pamphlet accusing him of gross indecency. The case opened amid great public interest at the Old Bailey on 23 November.
5. In the Alte Pinakothek, Munich.

MS HUNTINGTON

To Leonard Smithers
[*circa 29 November 1896*]

Pier View, Boscombe

My dear Smithers,

Am glad Dowson is at work on the *Liaisons*. We must make a fine thing of it.

Mother finished the Beaune, which thus saved whisky. Thank you for the book bill which is all right. Yes Bournemouth is at the world's end, no getting *to* it or *from* it. I pine for other spots, I can tell you.

May I have a copy of Max's album? What news of Symons? When does his Latin-titled book of verse appear?[1]

I don't often buy a book that is worth anything but the Prud'hon is really capital.

I shall look forward to the last volume of the *Savoy*.

Yours A B.

Moore wants me to illustrate *Esther Waters*!

1. *Amoris Victima,* published by Smithers in January 1897.

MS OXFORD

To André Raffalovich
Sunday [*29 November 1896*]

Pier View, Boscombe

My dear André,

I was so disappointed to hear that *Self-Seekers* will not appear till January. What a vexatious delay. Your kind invitation to South Audley Street and promise of fraternal care will keep my thoughts set on town. There will surely be some prosperous weather.

I have just received *The Pageant;*[1] two of the Moreaus (*Oedipus* and the *Hercules*) are perfectly ravishing. I often think of *your* Moreau, one of his most beautiful works.[2]

I am glad you liked *Count Valmont*. The album of fifty drawings is to appear I believe this week. Yes, I recollect Mrs Webster, and her nursing me through a very trying moment.

The adjournment of the Russell case[3] will give you a long rest from your work of criticism. I have been learning a great [deal] about the proceedings from someone who has been in court.

I am delighted that Gray has begun the translation of *Adolphe*. I wish I might put my hand to the pictures at once.

Has Rachilde sent her book in MS or proof? A reading of a book in handwriting is wretched work. I am curious, of course, to

know what the new novel is like and whether you find her an intelligent disciple.

I grieve much that you have been unwell.

My own health becomes daily, it seems, more satisfactory, though a sharp walk this morning left me rather breathless. Still I can scarcely call myself an invalid now. I am indeed grateful to you for all your kind thoughts of me.

Some rather good concerts are being given in Bournemouth just now, and I hope to be able to get to them, but am a little frightened of being out after sunfall. You must have had a great festival with Lamoureux.

I should like to have heard so much the arrangement of music from *Siegfried,* Act II; called I think 'woodland voices' or 'murmurs'.⁴ I read about it.

Mother joins me in kindest regards to Miss Gribbell and to yourself and John Gray.

I am yours very affectionately AUBREY BEARDSLEY

1. The issue for 1897. *The Pageant* was published as an annual by Henry and Co. For Gray's contributions see p. 233.
2. Raffalovich owned the water-colour *Sappho* by Gustave Moreau (1826–98).
3. The hearing was adjourned on Friday 27 November until the following Monday. Before the resumption one of the defendants fell ill and the case did not continue till 4 January. Four days later the jury found for Russell, and Lady Scott and the other defendants were imprisoned for eight months. Raffalovich evidently intended to write on the case.
4. *Forest Murmurs,* included in the concert of 20 November.

MS PRINCETON

To Leonard Smithers
[*1 December 1896*]

Pier View, Boscombe

My dear Smithers,

I would have written before—but—my teeth! I have just been and had a huge rock of a thing extracted. [*Drawing of a tooth with three long roots, under which Beardsley has written:* **Greatly reduced from the original drawing.**] More will I fear have to follow as milder measures are quite unavailing. Am so glad you will be able

P.V.

My dear Smithers.

—— I would have written before — but —
my teeth! I have just been & had
a large roll of a thing extracted.
More will you have to follow
as milder measures are quite
unavailing. . . . Am so glad you
will be able to sit down &
see poor wrecked & wretched me.
A thousand thanks for the two charming
books you have just brought out. Both
look capital; naturally I was
most interested in the Map. It is
a delightful album.
The final Savoy is A¹. Please
congratulate Symons, if you are
willing to him, on his half of the
production.

No. I do not seriously contemplate
illustrating either Collier or any
other waters . . So glad the Bedford

Greatly reduced
from the original
Drawing

Square House continues to progress.
Give my love to a certain bookseller if
you go to Brussels, in fact give him
anything you like except my address
or his money.
Faiblesse compels me to put down
my pen — so farewell

yours az

My mother sends kindest
regards.

comme ça

you see even my teeth are a little phallic.

to trot down and see poor wrecked and wretched me. A thousand thanks for the two charming books you have just brought out.[1] Both look capital; naturally I was most interested in the Max. It is a delightful album.

The final *Savoy* is A 1. Please congratulate Symons, if you are writing to him, on his half of the production.

No, I do not seriously contemplate illustrating either Esther or any other waters. So glad the Bedford Square House continues to progress. Give my love to a certain bookseller if you go to Brussels, in fact give him anything you like except *my* address, and *his* money.

Faiblesse compels me to put down my pen so farewell.

Yours A B

My mother sends kindest regards.

[*Drawing of a tooth with three long roots, beside which Beardsley has written:* Comme ça; *and below which he has written:* You see even my teeth are a little phallic.]

1. *Caricatures of Twenty-Five Gentlemen* and *La Fille aux Yeux d'Or*.

MS Oxford

To André Raffalovich
Tuesday [*1 December 1896*]

Pier View, Boscombe

My dear André,

Thank you so much for the packet of French novels. I have begun with Restif de la Bretonne,[1] he is tremendously interesting, and was heretofore only a name to me. I shall read *Les Rois*[2] next.

Half an hour ago I had a huge rock of a tooth taken out—with gas. Still I feel rather shaky after it. I'm afraid some more will have to follow. Milder measures are quite useless in my far gone state.

In haste,

Yours very affectionately AUBREY BEARDSLEY

Mother joins me in kindest regards to Miss Gribbell and to yourself and John Gray.

1. French novelist (1734–1806).
2. By Daudet, 1879.

MS Huntington

To Leonard Smithers
[*circa 3 December 1896*]

Pier View, Boscombe

My dear Smithers,

The tooth *was* as large as it was drawn. As you mention it, the printing of *Savoy* No 8 was a bit off. Yes *everything* is phallic shaped except Symons's prick.

How touchant of Hatchards. I have cashed earliest cheque. Many thanks. It will be nice to get a Willette[1] and a Rops.[2] And what is this demi annual to be? Who edits, who contributes? And what's the name? *The 6 months' child*?[3] I envy you not the excitement of moving. I shall be in Town (weather permitting) soon after Christmas. Raff has invited me to South Audley Street.

I was so sorry to hear that Mrs Smithers has been unwell. Please give her Mother's and my kindest regards, and accept the same for yourself.

What weather! Yours A B

I hear tragic things of Hubert Crackanthorpe.[4]

1. A. L. Willette (1857–1926), French painter and illustrator.
2. Félicien Rops (1833–98), Belgian painter and caricaturist.
3. In the Editorial to *The Savoy*, December 1896, Symons announced that a successor to the magazine would be published bi-annually.
4. Writer of short stories (1870–96), contributor to *The Savoy* and for a year editor of *The Albemarle Review*. When the closure of *The Savoy* was announced he had begun negotiations with another publisher, Grant Richards, to see if it could be carried on under his editorship. Richards travelled to Paris to discuss the question with him but before anything was arranged Crackanthorpe disappeared after a quarrel with his wife on 5 November. His body was discovered in the Seine on 23 December.

MS Huntington

To Leonard Smithers
4 December [*1896*]

Pier View, Boscombe

Dear Sir,[1]

I am deeply interested to hear that Bourgeois' *Siècle de Louis*

XIV has appeared in an English dress,[2] also that some of Mr Beardsley's superb library still lingers with you. Bourgeois' book I already possess in French, and Mr Beardsley's volumes are to my *certain knowledge* far too rare and costly to come within the limits of my modest purse. Knowing your great interest in all that Mr Beardsley does, I beg to offer you a large number of that great artist's autographs at a reduced rate.

<div align="right">Yours faithfully JOHN THOMAS</div>

1. Smithers's catalogue contained a number of Beardsley's books left behind when he moved from London. This letter, sent as a joke, was no doubt intended to help keep up the prices.
2. *Le Grand Siècle. Louis XIV* by Emile Bourgeois, published in 1896. The English translation, just published, was by Mrs Cashel Hoey.

MS OXFORD

To André Raffalovich
[*circa 10 December 1896*]

<div align="right">**Pier View**, Boscombe</div>

My dear André,
 I fear my much looked forward to visit in the New Year will never be paid. I have broken down again most unexpectedly. The attack came on out of doors and I had some way to walk in a dreadful state before I could get any help. Luckily I was able to find my way to a drinking fountain and a bath chair. So all begins over again. It's so disheartening.[1]

<div align="right">Yours very affectionately AUBREY BEARDSLEY</div>

1. On 10 December Ellen Beardsley wrote to Ross: 'We were out and nearly at the top of the hill leading onto the cliff. You might have tracked our path down, the bleeding was so profuse. I got him to the summer house at the bottom of the hill where there is a fountain, and a lady and gentleman who were sitting near took charge of him till I got a chair and took him home.'

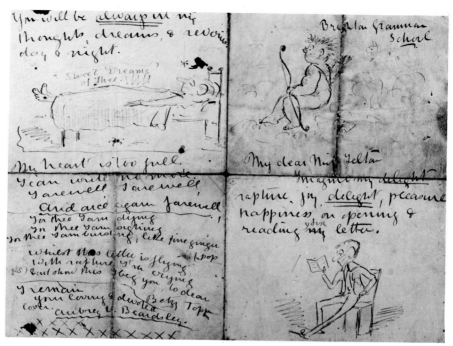

Letter, pages 14–15, to Miss Felton. Hitherto unpublished

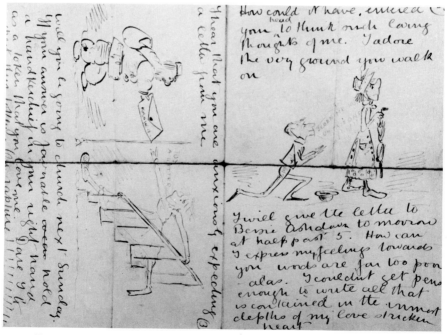

Letter, pages 14–15, to Miss Felton. Hitherto unpublished

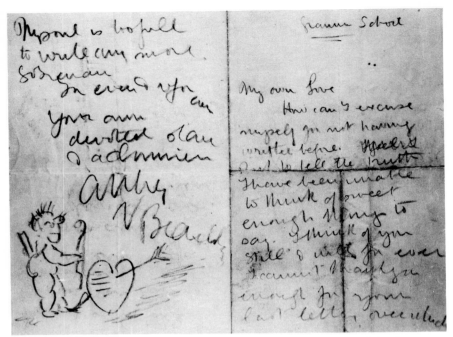

Letter, page 15, to Miss Felton. Hitherto unpublished

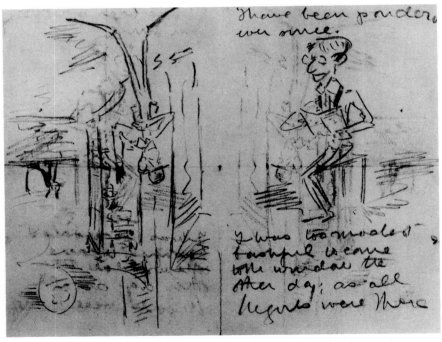

Letter, page 15, to Miss Felton. Hitherto unpublished

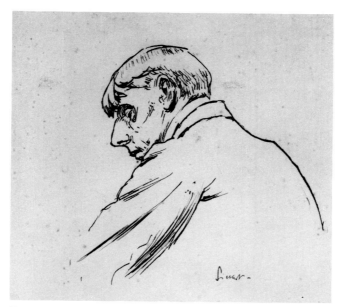

Aubrey Beardsley, *c.* 1894. From an ink drawing by W. R. Sickert

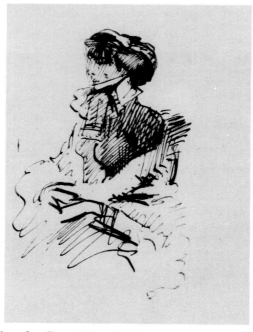

An early drawing by Beardsley, hitherto unpublished. It is accompanied by a letter dated 30 January 1931 from Miss Lilian C. Dash, in which she reports Mrs Beardsley as saying that 'it may have been "her" '

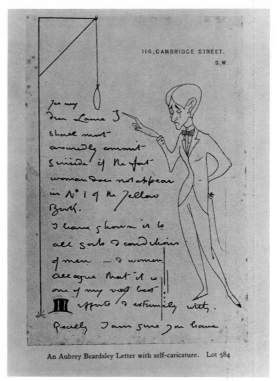

An Aubrey Beardsley Letter with self-caricature. Lot 584

First page of letter, pages 65–66, to John Lane

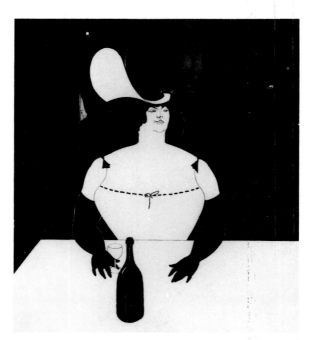

The Fat Woman by Beardsley. This is the drawing referred to in the letter on pages 65–66 to John Lane (*above*). It is a caricature of J. M. Whistler's wife and was not included in *The Yellow Book*. It was first reproduced in *To-Day*, 21 May 1894

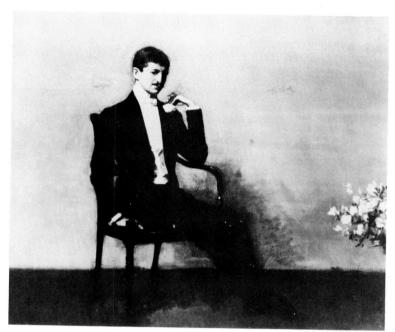

Marc André Raffalovich, *c.* 1895. From a painting by Sydney Starr

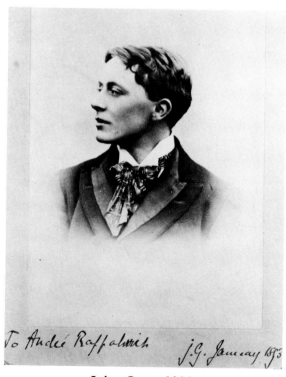

John Gray, 1893

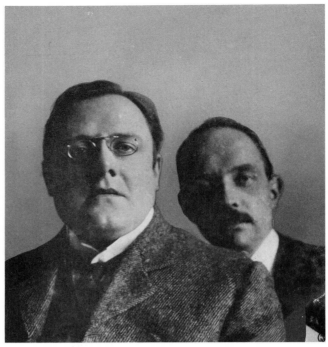

Leonard Smithers, *c.* 1895. In the background is H. S. Nichols, his partner from 1890 to 1895, with whom he had business relations

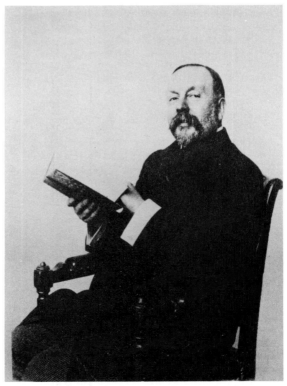

John Lane. From a photograph reproduced in *John Lane and the Nineties,* 1936

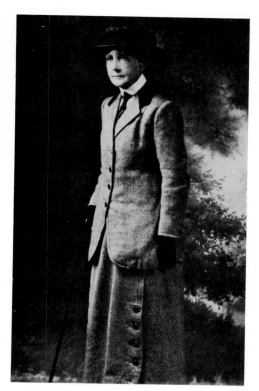

Mrs Ellen Beardsley

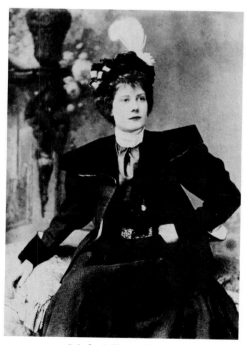

Mabel Beardsley

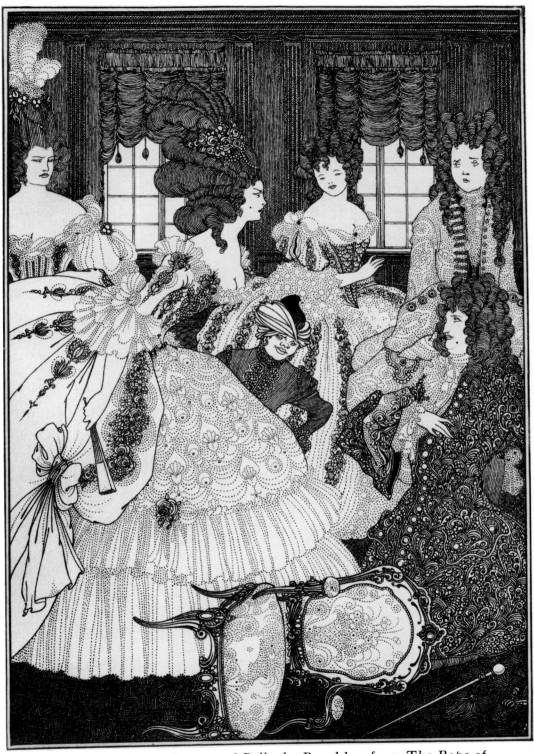

The Battle of the Beaux and Belles by Beardsley, from *The Rape of the Lock*, 1896

MS OXFORD

To André Raffalovich
[*circa 12 December 1896*]

Pier View, Boscombe

My dear André,

I have not had many returns of blood since the first and rather violent outbreak. You are quite right in your expectation that the attacks would now be thrown off more easily. My breathing was only affected on the first day, and has since become (what I have grown to look upon) as normal. I have been whiling away my semi-convalescent moments with Zola's *Rome*, in its thoroughly English dress.[1] I always melt over descriptions of the South and sunshine. You have of course read the book, and will recollect the very ludicrous passages about Botticelli.

I hear that the translation of *Adolphe* progresses bravely. What a charming little calendar Gray has sent forth.[2]

I have been suffering dreadfully from depression, a condition which seems to me next door to the criminal.

Mother joins me in kindest regards to Miss Gribbell and to yourself and John Gray.

I am yours always affectionately AUBREY BEARDSLEY

1. Translated by E. A. Vizetelly in 1896, the year of its publication in France.
2. *The Blue Calendar, 1897*, a small pamphlet of poems sent out by Gray as a Christmas card.

MS HUNTINGTON

To Leonard Smithers
Dimanche [*Postmark 13 December 1896*]

Pier View, Boscombe

My dear Smithers,

How is Brussels? Yesterday[1] I ventured out for a walklet in Winter Gardens. As I was ascending the Chine blood began to spout profusely. Imagine my distress, with no possible way of getting home

but on foot. I expected I should make an 'al fresco' croak of it. I struggled péniblement to where I expected to find a drinking fountain. There *was* one there, and so the pretty creature drank.[2] The cold water made things better, and I then had the good luck to find a donkey chair to drag me the rest of the way to P.V. There seems to be no end to the chapter of blood.

I am better however, today.

How *is* Brussels?

Thanks for volume 3 of the *Savoy*.

Mother joins me in kindest regards to Mrs Smithers and yourself.

Yours A B.

So glad you are able to spare time to come and see me miserable.

1. If Ellen Beardsley's date is right (see p. 224) this episode occurred three days earlier. The postmark date of this letter is confirmed by Beardsley's 'dimanche'.
2. An allusion to Wordsworth's pastoral 'The Pet Lamb'.

MS HUNTINGTON

To Ernest Dowson[1]
[Postmark 16 December 1896]

Pier View, Boscombe

My dear Dowson,

I wonder if you could send me a list of the initial letters you have already used in the *Liaisons*, and which of them are repeated and how many times. I wonder if you could keep me posted up to date on this subject. It would be good of you to send me a card now and then so that I can clear off the initial designs. I want to make different pictures for each letter.

Yours AUBREY BEARDSLEY

1. English poet (1867–1900) and one of the chief contributors to *The Savoy*. Beardsley had designed the cover of his *Verses* (Gallatin 954), 1896, as well as illustrating *The Pierrot of the Minute*.

MS HUNTINGTON

To Leonard Smithers
[Postmark 17 December 1896]

Pier View, Boscombe

My dear Smithers,

Bleeding has stopped. So glad you have at last tasted the *Latour*; simply too too isn't it? Were you drunk on that occasion? Why not lay down twenty dozen of it in the new house?

I expect you here daily. Have you got or could you get by any chance a pretty copy of Mme de Genlis' *Veillées du château*.[1] I wanted to present my ma with it on Christmas day. What sort of a crossing had you coming back? I suppose you take up residence now in le square de Bedford? I have quite forgotten le Grand Café Universel. I have written to Dowson for a list of initials up to date.

Yours A B.

1. A volume of short stories first published in 1784.

MS REICHMANN

To Max Beerbohm
[circa 19 December 1896]

Pier View, Boscombe

My dear Max,

It was so charming of you to send me your twenty-five gentlemen. Of course I like my own portrait best.[1] After that I enjoy the Lord William Nevill most.

I have just seen the *Saturday* supplement. Really Billy is incorrigibly good.[2] How finely frigid, as a piece of sculpture, is the Marcus Superbus.[3]

Boscombe must I think be one of Clement Scott's[4] watering places. I shall never forgive it.

Yours AUBREY BEARDSLEY

1. Caricature of Beardsley with toy poodle, previously published in *The Savoy*, April 1896.

2. *The Saturday Review* Illustrated Supplement for Christmas 1896. Rothenstein, who was art editor, designed the cover and contributed portraits of John Oliver Hobbes and Beerbohm Tree.
3. Caricature by Max Beerbohm of Wilson Barrett as Marcus Superbus in *The Sign of the Cross.*
4. Journalist and miscellaneous writer (1841–1904), editor of *The Theatre* and dramatic critic of the *Daily Telegraph.* In *The Saturday Review*, 12 September 1896, Max Beerbohm had published an ironically enthusiastic eulogy of Scott's *Lays and Lyrics* (1888) making great play with the poet's frequently ungrammatical devotion to English seaside resorts.

MS OXFORD

To André Raffalovich
Sunday [*20 December 1896*]

Pier View, Boscombe

My dear André,

I cannot thank you too much for your kind Christmas card, the photograph of yourself. What a capital portrait it is. I have always wanted to have a photographic souvenir of you, and the one you have just sent me will be much treasured. The floral note was I suppose supplied by the admirable Goodyear.

A fit of hard work has dispelled my depression.

Yes, we were all shocked by the earthquake that made a fruitful subject of conversation at that morning's breakfast.[1] The season of Advent gave quite an alarming point to the disturbance at the moment it was felt.

The weather in London just now must provoke anguish in the soul of everyone except the Marchesa.[2] Down here there is sunshine, but very capricious in its favours, which are withdrawn at a minute's notice. I have not ventured out since my last disastrous walk.

Unfortunately Pier View is situated half-way up a hill, so I have no level promenade at hand.

Everyone is leaving for Christmas, and an entirely new set of boarders arrive for the feast. I lose thus many old friends.

The mother of the late Slade Professor at Cambridge[3] is staying here now. She has been telling me much of her son. He was indeed a wonderful person. I don't remember ever having met Kegan Paul.[4]

There are some perfectly charming pictures in *The Saturday Review* supplement for Christmas. You have seen them of course.

This afternoon I have spent interviewing myself for the *Idler*,[5] and hope I have not said too many foolish things. We have long letters from Mabel. She does not love New York. I look forward to her return very much; it would be so nice if I could live in London, if for only the spring and early summer of next year.

Mabel and myself might set up temporary house together. I feel that we shall be better friends than ever after such a long separation, and six months of this horrid place will have made me abjectly thankful for the smallest gaieties and pleasures in town.

Mother joins me in kindest regards to Miss Gribbell and to yourself and to John Gray.

I am yours very affectionately AUBREY BEARDSLEY

1. Tremors were felt throughout Britain and some buildings were damaged in the Midlands and Wales on 17 December 1896.
2. Not identified.
3. J. H. Middleton (1846–96). His mother was the daughter of J. P. Pritchett, the architect of the Deanery, York.
4. Former Anglican parson, master at Eton, vegetarian, mesmerist and free-thinker (1828–1902) who in 1890 had become a Roman Catholic. He had been head of his publishing firm since 1877.
5. The material he supplied was used in 'Mr Aubrey Beardsley and his Work' in *The Idler*, March 1897.

MS OXFORD

To André Raffalovich
[*circa 22 December 1896*]

Pier View, Boscombe

My dear André,

There is quite a summer sun pouring into the room; delightfully unseasonable. My doctor this morning gave me a good character, and does not look upon London as being wholly impossible for me. I am so glad you are pleased with the album. There are many faults, alas, in its 'get up' owing to perfectly indecent haste in preparation. The more serious faults in the book I cannot excuse so readily. I was delighted at what you told me of Rachilde's letter.

I wonder what *Pilgrim's Progress* will be like? I have never read the book.

I envy you being able to assist at Midnight Mass. From where I am I shall not be able to hear the bells ring out and usher in the years.

How sad it is that Christmas, the most beautiful of all feasts, should have grown to be so displeasing a season to almost everybody. Nobody at Pier View but grumbles at its approach. I wish I had known you two years ago when I and Mabel had such a lovely Christmas tree, hung with such pretty things. I recollect some volumes of Verlaine and a very malicious caricature of Whistler[1] by myself were upon the branches.

I shall think of Mabel very much on the 25th. She will be on English soil I hope. Toronto most probably.

I read the list of your Christmas guests with much interest.

The edition of the *Liaisons Dangereuses* is beginning to take shape at last. Each letter (there are 170 odd) will have a separate decorative or illustrative initial. There will be ten full-page illustrations; and a frontispiece to each of the two volumes. The whole to be printed on art paper.

Many thanks for your nice long letter. Mother joins me in kindest Christmas regards to Miss Gribbell and to yourself and John Gray.

I am yours very affectionately AUBREY BEARDSLEY

1. Gallatin 780. First published in *Unknown Drawings*.

MS HUNTINGTON

To Leonard Smithers
[Postmark 22 December 1896]

Pier View, Boscombe

My dear Smithers,

I hope your journey up to town was not too cold. Conversation at table is much about the same; two more old women have arrived, one of them *owning* to eighty-three. Never be surprised to see my sallow face at No 4[1] any day. How did you find the Bedford Square mansion? I have been reading Dowson's translation.[2] It will want a

good deal of touching up, at least it seems so to me. I am living utterly in the alphabet, and dream of Ts and Ss.

Lautrec[3] in his letter to me asks for an Album (with an inscription from me in it) in order to review my work. You generally send him (on account of the *Courrier Français*) a copy of my books. I wish you would send him the book of fifty, with enclosed slip.

His address is

38 Rue Desborde-Valmore, Paris

Have had another wet dream.

It's all rot about Symons. Once a eunuch always a eunuch. Perhaps the story might be transferred to me, with equal truth. You want an anecdote for the *Idler*.

Yours A B.

I hope the leg has improved. Kindest regards from my lady mother.

1. Smithers's shop in Royal Arcade.
2. Only a little had so far been done.
3. Gabriel de Lautrec, French author (1867–1938) at this time one of the principal contributors to *Le Courrier Français*.

MS Huntington

To Leonard Smithers
[*Postmark 23 December 1896*]

Pier View, Boscombe

My dear Smithers,

Blessings be upon you for Christmas and New Year. The enclosed lady is I believe a most effective medium through which to obtain all worldly and spiritual benefits. Quite the most potent virgin and martyr on the calendar. You will see in Raffalovich's book what 'Monsieur Frère de Louis XIV' did with such relics and images.[1] The lace around the picture will do very well for the lace of her pantalons. There. I've given myself a cockstand! Still!

Yours ever A B

I have made you out a bootiful cheque.

My mother joins in kindest Christmas regards to Mrs Smithers and yourself.

1. *Uranisme et Unisexualité* pp. 294–5, quoting from the memoirs of

Monsieur Frère's second wife: 'Il apportait toujours au lit un chapelet d'où pendait une quantité de médailles, et qui lui servait à faire ses prières avant de s'endormir. Quand cela était fini j'entendais un gros fracas, comme s'il les promenait sous la couverture. Je lui dis: "Dieu me le pardonne, mais je soupçonne que vous faites promener vos reliques dans un pays qui leur est inconnu" Monsieur se mit à rire, et dit: "Vous qui avez été huguenote, vous ne savez pas le pouvoir des reliques et des images de la Sainte Vierge. Elles garantissent de tout mal les parties qu'on en frotte." Je répondis: "Je vous demande pardon, Monsieur, mais vous ne me persuaderez point que c'est honorer la Vierge que de promener son image sur les parties destinées à ôter la virginité." '

MS OXFORD

To André Raffalovich
[*circa 24 December 1896*]

Pier View, Boscombe

My dear André,

I can't tell you how much pleasure the little Watteau[1] has given me. A Royal treat. It is a delicious volume, and contains for me so many new friends as well as the old. The coloured frontispiece is adorable, I shall try to find out who made the block. How very generous the publishers have been with their illustrations, and how good their choice.

I really feel better since I opened the parcel.

1. *Antoine Watteau* by A. Rosenberg, 1896.

MS READING

To John Gray
25 December [*1896*]

Pier View, Boscombe

My dear Gray,

The volume of Landor[1] is perfectly charming. The conversation chosen is I suppose everyone's favourite. It is such a pleasure to have

it in a separate edition. Very many thanks for it. I heard of *Adolphe* rattling along on the typewriter. I am impatient to begin my part of the work.

I caught a horrid chill this afternoon. I had to fly from the dinner table in consequence, in a state of pain and fever. I suppose the layers of carpets and other dilatory people have allowed by this time possession of your flat.

I have been reading you with much pleasure in the *Pageant*. 'On the South Coast of Cornwall' is delightful, especially the last line of it.[2]

A curious child aged two has been brought to see me this afternoon. I asked him, as is the custom, what he was going to be. 'A bishop,' he replied in a firm voice. This has been his ambition for the last six months.

Yours ever AUBREY BEARDSLEY

1. *Epicurus, Leontion and Ternissa,* published by the Vale Press, 1896.
2. Gray contributed a short story, *Light,* and this sonnet, which ends:
 'The fishers have no thought but of the strong
 Sea, whence their food, their crisp hair, and their song.'

MS OXFORD

To André Raffalovich
25 December [*1896*]

Pier View, Boscombe

My dear André,

It was really too good of you to send me such a kind present. Mother has just given it me from you. Thank you very much indeed. I was so glad to receive your telegram on Christmas Eve.

I thought of you this morning, though I was unable to assist at any service. Mother has given me a very interesting life of Bossuet, and Liguori's little book on the Blessed Sacrament. Every one has been very kind here. The children of the house have had perfectly ravishing toys sent them, one a doll's house with lifts, electric bells, baths, etc. To say nothing of a perfectly Parisian cook, an obedient staff of servants, and a duchess, by the look of her, to be served by them.

Forgive this hastily written scrawl, for there is an early post today. I am writing you a more coherent letter in the immediate future.

Yours very affectionately AUBREY BEARDSLEY

Mother joins me in kindest regards to Miss Gribbell and to yourself and John Gray.

MS Ross

To Robert Ross
[circa 25 December 1896]

Pier View, Boscombe

Dearest Robbie,

It was too sweet of you to send me such a lovely present. I can't thank you enough for it. Just what I wanted.

Christmas has been abominably hot and glaring here, blinds down and windows open all the time.

I want you to forgive me for having plagiarized one or two of your good things you told me you had written in an imaginary interview with me a long time ago. *The Idler* is publishing something about me from notes of my own, and I stuck in boldly a few Robertian plums. I hope you won't mind. I am getting a little better now owing to compulsory hard labour.

Thanks so much for thinking of Mabel, she will be grateful I know for any introductions.

Mother was delighted with the flowers you sent her. She joins me in tenderest seasonable wishes, etc.

Yours very affectionately AUBREY BEARDSLEY

MS REICHMANN

To Max Beerbohm
[circa 27 December 1896]

Pier View, Boscombe

My dear Max,

I should have answered your charming letter many posts before this, but my case has taken such a serious turn for the worse, that I have been left without any energy.

My plans are dreadfully unsettled. More than anything, my dear Max, I should like to renew your acquaintance, but it is just possible I may have to leave in a few days for some more bracing place. At present I have to lie low and keep on doing nothing. All this is so unexpected. As soon as the Doctors have come to a final decision as to where I am to go I will write to you. My expectation is on tip-toe for your article in *To-morrow*.[1] I know it will be quite the most charming thing, and coming from you it will have great weight with me.

Yours AUBREY BEARDSLEY

1. Review of *Fifty Drawings* in *To-Morrow*, January 1897.

MS OXFORD

To André Raffalovich
[*circa 27 December 1896*]

Pier View, Boscombe

My dear André,

I am up a little today, and hasten to write to you. I know Fr. Christie[1] by sight only, I recollect him attending the Oratory in his lay days.

I am so entertained by the study of Zola.[2] I did not know such a book had been published. The idea of such interviews is good enough if you could imagine every distinguished person allowing himself to be really frank. Zola was a capital person to start the series, as he has the reputation of being a good bourgeois with no need to be reticent about his tastes. The memory tests were interesting, especially those in which he failed to attribute well-known passages to their right authors. I recollect in an interview with Zola in *Le——? Illustré* some years ago, he said that *Manon Lescaut* was a book he had read many times, and always had beside him.

Thanks many times for the volume. I still continue in a very doubtful state, a sort of helpless, hopeless condition, as nobody really seems to know what *is* the matter with me. I fancy it is only change I want, and that my troubles are principally nervous. I have been trying to take arsenic but it has disagreed most dreadfully with me.

Please forgive a short note and thanks for your last kind letter.

Mother joins me in kindest regards to Miss Gribbell and to yourself and John Gray.

I am yours always affectionately AUBREY BEARDSLEY

1. Father Henry James Christie of the London Oratory.
2. By Edouard Toulouse, 1896.

MS HUNTINGTON

To Leonard Smithers
[Postmark 31 December 1896]

London D.V.
Boscombe (pro tem.)

My dear Smithers,

Forgive me my pettish silence. Mais, j'ai souffert! . . .

The last week has brought things to a climax, so tomorrow (New Year's Day) I am to have a grand specialists' consultation around me to decide whether I can come up to town. Thanks for the *Daily Mail*.[1] Touching utterance. A lady has just written to ask me if I would be kind enough to send her a copy of verses upon any of my pictures. Whereupon I wired the following chaste thing.

> There was a young lady of Lima
> Whose life was as fast as a steamer.
> She played dirty tricks
> With a large crucifix
> Till the spunk trickled right down her femur.

What a bore about the *Liaisons*.

Thanks for the additional cahiers.[2]

Ye gods what a feast is Christmas! What did you do with yourself?

Yours ever A B

I enclose enfin the bootiful cheque.

Mother has heard nothing about the piano from the other party.

1. Review of *Fifty Drawings*, 29 December 1896.
2. Of Dowson's translation of *Les Liaisons Dangereuses*.

Part VI

1897

IN the last fifteen months of his life Beardsley was for the first time
beaten into submission to his illness. Except for short periods
the physical effort required by his work became too great for
him—a tragedy all the greater because his imaginative powers were
unimpaired. His few drawings of this period show both that he was
still capable of rapid development in style and still able to gain imme-
diate mastery over new media and techniques. From now on his life,
in physical terms, is a sad succession of slow recoveries, journeys
followed by a brief revival of spirits, short spells of work and then
again collapse.

Taken, however, as a document of the growth of religious belief,
these late letters give a remarkable account of a conversion and
its aftermath. Gradually weakened into longer stretches of helpless-
ness and misery, Beardsley began to take seriously the idea of Roman
Catholicism. In this he was given every encouragement by Raf-
falovich, and on 31 March 1897 he followed the example of his sister
and was received into the Roman Catholic Church. His conversion
was by no means perfect; he was often more interested in the trap-
pings of his new faith, the ceremonial and the details of hagiology,
than in its central meaning; he was not always sincere, and side by
side with the platitudinous pieties of his letters to Raffalovich he
continued to write cheerful improprieties to Smithers and once
offered him erotic drawings; to Pollitt he admitted: 'This morning
I was closeted for two mortal hours with my Father Confessor, but
my soul has long since ceased to beat.' And yet the balance of the
evidence must incline one to the view that he accepted the faith and
discipline of his religion whole-heartedly, and in the end found in it a
strength which supported him through the agonizing last stages of
his disease to which otherwise his spiritual resources might have
been unequal.

Although Beardsley seemed desperately ill at the time of his con-
version he made such a quick recovery that within ten days he was
able to travel to Paris with his mother who on 22 April wrote to

Ross: 'Paris is doing wonders for Aubrey. I can't believe my eyes seeing him prancing about as if he had never been ill . . . He moves about like his old self—in short he is a miracle.' The recovery as always was illusory, but its repetition each time he travelled strikingly supports the methods of his doctors, whose prescriptions were of no use in halting the physical progress of the tuberculosis but of undoubted value in making life endurable for him by constantly giving him hope.

As soon as his constitution started to weaken afresh he would be advised to move on. After only six weeks in Paris he settled in S. Germain. Two months later he was off to Dieppe for the summer, then back again to Paris until the fog and ice of November made him set off on his last journey to Menton.

MS OXFORD

To André Raffalovich
[circa 4 January 1897]

Pier View, Boscombe

My dear André,

Just a little line to give you rather bad news of myself. I have for the moment collapsed in all directions and am frightening the doctors not a little. All this is unexpected and unexplained. As soon as I am strong enough to move, I am to be taken to some more bracing place.

Thank you so much for your last kind letter. Please forgive a very short reply, I am in such an incapable condition. It is so vexing to begin the New Year so wretchedly. Mother joins me in kindest regards to Miss Gribbell and to yourself and John Gray.

I am yours always affectionately AUBREY BEARDSLEY

MS HUNTINGTON

To Leonard Smithers
[Postmark 4 January 1897]

Pier View, Boscombe
Bed

My dear Smithers,

I wonder if it would be possible for you to come down to see me

here at the week's end. The doctors have found me in a critical condition and there is some talk of my leaving Boscombe. They say that if I cannot get out of my present depressed state Boscombe will do for me; and that London itself would be a lesser risk. I am indeed in a shaky feverish state. All this is rather sudden and unexpected.

Thanks for your letter. Forgive a short note. I am in such an incapable condition.

Yours ever A.B.

To Leonard Smithers[1]
5 January 1897

Pier View, Boscombe

. . . It is most vexatious about the Voltaire. There have been a good many complaints here about undelivered parcels. . . . Please let me know what date you sent it off and description of the package. . . .

I am (pro tem) bed-ridden. I hope you will be able to come down. I am sending the Bauer paper signed.[2]

1. Text from Catalogue No 343, Maggs and Co.
2. Possibly a form of authentication for a drawing sold through Smithers.

MS HUNTINGTON

To Leonard Smithers
[*Postmark 6 January 1897*]

Pier View, Boscombe

My dear Smithers,
Voltaire arrived all right. From Ashworth's note I imagined you had sent it some time ago. It is a pretty copy. Will you keep it for me? You mustn't bother about coming down if there is any difficulty about it, or it disarranges your plans. I am in a highly negative state just now, with only sufficient brains to be amused with *Les Mystères de Paris*.[1] Perhaps it has been influenza I have suffered from. All the symptoms. Doctors duffers.

I quite forgot to return you the cuttings for your press book. I enclose them now. I feel abominably 'cornered' being like this. I want your advice as much as anything on the subject of where to stay if I come up to town.

<div align="center">In haste,</div>

<div align="right">Yours ever A B</div>

Thanks about piano.

1. A sensational novel of the Paris underworld by Eugène Sue, 1848.

<div align="center">MS HUNTINGTON</div>

To Leonard Smithers
[Postmark 7 January 1897]

<div align="right">Pier View, Boscombe</div>

My dear Smithers,

So sorry to hear about the leg. You mustn't dream of coming down here if the journey etc. will be bad for you. It is such a serious trouble. No news except that a whale has been washed up onto the Boscombe beach.

Don't feel bound in any way about the pianette. I'm afraid you expected a larger affair. Of course it is quite a small instrument. I fancy somebody else would be willing to have it if you would rather not.

I hope I shall hear better news of yourself in your next.
Silly little O.[1]

<div align="right">Yours ever A B.</div>

1. Probably Olive Custance. See p. 250.

<div align="center">MS REICHMANN</div>

To Max Beerbohm
[circa 10 January 1897]

<div align="right">Pier View, Boscombe</div>

My dear Max,

I am allowed up a little today, so hasten to write to you.

I needn't tell you how charmed I was with your review in *To-Morrow*. It is quite one of your most brilliant essays, and I am proud indeed to be the subject of it.

I wish, dear Max, I could write you a longer letter of thanks, but I am so dreadfully feeble that I dare not trust myself to composition. You cannot imagine how awful it is to be in this constant state of fatigue and nullity.

<div align="right">Yours ever affectionately AUBREY BEARDSLEY</div>

MS HUNTINGTON

To Leonard Smithers
[Postmark 10 January 1897]

<div align="right">Pier View, Boscombe</div>

My dear Smithers,

I am sorely distressed to hear about your leg. I do hope that your recovery is daily. You mustn't dream of coming down here in such a risky state, I should be dreadfully sorry to think I was the cause of your having done so. The journey and the absence of nursing would be sure to throw you back horribly.

All right about the Sandys.[1] Pennell wants a copy, and if he should apply to you for one and you are unable to supply him with it, mine is at your disposal.

What a charming article Max has written on my album in *To-Morrow*. You have of course read it.

<div align="right">Yours in great haste for post A B.</div>

1. Frederick Sandys (1829–1904), pre-Raphaelite artist. Pennell's article 'A Golden Decade in English Art' in *The Savoy*, January 1896, had two of Sandys' woodcuts among the illustrations.

MS MIX

To Leonard Smithers
[Postmark 13 January 1897]

<div align="right">*[Pier View, Boscombe]*</div>

My dear Smithers,

I am awfully sorry to have such a bad account of your leg, still it

must be a blessing to feel that the treatment (however unpleasant) is doing you good. *My* treatment is only making me worse. Good old Dowson. I have today re-read *La Pucelle* with infinite pleasure and shall look forward more than ever to *your* edition.[1]

I tried to make a grand effort to get up to town this week, but every obstacle has been put in my way. I feel utterly helpless and deserted down here, and at the mercy of my surrounders. The way I have been lumbered into this place and kept here is simply disgraceful.

My mother joins me in kindest regards to Mrs Smithers and yourself.

I am yours ever A.B.

Les Liaisons Dangereuses!

1. Dowson had recently completed a new edition (prepared from two older translations) of Voltaire's mock-epic *La Pucelle*. It was published by Smithers in 1899.

MS HUNTINGTON

To Leonard Smithers
[Postmark 14 January 1897]

Pier View, Boscombe

My dear Smithers,

The large-paper copy of the Album[1] is in every way worthy of its price, and better than the small edition a thousand times. How well the half-tones have come out, and such drawings as *St Rose of Lima* are simply glorified. Please accept my thanks. The cover looks sumptuous. I hope your recovery is sufficiently rapid.

Of the Voltaire thirty volumes have arrived which have pleased me very much. Let me know if you are thinking of sending the rest as I may be warehousing my books here any day.

Hoping to have fairish news of you in your next.

Yours in postish haste A B

1. Printed on Imperial Japanese vellum and sold at two guineas.

MS HUNTINGTON

To Leonard Smithers
[*Postmark 16 January 1897*]

Pier View, Boscombe

My dear Smithers,

I see from an ancient letter of yours that the Voltaire *is* only from 1–30. Please forgive my 'asking for more'. Such a drivelling babe have I become.

We leave here on Tuesday for Bournemouth. I will let you know my new address (should you care to have it) as soon as I know it myself.

Today it is snowing. Ugh.

Yours ever A B.

Am beginning to feel a little more myself again, and have been able to divorce myself from my own bed.

Mother joins me in many tender inquiries after your health. I do hope you are better.

MS THOMAS

To Horace G. Commin[1]
Saturday [*Postmark 16 January 1897*]

Pier View, Boscombe

Dear Mr Commin,

I should be much obliged if you would kindly send someone to pack my books for me on Monday (18th). I should like to warehouse them with you for a short time. There will be about 230 volumes to look after.

Would you get for me as soon as possible (in the ordinary 3 fr 50 edition) *Madame Bovary* (Flaubert) and *Les Liaisons Dangereuses* (Laclos).

Yours faithfully AUBREY BEARDSLEY

1. A Bournemouth bookseller who opened his shop at 100, Old Christchurch Road, in 1892. Beardsley's books were packed by his assistant, A. E. Cosstick, who remained with the firm until the Second World War.

MS OXFORD

To André Raffalovich
Saturday [*30 January 1897*]

Muriel, Exeter Road, Bournemouth[1]

My dear André,

It has been weary waiting to write to you. But at last I am strong enough to trail a pen. Thank you very much for many charming letters. My mother has told me of your generous concern for me in my illness. How good of you to have such a kind thought. Your sweet friendliness helps me over such alarming difficulties. Of course I cannot thank you adequately. I must write you a much longer letter in a few days when I am feeling stronger.

I miss too *Le chat malade* in the little volume of Watteau.

With kindest regards to all.

Yours very affectionately AUBREY BEARDSLEY

Do you know Sainte-Beuve's *Volupté*?[2]

1. Beardsley's illness had become critical on 17 January and for the next week his life was in danger. He was not strong enough to be moved until nearly the end of the month, when he was carried downstairs in an invalid chair and taken to Bournemouth in a heated carriage.
2. Published in 1834.

MS HUNTINGTON

To Leonard Smithers
Sunday [*Postmark 31 January 1897*]

Muriel, Bournemouth

My dear Smithers,

I rejoice that your leg progresses so well. I am just strong enough today to push a pen along.

Many thousand thanks for your cheque que j'ai cashé. So glad you can come down next week. Kindest regards.

Yours ever A B.

MS OXFORD

To André Raffalovich
Sunday [*1 February 1897*]

Muriel, Bournemouth

My dear André,

I hope fine weather will soon tempt you to come to Bournemouth. John Gray wrote to me that you all thought of spending some days here in February. How nice it will be to see you after such a long absence. Our new rooms are very pleasant, and I am already much more happy. The health improves but I hardly dare to boast yet. I have just finished reading what has been for me an extraordinarily beautiful work, *Volupté*. I had not the faintest idea that Sainte-Beuve had written anything like it. If you have read the book it would be so charming of you to write me a few lines about it: when your hand is freed, and if you can spare me the time. My little library is in durance vile for the moment, but as the new quarters have proved a success I shall have my books unpacked and brought to me in a day or two.

Is it not good news about Mabel? Though it is sad of course to think one will not see her for so long.[1] Before June my lungs may have done dreadful things. Still I hope with much confidence now to see her again. A fortnight ago I really felt wretched over her delayed return. Dear girl, she would feel it dreadfully if she did not find me here when she came back.

Mansfield's business manager is an old schoolfellow and friend of mine and a most kind hearted and devoted creature.[2]

Yours very affectionately AUBREY BEARDSLEY

1. Mabel Beardsley had left Bourchier's company to join Richard Mansfield's.
2. C. B. Cochran.

MS HUNTINGTON

To Leonard Smithers
[*Postmark 4 February 1897*]

Muriel, Bournemouth

My dear Smithers,

I hope your amendment has been rapid enough to allow you

down here at the week's end. It will be pleasant to see you again. It seems ages since you were here last. I progress mildly towards comparative health; but have of course lost long ago anything in the nature of hopefulness. Whom the gods love etc.

The weather is middling just now, but any weather is better than that filthy frost. I have only just remembered today that I had made pictures for a play of Dowson's. It seemed so funny to me that there was still something more of mine to appear. With kindest regards conjointly with my mother's.

Yours ever A B.

MS READING

To John Gray
[*circa 4 February 1897*]

Muriel, Bournemouth

My dear Gray,

I have to thank you for many letters. I suffer a little from the name of this house. I feel as shy of my address as a boy at school is of his Christian name when it is Ebenezer or Aubrey.

I am so interested in your Dominican artist,[1] because I have been wondering more than I can say what his work can be like. Your letter has really made me curious. Do you know of Fr. Philpin[2] of the Brompton Oratory? He is I believe the doyen of the community, and a considerable painter. But what a stumbling-block such pious men must find in the practice of their art.

Bournemouth apparently makes no pretence of being any better than other places in the winter. I have not yet dared to be taken out, even in a chair. Still my amendment is daily. I am amusing myself by copying a twenty-year-old photograph of Sarah Bernhardt. Such a charming thing.

Yours ever AUBREY BEARDSLEY

1. Fr. Sebastian Gates (Gray's note), exhibitor at the Royal Academy and church decorator.
2. Fr. Felix Philpin de Rivière, ordained in 1839.

MS O<small>XFORD</small>

To André Raffalovich
[*circa 4 February 1897*]

Muriel, Bournemouth

My dear André,

I hope your hand is not being too obstinate. Alas, that the education of the left hand is considered unnecessary. Mine is quite useless to me even in the most trifling matters. I want to hear more of the youth who plays Burmese music.[1] John Gray has half promised me a letter from you about him. I am afraid I have but scanty materials for *this* letter. I have had no return of bleeding and the doctor has been able to leave me unvisited for a few days. It is such a change to feel at all hopeful. We get pleasant letters from Mabel who finds the new engagement very agreeable. Madame Dubarry in *Cagliostro* and Mrs St Aubyn in *Beau Brummel* have fallen to her lot already. She will enjoy so much, I know, having a good number of new parts to study.

What gaieties are you having in town?

I look daily for some weather that may be likely to tempt you down here. John Gray told me of a projected tour of Provence, and that you have made Beyle[2] your Baedeker. Will that be a spring or summer holiday?

I am looking forward, my dear André, much to a letter from you.

I am yours always affectionately AUBREY BEARDSLEY

1. Oswald Cumberland, mentioned also on pp. 248 seq.
2. Presumably Stendhal's *Mémoires d'un Touriste*, 1838.

To Leonard Smithers[1]
[*circa 5 February 1897*]

[*Muriel, Bournemouth*]

My dear Smithers,

Extraordinarily delighted that you are able to travel. Come to us of course. I hope you will have a bearable day for the journey.

In frantic haste,

Yours A B

1. Translated from *Briefe Kalendernotizen.*

MS OXFORD

To André Raffalovich
Sunday [? *7 February 1897*]

Muriel, Bournemouth

My dear André,

I was so delighted to receive a letter of yours again. Many congratulations on the hand's recovery. Arsenic is to my mind an atrocious drug. My doctor has insinuated it into several of my medicines, with signal failure. I have at last rebelled formally against its presence in any prescription. I hope the effects of the overdose have by this time quite passed away.

I was greatly interested in the portrait you sketched me of your little friend, designated for the priesthood.[1] I sympathize with him utterly in all his school troubles, for I know how much more bitter are these troubles to bear than any others that come in later life. I rejoice with him in his escape from so much anguish. There will be no more tears, I am sure, at St Mary's College.[2]

I am beginning to think cheerfully of the coming spring, to hope that I may be well enough to enjoy the sight of new leaves. Last year I was robbed shamefully of my April and May; I believe that accounts entirely for my persistent wretchedness ever since.

Is it true that Ed. Toulouse, who wrote the book you sent me on Zola, has been able to find no one else to submit to his questionings, and that Sarah Bernhardt turned him indignantly out of her house? I have been reading a very charming little volume of Crébillon's *La nuit et le moment*,[3] a perfectly delightful piece of work. My chances of recovery improve every day. Tomorrow I am to go out in a chair, if the weather is kind and gentle.

I am yours very affectionately AUBREY BEARDSLEY

I have just received your letter of Sunday. Many thanks. We are so pleased that the proposed visit to Bournemouth is to be paid so soon.

1. Oswald Cumberland.
2. Mount St Mary's College, Derbyshire.
3. Published in 1755.

MS HUNTINGTON

To Leonard Smithers
[Postmark 9 February 1897]

Muriel, Bournemouth

Here is, my dear Smithers, the backlet for Balzac,[1] which I hope will suit. Let me know if the white lines should be *firmer*. I didn't like to make them too hard. Hope you got to town in comparative comfort; and that the leg has not suffered from your trip. I went out today for a little in a chair, the fresh air tired me rather.

Yours ever A B.

1. Grotesque mask (Gallatin 948) for the spine of Smithers's eleven-volume edition of *Scènes de la Vie Parisienne,* published in 1897.

MS OXFORD

To André Raffalovich
Thursday [? *11 February 1897*]

Muriel, Bournemouth

My dear André,

Very many thanks for your letter and the *Archives*.

I shall look forward with great interest to the continuation of your article.[1]

Miss Hawtrey's book[2] must be capital. The education of children in England is indeed a thing to make one aghast. So much prudishness at the expense of purity. Such criminal ignorance.

I am most envious of Joseph, the young Swiss whose conduct of life puts no barriers in his way to the practical acceptance of what he believes in.[3]

Heine certainly cuts a poor figure beside Pascal. If Heine is the great warning, Pascal is the great example to all artists and thinkers. He understood that, to become a Christian, the man of letters must sacrifice his gifts, just as Magdalen must sacrifice her beauty.

Do not think, my dear André, that your kind words fall on such

barren ground. However I fear I am not a very fruitful soil; I only melt to harden again.

I hope Master Oswald's penny will inspire a veritable chef d'oeuvre. So large a price is seldom given for masterpieces of fiction. Oswald will never make a publisher.[4]

I am yours very affectionately AUBREY BEARDSLEY

I am feeling stronger today and hope soon that material things will no longer be a trouble to me. That is a hope I owe to you.[5]

1. 'Annales de l'Unisexualité' in *Archives de l'Anthropologie Criminelle.*
2. *The Co-Education of the Sexes,* published in 1896.
3. Joseph Tobler, Raffalovich's butler, converted to Roman Catholicism later in the month.
4. The boy offered someone [i.e. Raffalovich] a penny to write him a story (Gray's note).
5. Raffalovich now began to pay Beardsley a regular allowance.

MS HUNTINGTON

To Leonard Smithers
11 February 1897

Muriel, Bournemouth

My dear Smithers,

Thanks for letter. Glad you like the masque. I have begun *Mdlle de Maupin,*[1] I think it will be a nice picture. My 1001 Zolas have arrived and are amusing me greatly. I hope you will soon have forgotten the existence of such things as surgical bandages. Eleven pages from Olive[2] this morning plus two pages of verse. Ye gods! If I were only Symons!

Yours ever A B.

1. A water-colour drawing (Gallatin 1084) to illustrate Gautier's novel.
2. Olive Custance (1874–1944), whose poems *Opals* were published by Mathews in 1897. She was at this time a passionate admirer of John Gray. In 1902 she married Lord Alfred Douglas.

MS Huntington

To Leonard Smithers
[Postmark 13 February 1897]

Muriel, Bournemouth

My dear Smithers,

Many thanks for letter and cheque. A thousand thanks. What a touchant note from Florence Fitzgerald.[1] I do hope the leg continues to progress obediently. So pleased to think you can come down next week. You will find *one* of your authors here, as well as your only A B, I mean the creator of "self-seekers". You will also find Nuits, but not *the* bottle. I have demolished it.

Nana[2] is a charming book. She shall be one of six.

My newly acquired virginity continues to be broken only by rêves mouillés.

No news. Bournemouth is a *leetle* dull. Perhaps you've noticed it. Paris, for instance, might be more lively. I am joined in kindest regards.

Yours ever A B.

1. Not identified.
2. By Zola, published in 1880.

MS Princeton

To H. C. J. Pollitt
[Postmark 14 February 1897]

Muriel, Bournemouth

My dear friend,

Enchanted to get your card. Do come down and see me. I will expect you Saturday. America will never see me in *this* incarnation. I have been ill beyond expression, nearly went away altogether. The portrait is of course an oeuvre d'art.[1] I shall be on tip-toe to see it.

Ever yours AUBREY BEARDSLEY

1. The Whistler portrait.

MS HUNTINGTON

To Leonard Smithers
Sunday [*Postmark 14 February 1897*]

Muriel, Bournemouth

My dear Smithers,

Have I acknowledged *Veillées du Château*? It has arrived all
right. What on earth possessed my mother to ask for such a dull
book God only knows. Monsieur Pollitt comes down here on Friday
to stay till Saturday eve. If in the meantime you see him, would you
not say something to him about the dignity of art and the necessity of
artists! Insinuate a reference to Maecenas.

Today the weather is quite decent here. I chafe all the same.
Mdlle de Maupin will be charming.

I am thinking much of London. I must get rooms with a studio.
Would you advise me to advertise? Bloomsbury is my best quarter.
You see Mabel will be back sooner or later and she must have a little
'ome.

Joined in kindest regards and inquiries.

Yours A B

MS OXFORD

To André Raffalovich
[*16 February 1897*]

Muriel, Bournemouth

My dear André,

So many thanks for your kind and sympathetic letter. John Gray
has been with us today. I was so glad to see him again. He tells me
your hand is still obstinate in its refusal to mend. How trying it must
be. He exclaims at my rude health.

I have never heard Fr Sebastian[1] preach; he ought to be impres-
sive in the pulpit, with such a fine presence.

The really winter weather looks as if it were going to give way
to something milder here, and I pray that nothing so unpleasant as
rain or an east wind may trouble your visit.

I have been stupidly nervous about myself for the last two days. In fact I have sulked shamefully. You must prepare your severest advice for me on the 18th. I am very anxious for you to have a chat with my doctor here. I wonder if you would. You know doctors are so reticent to their patients, and their patients' immediate relations. But nothing is gained by not knowing how far really the trouble has gone. I feel a little apprehensive. This is a sad scrawl, but I am in haste for the evening post.

Please give my kindest regards to Miss Gribbell.

Yours very affectionately and as a younger brother

AUBREY BEARDSLEY

1. Fr. Sebastian Bowden (1836–1920), three times Superior of the Order of Oratorians in England and the best known of the preachers at Brompton Oratory.

MS HUNTINGTON

To Leonard Smithers
[Postmark 16 February 1897]

Muriel, Bournemouth

My dear Smithers,

In frantic haste. Gray arrived here today, he precedes the others. Miss Fitzgerald's address is as per enclosed slip. I can't read it. This morning I wrote you an utterly depressed and hopeless letter. Tore it up. Thousand thanks about studio. So glad leg improves. Am writing again.

Yours ever A B.

MS HUNTINGTON

To Leonard Smithers
[Postmark 18 February 1897]

Muriel, Bournemouth

My dear Smithers,

So like me to leave out Miss Fitzgerald's address. Now you have it. I have just put off Pollitt by wire. I hope it will reach him at

Cambridge. I bear up. I am sorry enough that you are not coming down this week. Still I think you are right in postponing the visit as anything much in the way of a talk, beyond a tête-à-tête, might overtire me. I hear from Miss Custance that London is beginning to look nice. The doctor thinks that, in consideration of my state of mind, London will be my best place in a month or so.

It would be awfully good of you to make one or two inquiries about rooms. But you mustn't bother. My mother will most probably come up to town in March to do some room hunting. I wonder what Burr's[1] would charge for a private sitting room. Très nécessaire. I am doubtful about Mabel's movements. She seems to be worriting herself about me and might come back any week. If I can only keep off blood spitting I may drag along all right. I hope *your* troubles are leaving you as they should. I am brighter today.

<div align="right">Yours ever A B.</div>

1. A private hotel in Queen Square near the British Museum.

<div align="center">MS PRINCETON</div>

To Leonard Smithers
[Postmark 19 February 1897]

<div align="right">Muriel, Bournemouth</div>

My dear Smithers,

I progress fairly. How are you? Have you seen *Dodo* Benson's new novel?[1] It contains three immortal references to your humble servant. There will be a statue yet. I heard there was something in the *Telegraph*.[2] Tell Ashworth that I am dying to do his book plate.[3] The Russian prince[4] has arrived. Mother in a state of depression not to be equalled even by

<div align="right">Yours A B</div>

1. *The Babe B.A.* by E. F. Benson, whose *Dodo* appeared in 1893.
2. Review of *Fifty Drawings*, 17 February 1897.
3. Beardsley never made this design, but Ashworth later used the design for the *Savoy* prospectus (Gallatin 1030).
4. i.e. Raffalovich.

MS Huntington

To Leonard Smithers
[Postmark 21 February 1897]

Muriel, Bournemouth

My dear Smithers,

A line. Many thanks for your note. Am glad the leg behaves itself.

I am to come to town at the end of March. That is a cert now. Doctor's orders. Thanks for the *D.T.*

Yours hastefully A B

MS Huntington

To Leonard Smithers
[22 February 1897]

Muriel, Bournemouth

My dear Smithers,

I hope the cold has passed away. Once more I am alone. Just a little tired. I have heard vaguely of some rooms in Manchester Street. Nothing settled yet. The doctor insists on town for me, and after town, Brighton. That will be for August. I shall expect to see you this week. Do come down. How is the jambe? I should never be surprised to see my sister returned any day. She seems to be fussed about my illness. I have been able to get out a little lately. The weather has been fairly decent.

When does that foolish book *The Pierrot of the Minute* propose to be ready?

I am being pursued for a bill for 11/3. Christian martyrs not in it with me.

I dread my exit from Bournemouth, but surely no one will be so hard as to expect more than 1d in the pound from me. What a ballsome existence it is.

Yours ever A B.

MS OXFORD

To André Raffalovich
Monday [*22 February 1897*]

Muriel, Bournemouth

My dear André,
 I hope you are not troubled with any fatigue after your journey.
 Your visit here was much too short. But it was so nice to get a sight of you for so short a time. I am sure your arrival inaugurated a season of good health for me, and fine weather. I look forward very much to seeing Fr. Bearne[1] tomorrow; it was so good of you to interest him in me. Thank you, dear André, for all your kind thoughtfulness.
 We have just heard from Mabel. The letters which announced my relapse and my recovery reached her simultaneously, so she had wherewithal to weep over, and to dry her tears, all at once. I shall never be surprised to hear of her return any day.
 The rooms in Manchester Street have awakened great expectations; nowadays I shall begin to count my weeks, in schoolboy fashion, as the end of the term approaches.
 The French papers entertained me greatly. I am writing this letter hurriedly to be in time for the post.
 I am yours very affectionately AUBREY BEARDSLEY

1. The Rev. David Bearne S.J. (1856–1920) who five weeks later received Beardsley into the Roman Catholic Church. He was himself a convert and was ordained in 1896. In later years he became a popular author of boys' books.

MS OXFORD

To André Raffalovich
Wednesday [*24 February 1897*]

Muriel, Bournemouth

My dear André,
 So many thanks for your kind letter. Father Bearne came to see me yesterday, but unfortunately I had not the opportunity of talk-

ing to him as much as I should have wished. He was most charming and promised to come to see me often. I felt much drawn towards him and I believe he will be a good friend of mine. He has lent me a long life of Saint Ignatius Loyola, and I am reading for the first time a history of the growth and foundation of the Company. Master Oswald's letter is admirable. I can appreciate all his wants, except the one for a watch. To live in South Audley Street and to serve as an acolyte at Farm Street,[1] is certainly an ingenious programme. I am touched to think of his childish prayers for me. I hope some day I shall have the pleasure of meeting my little beadsman. I wonder whether it would amuse him to receive some little present and a letter from a stranger? You could tell me if there was any story or picture book, or something of that sort that might please him. Do let me know. I hope he will not have too severe tumbles in the skating gallery of Mount St. Mary's.

It is so good of you, my dear André, to inquire about rooms for me. This letter will I suppose cross one of yours with some news of Manchester Street. The weather has been a little colder here, so I have not ventured out today. I shall miss a very kind friend at my side next time I am charioted up to the east cliff. I was so interested in what you tell me of Reichmann's book,[2] and the remarks of Havelock Ellis in English.[3]

Thank you very much for the *Journal*. It is really so kind of you to send it me. It interests me hugely every morning. I look forward to the book about George Sand,[4] I am all gratitude. I did not know that Huysmans had announced a new work.[5] How thoughtful you are, dear André. I can never thank you enough for your care for my well being and progress. I *do* hope I am the most grateful of creatures.

I am yours always affectionately AUBREY BEARDSLEY

1. The Jesuit Church in Mayfair.
2. Perhaps *Die Jesuiten und das Herzogthum Braunschweig* by Matthias Reichmann (1890).
3. Probably *Sexual Inversion*.
4. *Une Histoire d'Amour* by Paul Mariéton.
5. *La Cathédrale*, 1898. Joris-Karl Huysmans began to correspond with Raffalovich in 1896. His gradual conversion to Roman Catholicism is recorded in *En Route* (1895).

MS HUNTINGTON

To Leonard Smithers
[*Postmark 25 February 1897*]

Muriel, Bournemouth

My dear Smithers,

So glad you can come down. I think you will find me looking more fit. I offered up instant prayers on reading of your new eruption. I do hope it will come to nothing. My sister gets on capitally with the Mansfields, but still she is naturally getting a little homesick. What about Conder?

I have paid that 11/3 pauvre mufle that I am. Now I have another bill—for 6d. Exciting work clearing off these debts of mine. Sir Walter Scott not in it with me. I shall look forward to the *Pierrot*.

I had a tiny return of blood two mornings ago, which I kept to myself; so don't say anything about it. Still I fancy I progress.

Joined in kindest regards.

Yours ever A B.

MS OXFORD

To André Raffalovich
Thursday [*25 February 1897*]

Muriel, Bournemouth

My dear André,

Mariéton's very interesting volume arrived this morning. Thank you so much for it. What a nice ample creature George Sand is. Like a wonderful old cow with all her calves. I recollect, long ago, in my first boyhood, beginning a novel, the heroine of which became sadly spoiled by reading *Lélia*.[1] She also refused to eat at meals, but carried bonbons and sweet biscuits about with her in her pocket. I have quite forgotten her name. I am reminded of her by the first pages of the *Histoire d'Amour*, and by the pangs of hunger I am suffering just at this moment. Dinner not to appear for another hour, and no confiserie at hand.

Spring cleaning is going forward at Muriel today, which has

made me nervous and cross, it is so trying to hop about from one room to another.

I had a letter from Mabel this morning. She seems in better spirits, but I am aghast at the amount of travelling she has to get through before the tour comes to an end. I do hope she won't "knock up" while she is over there. Of course I don't like to advise her to come back. Still I believe it would be best for her to do so. What a pity the other tour did not end normally.

I am receiving long lectures here, from pillars of the Anglican faith, à propos of my communications with the kind Fathers of the Sacred Heart.

Please give my kindest remembrances to Miss Gribbell and to John Gray.

I am always yours very affectionately AUBREY BEARDSLEY

1. Published in 1833.

MS OXFORD

To André Raffalovich
Friday [*26 February 1897*]

Muriel, Bournemouth

My dear André,

I think a letter of mother's must have crossed yours of this morning. She tells me that she has settled to remain with me as she will not be taking up any work. Of course I don't know what difficulties have been raised. However I am sure it will be all right.

I thought of you much at four o'clock today.

I will tell Fr. Bearne the story of Joan. It is surely a most edifying one. Thank you so much for your suggestion as to what I might send to Oswald.

Where on earth may prayer books in Tartan covers be found? I believe anybody who had lived much on mountains would have made the same choice as your Switzer.[1] I am sure the Swiss are the real leaders of taste in Europe.

Did you have bagpipes at your dinner last night?

Here I am stopped by a demand for the letter for post. A thousand thanks, my dear André, for your kind well-wishes.

I am yours very affectionately AUBREY BEARDSLEY

1. Joseph Tobler who was received into the Roman Catholic Church at Farm Street on 24 February 1897.

MS Oxford

To André Raffalovich
Saturday [*27 (and Sunday 28) February 1897*]

Muriel, Bournemouth

My dear André,

Thank you so much for all your kind efforts in Manchester Street. I am so sorry Mrs Eversfield has no accommodation. I think the idea of an hotel (with a lift) is a very attractive one, especially as there may be some chance of Mabel coming back sooner, and it is so difficult to get extra rooms in lodgings. The drawbacks would be the (possibly) too heavy expense for the private sitting-room— they set such a price upon them in hotels—and the arbitrary per head charges for meals. You see meals for two should *not* be double the cost of meals for one. Of course some arrangement might be made. But if the hotel turns out too ruinous, and our expenditure in these matters could not be controlled, then we will decide for lodgings, and should be so glad to rely on your judgment and decision in the choice of them. I cannot say how good it is of you, dear André, to assist us in the discovery of our new home. We will leave Bournemouth on Tuesday April the 6th.

I shall recollect the answer you have given me when I am assailed next time with cross-questionings from Anglican pillars, and will make a shield of Mabel's example. I'm afraid I was not able to get anything really nice for Oswald Cumberland, as the little Catholic shop here did not offer very much choice of pictures. I have sent him a small picture representing the Chalice and Wafer in the Blessed Sacrament, and a little volume of miniature lives of the Saints, one for each day of the year. I hope I have done nothing wrong. I was able to take a very charming drive today, the sunshine and soft winds seem to do me a world of good.

I shall receive very gratefully and very affectionately the wonderfully kind help that you give me, offered with so much intention and so much gentleness. I am greatly touched by all that part of your letter in which you speak to me of this matter, and I entirely appreciate the thoughtfulness in your view of the practical side of the

"transaction". I know well enough how difficult it is to spread a lump sum equally over a given number of weeks, and in helping me with so much judgement you are helping me doubly. Be assured that your brotherly affection finds a very warm response in my heart. Thank you again many times for your letter. I expect I may be seeing Fr. Bearne this afternoon (Sunday).

I am always yours very affectionately AUBREY BEARDSLEY

I had a youth from Cambridge to see me yesterday,[1] one of the originals I fancy of the *Babe*.

1. Pollitt.

MS READING

To John Gray
[Postmark 1 March 1897]

Muriel, Bournemouth

My dear Gray,

I was so glad to get a letter from you, and such a charming copy of verses. Your last line is quite in the manner of Mons. Durant.[1] Very many thanks for the sight you have given me of the 'Roman Phial'.[2]

The delay caused by Glasgow and its Master[3] has only whetted my appetite for the early pages of *Adolphe*.

Today my observations of wind and sun led me to very false conclusions. I soon had to tell my cocher to turn back, and I find myself writing this with frozen fingers.

How is Benack?[4]

I am joined in kindest regards,

Ever yours AUBREY BEARDSLEY

1. Dante Alighieri (Gray's note).
2. Gray's poem 'The Phial' was published in *The Acorn*, 1905.
3. Possibly the Annual Festival of St Andrew's Cathedral, Glasgow, and the testimonial presentation to its administrator on 23 February.
4. A black kitten (Gray's note).

MS OXFORD

To André Raffalovich
Monday [*? 1 March 1897*]

Muriel, Bournemouth

My dear André,

I received a very acceptable parcel of books from Burns and Oates[1] this morning; and it is you I know that I must thank for them. Thank you very much. The volumes are quite new to me. I shall read them very carefully for I fear I am sadly equipped for the fray controversial, into which one is sometimes forced to enter.

Father Bearne was with me this afternoon, and stayed quite a long time, so I had a much more fruitful conversation with him. I think our friendship would rapidly mature. He was much interested in what you asked me to tell him about Lady Grantley's daughter, and rejoiced in such a happy issue.

I feel I am really getting stronger now. I heard today from a doctor that Pier View was badly situated for a consumptive patient, and that the move we made last month has probably saved me. How I wish I had come into Bournemouth before the winter, I might have escaped so much trouble.

Forgive a very scanty letter. I wait anxiously for news from Mabel.

I am always your very affectionate AUBREY BEARDSLEY

1. Roman Catholic publisher and bookseller.

MS OXFORD

To André Raffalovich
Wednesday [*3 March 1897*]

Muriel, Bournemouth

My dear André,

So many thanks for *Self-Seekers,* welcome enough after so many delays in its coming out. How nice it looks. Visitors and some unavoidable letter writing have not left me time to get far into the

charming and witty book, but with five chapters to my credit may I congratulate you on a delightful piece of work.

March has set in here in fine seasonable style, with winds that humble the pines and have taken off a great part of the roof of Newlyn's Hotel.

I am so grieved to hear of the trouble of a friend of yours. Your kind counsel and advice will I am sure do much to lessen the sorrow.

Father Bearne has just spent a few minutes with me and has lent me such a beautiful life of St Aloysius, full of the most charming pictures. I am very grateful to you for having introduced so kind a friend to me as Fr Bearne.

I have finished Mariéton's book on Sand and Musset. With the recollection I have of a portrait—seen somewhere—of George Sand, the love stories seem to me inexplicable. I am devoured with curiosity to see some of Alfred de Musset's drawings.

I am always yours very affectionately AUBREY BEARDSLEY

MS PRINCETON

To H. C. J. Pollitt
Wednesday [*Postmark 3 March 1897*]

Muriel, Bournemouth

My dear friend,
The little drawing for Juvenal VI 237–8 is done.[1]
Abditus interea latet et secretus adulter,
Impatiensque morae pavet et praeputia ducit
It looks very well; shall I confide it to the post? So pleasant to have a sight of you the other day. Where did you dine after all? The local photographs[2] turn out quite a success. I shall have a copy for you in a day or so I suppose.

By the way (if you have not already put it in hand) the book-plate block[3] will be best made by Carl Hentschel of Fleet Street, E.C. I hope my crazy lettering will come out all right.

March has entered here with the mighty voices of winds from all the cold quarters. I am cut in two and write this with frozen fingers. April 6th sees me in Town.

Yours ever AUBREY BEARDSLEY
How is the full length?[4]

1. *The Adulterer*. Beardsley had evidently left the drawing unfinished in August 1896 and sold it to Pollitt on his visit to Bournemouth four days before the date of this letter.
2. A set of photographs of Beardsley taken by W. J. Hawker of Bournemouth. One of them is reproduced in *Robert Ross: Friend of Friends,* edited by Margery Ross (1952).
3. See p. 167.
4. i.e. The Whistler portrait.

MS Huntington

To Leonard Smithers
[Postmark 3 March 1897]

Muriel, Bournemouth

My dear Smithers,

 I hope you feel refreshed and rejoiced after your stay in these southern parts. A lady is becoming visible on the end sheet of *Alciphron*.[1] Shall I post you the book when it is done? I have just got a letter from Kitty Savile Clarke who groans over the non-arrival of the book of fifty drawings; which non-arrival is explained I imagine by the simple fact that the Clarkes have given up their house in Alexandra Street (No. 26) and are now in Cadogan Square (No. 59). I am writing to explain this to her. I have written at great length to Mdlle Custance, so I hope she will be good for a copy of *Pierrot*. I hope you are not haunted too cruelly with visions of designing Jesuits. Thanks for the immortal novel,[2] I shall get my mother to read it for me.

 Such beastly winds here, Newlyn's Hotel has nearly had its roof taken off, so you see your bottle of Margaux has been avenged.

 Streaks of blood still may be seen on my handkerchief. Still— joined in warmest regards,

Yours A B.

How's the leg?

1. The book he bought from Smithers in November 1896. Beardsley's drawing is not recorded.
2. *Self-Seekers*.

MS OXFORD

To André Raffalovich
[*circa 4 March 1897*]

Muriel, Bournemouth

My dear André,

So many thanks for your kind note and enclosure.

I am in bed again, as you may infer from this pencilled writing, with an attack of blood spitting. It came on this morning at 3 o'clock, rather severely, and I was dreadfully nervous. Dr Harsant[1] takes a mild view of the new trouble and thinks I shall pull round in a few days. March winds have done it. Forgive a short letter, as I must not sit up too much.

Yours very affectionately AUBREY BEARDSLEY

1. A Bournemouth doctor (*d.* 1914). A month earlier he had told Ellen Beardsley that her son could not last another winter and might die at any moment.

To Leonard Smithers[1]
[*circa 4 March 1897*]

Muriel, Bournemouth

My dear Smithers,

A thousand thanks for the cheque.

Bed and blood once more. Simply horrible. These March winds have played the devil with me.

Alciphron will be pretty. I cannot write much as I am not allowed to sit up.

What an ignoble existence.

Your old A B.

1. Translated from *Briefe Kalendernotizen*.

MS OXFORD

To André Raffalovich
Friday [*5 March 1897*]

Muriel, Bournemouth

My dear André,

I am a little better today, but not yet allowed out of bed. I hope to be up tomorrow. Thank you so much for your letter. I do pray that you will not give yourself too much trouble over the search for rooms. Really you must not, for I know you always have so much to do and to think about.

I am glad to think of your friend finding consolation.

The life of St Aloysius is perfectly charming, what a most lovable creature he must have been. The life is written by Fr. Virgil Cepari, S.J., and is edited with a great number of interesting notes. Perhaps you know the book.

What are Captain Burrard's poems and novels like?[1]

I am amused at the account of my dinner with Harland. I have never left him in the middle of any meal, and never at any time have I been in a boat with evening clothes. But what a pity to spoil such a charming story.

I look forward to the messages from Rachilde, Oswald and Fr. Bampton. I am reading that chapter in Newman's book.

I am always yours most affectionately AUBREY BEARDSLEY

1. William Dutton Burrard (1861–1938), novelist and miscellaneous writer. His poems *Out of the Depths* appeared in 1892.

MS HUNTINGTON

To Leonard Smithers
Friday [*Postmark 5 March 1897*]

Muriel, Bournemouth

My dear Smithers,

I am a little better today but still in bed. So glad that the doubts about *Père Goriot*[1] have been settled. There will be room for *one*

whole lady on *Alciphron's* end paper. I will send it by parcels post. Thanks for writing to the Savile Clarke. I have thanked Raff for the immortal work. I will send you a *Mdlle de Maupin* next.

A huge letter this morning from Olive Custance. She must buy me in large-paper if she expects me to read her letters. So glad the leg gets better. Has Hawker sent you your proofs yet? Mother's arrived today, two of the little ones are very good, the cabinets less so. My temper has not been sweetened by this last attack of mine. I grind my rotten teeth.

Yours ever A B.

Joined in kindest regards.
Thanks for slip from *Echo*.[2]

1. Smithers's preliminary announcement of *Scènes de la Vie Parisienne* did not include *Le Père Goriot* in the seven volumes planned.
2. Review in the issue for 27 February of Owen Seaman's *Battle of the Bays,* a collection of parodies of *Yellow Book* poets.

MS PRINCETON

To H. C. J. Pollitt
[*Postmark 7 March 1897*]

Muriel, Bournemouth

My dear Friend,

Many thanks for your letter. I have just had another horrid attack of blood spitting, perfectly alarming. I am sending you the photograph and the Juvenal. Doctor's orders will not let me sit up and write you a nice letter. I must be brief against my will, though as a matter of fact I have nothing whatever to write about. I pray you will get a handsome Aristophanes, a sumptuous quarto, something worthy of Aristophanes, myself and maroquin.

I am still in the depths of uncertainty as to my new home in London. Heaven permit that I may get there. The Juvenal may as well be catalogued at ten sovereigns, use however your own royal discretion.[1]

I am ever your vassal A B.

May Hentschel do nothing with the bookplate but what is utterly right.

1. Beardsley evidently means the price Pollitt is to pay him for the drawing.

MS Oxford

To André Raffalovich
Sunday [7 March 1897]

Muriel, Bournemouth

My dear André,

Many thanks for your card.

I am up a little today but the blood has not ceased yet. I can quite understand how difficult it would be to take rooms in advance. How good of you to make inquiries. This last attack of mine has been rather venomous and is rather obstinate too. It upsets all my plans. Dr Harsant speaks more seriously of my condition and is a little frightened of his promise to allow me up to Town. It will be hard for me to give up my trip to London. I counted on it so much, and thought of it as something certain. Still I suppose I must be resigned about it. It *would* be wiser no doubt to move to a place where I could rest straight off for five or six months. Dr Harsant spoke of one or two places in Brittany, he seems to be losing faith in England for my case. Do give me your best advice, dear André, about it all. You told me of some place (near Bordeaux was it not) that you knew and liked. I fancy I can count my life by months now.

Fr Bearne has spent this afternoon with me. He was most kind and sympathetic and we had much to talk about.

I am always yours most affectionately AUBREY BEARDSLEY
P.S. Please thank Mrs Ian Robertson[1] for interesting herself so kindly about me.

1. Sister-in-law of Johnston Forbes-Robertson and daughter of Joseph Knight (1829–1907), editor of *Notes and Queries*.

MS Huntington

To Leonard Smithers
[*Postmark 7 March 1897*]

Muriel, Bournemouth

My dear Smithers,

This has turned out to be a rather venomous attack. All my plans will I am afraid have to undergo revision. London I fear will

be too great a risk. You see I may not have many months now to live, and I must arrange my future for some definitely settled spot. God only knows where that will be. My doctor today speaks of Normandy or Brittany, he is frightened to let me go farther. I shall be able to tell you more in a day or so. The blood is obstinate despite Gallic Acid and Ergotine. All the *Idlers* in Bournemouth have been sold out so I have not seen the article yet.[1] Claret egad!

I hope you progress all right.

Joined in regards of the kindest.

Yours in a state of decay A B

1. See p. 229.

MS HUNTINGTON

To Leonard Smithers
[*circa 8 March 1897*]

Muriel, Bournemouth

My dear Smithers,

Blood still oozes, but shows occasional signs of relenting. When you pray, pray for me, at the top of your voice. *Père Goriot* I have *always* seen put in the *Vie Parisienne* and I vow it ought to be there. The definitive edition of Balzac was *I fancy* in 1850, the year of his death. Is it an incomplete edition? Perhaps I am all wrong about this but you can find out everything from the bibliography at the end of Wedmore's life of B.[1]

March is a fiendish month and must settle scores of people. May I not be one of them.

By the way if you care to have a head of Balzac let me know, and what size it should be.[2]

Yours joined in kind regards. Ever A B

1. Published in 1890.
2. Gallatin 947, reproduced in *Later Work.*

MS Oxford

To André Raffalovich
Tuesday [*9 March 1897*]

Muriel, Bournemouth

My dear André,

I am rather more cheerful today. The blood has not ceased oozing yet, but it does not come up in such large quantities. In my present state *no* plan can be entirely without drawbacks. When a new one is proposed, one seems to see only the rosy side of it, but after it has been discussed a little the weak places in it become painfully evident.

I suppose I must put *all* plans out of my head for the moment, and prepare myself to abide by Doctor's decisions as soon as my health shows signs of allowing me to make an immediate move.

The weather here is a little milder today, and I am all the happier for the change. Of course I have the fine weather to face now, so must not utterly lose heart. I am so frightened of not getting the full benefit of the spring and summer, and repeating my last year's mistakes. I haven't the ghost of a chance of improving unless I am able to spend some of my time out of doors, and attacks such as I am having make me very nervous about taking exercise. I feel abominably cross as well as depressed when I think of the horrible way I am handicapped.

Will you thank for me, my dear André, the kind Dominican you tell me of, and Father Ambrose,[1] and indeed all who have taken such a kind interest in my poor troubles. Father Bearne has just sent me an admirable little manual of Catholic belief, and has invited me to send for him whenever I have any question to ask.

Thank you many times for your letter so full of sympathy and encouragement. You will forgive me for being sometimes peevish and complaining, but really it is hard to remain tranquil with so many setbacks.

Kindest regards to all.

I am yours most affectionately AUBREY BEARDSLEY

The enclosed has just come from the local photographer. I wondered if you would care to have it.

1. Not identified.

MS PRINCETON

To H. C. J. Pollitt
[*10 March 1897*]

Muriel, Bournemouth

My best Friend,

A thousand thanks for your envelope and all that in it was. I pray you are not wholly displeased with my note to Sat. VI.

I have just made a frontispiece to *Mdlle de Maupin*, a pretty thing, to be bound up by Smithers in a 3fr 50 copy of the beautiful book. You will hear more of it in some catalogue of his. I am agog to see the bookplate. My bloody disasters still continue, but show today some signs of waning. I dispatch this by the midday post, so come to an end.

Joined in regards.

Yours A B.

MS OXFORD

To André Raffalovich
Wednesday [*10 March 1897*]

Muriel, Bournemouth

My dear André,

Many, many thanks for your line of inquiry and kind enclosure.

The blood is still very obstinate, but does not, I am glad to say, keep me a prisoner in bed.

You see my cough keeps re-opening the wound; in the morning, especially, what comes up from my lung is horribly rosy.

However Dr Harsant thinks there is not much fear of it becoming chronic. Oh, how tired I am of hearing my lung creak all day, like a badly made pair of boots.

One thing consoles me; I get very cheerful letters from Mabel now. She seems to be having such a good time, and to be a great success.

I suppose I may console myself a little too, with the fact that the wind is no longer in the east. You can hardly guess the irritation caused by an east wind to anyone in my state.

I think of the past winter and autumn with unrelieved bitterness; what murderous weather; the most radiant spring, the most scorching summer can never make up for the last six months.

Ill temper I am told is sometimes a sign of approaching convalescence. If it is, my dear André, I must not lose hope.

I am always yours most affectionately AUBREY BEARDSLEY

MS HUNTINGTON

To Leonard Smithers
[Postmark 10 March 1897]

Muriel, Bournemouth

My dear Smithers,

Many thanks for your letter and copies of *Pierrot*.[1] I will let you have the Balzac head on Saturday or Monday. I send you by this post a most charming frontispiece for *Mdlle de Maupin*, which I hope you will approve. It seems to me it would be worth while having a block made from it. I have drawn it to go into the ordinary 3fr-50 edition.

The blood has not made its peace with me yet, still I feel pretty well. How annoying not to find out the truth and nothing but the truth about Father Goriot. I believe the public will clamour for him in any edition of the *Vie Parisienne*.

I look forward to seeing your photograph, really Hawker is rather good I think. Mother's midgets came out rather well[2] (this sounds like an account of the birth of twins.) She sends her kindest regards and awaits with previous gratitude her parcel of books!

I am,

Yours ever A B

1. Dowson's *Pierrot of the Minute,* just published.
2. Small prints of her photograph.

MS Huntington

To Leonard Smithers
[*Postmark 12 March 1897*]

Muriel, Bournemouth

My dear Smithers,

So glad you approve of the *Maupin*. Let me have a proof as it will guide me in future colour work. Swan should of course make the block for they (by the 'autochromatic process') can procure the *colour values*.

I am sending you another frontispiece ere long.

Yours ever A B.

MS Oxford

To André Raffalovich
Friday [*12 March 1897*]

Muriel, Bournemouth

My dear André,

Such a burst of sunshine today, a perfect festival of light. Still it is weather to keep one over the fire, and I do not venture out. My best efforts, alas, do not avail to keep off the oozing of blood. It is a relief though that the trouble gets no worse. So long as my handkerchiefs become no redder I do not anticipate any violent attack or lose hope of it clearing up sooner or later. Dr Harsant has been able to examine my chest thoroughly today, as blister wounds have healed up. I don't think he discovered anything that could alarm me immediately. The right lung which I am so nervous about, has got no worse, and the disease in the left has advanced but very slightly. He thinks perhaps the haemorrhage mixture I am taking is beginning to lose its astringent effects, so he has changed my medicine. I hope the new one will prove effectual, and that I shall be able to give you a better account of myself next week. At present my mind is divided between the fear of getting too far away from England, and the fear of not getting enough sunshine, or rather sun warmth, near home.

We have had a wire from Mabel offering to return if it should be necessary and have sent her of course a reassuring answer. It was

so sweet of her to think of giving up her engagement with the Mansfields for me.

I have read the chapters you indicated in Newman's book. How truly admirable they are.

 I am yours always most affectionately AUBREY BEARDSLEY

Oswald Cumberland has written to thank me for the little books in a rather pathetic letter.

MS PRINCETON

To Leonard Smithers
[*circa 13 March 1897*]

 Muriel, Bournemouth

My dear Smithers,

Here is the head of Balzac, a very good portrait too as you will see. I take it, it will be printed thus more or less.

Blood is better today, but still makes itself visible.

 Ever yours A B.

MS OXFORD

To André Raffalovich
Monday [*15 March 1897*]

 Muriel, Bournemouth

My dear André,

How thankful I am to be able to tell you that the blood appears much less frequently and in much smaller quantities. A few days, I dare say, will see the end of it.

Thank you so much for your letter and the Journal. I am grieved indeed that yours has been "the dog's life"; I hope all the worries have been transient.

The story about Father Gates is perfectly charming. What a pretty scene it must have made.

Rachilde's novel will I am sure interest me much. It is very good of you to send it me.

music

my dear Smithers

Here is the head of Balzac, a very
good portrait too as you will see
I hope it, it will be printed thus
more or less

+ mask
* Portrait

Beard is better to day, but
still makes itself visible

ever yours

aB.

I have read a little about the Blessed John Berchmans in my life of St Aloysius. Those two with St Stanislaus Kotska make a very beautiful trinity, do they not?

I am looking forward to having dear Fr Bearne with me this afternoon. Yes, the London delay is very trying, still I suppose I must be patient. I am going to do my best to lay in a good stock of strength and health here. I am sure, dear André, you will pray that my efforts may be rewarded with success.

Please thank Miss Gribbell and John Gray for all their kind sympathy.

I am always yours most affectionately AUBREY BEARDSLEY

MS PRINCETON

To H. C. J. Pollitt
[Postmark 15 March 1897]

Muriel, Bournemouth

My dear Friend,

How very good the proofs are. Hentschel had better leave the block as it is. He made it admirably. The lettering looks quite charming. I am sorrowful indeed to think of you as a shadow of your former self. *My* troubles are on the wane, but what a beastly time I have had.

You are quite right, the Juvenal drawing is admirable. I long to hear of your having acquired some superb quarto into which it can be bound.

I am a mass of plans nowadays, spend my time over an atlas seeking for some little home. Can find nothing.

Your limner A B.

MS HUNTINGTON

To Leonard Smithers
[Postmark 15 March 1897]

Muriel, Bournemouth

My dear Smithers,

March has exasperated me. Je m'enrage. How is Symons? The

blood lessens daily; I shall soon dry up now. I am engaged on a very pretty picture. How soon does Dieppe become tolerable?

Joined in kindest regards.

Ever yours A B.

When are we to get your photos?

MS OXFORD

To André Raffalovich
Tuesday [*16 March 1897*]

Muriel, Bournemouth

My dear André,

So many thanks for the numbers of the *Mercure*. Rachilde's novel looks very readable.

Spring is making great demonstrations here this morning. I am able to leave my window open and breathe a little wholesome air. Yesterday afternoon I had a fresh cause for worry. The blood having ceased almost entirely to come from the lung, began to flow rather copiously from the liver; at least Dr Harsant supposes that the new haemorrhage comes from there. He thinks I am suffering from congestion of the liver. I was in a dreadful fright about it, and too weak and nervous for anything. Fr Bearne called in the middle of it all and was all kindness and sympathy, and sent me such a large packet of charming books from their library to keep me amused. There has been no return of the trouble today, and I am rather laughing at myself for my fear of yesterday. I don't think anything really serious is going to happen.

I am always so glad to get the *Journal* and it is more than good of you to trouble to send it to me.

I am yours ever most affectionately AUBREY BEARDSLEY

MS HUNTINGTON

To Leonard Smithers
Tuesday [*Postmark 16 March 1897*]

Muriel, Bournemouth

My dear Smithers,

Many thanks for your letter. I have done no new drawings for

the *Morte Darthur*. I had not the least idea that Dent had brought out a new edition of Malory,[1] or had used any pictures of mine in it. I have ordered the book and will be able to tell you what the frontispieces are like.

How pretty is the *Grove*.[2]

New alarms! The blood having stopped coming from the lung, immediately begins to flow from the liver in considerable quantities via the bum. It seems my liver has become enlarged and congested. Perfectly beastly is it not?

I shall not be allowed up to town for some time now, if ever, so I hope to see you at Bournemouth again. Weather is variable nowadays and I dare not venture out.

Ever yours A B.

1. Miniature edition in four volumes containing Beardsley's frontispieces and title-page ornaments (reduced from the 1893–4 edition) but no other illustrations.
2. Probably *A Dictionary of Music and Musicians* by Sir George Grove, first published 1879–89, but perhaps he means *The Golden Grove* (see p. 300) .

MS Huntington

To Leonard Smithers
[Postmark 16 March 1897]

[*Muriel, Bournemouth*]

My dear Smithers,

I have just seen the little *Morte Darthur* that Dent is reprinting. The frontispieces are reproductions from full pages of mine in the large book. They look rather pretty.

Ever A B.

MS Oxford

To André Raffalovich
Wednesday [*17 March 1897*]

Muriel, Bournemouth

My dear André,

So many thanks for your kind letter and enclosure. I really won-

der what would have happened if it had not been for your goodness. I have certainly made a great advance every way since January. It seems I had no cause for alarm with my new symptom, as there has been no return of haemorrhage. The lung too is quieting down. Dr Harsant has just been in and seems quite satisfied.

This letter has been quite spoilt by late afternoon callers, and I have not now any time to finish it properly.

Oswald must learn to like bread and butter, an acquired taste, I must admit. *I* have acquired it after many years of effort.

I shall look forward to the life of St John Berchmans. I did not know that he was fully canonized, and imagined him only 'Blessed'.

By the way, I have just got myself a paint-box; there have been quite happy results.

I must leave off here.

I am joined in best regards to all.

> Yours always most affectionately AUBREY BEARDSLEY

Thanks for the *Journal*.

MS HUNTINGTON

To Leonard Smithers
[*18 March 1897*]

> Muriel, Bournemouth

My dear Smithers,

Symons' notices[1] are charming. I am delighted to hear that Boussod Valadon[2] have the *Maupin* in hand.

I have piles of talk to talk to you; and do hope you will be with us on Friday as you suggested.

The two pictures reprinted by Dent are *The Lady of the Lake and Arthur* and *Morgan le Fay Giving the Shield*. There are two more volumes yet to appear. King *is* an old friend of mine.

The writ[3] was served the same day as I sent it to you, viz. Tuesday.

In haste and joined in best regards.

> Yours ever A B.

The L.P. *Pierrot* is delightful.

Could you manage to bring down with you any fully illustrated book on Paris?

I am making the Palais Royal the background in my present picture,[4] and should so much like a photograph or some drawing of the P.R.

We have a room reserved here for you. Wire your approach.

1. Probably reviews of his *Amoris Victima*.
2. Boussod, Valadon and Co reproduced the drawing in colour.
3. Issued my Doré. See p. 284.
4. His illustration to 'The Celestial Lover'. The drawing was probably not finished and is unrecorded. Three pages of Beardsley's notes for the story are preserved in Princeton University Library.

MS OXFORD

To André Raffalovich
[*18 March 1897*]

Muriel, Bournemouth

My dear André,

Today I have absolutely ventured to a concert,[1] and there have been no disastrous results. Beethoven No. 4 was given, the first time of hearing for me, and a great treat after my long exile from music. Dr. Harsant was at my side in attendance, ready to feel my pulse, and help me in case of calamity.

I am so glad to have the life of St John Berchmans, it has just arrived. It will be so interesting to compare it with the life of St Aloysius.

I have not yet begun the *Factices*. Most of my time is spent just now in sketching out pictures to be finished later. Boussod Valadon are reproducing in colour a little frontispiece I have made for *Mdlle. de Maupin*. I am awfully anxious to see how it comes out. I am hoping they will do all my work for me now.

This afternoon a Miss Scott Daymer[2] called. She was with Mabel in America so gave us a lot of interesting news. Today I heard from Mabel herself, she seems to be worrying very much about me. I must write her a good account of myself tomorrow. I am really feeling much brighter and stronger.

You have never told me, dear André, of the progress of your hand, and how long black silk bandages were necessary. I do hope they are now things of the past.

I am ever yours very affectionately AUBREY BEARDSLEY

1. At the Winter Gardens. The Bournemouth Municipal Orchestra was conducted by Dan Godfrey.
2. Not identified.

MS PRINCETON

To A. W. King
Thursday [*18 March 1897*]

Muriel, Bournemouth

My dear King,

I was so very glad to get a note from you. I have indeed been seriously ill for the last year, and all work more or less put a stop to. With the approach of spring I am beginning to regain strength and spirits, and to take up my pens, pencils and brushes once more. I shall stay here most probably for another six weeks or two months, and then to France! How much I should like to see you again, but going northwards will be an impossible programme for me nowadays. Why not spend a few days of your holidays with me in Dieppe where I shall be staying in the summer? Would that be possible?

Forgive a skimpy note, I will write to you soon a much more satisfactory letter.

My mother sends her kindest regards to you.

I am ever yours AUBREY BEARDSLEY

MS READING

To John Gray
Friday [*Postmark 19 March 1897*]

Muriel, Bournemouth

My dear Gray,

I was immensely pleased with the translation from Grillparzer,[1] and must thank you very much for letting me have a sight of it.

What is its destination?

I return it to you according to your wish. The character of Medea is most sweet and enchanting.

My health troubles have for the moment relapsed into silence, and I am left almost without anything to write about.

I wonder if you could tell me the right place for *Père Goriot* in the *Comédie Humaine*. Should it be in the *Vie Privée* or the *Vie Parisienne?*

In the édition définitive of Balzac *Père Goriot* is in the *Scènes de la Vie Privée,* but all earlier or subsequent editions place him in the *Scènes de la Vie Parisienne*. It is rather important for me to be certain of his really right position, and I should be so glad if you would help me to a correct solution of my difficulty. I have no means of finding anything out here.

Such blessed weather today, trees in all directions are putting forth leaves.

With kindest regards from my mother.

Yours ever AUBREY BEARDSLEY

1. This seems not to have been published.

MS EASTON

To Julian Sampson
22 March [*1897*]

Muriel, Bournemouth

My dear Julian,

So glad to get a letter from you. I have been abominably ill all this year, and am now off to France for a change of everything. As this month's *Idler* will inform you I have 'not long to live'. Still I hope to make out twelve more months before I go away altogether. London will never see me again, for bacilli flourish rather too vigorously in its giddy atmosphere. Chastity has almost become a habit with me now, but, my dear Julie, it will never become a taste. Sweetest messages to Monsieur Morgan.[1]

Ever yours AUBREY BEARDSLEY

1. George Thomas Morgan, who lived with Sampson at 24 St. James's Square.

MS Good

To John Gray
Tuesday [*Postmark 23 March 1897*]

Muriel, Bournemouth

My dear Gray,

A thousand thanks for your kind information. I am most grateful for it, but pray I have not given you too much trouble.

I will abide by the édition définitive.

Such ravishing weather here.

Ever yours A.B.

MS Oxford

To André Raffalovich
Wednesday [*24 March 1897*]

Muriel, Bournemouth

My dear André,

So many thanks for your words of promise and very kind enclosure.

Rachilde has just sent me her novel with a charming dédicace inscribed in it. I am writing her a note of thanks this evening.

Tomorrow morning I hope to be well enough to go up to the Catholic Church to see Fr Bearne. I am quite near. The Jesuit library has just lent me Crétineau Joly's history of the Order.[1] Have you ever read it?

For the moment fine weather is having a great triumph here, but my content is sadly mixed with impatience. I think it must be exactly a year today since I broke down so tragically at Brussels. Then I suppose many people did not think I should live twelve months, whilst *I* should have been beside myself if I had thought that I should be in twelve months no better than I am now.

Goodbye, my dear André.

I am always yours most affectionately AUBREY BEARDSLEY

1. *Histoire de la Compagnie de Jésus*, 1844–6.

MS PRINCETON

To Leonard Smithers
Wednesday [*24 March 1897*]

Muriel, Bournemouth

My dear Smithers,

Doré has accepted my terms. So I fear no longer for my shirts and socks. Many thanks for your letter and numerous enclosures. Yes the weather is blesséd, I prosper in it. 'The Celestial Lover' is the person who occupies the unoccupied chair at the table in my picture, in the end he makes short work of an intruding and *un*-celestial amant, who pays far too much attention to the lady with the petit banc.

I have been out for quite a time today and feel duly refreshed. I stay in Bournemouth now from day to day.

Did the books arrive all right? Many thanks for housing them.

Yours toujours A B.

Good old review!

MS PRINCETON

To H. C. J. Pollitt
Wednesday [*Postmark 24 March 1897*]

Muriel, Bournemouth

My dear Friend,

I have been fussed lately beyond all words. Not this time mere pulmonary irritation, but assaults from the vulgar world without. Imagine me being served suddenly with a horrid writ for a bill which I have owed long enough to be forgotten by everyone concerned with it. Hence many tears, and the imminent levying of an execution upon my goods and chattels. Oh, mon cher ami, if you could but lend me twenty sovereigns on account of *Bathylle* and a coloured *Lysistrata*![1] 'Plague upon the fellow,' I can hear you say. Still, phrasing aside, I am in the deuce of a hole. You see my state of health (much improved of late, by the way) will not yet allow

me to make an impromptu flitting. So if it is not too impossible for you at this moment pray lend me your assistance.

Your suppliant and ever AUBREY BEARDSLEY

1. *Bathyllus in the Swan Dance* (Gallatin 1074), apparently left unfinished in August 1896, and a hand-coloured set of the *Lysistrata* drawings.

MS OXFORD

To André Raffalovich
Friday [*26 March 1897*]

Muriel, Bournemouth

My dear André,

I was very glad to get your letter, and so interested to learn of your Lenten exercises.

I had such a profitable talk with dear Fr Bearne yesterday morning. I saw him at the Catholic Church. He was so kind and patient with me, and explained the creed of Pius IV most fully.

Yes it would be pleasant to go on 'famously'. Perhaps I shall.

My nerves certainly are a different thing now to what they were two or three months ago. Drawing of course tires me on account of the mere physical exertion required when I attempt to bring anything to completion. Still I can plan out things easily now. I am also writing a little again. Cazotte[1] has inspired me to make some small contes. I have one on hand now called 'The Celestial Lover'. I hope it will be good. I am also making a coloured picture for it. Please forgive all this but I have nothing more notable to tell you of myself. I am all gratitude for so much good-natured weather; even London I believe is behaving itself nicely.

What a pretty naïve letter Oswald writes.

I am beginning to marvel at my continually increasing capacity for drinking milk. It is simply Providential.

I am yours ever very affectionately AUBREY BEARDSLEY

1. French author (1719–92).

MS Princeton

To H. C. J. Pollitt
Friday [*Postmark 26 March 1897*]

Muriel, Bournemouth

My best good Friend,
It really was too charming of you, and Bathylle shall be scrump-tious. You are the great enchanter who has dispersed Bailiffs with a stroke of your pen. Bathylle is going to wear one or two flounces of lace and a faded scarlet sash. The swan who performs with him shall be the most handsome bird conceivable. I mean to let you have the thing imminently. Just at this moment I am finishing a coloured Frontispiece to a small conte of mine called 'The Celestial Lover'; and a pretty thing it is. My heart bleeds at the thought of the candlestick, and I feel a brute—yet how relieved!

This morning I was closeted for two mortal hours with my Father Confessor, but my soul has long since ceased to beat.

Good-bye, mon ami, and again an infinity of thanks.

Yours entirely, pen and pencil, AB.

MS Huntington

To Leonard Smithers
Saturday [*? 27 March 1897*]

Muriel, Bournemouth

My dear Smithers,
My good mother's cheque was for £2.10s., so correct your counter-foil. The Lady with the petit banc shall be finished long before I leave here. I have made up my mind to illustrate *Mdlle de Maupin*, come what may.[1] By the way, what about the bear episode?

Weather is delightful.

Ever yours

A thousand thanks for taking in the books. I didn't send the book-case.

1. Beardsley completed six pictures for *Mademoiselle de Maupin*

(Gallatin 1084–9). The plan to illustrate the book was abandoned in October 1897, when it became clear that the cost of publication was beyond Smithers's resources. The drawings were issued in portfolio in 1898 after Beardsley's death.

MS Oxford

To André Raffalovich
Tuesday [*30 March 1897*]

Muriel, Bournemouth

My dear André,

This morning, alas, saw a slight return of bleeding. Yesterday was so cold and wintry, and my lung got into a very irritable state, therefore I was not entirely surprised at this little relapse. Dr Harsant suggests that I should soon get into some much warmer climate, but does not think that I should venture further than the south of France. Of course that is a delightful programme if it is only possible to carry it out. I have asked Dr Harsant to write to you about me, as he will be able to give you a much more business-like account of my present state of health than I could. You will know better how to advise me when you have heard from him. I believe in some ways he is rather satisfied with me.

Though I often get depressed about myself, still I cannot help feeling sometimes that the end is less near for me than it seems. I know the disease cannot be cured, but its progress surely may be prevented from becoming rapid. Don't think me foolish to haggle about a few months, you will understand, dear André, how precious they may be to me for many reasons now. I am beginning to look forward to bringing out two or three pictured contes; it is good of you to give me such encouraging words.

I am dreadfully sorry to hear of Father Sebastian Bowden's illness and hope it is not really serious.

We heard from Mabel yesterday. She will be home in nine weeks. The dear child has I know been very homesick all this time. How jolly it will be to see her again.

Fr. Bearne has been with me this afternoon, and tomorrow, dear André, the kind name of brother you give me will have a deeper significance.

I will write much more about this to you tomorrow.

I am always yours very affectionately AUBREY BEARDSLEY

MS PRINCETON

To H. C. J. Pollitt
[*Postmark 30 March 1897*]

Muriel, Bournemouth

My dear Maecenas,
 The doctor sends me off to Mentone, owing to further signs of trouble. I hasten with *Bathylle*. In a frantic hurry.

Ever your artificer AUBREY

MS OXFORD

To André Raffalovich
Wednesday [*31 March 1897*]

Muriel, Bournemouth

My dear André,
 Very many thanks indeed for your little line and kind enclosure.
 This morning I was received by dear Father Bearne into the Church, making my first confession, with which he helped me so kindly. My first communion will be made next Friday. I was not well enough to go up to the church, and on Friday the Blessed Sacrament will be brought me here. This is a very dry account of what has been the most important step in my life, but you will understand fully what those simple statements mean. I don't feel I can write a long letter today.
 Your letter has just arrived. I am touched more than I can say with all your loving sympathy.
 I am feeling so happy now.
 Goodbye my dear friend and brother, and with the deepest gratitude for all your prayers.
 I am ever yours most affectionately AUBREY BEARDSLEY

MS Huntington

To Leonard Smithers
[*? 31 March 1897*]

Muriel, Bournemouth

My dear Smithers,

So glad you have been able to knock off so round a sum from your rates and taxes. Thanks for the catalogue. It looks nice.

I haven't been able yet to settle on the day I leave here but will write to you immediately I know and suggest some place of meeting.

Could you come down here?

Ugh! such weather here.

Freezing.

Je suis catholique and ever yours A.B.

MS Oxford

To André Raffalovich
Thursday [*1 April 1897*]

Muriel, Bournemouth

My dearest Friend and Brother,

You are really too good and kind to me, I can never thank you enough for all your goodness. Your wonderful generosity makes some warmer climate quite possible for me. I feel confident that the change will give me a new lease of life. Dr Harsant thinks that on the whole Mentone will be the best place for me. Shall that be settled on? The move could be made next Tuesday at the earliest.

I am told to fear nothing from the journey. How thoughtful is your suggestion that some one should be with me on boat and train. The greatest help I could have would be in the matter of looking after luggage at Custom House, moving it across Paris and making arrangements at any hotel. I believe the ubiquitous Cook will be able to supply us with some one who will pilot us all our way, and relieve one of a world of worries. I am writing to Cook's to see what can be managed. To be independent of one's luggage is the greatest blessing a traveller can ask. I shall know more about all this in a day or so.

I can't tell you how much I look forward to the South. It is bitterly cold here just now, but I have been getting into quite a glow over a packet of Rivieran photographs. There is I notice at Mentone a delightful seventeenth-century church, very similar, by the way, to one that I am putting in the background of a picture at this moment.

Father Bearne came to see me this afternoon, and brought me such a dear little rosary, that had been blessed by the Holy Father. He explained to me the use of it. I feel now, dear André, like someone who has been standing waiting on the doorstep of a house upon a cold day, and who cannot make up his mind to knock for a long while. At last the door is thrown open and all the warmth of kind hospitality makes glad the frozen traveller.

I am writing to Mabel tomorrow to tell her the good news. How happy she will be about it. What an unspeakable comfort it is to me to feel she has such a good friend as you and that any dark moment that may come into her future will be made lighter by your kind sympathy. You are truly our brother.

As I told you I make my first communion tomorrow at eleven. Do think of me just then.

My great difficulty for some time yet, I fear, will be dryness and difficulty in prayer. You will I am sure help me in yours. Goodbye, dear André.

I am always very affectionately AUBREY BEARDSLEY

MS HUNTINGTON

To Leonard Smithers
[? 1 April 1897]

Muriel, Bournemouth

My dear Smithers,

This morning there has been a slight return of blood. The doctor has arrived and sends me post-haste to the South of France. Mentone I fancy it will be. The *Lady and the Déjeuner* will be my last effort at Bournemouth. She has rather changed since you saw her last, but is still delicious. What about seeing you before I leave these shores? Could you manage to come down again here? I don't know what chance I shall have of seeing you in Town on my way through.

Thanks many times for looking after my books for me. I will take the Duntzer's *Life of Goethe* (two volumes 5/-) [1] from the catalogue if I may. My spirits have gone up at the prospect of the change. Drop me a line.

Ever AB

[On back of envelope]
Put the Goethe with my other books.

1. *Goethes Leben* by H. Duntzer (English translation, 1883).

MS OXFORD

To André Raffalovich
Friday [*2 April 1897*]

Muriel, Bournemouth

My dear André, my dear Brother,
The Blessed Sacrament was brought to me here this morning. It was a moment of profound joy, of gratitude and emotion. I gave myself up entirely to feelings of happiness, and even the knowledge of my own unworthiness only seemed to add fuel to the flames that warmed and illuminated my heart.

Oh how earnestly I have prayed that the flame may never die out!

My dear André, I understand now so much you have written to me that seemed difficult before. Through all eternity I shall be unspeakably grateful to you for your brotherly concern for my spiritual advancement.

This afternoon I have felt a little sad at the thought of my compulsory exile from Church just now; and that the divine privilege of praying before the Blessed Sacrament is not permitted me.

You can guess how I long to assist at Mass, and you will pray, I know, that I may soon be strong enough to do so.

Goodbye dear André.

I am yours very affectionately AUBREY BEARDSLEY

To André Raffalovich
Saturday [*3 April 1897*]

Muriel, Bournemouth

My dear Brother,

Just a few lines of heartfelt thanks for your wonderfully kind gift. It is so good of you, so thoughtful. Many many thanks.

I have heard from Cook this morning and if I travel on Thursday I shall have the benefit of one of their ordinary courriers whose duty it is to make all arrangements about luggage, etc. If this is settled on I should leave Bournemouth on Wednesday and spend the afternoon and night in London, staying at the Hotel at Charing Cross which is the station of departure for Folkestone.

I shall be very grateful for those few hours in Town that will give me the chance of seeing you and having a nice long talk about everything. I have heard of a good and moderate hotel at Menton, 'The Victoria'; and have written to them about rooms and terms. Dr Harsant has just paid me a visit, and has consequently cut my letter rather short.

How I must thank you for your Watch before the Blessed Sacrament! I have made and will make fervently the exchange you ask.

Father Bearne did not baptize me as he was satisfied that I had already received the Sacrament with all the necessary form. You know I have a second name that will make one of the St Vincents my patron.

There is a St Vincent of Lerins, a Saint of *Provence* who should be my immediate patron now.

With much love dear André.

I am ever yours very affectionately AUBREY BEARDSLEY
Please tell John Gray that I am writing to him and thank him for me for his kind letter.

To John Gray
Saturday [*3 April 1897*]

Muriel, Bournemouth

My dear Gray,

Thank you so much for your very kind and sympathetic letter,

and for your thought of me on Friday morning. It is such a rest to be folded after all my wandering. I feel sadly my inability to attend any services at Church just now; it has even been impossible for me to spend a few minutes before the Blessed Sacrament, as we have been having absolutely winter weather. But I so hope there will come some fine weather that will allow me to pay a visit to the Sacred Heart before I leave Bournemouth. I have had the least possible return of my trouble this morning, and have flown to a blister for relief. Nothing serious I think is going to happen.

I am all impatience to get to the South, and I have the most entire faith in the healing qualities of sunshine and sun warmth. Photographs of Mentone make it charming. It seems they are having a glorious season there, and I am told to be well prepared for the extremes of heat.

I have just been presented with a Johnson's Dictionary, a second edition in two mighty folios. They grow bigger every time I look at them.

With heartfelt thanks for all your kind wishes for my spiritual welfare.

I am ever yours AUBREY BEARDSLEY

My mother sends her kindest regards.

MS HUNTINGTON

To Leonard Smithers
Saturday [*3 and Sunday 4 April 1897*]

Muriel, Bournemouth

My dear Smithers,

As far as arrangements have gone my plans stand thus.

I leave here on Wednesday.

Spend the night at Charing Cross Hotel.

Leave Charing Cross next morning at 11.30 for Folkestone. From thence to Boulogne and from thence to Mentone via Paris. I will write and generally communicate with you on any alteration of this scheme. Our tender tearful meeting and farewell can be arranged when I know what time I shall get to Town.

A thousand thanks for the cheque que j'ai cashé.

I am rather better now, the bleeding only lasted two days.

Still I feel rather off colour.

(Sunday). A little more blood this morning. I expected much worse things after a perfectly awful night.

Yours, toujours AUBRÉ

MS OXFORD

To André Raffalovich
Monday [*5 April 1897*]

Muriel, Bournemouth

My dearest Brother,

Superintendence of packing and farewell visitors have taken up all my time today, and left me but a few moments for my letter. I shall arrive on Wednesday (Waterloo) at 4.45 in the afternoon. How kind and sweet of you to come and meet me and to allow me the luxury of your carriage. I think of staying two or three days in town and getting an opinion about my state from Dr Symes Thompson who, by the way, knows my case. Yesterday morning and this morning there have been slight returns of bleeding, and Dr Harsant seems a little uncertain about allowing me such a long journey without a second advice. However we shall be able to have a good talk about the immediate future on Wednesday. I look forward tremendously to seeing you.

As my stay in Town is to be prolonged I think some quieter hotel than the Charing Cross would be better for me, and I have written to the Windsor in Victoria Street to know if they can take us in. I hear London is very full just now and that I may have some difficulty in getting rooms. I should *much like* to see one of the Fathers when I am in town. How kind of Fr Bampton to promise to write to me. I was so pleased to have a sight of Fr Sebastian Bowden's letter. I have kept it by me. It is good of him to say a Mass for me. I do hope the dear Father will soon get well. I shall miss Father Bearne very much when I leave here. He has been such a kind and sympathetic friend to me, and of course has the most important place in my memory.

Please forgive such a hurried and ill-written letter.

I have a heap of things to talk to you about.

Our boxes are all packed ready for any move anywhere.

I have just got a *Garden of the Soul*[1] and a little *Testament* from the Catholic bookshop here. It is kept by such an amusing old Frenchwoman who has taken the deepest interest in my conversion.

Goodbye, my dear André, with best love to all.

Yours most affectionately AUBREY BEARDSLEY

1. Prayer book for the laity by Richard Challenor, first published in 1740.

To Leonard Smithers[1]
[*Postmark 5 April 1897*]

Muriel, Bournemouth

My dear Smithers,

More blood. Plans all upset again. Am coming to Town to see a doctor.

Ever yours A B

1. Text from Walker.

MS OXFORD

To André Raffalovich
Tuesday [*6 April 1897*]

Muriel, Bournemouth

My dearest Brother,

I have just said goodbye to Father Bearne. He has been so kind and sympathetic all this time and I felt very sad at saying farewell. I am grateful indeed to you for having introduced me to such a good friend.

I am looking forward to tomorrow more than I can say.

The Windsor Hotel has just wired that they have rooms. I am cherishing a timid hope that there will be kindly weather for the journey to town.

With best love to all,

Yours most affectionately AUBREY BEARDSLEY

MS London

To John Lane
[? *7 April 1897*][1]

[*Bournemouth*]

My dear Lane,

I wonder whether you would care to have a copy of the photograph Cameron took of me when I was in town. I am sending you one by this post.

I have had another bad return of haemorrhage. I am only just convalescent. The doctor is sending me further south and I start today for a warmer climate. Beaulieu (near Monte Carlo) is the place I have been advised to go to. It is quite useless to attempt to winter in England. In the meantime, till I have settled down, my address is 4, Royal Arcade, W.

With kindest regards from my mother and myself,

Yours very sincerely AUBREY BEARDSLEY

My mother will be with me.

1. This letter cannot be dated with certainty. It may have been written from Paris on 18 November 1897.

MS Oxford

To André Raffalovich
Saturday [*10 April 1897*]

Hôtel Voltaire, Paris

My dearest Brother,

Our travelling went off so capitally, thanks to the kind care of Dr Phillips.[1] I don't know what we should have done without him.

I felt a little unwell in the train on the way to Dover but nothing happened.

The sea was beautifully calm and unruffled. From Calais to Paris my spirits and appearance improved every half hour. This hotel has *no* lift but they seem very willing to carry me up and down stairs, and they carry me, by the way, quite nicely. Our proper rooms

have not been allotted to us yet. I will give you full particulars about them when we are installed.

I think Dr Phillips was surprised at the way in which I got through the move. I don't feel in the least tired.

My little stay in London was such a bright and happy one, now I [am] again looking forward to seeing you. Paris you will find looking perfectly sweet. Such delicious tender green upon the trees. From my window I have a view which pleases me more than I can say. I think of you, dear André, at every turn with affection and with gratitude. Love from us to all. With much love,

Very affectionately AUBREY BEARDSLEY

1. Raffalovich's doctor, practising in John Street, Mayfair.

MS PRINCETON

To Mabel Beardsley
Samedi [*10 April 1897*]

Hotel Voltaire, Paris

Dearest Mabel,

Here we are as you see by my flourishing address. I am another creature since I left Bournemouth. André R. lent us his doctor as an escort for the journey and we travelled *en prince*. I got a bit ill in the train on the way to Dover, but nothing occurred and afterwards I improved half hourly. Paris is the blessed place it ever was, and I have been walking for the first time for four months. Have been out in fact for the best part of the day. Lunched at a Duval.

Mother cannot abide Paris, and is utterly British over everything.

I am bringing out a third edition of the *Rape of the Lock*.[1] A tiny pocket edition, for which my pictures are being reduced to well-nigh postage stamps. I am making a coloured fore-page for it. 'Twill be a charmette.

We spent two days in London, André provided for us such a dear little flat at the Hotel Windsor, and gave me a lot of beautiful pi books. Father Bampton came to see me, and was so sorry that I had to leave the next day as he would have arranged for Cardinal Vaughan[2] to come round and confirm me. I really don't know when

I shall get confirmed now. Of course I have made my first communion. I wasn't baptized by the way.

My room here is delightful, looking over the quai and on to the Louvre, such a luvly voo.

I suppose you will have to go to London before you join us here. Of course it would be quite simple for you to book to Havre or some French port.

An article is about to appear on me in the *Mercure de France*.[3] Homages to the Mansfield. Remembrances to Cochran.[4] Have you heard about Tree?[5]

Ever loving AUBREY

1. The Bijou edition, published by Smithers in 1897. It is the third only in the sense that the twenty-five large-paper copies of the first are counted as a separate edition. There was a new cover design.
2. 1832–1903, Archbishop of Westminster since 1892.
3. This article by Henry D. Davray appeared in *L'Ermitage*, April 1897.
4. Davray was a frequent contributor to both papers.
 He had gone to the United States in the early eighteen-nineties. In 1895 he produced Ibsen's *John Gabriel Borkman* in New York and was now Mansfield's business manager.
5. Mabel Beardsley seems to have asked Beerbohm Tree for a part on her return. The reference may, however, be to the announcement on 8 April that Charles Brookfield, who had quarrelled with Tree some years earlier, was to join his company at Her Majesty's Theatre.

MS HUNTINGTON

To Leonard Smithers
Saturday [*10 April 1897*]

Hôtel Voltaire, Paris

My dear Smithers,

I managed the journey simply splendidly, and am as fit as a fighting cock today. Have been walking the streets as pertinaciously as a tart. A Duval gave me my first déjeuner here. Such a treat to sit in a public place again to eat. Variable sort of weather here, but not bad on the whole. I have begun the new *Rape* drawing. It shall be pretty. My room overlooks the quai, such a jolly view. I have an alcove bed that curtains off in the daytime and leaves me quite a nice little salon for the daytime. Paris is very full. We had difficulty

in getting rooms. I have just bought a book on Canaletto, and one on La Tour.

I look forward much to seeing you in this sweet city.

Joined in all kind wishes,

Ever A B.

MS OXFORD

To André Raffalovich
11 April [*1897*]

Hôtel Voltaire, Paris

My dearest Brother,

If I only dared to boast I should give you a very flourishing account of myself, health and spirits. I scarcely feel any fatigue from walking, and I am spending just now a good deal of time out of doors. The weather is still rather cold, but there is delicious sunshine today. We have not yet been able to move into our right rooms at the Hotel, and for the moment I suffer mild discomfort on floor the fourth.

I like the Voltaire very much, particularly for its situation. A real drawback, however, is that I shall not be able to get a private sitting-room, not even a *tiny* salon; but my bed is in an alcove and, curtained off, leaves quite a nice room for the day. There is a charming bookshop one door from the Voltaire. I have just asked for their catalogue, and bought such an interesting book on Molière and the Comédie Italienne, that has very amusing cuts.

The nearest church to me is S. Thomas d'Aquin, in Rue du Bac, a large handsome place, nice and warm too; I feel quite strong enough now to attend services.

Thank you so much for the Golden Manual,[1] it must be surely quite the best book of its kind.

I rejoice greatly at being here again, not so long ago I found myself shedding real tears at the thought of having seen Paris for the last time. How surprised Mabel will be when she knows our latest move, and enchanted too at the prospect of joining us in the city beautiful. I have just written to her.

It is quite wonderful how well Paris air suits my trouble. I am thankful indeed to Dr Phillips for his sage advice. You cannot

imagine how kind and thoughtful he was all through our voyage here. I had not a thing to trouble about from beginning to end of the journey.

I write this at a Café that gets very full during the entr'actes at the Théâtre Français, where a matinée of *L'Avare* is in progress.

Good-bye dear André, I shall look forward much to your arrival. Love from us to all.

With much love very affectionately yours AUBREY BEARDSLEY

The pen they have given me has compelled me to reverse my writing.

1. Probably *The Golden Grove, a Manuall of Daily Prayers and Letanies,* by Jeremy Taylor, 1655.

MS HUNTINGTON

To Leonard Smithers
Dimanche [*11 April 1897*]

Hôtel Voltaire, Paris

My dear Smithers,

Such a blessed treat to be here again. Imagine me letter writing in a café, with sun blinds drawn down all round, and a theatre entr'acte bell ringing, and people clamouring for books. I shall drop into a Symonsy mood if I don't take care, I am worlds better.

Hôtel Voltaire pleasant enough, we haven't got into our proper rooms though and shall have to wait two or three days yet.

Is Leigh Hunt's *Restoration Dramatists* (first edition) [1] worth getting at 5 frs?

Ever yours A B.

Paid S. Romain. [2]

1. Published in 1840.
2. See p. 148.

MS Oxford

To André Raffalovich
12 April [*1897*]

Hôtel Voltaire, Paris

My dearest Brother,

I still keep so wonderfully well and am able to be out of doors a great deal. I look back with amazement now at my little tentative walks on the cliff at Bournemouth.

I spent such a happy half hour this afternoon at St Sulpice (my favourite church in Paris). You were recollected, dear André, very affectionately in my poor prayers, sadly stumbling and imperfect things as yet.

St Theresa's life of herself is indeed a brilliant work. I had not the faintest idea she had written anything so important; I am very grateful to you for having given me her works.

Father Ollivier[1] has been preaching with most extraordinary success, his sermons are being printed as they are preached and are being sold everywhere. I have just bought the last published, 'Sur l'infaillibilité de l'Eglise enseignante'. I wish I could have heard him.

The weather is perfectly goodnatured, but not splendid yet.

 Good-bye, dear André,

 With much love

 Yours most affectionately AUBREY BEARDSLEY

Best love from us to all. I hope John Gray is enjoying the best of journeys to Regensburg.

1. Six Lenten addresses on the teaching of the Church, given at Notre Dame.

MS Oxford

To André Raffalovich
13 April [*1897*]

Hôtel Voltaire, Paris

My dearest Brother,

So many thanks for your two letters just received.

I have been making enquiries about rooms at some other Hotel. A suite of two bedrooms with Salon is difficult to get at hotels

without lifts, and simply ruinous at hotels that *have* lifts. About 40 frs. to 50 frs. a day is asked even at moderate places for the rooms we should want. Of course just now the search is made more difficult by the approach of Easter!¹ At the Voltaire people are being turned away all day. If we stay where we are we shall come into our right rooms tomorrow. I find that the bed in mine is walled—not curtained off—and they are willing to make for me any arrangements that will add to the comfort of the room. However the chief thing in favour of this hotel is the fine view and great open space in front of it, which will be a great blessing in the warmer weather. The service here is good and the garçons are most willing to chair me upstairs as often as I want to mount. Then the prices are moderate.

Would you advise me to stay, anyway till holiday times are over?

How good of you to write about me to Huysmans.² I look forward to meeting him immensely.

I am writing to Mrs Ian³ asking her and her daughter to lunch with us this week. Thanks so much for giving me her address. She is such a kind and cheerful creature.

Mother went round for me this morning to S. Thomas d'Aquin, to enquire for someone who would look after me at Easter. L'Abbé Vacossin, vicaire de S. Thomas d'Aquin, will hear my confession on Easter Sunday afternoon, and will bring me the Blessed Sacrament at 8 o'clock on Easter Monday. I hear that my Abbé is the most charming person imaginable. It took him a long time to be able to grasp the fact that *I* was Catholique and that *Mother* was not. He says they will have a most wonderful High Mass at his church on Easter Sunday. By the way S. Thomas d'Aquin is my parish church.

The weather is perfectly lovely here today, much too hot for an overcoat, though I've worn one out of a sense of duty. I am quite a different creature to what I was last week, and if no disasters are imminent you will be surprised at my improvement.

I have just picked up on the Quais a copy of *Le Parfum de Rome*.⁴ The book and print shops are an evergreen joy to me. I am really happy in Paris, and have never loved it so well as this time. Best love from us to all. Goodbye, dear André, with the greatest affection. AUBREY BEARDSLEY

1. Easter Sunday fell on 18 April.
2. Three of Raffalovich's letters to Huysmans are printed in *Two Friends*, edited by Brocard Sewell, 1963, but this one is not among them, and there is no evidence that Beardsley ever met Huysmans.
3. Mrs Ian Robertson.
4. By Louis Veuillot, 1862.

MS Huntington

To Leonard Smithers
13 April [*1897*]

Hôtel Voltaire, Paris

My dear Smithers,

A thousand thanks for your letter and enclosure. I am simply A 1. I haven't been able to settle down to work yet as I have not yet got a decent room to work in. Tomorrow however that will be all right.

I eat and drink nowadays like any ordinary mortal.
Hope to see you soon.

(In haste) Ever A B

MS Princeton

To H. C. J. Pollitt
14 April [*1897*]

Hôtel Voltaire, Paris

My dear good friend,

Here I am and as right as ninepence. Eat sleep live and drink just like my old self. A perfect resurrection. Do come over here this spring.

Tomorrow I shall begin to interest myself in picture making and the limning of Bathylle.

Paris is quite sweet.

Ever AUBREY

MS Oxford

To André Raffalovich
Thursday [*15 April 1897*]

Hôtel Voltaire, Paris

My dearest Brother,

Forgive my writing in pencil, the pens at the Café de la Paix are quite impossible. Mrs Ian has been lunching with us today. I was so glad to see her. She is the brightest, most encouraging person imaginable, and has been lecturing me about diet. Hot water and rosbif make up her programme. I know she is right, only although

the menu seems so simple, it is a difficult one really to put into prac-
tice. I have a personal experience of hot water and know what won-
ders it works.

I am sure Rachilde's Tuesdays are charming, I hope I shall make
my bow in her salon ere long.

I am fairly installed in my new room now. It is quite comfort-
able and has a splendid view. Mrs Ian was enchanted with it. It's
so sweet of you to make friends for me here.

If I only continue to improve as I have been doing for the last
few days I shall be comparatively strong and well, quite soon.

For instance today I have walked quite easily from Lapérouse
(opposite Notre Dame) to the Café de la Paix. Then I eat and drink
more than double what I did at Bournemouth; and also sleep per-
fectly.

I was so interested in what you wrote about S. Thomas d'Aquin.
Will you pray, my dear André, that he may intercede for me?

I was reading his life in Ribadaneyra[1] last night. Ribadaneyra
is delightful, he doesn't condescend to dates, but considers 'once
upon a time' quite enough for the inquiring faithful.

I am much pleased with the biography of S. Francis Borgia. We
get very cheerful letters from Mabel. Of course she has not heard
yet of our wondrous move. I believe I should be strong enough to
accompany her if she returned to Mansfield in the autumn. I'm
sure she won't go back in any other conditions.

Good-bye, dear André, I think so much of you always and every-
where.

<div style="text-align:center">With much love,</div>

<div style="text-align:center">Most affectionately, AUBREY BEARDSLEY</div>

Best love from us to all.

1. Pedro de Ribadaneyra (1526–1611), Jesuit preacher and author of
Flos Sanctorum. His life of St Francis Borgia was published in 1592.

<div style="text-align:center">MS HUNTINGTON</div>

To Leonard Smithers
Thursday [*15 April 1897*]

<div style="text-align:right">Hôtel Voltaire, Paris</div>

My dear Smithers,

I get on grandly. Paris is simply charming. You won't know me

again. Betts[1] cashed the cheque with all possible grace. I lunched at Lapérouse today as one of the Forbes Robertson family was with us. *Truite de Rivière*! Ah! and *Pontet Canet*! *Fraises*!

After many changes I have settled finally into a room here. Quite a pleasant one, almost as good as a sitting-room, and simply a ripping view. I write this from the Café de la Paix.

I am putting myself on a hot water diet now. I believe it will do wonders for me. So many thanks for forwarding on to me letters packets etc etc.

<div align="right">Ever yours A B</div>

Am longing to see proofs of the *Rapelets*.[2]

1. Smithers's bank in the Rue Castiglione.
2. The Bijou edition of *The Rape of the Lock*.

MS READING

To André Raffalovich
[*circa 16 April 1897*]

<div align="right">Hôtel Voltaire, Paris</div>

My dearest Brother,

The Baronne Dufour[1] came to see us today and paid us a most charming visit. We talked much of the Church, of art, and of yourself. How sweet and sympathique she is. We shall see her again on Sunday. Rachilde has just written to ask if she may come to see me tomorrow. I am sure I shall like her tremendously. Another visitor has been L'Abbé Vacossin who promises to look after me nicely.

They have arranged a little sitting-room for me at the Hotel, the dual arrangement made things a little difficult. I fear I am going to be sorely tempted by the book shops here, such pretty last century bindings attract one from a distance, even when literature is furthest from one's mind.

I have not found a copy of *Les Odeurs de Paris*[2] yet.

Your cousin[3] spoke of Versailles as being such a charming place to spend the summer at. You see I am never tired of plan making, and am already thinking of July and August.

I am finding Mrs Ian's hot water programme very difficult to carry out thoroughly. The beef however is simpler to get. My

appetite is perfectly huge now, and I clamour for five meals a day.

I look forward more than I can say to your arrival; do you pay a return visit on your way back from Touraine?

The weather is a little unsettled today, and in Bournemouth I should have been depressed. Here I have a constant flow of good spirits. Every day I appreciate the beauty of Paris more, it is the city of satisfying proportions, such a joy after the horrid squareness of England.

I am making a coloured frontispiece for the *Rape of the Lock*. I think I told you we were bringing out a tiny edition of it.

Thanks so many times for all your kind letters, they are always so cheerful, so encouraging and so wise.

With much love,

Most affectionately AUBREY BEARDSLEY

Mother joins me in best love to all.

1. Not identified.
2. By Louis Veuillot, 1866.
3. Probably the Vicomte de Chaptal (see p. 429).

MS HUNTINGTON

To Leonard Smithers
[Postmark 18 April 1897]

Hôtel Voltaire, Paris

My dear Smithers,

Many thanks for your letter, and proof of *Rape*. I have had the hell of a job to settle down to work, so many people to see. Thanks for the clothes. I had no duty to pay. I had some *delicious* Margaux yesterday (Lapérouse) at some one else's expense.

Look forward to your coming over and joining me in grands vins.

Ever A B

Quite a decent notice of the *Rape* in the Saturday.[1]
German papers are talking of my conversion.

1. Review of the 1896 edition, *Saturday Review,* 17 April 1897.

MS HUNTINGTON

To Leonard Smithers
[*Postmark 20 April 1897*]

Hôtel Voltaire, Paris

My dear Smithers,

I have thought and wrought over the new *Rape* drawing to an extent. The result of my efforts leads me to decide on making a largish picture for great reduction in the manner of the others and equally elaborate. I have caught the most filthy cold and feel feverish and horrid.

Ever A B.

MS PRINCETON

To William Heinemann
Saturday [*24 April 1897*]

Hôtel Voltaire, Paris

My dear Heinemann,

I was so sorry to miss you and your brother here today. I should have liked so much to have a sight of you before you left Paris.

I shall be delighted to do you a drawing for your book on dancing[1] if you would really care to have one. Please let me know when I should have it ready. I thought of doing a picture of Bathyllus, the famous Roman dancer (Juvenal VI). Would that be suitable?[2]

Most sincerely yours AUBREY BEARDSLEY

1. Vuillier's *History of Dancing,* published by Heinemann in 1898.
2. Instead of this Beardsley contributed *Arbuscula* (Gallatin 1062).

MS HUNTINGTON

To Leonard Smithers
[*26 April 1897*]

Hôtel Voltaire, Paris

My dear Smithers,

Many thanks for your letter (and Sotheran's). I have just got two

delicious engravings from the Goncourt sale.[1] *Toilette pour le bal* and *Retour du bal* engraved by Beauvarlet after de Troy. Ravissants!

I keep flourishing. Raffalovich is staying in Paris just now and leaves in a few days.

I haven't fairly settled down yet or you should have had your new *Rape* drawing and cover long ere this. I look forward hugely to your arrival. We will have a few chaste busts.

Ever A B

Kindest regards from my mother.

1. The sale was held 26–28 April.

MS PRINCETON

To Mabel Beardsley
Monday [*26 April 1897*]

Hôtel Voltaire, Paris

Dearest Mabel,

I don't know when Mother wrote to you last, I believe it must be a deuce of a time. It is quite too nice to be here. André, Miss Gribbell and John Gray are staying in Paris now, on their way to Touraine. It's amusing to have them. Yesterday we had a charming lunch party at Lapérouse. Rachilde and some long haired monsters of the Quartier were with us. They all presented me with their books (which are quite unreadable). Smithers will be over next month, and also Robbie. It's quite wonderful the way I have recovered; everyone says I don't look a bit malade, still everyone is truly sympathetic. I met Heinemann two or three days ago. He was amazed to see me out of bed. I am doing a picture for a book on dancing that he is just going to bring out.

André introduced a pleasant Jesuit[1] to me this afternoon. You know they are not allowed in France, still the Jesuits have a regular palace here in the Rue de Sèvres.

I have heard of a charming little place not far out of town where the summer could be spent. Ville D'Avray. I wondered if you knew it. I have half a mind to take a tiny furnished house for a couple of months. It is so easy to get service here. Houses too are cheap. How

long will you stay in London before you come over? We were so interested in the notice of you in the Chicago paper. I hope the interview will be amusing. I have not been able to get up to see Blanche yet. I mean to tackle him about the portrait.[2] By the way I have bought two such delicious dix-huitième engravings from the Goncourt sale. *Toilette du Bal, Retour du Bal* engraved after Troy. Dreadfully depraved things.

Ever loving AUBREY

Remembrances to Cochran.
Homages to Mansfield.

1. Père Coubé of the Jesuit house in the Rue de Sèvres.
2. See p. 100.

MS PRINCETON

To Leonard Smithers
[circa 27 April 1897]

Hôtel Voltaire, Paris

My dear Smithers,

Here is *a* cover for the little *Rape.* I want them to insert their type for lettering as per enclosed slip

> THE
> RAPE
> OF
> THE
> LOCK

Will this drawing reduce and look at all decent? I will do another at once if it won't. *Implore* them to make a careful block. There is by the way some *Chinese white* on the drawing so let it not be touched with indiarubber.

I went to the Bois yesterday for the first time in my life, quite charming there. The weather has not yet made up its mind to be really decent yet, still—

The Pauillac at Lapérouse is *excellent*! only 2 fr a bottle. Where will you stay when you come over? Will it be alone!?

Ever AUBREY B.

To Leonard Smithers[1]
[*circa 29 April 1897*]

Hôtel Voltaire, Paris

My dear Smithers,

So glad to hear you are coming over thus soon.

I enclosed lettering with the cover merely to show you that I had not shirked the trouble of doing them, but at the same time I wanted type used. Yet the dots make me feel doubtful as to the success of the designs on cloth. Of course the cloth must be deucedly smooth.

We have been having splendiferous weather here. I discovered a new (or rather old) restaurant yesterday; the Café Joseph in Rue Marivaux; truly excellent and a waiter there who cuts up chickens miraculously. I believe there is a little hotel somewhere near the Rue S. Roch (if not absolutely in it) called Hotel S. Romain (or Ste Romaine?), I forget which. I fancy I must have stayed there once myself and have an idea it was quite comfortable. You might give it a trial.

Ever and au revoir AUBREY BEARDSLEY

1. Copy in another hand in the Library of University College, London.

MS PRINCETON

To Henry Davray[1]
Friday [*30 April 1897*]

Hôtel Voltaire, Paris

My dear M. Davray,

Please pardon an invalid's delay in answering your kind letter and acknowledging the copy of *L'Ermitage*. I hardly know how to thank you sufficiently for so generous and sympathetic an article. It

has given me the greatest pleasure. I should be so glad to come up and see you one evening but I dare not yet venture out at night.

Will you then give me the pleasure of your company here on Tuesday (4 Mai) for déjeuner at 12 o'clock? Leonard Smithers will be with us.

Very truly yours AUBREY BEARDSLEY

1. 1873–1944. French literary journalist and translator, at this time principal reviewer of foreign books for *Le Mercure de France*.

MS PRINCETON

To William Heinemann
Friday [*30 April: date of receipt 1 May 1897*]

Hôtel Voltaire, Paris

My dear Heinemann,

Many thanks for your letter. I will certainly let you have the drawing well before 1 June.[1]

In haste,

Yours very sincerely AUBREY BEARDSLEY

1. It was not completed until late August.

MS OXFORD

To André Raffalovich
Monday [*3 May 1897*]

Hôtel Voltaire, Paris

My dearest Brother,

I felt very sad when you left. I do hope I shall soon see you again, and wish you could pay us a return visit to Paris. Dr Prendergast[1] has not called yet. His medicines seem to have done wonders. I had a horribly restless and wakeful night, and this morning there has been a very slight oozing of blood. Of course I am staying

indoors, and do not expect any further return of the trouble. Rachilde has just paid me a charming visit; she came to carry me off to a show of Bouillon's[2] work in the Rue Bonaparte. She was most concerned over my little relapse. I am longing to hear all about Touraine, and the beauties of Azay-le-Rideau, Chenonceaux, Chaumont, etc, etc. Please forgive rather a short letter today. Dear André, I really don't know how I can ever thank you for all your sweet sympathy and kindness, all your generosity. I have received your wonderful present this afternoon and feel perfectly bewildered. Many many thanks. I will write again tomorrow and hope to be able to tell you that I am quite well again. Best love from us to all.

With much love,

Yours AUBREY BEARDSLEY

1. An English doctor recommended by Raffalovich.
2. Henri-Théophile Bouillon (1864–1934), a well-known sculptor.

MS OXFORD

To André Raffalovich
Tuesday [*4 May 1897*]

Hôtel Voltaire, Paris

My dearest Brother,

I was so pleased to get your letter. I am *quite well again* today and able to get out. I'm sure you are going to have the most delicious time in Touraine. The flowering shrubs upon the banks of the Loire sound fragrant and tender. I wonder if you will discover any ancient hors nature who have returned to their province and become honest Tourangeaux?

How very kind of Madame Raffalovich[1] to think of sending me introductions to Roll[2] and Eugène Muntz.[3] Of course I shall be perfectly delighted to have them.

I mean to take your advice about meals. I believe that eating in silence and alone is dreadfully bad for the digestion.

Yesterday I felt sadly depressed over the return of bleeding; I beg of you, dear André, to help me with your prayers against these relapses, and also that I may be wise enough to avoid ridiculous little imprudences that may set the trouble going.

Good-bye, dear André.

With much love,

Yours very affectionately AUBREY BEARDSLEY

Mother is much better today and joins me in best love to all.

1. Raffalovich's mother.
2. Alfred Philippe Roll (1846–1919), French portrait and landscape painter.
3. 1845–1903. Art historian and librarian of the Ecole des Beaux-Arts. His life of Leonardo da Vinci appeared in 1899.

MS ANDERSON

To Louis Octave Uzanne[1]
4 May [*1897*]

Hôtel Voltaire, Paris

Dear Monsieur,

I was so sorry to miss you when you called this afternoon, and I regret to say that I shall not be at home this evening at the time you mention. It would give us much pleasure if you would take déjeuner with us here next Thursday (6th) at 12 o'clock.

Yours truly AUBREY BEARDSLEY

1. French author (1852–1931), editor of *Le Livre*.

MS OXFORD

To André Raffalovich
[*5 May 1897*]
[Headed paper of the Café de la Paix]

Hôtel Voltaire, Paris

My dearest Brother,

The fire at the Charity Bazaar[1] here has caused, you can imagine, the most utter consternation. Last night cafés and theatres were almost empty.

Everybody has lost somebody.

Blanche writes to me this morning that several of his friends were burned, and consequently puts me off a second time for lunch.

I heard the news of the disaster first at Rachilde's whilst the fire was still burning.

I am going to Doucet's[2] on Friday led by Miss Fanny[3] and Jean de Tinan.[4]

By the way M Davray is going to give me French lessons every day, but thereby will cut away my last excuse for being unable to speak French.

Mother is almost quite well now and able to get out.

My own poor health has suffered no further shocks. I make a point of eating beef at every meal.

I hope Touraine continues to be enchanting. With best love to all.

Ever yours most affectionately AUBREY BEARDSLEY

I suppose Gray knows of *Callot's* singularly interesting eau-forte of the Martyrdom of St Sebastian. There is a charming soldier in the background picking up the arrows that have missed the Saint.

1. Over two hundred guests were killed in the fire at the Charity Bazaar in the Rue Jean Goujon on 4 May 1897.
2. Jérôme Doucet, poet and playwright (*b.* 1865).
3. Not identified.
4. French symbolist author (1875–99) .

MS HUNTINGTON

To Leonard Smithers[1]
[*5 May 1897*]

[*Hôtel Voltaire, Paris*]

My dear Smithers,

Forgive such a filthy scrap of paper, the only piece I could lay my hands on here. What a fire! Blanche had to put me off for lunch owing to his having lost several friends in it.

I shall be wise I think to stay indoors this evening as I am horribly fatigué.

You might come in and have a look at me somewhere about ten.

Ever A B.

1. Addressed to Smithers at the Normandy Hotel and delivered by hand.

MS OXFORD

To André Raffalovich
Friday [*7 May 1897*]

Hôtel Voltaire, Paris

My dearest Brother,

I was so glad to get your letter. I am more grateful than I can say for Mother's masses and for mine. It will be delightful to have a sight of you on your way back, and I hope you will not arrive in Paris too late for a meeting. Octave Uzanne has been telling me a great deal about Egypt as a winter home. Luxor near Cairo seems to be capital in every way and quite cheap. One can live there very well on ten shillings a day. Uzanne will give me some addresses. I am so glad you find Touraine amusing and pray that you are not having such abominably cold winds as we are suffering from here. Overcoats and comforters quite the order of the day.

I am reading a delicious book for the first time, *The Thousand and One Nights*, in Galland's translation.[1] I have just finished the cover for *Ali Baba*,[2] quite a sumptuous design. M Lecoffre of the Rue Bonaparte has received his 14 frs odd.[3]

Joined in best love to all.

With much love,

Yours very affectionately AUBREY BEARDSLEY

1. Published 1704–17, the first translation into a modern European language.
2. Gallatin 1057, first published in *Second Book*. Beardsley now resumed his plan to illustrate *Ali Baba,* but did not produce any further drawings for it.
3. A bookseller's bill Beardsley paid for Raffalovich.

MS READING

To John Gray
Friday [*Postmark 7 May 1897*]

Hôtel Voltaire, Paris

My dear Gray,

Many thanks for your letter. I don't know at all where you would be likely to find Callot's *S. Sebastian*. Perhaps Armand Durand have reproduced his etchings. You would certainly be interested in this

particular one. I see that a Callot has been brought out in Leroi's series of *Artistes Célèbres*. It is just possible you would find the *S. Sebastian* in it. I am delighted to hear we shall have a chance of seeing you on your return journey.

Kindest regards from my Mother.

Ever yours AUBREY BEARDSLEY

MS OXFORD

To André Raffalovich
Monday [*10 May 1897*]

Hôtel Voltaire, Paris

My dearest Brother,

It will be quite charming to dine with you this evening. We will be with you at seven o'clock. I look forward to hearing of your adventures at Langeais.

With much love,

Yours very affectionately AUBREY BEARDSLEY

MS OXFORD

To André Raffalovich
Wednesday [*12 May 1897*]

Hôtel Voltaire, Paris

My dearest Brother,

It was so nice to have a little sight of you on your way home. I hope the crossing was all it should be.

I have just heard from Mabel. She does not sail till the 22nd. There seems to be no end to the delays for her return. The weather here is being too unfriendly for anything, so St Germain has not yet been visited. By the way, dear André, I had meant to ask you what the formalities are in the presentation of a letter of introduction in France. I do wish you would tell me.

I am buying your bonbons to-day and tulips, and will have them conveyed early on Friday morning to Madame Vallette.[1]

Hello's book[2] is indeed wonderfully interesting, so many thanks for it. I continue to progress favourably and to nurse my new strength with extreme care.

Best love from us to all.

With much love,

Ever yours very affectionately AUBREY BEARDSLEY

1. i.e. Rachilde.
2. Probably *Le Siècle, les Hommes, les Idées* (1895) by Ernest Hello (1828–85).

MS D'OFFAY

To John Gray
Thursday [*13 (Postmark 14) May 1897*]

Hôtel Voltaire, Paris

My dear Gray,

This is a cheap reproduction of Callot's *Saint Sebastian*; I hope it may be of some use to you.

Please let me know when there is anything I can do for you in Paris.

Ever yours AUBREY BEARDSLEY

MS OXFORD

To André Raffalovich
Saturday [*15 May 1897*]

Hôtel Voltaire, Paris

My dearest Brother,

I was so pleased to get your letter. So many thanks for it. I have just had an amusing note from Rachilde thanking *me* for the bonbons. I have explained to her that they were *your* sweets.

Today is delightfully fine and has been spent at S. Germain. I am quite enchanted with the place; the Bois is simply Elysian. We found rooms at an hotel immediately, and our address on and after

next Friday will be Pavillon Louis XIV, Rue de Pontoise, S. Germain.

You cannot imagine how pretty the Hotel is, and with such a nice garden. We are the first arrivals there this season; in fact the Hotel is not yet ready to receive anyone, as the proprietors have only just closed their Hotel at Nice. The Pavillon opens on Thursday. **Our** rooms are most charming and cheap, 4 and 3 frs. a day respectively. We are really very lucky to have got them, I did not expect to find anything so moderate at S. Germain. The Hotel is scarcely fifty yards from the Terrace and Park. The Church of S. Germain promises to be rather sumptuous and ornate in all its doings. It is not a minute's walk from the Hotel. Indeed everything one could possibly want—including coiffeur—seems to be in or near the Rue de Pontoise.

There is an ascenseur (10 cent.) at the station.

I believe the air of S. Germain will do the greatest wonders for me; it is deliciously pure and fresh.

You see my dear André I brim over with gratitude to you. How I wish you could spend some of the summer with us. You will find perfectly charming accommodation at the Pavillon Louis XIV.

How kind of le Père Coubé to come and see us. I expect his retreat is over now. I look forward much to having a sight of the house in the Rue de Sèvres.

Please forgive a rather straggling letter, but I am a little tired after my excursion to S. Germain. The train makes a long journey of it.

I am writing again tomorrow.

With best love from all to all,

Ever yours very affectionately AUBREY

MS OXFORD

To André Raffalovich
Monday [*17 May 1897*]

Hôtel Voltaire, Paris

My dearest Brother,

So many thanks for your letter with letter of introduction. I will present the introductions as you direct.

Please forgive, dear André, a very short letter, as I have not yet recovered from a very severe attack of sickness which overwhelmed me yesterday. I was grateful beyond words that the retching did not affect my lung. I expect I shall be all right tomorrow. It is so vexing to be unwell during my last few days here, especially as I have breakfasts to turn up at every day till Friday. The weather improves hourly.

It will be very kind of Malcolm Drummond[1] to call on me. I shall be very pleased to see him. If I am at St Germain I hope he will find time to come over.

I was very interested to hear that you have become a Little Oratorian.[2] Does not your confraternity have its services in that pretty chapel across the Oratory garden?

Mother continues to be rather unwell, I am sorry to say. I feel so uneasy about her. For the moment she is not allowed to take any food; only milk and Vichy water.

She joins me in best love to all.

With much love,

Ever yours very affectionately AUBREY BEARDSLEY

1. Not identified; possibly Groom-in-Waiting to Queen Victoria (1856–1924).
2. The Little Oratory, a confraternity of clerics and laymen, was founded by St Philip Neri to visit hospitals and to take the discipline at the exercises of the Passion.

MS O'CONNELL

To Leonard Smithers
Monday [*17 May 1897*]

Hôtel Voltaire, Paris

My dear Smithers,

I send by this post the proof of *Mdlle de Maupin,* and cover of *Ali Baba.*

The cover has a good deal of chinese white on it so beg them *not* to *rub* or *touch* the drawing at Naumanns.

The weather begins to improve here. I pray it will be piping hot at S. Germain.

I have just vomited up the meals of the last two or three days. You see your Saint Marceau (royal rosé) has been avenged.

Ever AUBREY BEARDSLEY

MS READING

To André Raffalovich
Wednesday [*19 May 1897*]

Hôtel Voltaire, Paris

My dearest Brother,

So many thanks for your letter. Paris has been perfectly charming these last few days and I have enjoyed myself enormously. All the same I long for S. Germain, for I begin to feel the want of quiet, and fresher air. I mean to spend as much time as possible out of doors.

We leave on Friday morning. Mrs Meygenberg[1] (an American lady who Mrs Ian was staying with here) has very kindly lent us her servant to look after our packing and see us safely installed in our new quarters.

Mother is much better but still quite unable to cope with eleven trunks.

Father Coubé is coming to see us tomorrow. I look forward very much to meeting him again.

Clyde Fitch[2] was really quite pleasant.

Will Rothenstein has just dropped in and made a very admirable portrait of me.[3] I was so glad to see him again. He has shown me a lot of charming work he has been doing lately. A portrait of Rodin is really fine.

In haste, ever with much love,

Yours very affectionately AUBREY BEARDSLEY

Mother joins me in best love to all. The doctor has just been and forbids her to move to S. Germain this week. So I shall go alone on Friday.

1. Not identified.
2. American playwright (1865–1909).
3. Lithograph drawing reproduced in Rothenstein's *Liber Juniorum* (1899).

MS Oxford

To André Raffalovich
Thursday [*20 May 1897*]

Hôtel Voltaire, Paris

My dearest Brother,

Dr Prendergast finds Mother less well today. She is suffering from a severe attack of gastritis. Of course she is in a terribly weak condition and is unable to take any sort of food, and I fear if she does not rapidly improve the trouble may develop into peritonitis. The doctor will let her know tomorrow what her chances are of joining me soon at S. Germain.

Le Père Coubé has just paid me a most charming visit, and is going to give me an introduction to a Jesuit Father at S. Germain.

Mother joins me in best love to all.

With much love,

Yours very affectionately AUBREY BEARDSLEY

MS Oxford

To André Raffalovich
[*? 22 May 1897*]

Pavillon Louis XIV, Rue de Pontoise,
S. Germain

My dearest Brother,

I have arrived here quite well and safely. Mother (who is a little better today) will join me in a few days. I am quite delighted with the new place and feel better already. The cooking is good. Such nice coffee. I am sorry to say I was robbed of a note for 100 frs. at the Voltaire just before I left. I was so wretched about it, not on account of the loss, but because I had really been most generous to all the servants whilst I was staying there. I am almost certain I know who took it.

However my sorrow was dispelled by a very pleasant lunch with Octave Uzanne, and above all by a visit to the Jesuits' house in the Rue de Sèvres. Father Coubé showed me the drawings of Jerusalem,

Athens and Carthage. Rome was absent. They are wonderful drawings, and delightfully unpedantic. I took the opportunity of making my confession to the dear Father, who was kind enough to hear it out of hours.

I was surprised to find they had such a large church attached to the house.

My sickness began in the train coming back from S. Germain last Saturday. It was such a hot afternoon, and nowadays I become dreadfully sea-sick en chemins-de-fer.

I have never heard Berlioz's 'Harold'. In fact I know very little of his (Berlioz's) music. Mottl's concert[1] must have been a great treat, and it was a great chance to hear the whole of 'Harold'.

I shall present my introductions here the first thing next week. I am truly grateful to have them.

> With much love to all,
>
> Ever yours affectionately AUBREY BEARDSLEY

1. On 18 May 1897.

MS OXFORD

To André Raffalovich
[23 May 1897]

S. Germain

My dearest Brother,

I am glad to say mother has been well enough to join me here. The weather is quite adorable now, and I was able to sit out quite early today. This morning I was in time for a 9 o'clock mass at S. Germain. It is such a nice church, and I see from one of the confessional boxes that a Jesuit Father hears confessions every Saturday there.

The little town is too sweet for words; so many charming old hotels with tablets on their gateways naming the great people who used to live there. There is a delightfully romantic one in the next street: 'Ancienne Résidence des Cardinaux Barberini et Letellier'. I find it great rest to be in such a small town, everything is so beautifully near to one; we have a choice of five or six places to feed at within a stone's throw of each other.

> With much love,
>
> Ever yours very affectionately AUBREY BEARDSLEY

MS PRINCETON

To Leonard Smithers
[*circa 23 May 1897*]

S. Germain

My dear Smithers,

Just a line to say I have sent off about thirty volumes to you; or rather my mother has. She tells me that they could not tell her at the hotel how much carriage would be; so she left it to be paid at the other end. A thousand apologies for troubling you, and do let me know at once what I owe you.

In haste,

Ever yours AUBREY BEARDSLEY

MS READING

To John Gray
[*Postmark 25 May 1897*]

S. Germain

My dear Gray,

I was so glad to get your letters. I am sending you by this post the portrait you are kind enough to ask me for.

S. Germain is resting me beautifully, it is such a blessing to have no distances to cover. My sickness upset me horribly, and I am only quite well again today, the recovery being helped greatly by the excellence of the food here. The cooking by the way is rather expensive. I am surprised to hear that the *Venus between Terminal Gods*[1] is for sale in the Royal Arcade. I did not know that Smithers had it.

All that I have yet seen from S. Germain, of Paris, is the Eiffel Tower and the Sacré Coeur; all between the two is lost in smoke or something. There is a charming fair going forward just outside our forest, such pretty theatres for Guignol and all sorts of fantoccini under the trees.

I am distressed to hear of your gouty touches, it is too cruel to have them under a boot. I am joined in kindest regards.

Ever yours AUBREY BEARDSLEY

1. Gallatin 861, one of the drawings Beardsley made in 1894–5 for *The Story of Venus and Tannhäuser*. In the iconography in *Fifty Drawings* it is catalogued as the property of H. Henry and Co.

MS HUNTINGTON

To Leonard Smithers
[*Postmark 25 May 1897*]

S. Germain

My dear Smithers,

I am extremely proud of this paper so I beg of you to make no more slighting references to it. Certainly I think the *Ali Baba* should be printed in gold. My Casanova is in six volumes with the imprint—

Bruxelles

Royez editeur

1887

It boasts on the title of being 'Edition originale la seule complete.' I wish you would tell if it is really anything like complete. I bought it in a hurry before I left Paris from Gateau. But then Gateau is a very honest man. He vowed that it contained more than Garnier's edition in eight volumes.

Are you still interested in Casanova?

Joined in kindest regards.

Ever yours A B.

The move and my mother's illness has played the deuce with me. But there [has] been no blood.

MS OXFORD

To André Raffalovich
Tuesday [*25 May 1897*]

S. Germain

My dearest Brother,

I have recovered thoroughly today from my little trouble. The 'terrace' is going to do great things for me. This afternoon the

creaking in my lung has left me owing to several hours spent in the open. The weather is warm enough now to let me sit down out of doors so I am able to prolong my outings indefinitely. Father Henri is the name of the Jesuit priest here, he is a dear cheerful old man, and the most friendly person imaginable. Father Coubé most kindly wrote to him about me, so we had the pleasure of a visit from him soon after we had arrived.

He asked me if I had completed my military service yet in England, and I felt quite ashamed to confess that we were not expected ever to do anything at all for our country.

Mabel writes to us that she will be in town on June 1st. I wonder when we shall see her here and what her plans will be.

Good-bye, dear André.

> With much love,
>
> Yours very affectionately AUBREY BEARDSLEY

MS HARVARD

To William Rothenstein
[Postmark 25 May 1897]

S. Germain

A line in haste to acknowledge your letter and enclosure. So many thanks. I will write to you in a day or so. The move has fatigued me horribly.

AB

MS OXFORD

To André Raffalovich
Friday [*28 May 1897*]

S. Germain

My dearest Brother,

So many thanks for your letter. I was wondering on St Philip's day[1] whether Father Sebastian Bowden was well enough to attend the Oratory Festival. I was quite forgetting that you have another

Father Sebastian. Is he not the painter? Fr Henri came to see us on the eve of Ascension. He is going to make me known to the Aumonier of the Pensionnat of St Thomas here, who will bring me the Blessed Sacrament whenever I communicate. The Pensionnat has a charming chapel attached to it where the mass is sung by the pensionnaires. Fr Henri is their confessor. I was surprised when he told me that the Jesuits had three houses in Paris besides the one in the Rue de Sèvres. Their house here is the maison de campagne for the Fathers of the Rue Madrid. I am going to see it some day next week.

Monsieur Bertrand[2] has been to see us, and has sent me a permission to work at the Château valable for one year. He is such a charming old gentleman.

I have been rather nervous and worried lately, living on thorns, but have made valiant attempts to get good out of S. Germain.

I am with much love,

Ever yours very affectionately AUBREY BEARDSLEY

1. 26 May. Ascension Day 1897 fell on 27 May.
2. Alexandre Bertrand, archaeologist, editor of the *Revue Archéologique* and curator of the museum at S. Germain-en-Laye, (1820–1902).

MS PRINCETON

To Leonard Smithers
[Postmark 28 May 1897]

S. Germain

My dear Smithers,

S. Germain commands a clear and easy view of the Eiffel Tower and the church at Montmartre. The journey in the train is about half an hour. I am awfully glad you will be over here again soon. You will find S. Germain delightful, unless you are tempted to spend the evening in it.

Casanova is perfectly stunning. Why don't you insert some pictures in some of your 400 copies?

My mother has been suffering from gastritis and has been really ill. I don't fancy she will ever be well as long as she is in France.

As for me I live rather on thorns and am worried out of my life.

Ever yours A B.

Yes, S. Lazare is the station.

MS PRINCETON

To Louis Octave Uzanne
31 May [*1897*]

S. Germain

Dear Monsieur Uzanne,

I shall look forward much to the pleasure of seeing you next Thursday. I wrote to Mr Smithers more than a week ago about the couverture,[1] and he promised to send you a proof as soon as possible. I have read *Thémidore*.[2] It is indeed a charming book, and I should have much pleasure in making an illustration for it.

I shall be glad to see the copy of *La bonne chanson*.[3] My mother joins me in kindest regards.

Yours most sincerely AUBREY BEARDSLEY

1. Of *Ali Baba*.
2. Beardsley did not illustrate this book by Uzanne.
3. By Verlaine, 1870.

MS OXFORD

To André Raffalovich
31 May [*1897*]

S. Germain

My dearest Brother,

I have put myself into the hands of a doctor here, of whom I have been hearing great things. He is a Dr Lamarre[1] and is said to be one of the most learned and skilful doctors in France.

A painful ulcer on my tongue suggested the visit, and naturally I took the opportunity of having so valuable an opinion on my more serious trouble at the same time. He says that with care there is not the faintest doubt of my entire recovery. He raised his hands in horror when he was told that I had spent a year at Bournemouth. Nothing, he exclaimed, could have been much worse for my case, unless it had been the South of France.

Mountain air is apparently what I require. He spoke very hopefully of my chances here, and told me of a number of cures effected

by forest air. The terrace he will not allow me to approach. He has ordered me to get up every morning at four o'clock and take two hours' airing in the Bois, then to come home, rest and sleep; and continue the promenades at my pleasure during the day. I am never to be out after five o'clock and am to retire to bed early in the evening. I begin the treatment tomorrow. Dr. Lamarre inspires the greatest confidence in me. He made a very thorough examination of my lungs. I certainly must have made great advances since I left England judging from the sounds his percussions produced.

I am writing this in such haste to be ready for the post.

We had a most charming visit from Father Henri on Saturday. You would be perfectly delighted with him, he is such a dear saintly old man. I am so glad there is a Jesuit here to hear confessions.

With much love,

Ever yours very affectionately AUBREY BEARDSLEY

1. Edouard Louvet Lamarre (1840–1924).

MS HUNTINGTON

To Leonard Smithers
[Postmark 31 May 1897]

S. Germain

My dear Smithers,

So many thanks for your letter and cheque. I live on thorns because I am more or less in the mortal funk of the pauper's life— and death. Would to God I had done even *one* piece of black and white work—transcendental or otherwise. Whilst my present filthy life goes on I shall do nothing. I look forward very much to my sister's return.

Do you want any erotic drawings? I hope you have found something pleasant out of your two typewriters.[1]

Ever A B

Did you by the way ever send back any bookcases to Bournemouth?

1. i.e. secretaries.

MS Oxford

To André Raffalovich
1 June [*1897*]

S. Germain

My dearest Brother,

I had this morning such a bad attack of blood spitting. I had really hoped with all the care I have been taking lately that the trouble might have been averted. Still I was not entirely surprised at the haemorrhage as my lungs have suffered a great deal from ominous crepitations the last two weeks. The bleeding has stopped this afternoon. Of course I feel perfectly wretched.

So many thanks for your letter. I shall be very glad to see Malcolm Drummond if he comes to Paris.

 With much love,
 Ever yours very affectionately AUBREY BEARDSLEY

MS Princeton

To H. C. J. Pollitt
Wednesday [*2 June 1897*]

S. Germain

My dear good friend,

Your charming note found me laid in bed with a new gush of blood. However today the bleeding has ceased and has left me less of a wreck than usual. Really I have improved in my poor health wondrously. I haven't done a stroke of work since I left England, save a couverture for *Ali Baba*. Of late my every hour has been spent with Casanova who is a great person and a great writer into the bargain. But you know him better than I do most probably. Would that I had strength to make some pictures for him. God only knows when I shall be able to work again.

I should like to have seen the Evans portraits,[1] but you were quite right not to send them if you ever wanted to see them again.

Juvenal is *not* on the index.

S. Germain is a sweet place with a lovely wood, in which my

doctor has ordered me to stroll from four to six every morning. I fear the treatment is going to complicate my life terribly. Still the woods at dawn will be surely adorable.

Ever AUBREY BEARDSLEY

1. Photographs of Pollitt.

MS OXFORD

To André Raffalovich
Wednesday [*2 June 1897*]

S. Germain

My dearest Brother,

I have had no return of haemorrhage today, and have been able to get out for a walk in the forest. Madame Bertrand has just been telling us what a good doctor M. Lamarre is. I expect I shall have to pay him a visit soon to get my wretched tongue cauterised. I believe the operation is however perfectly painless.

We had a wire from Mabel this morning announcing her safe arrival at Liverpool. Please forgive a short note. Quite amusing people are beginning to arrive in S. Germain and in the Pavillon Louis XIV.

By the way is Lecoffre of Rue Bonaparte a publisher and seller of religious books?

With much love and more thanks than I can say for all your kind prayers,

Ever yours very affectionately AUBREY BEARDSLEY

MS HUNTINGTON

To Leonard Smithers
[*Postmark 3 June 1897*]

S. Germain

My dear Smithers,

Many thanks for your packet of letters. I was busy all yesterday

evening writing cheques for all those bills. Such a weight off my mind! The doctor here, a certain M. Lamarre, who is learned, famous, and décoré, gives a very hopeful opinion of the state of my lungs, and says I can scarcely be called a consumptive at all. He says that with care I may be entirely cured of my weakness, and orders me to walk in the forest here from four to six every morning. I have not begun the treatment yet, as a few hours after I had left the Doctor I had a most violent attack of haemorrhage. However it has passed away quite quickly and has left me feeling rather better if anything. I was not surprised at being overtaken with it, as I have been worrying horribly lately and have consequently digested none of my food.

I liked Billy's portrait of me immensely, a very distinguished affair. Although my nose is not tip tilted yet at the same time it is. Hence my subtle beauty. We had a wire from Mabel yesterday announcing her safe arrival at Liverpool. My love, my tender love to Arthur.[1]

Yours ever A B.

1. Symons.

MS PRINCETON

To William Heinemann
Thursday [*3 June 1897*]

S. Germain

My dear Heinemann,

I do hope you will be able to find time to come over here to see me. It is only about half an hour in the train (from S. Lazare). Could you take lunch with us on *Sunday* morning at twelve o'clock?

I am just recovered from a severe outbreak of blood spitting.

Very sincerely yours AUBREY BEARDSLEY

If Sunday does not suit you please suggest some other day.

I don't know how long you are staying in Paris.

MS Oxford

To André Raffalovich
Friday [*4 June 1897*]

S. Germain

My dearest Brother,

Mabel's arrival this morning was such a great surprise and such a great pleasure for me. I think she looks wonderfully well considering all her voyaging; and not changed at all since I saw her last. Only occasional touches of an accent which I am sure she has acquired *since* she left America.

I hear you have Father Gates staying with you. Your visit with him to the New Gallery[1] must have been most charming and instructive. It was a delightful idea of Master Oswald to head his list of wants with the Ignatian motto.[2] How does he prosper at St Mary's? He is becoming I suppose quite a latinist. My dear André, I have it so much on my mind, that I have not yet written to Father Bampton, but I was frightened of bothering him with a letter about myself.

I am quite recovered from my attack, and really feel better now than I did before it occurred. I was living rather in dread of it for the last two or three weeks. I was so sorry to hear of Miss Gribbell's illness and hope she has now nothing to fear. Tomorrow dear Père Henri comes to see us. I am so anxious for Mabel to meet him.

I am always so glad to get your letters; so many thanks for your last note. Best love from all to all.

Yours with much love,
Very affectionately AUBREY BEARDSLEY

1. Summer exhibition of work by living artists.
2. Ad majorem Dei gloriam.

MS Oxford

To André Raffalovich
Sunday [*6 June 1897*]

S. Germain

My dearest Brother,

I wish I always felt as well as I do today. Mabel is quite amazed at my improvement. Dr Lamarre came to see me yesterday and found

my tongue much better, so the painless operation is not to be performed. He says my crachement has relieved me very much and he was most pleased with my general condition. Father Henri had just been to confess me, and had been so kind and encouraging, so I had two different causes to make me full of hope and gratitude.

This morning I communicated with Mabel at the Chapelle of the Pensionnat S. Thomas. It is such a dear little church, and the Mass was sung by the Pensionnaires really very well. The sisters are quite charming and looked after us so kindly. You can imagine how happy the service made both of us. I shall always attend S. Thomas' Chapel in future. The aumonier seems very nice, I believe he is coming to see us. He preached a short sermon this morning with a great deal of style and unction.

Whit Sunday has filled the garden here with breakfasters, and the place looked so gay and pretty, the weather being quite adorable. I hardly ever go into the town but spend my time under the alleys, and amongst the rose trees of the Pavillon. It's so jolly having Mabel here. She has made great friends with the dear Père Henri.

Good-bye, dear André, we all join in best love to all and hope Miss Gribbell is now quite well.

> With much love,
> Yours always very affectionately AUBREY BEARDSLEY

MS HUNTINGTON

To Leonard Smithers
[Postmark 8 June 1897]

S. Germain

My dear Smithers,

Just a line. My grand attack of bleeding has done me a lot of good. The Doctor has taken a most hopeful view of me and says I am quite curable. He advises Monte Carlo for the winter on account of its gaiety. Such weather and such food here. I feel A 1.

> Ever yours and joined in kindest regards AUBREY BEARDSLEY

MS OXFORD

To André Raffalovich
Friday [*11 June 1897*]

S. Germain

My dearest Brother,
 I was so glad to get your letter. Dear Mabel leaves us today. I
hope she will give you a good account of me. How much I should
have liked to have been present at the meeting of Arthur Symons and
Father Sebastian Gates. Symons has I suppose returned with an olive
tint from Italy and has written I am sure more sonnets than is good
for him.
 I am most interested to hear of Raymond Roze's reception by
Fr Bampton. He will make a good Catholic.
 I am just going to begin *Evan Harrington*[1] and expect a great
treat. Do you know the *Mercure* is going to publish a thing of Mere-
dith's—the 'Essay on Comedy'—translated by Davray,[2] who is meditat-
ing also a version of one of the novels. I shall look forward very
much to John Gray's story in the *Revue Blanche*.[3]
 The weather is rather cold here just now, still I have not suffered,
and am able to be out of doors quite a lot.
 I am with much love,
 Always yours very affectionately AUBREY BEARDSLEY

1. By Meredith, 1861.
2. September–October 1897. Davray did not translate any of Meredith's
 novels.
3. 'Daphné', in the issue for 15 June 1897.

MS HUNTINGTON

To Leonard Smithers
[*Postmark 11 June 1897*]

S. Germain

My dear Smithers,
 Thanks for your letter. I still continue to be fairly well but also
still continue to be hugely depressed. I would forgive this abject sort

of life if I only made rapid progress towards recovery, but to go on month after month unable to turn my hand to anything is quite loathsome. Yes the cooking here is decidedly superior, quite as good as you would get at a first class restaurant in Paris.

Do you know if Trübner has published yet Volume 5 of Wagner's prose works?[1] My sister has been and gone. I suppose she will have seen you by this. Why does not the Queen stop at the Royal Arcade on the 22nd to receive congratulations and a privately printed copy of something or other.[2]

By the way I see they are playing *Tristan and Isolde*[3] in town now; you ought to go.

With best wishes,

Ever yours AUBREY BEARDSLEY

1. *Actors and Singers.* The title-page is dated 1896 but the preface is dated January 1897.
2. Queen Victoria's Diamond Jubilee was celebrated on 22 June 1897. The royal procession from Buckingham Palace to St Paul's passed along Piccadilly.
3. On 14 June.

MS READING

To John Gray
12 June [*1897*]

S. Germain

My dear Gray,

I have found that I sleep better between four and six in the morning than at any other time, so I have had to rearrange Doctor Lamarre's programme. I found that rumours of my early walks had reached my barber this morning, and all present, including M. Bertrand, congratulated me warmly on having stayed in bed. Doctor Lamarre however, declares that my room is quite near enough to the forest to allow my opened window to give all the morning air I need.

When does the story appear in the *Revue Blanche*? I look forward to it with the greatest interest and am so curious to know what you have written that is going to shock me. Of course I should like, more than I can say, to do something for your conte, if you will allow me.[1]

Paris is taking a long time to find its way to S. Germain, which leaves me the garden and sitting-room to myself.

The forest too is quite my private territory.

So many thanks for your letter.

With best love,

Ever yours AUBREY BEARDSLEY

Mother sends her kindest regards.

1. Beardsley did not illustrate 'Daphné'.

MS OXFORD

To André Raffalovich
13 June [*1897*]

S. Germain

My dearest Brother,

Mabel has left such splendid weather behind her. This morning I was at the dear chapel of S. Thomas and after I spent a pleasant retreat in the forest. I hear that somewhere amongst the trees is the shrine of Notre Dame des Anglais. I mean to make a pilgrimage to it tomorrow.

Dr Lamarre came to see me yesterday and was most encouraging. He says my improvement in the week past is wonderful. My silly tongue progresses not so well. I dread having it cauterized as that will put me upon uninteresting food for several days.

Father Henri paid us a little visit the same afternoon and gave us such an amusing account of the last suppression of the order in France,[1] and the ruses to which they had recourse to keep themselves together. The dear Father seems to have been very hospitable just then, and to have invited whole houses of Jesuits to his bed and board as 'friends'.

I wonder if you have found the opera amusing this season, and the theatres.

With much love,

Ever yours very affectionately AUBREY BEARDSLEY

1. In 1880 the Jesuit houses in France were closed and the schools secularized.

MS PRINCETON

To Louis Octave Uzanne
15 June [*1897*]

S. Germain

Dear Monsieur Uzanne,

I am so sorry that after all I am not to illustrate *Thémidore,* and it is with much regret that I return you the charming conte. It might have made such a pretty volume.

I hope that you have had a most pleasant stay in London.

Looking forward very much to the pleasure of seeing you again whenever you are at S. Germain.

I am very sincerely yours AUBREY BEARDSLEY

My mother joins me in kindest regards.

MS OXFORD

To André Raffalovich
16 June [*1897*]

S. Germain

My dearest Brother,

I was so glad to hear of dear Father Sebastian Bowden being back at the Oratory. A penitent of one of the Oratorians (Fr Philpin) is staying here just now. The penitent is a Spaniard and speaks with great enthusiasm of the Catholic Churches in London.

I am finding the forest a splendid umbrella in this hot weather. The page boy here carries my chair to some charming shady spot every morning and calls for me again at lunch time. Everyone in the hotel notices how much I have improved in the last few days. The Bertrands I am sure look on me as an utter fraud.

How amusing the Fisher[1] concert must have been; and Mrs Bernard Beere reciting the *Portrait!*[2] How glad Mabel must be to be back in London again. I am longing to hear of her theatrical plans. Was Father Chew at Bournemouth as lately as last year? I don't recollect hearing of his name.

Thank you so much, dear André, for your letter.

With best love from us to all.

Ever yours very affectionately AUBREY BEARDSLEY

1. A slip for Richter, who conducted the Wagner concert at the Queen's Hall on 14 June.
2. Poem by Owen Meredith (pseudonym of 1st Earl of Lytton, 1831–91).

MS PRINCETON

To Mabel Beardsley
[*17 June 1897*]

S. Germain

Dearest Mabel,

So glad to get a letter of you. Pau I know nothing of but no doubt it is charming and suitable. I wondered if any place in Germany would be good for the autumn. However there is plenty of time. We had such a delicious drive this afternoon in Marli Forest. Very much more wonderful and pretty than the wood here. The drive has done me a lot of good.

I saw the advertisement of the Fisher concert in the *Telegraph* and wondered what it would be like.

Cochran has written me to day to thank me for the photo. He tells me he has definitely broken with Mansfield, and says many charming things about yourself.

I and mother are going to take German lessons here, by way of doing something. I of course shall always be at the bottom of the class. *Don't* by the way tell Raf of the lessons.

So glad you will be able to come over here again.

Ever loving AUBREY

I am longing to hear about *your* plans.

MS OXFORD

To André Raffalovich
18 June [*1897*]

S. Germain

My dearest Brother,

Such an unpleasant change in the weather. I wander about the

house all day in an overcoat and still know that it is cold.

Were you at the Oratory yesterday? Do they not have a very beautiful service in their garden for Corpus Christi?

I have just taken my first lesson in German, and have mastered with great difficulty and repugnance the written German character.

The Professor is a recommendation of Madame Bertrand's and comes three times a week for an hour. I long to struggle through a book, and have ordered a *Werther*[1] in German and French. I shall look to you, dear André, for some hints about the study of German. Another fortnight will I suppose find you at Weybridge not too wearied I hope after all the fin de juin tumult.

Goodbye and with much love.

Ever yours very affectionately AUBREY BEARDSLEY

1. By Goethe, 1774.

MS OXFORD

To André Raffalovich
19 June [*1897*]

S. Germain

My dearest Brother,

I hope this will reach you on the morning of the Feast of S. Aloysius,[1] and I pray of you to remember me in your devotions to him.

Thank you so much for your kind letter. These fearful outbursts of bad weather have tired me very much; still I am well enough to have surprised Père Henri who has just been to see me, and who expected to find me seriously unwell after these violent storms.

We don't know of any English people at S. Germain. Dr Lamarre says that there used to be quite a large English colony here, but that it has now quite disappeared.

Paris sends me friends occasionally. On Thursday an introduction of Will Rothenstein's lunched with us. He turned out to be pleasant and amusing; I wished he had been staying longer here. One certainly does feel rather isolated sometimes.

I find it very difficult to get books here, and one is not always able to give a sufficiently exact description of a book to write to Paris

booksellers for it. I should be very grateful to you, dear André, if you could tell me of some good life or study of S. Mary Magdalen.

Le Père Henri has just spoken to me of one by Lacordaire,[2] but does not know where I could get it. On Sunday the dear Father takes me to the Chapel of the Carmelite Convent, and will find for me some special prayers for S.M.M. You know the Carmelites have a great devotion for her.

> With much love,
>
> Ever yours very affectionately AUBREY BEARDSLEY

I hope the blue glass does not depress you.

1. 21 June.
2. Published in 1860.

MS OXFORD

To André Raffalovich
24 [*June 1897*]

S. Germain

My dearest Brother,

So many thanks for your letter. Mother has been wanting to write to Dr Phillips for some time to ask him one or two questions about me, but I would not let her as I felt shy about worrying him. Also the very uncertain and variable condition of my health lately would make any report rather misleading. However it is most kind of you to suggest a letter to Dr Phillips, and we shall both feel it a great privilege to have his most valuable advice.

After all Père Henri was able to find me two or three very interesting lives of S. Mary Magdalen, one, rather short, by Lacordaire, another quite a big volume by the Jesuit Father Valuy.[1] The Carmelite devotions I have not yet got as they only exist here in handwriting.

A spell of such hot weather as we are having now should really nurse me into something less feeble and useless; anyhow fill me up a little.

How splendid the Nuntio's Mass must have [been].[2] I saw that Cardinal Vaughan was holding a reception. A great gathering I suppose of notable Catholics.

Good-bye, dear André,
 With best love from us to all,
 Ever yours very affectionately AUBREY BEARDSLEY

1. Published in 1867.
2. In the course of the Jubilee celebrations in Westminster Cathedral
on 20 June.

MS OXFORD

To André Raffalovich
30 June [*1897*]

 S. Germain

My dearest Brother,
 I was so glad to get your little note written so kindly in the midst
of all your packing worries and fatigues.
 I had a letter from Malcolm Drummond the other day telling me
that he and his mother were staying in Paris. They will be lunching
with us tomorrow and I look forward very much to their visit. The
great heat here has turned to storms. Last night we had a succession
of them, and I was not very surprised this morning to find that blood
had oozed a little in the night. My nights trouble me dreadfully
nowadays.
 The German goes on slowly. The grammar is quite inaccessible,
however I begin to read a little.
 Carmel has sent me some beautiful devotions through le Père
Henri, who comes in often to see me and cheers me so much.
 I suppose your next letter will give me your address at Wey-
bridge. I do hope you are going to have the most charming holidays
there.
 With much love,
 Ever yours very affectionately AUBREY BEARDSLEY
Mother joins me in best love to all.

MS Oxford

To André Raffalovich
30 June [*1897*]

S. Germain

My dearest Brother,

A line in haste. I cannot help feeling that a letter of Mother's to Dr Phillips and one of mine to yourself (posted on Thursday evening) have miscarried in the post.

Mabel wires to us this afternoon that Dr Phillips has *not* received his. It would be so good of you, dear André, to wire if there has been any mistake.

Very affectionately yours AUBREY BEARDSLEY
Dr Phillips' letter was addressed to 13 John Street, Mayfair.

MS Oxford

To André Raffalovich
2 July [*1897*]

S. Germain

My dearest Brother,

I will take Dr Prendergast's advice at once. This afternoon we go into Paris, and tomorrow morning will see Dr Prendergast. I feel nervous about making the journey twice in one day. I will let you know what he says at once. Your idea of a little change at the sea is quite charming. I seem to feel the want of a bracing air. What a nuisance about Dr Phillips. I was quite upset about it. Mother wrote again yesterday, and I pray that the postal fates have been more kind this time.

How interesting your day must have been at Netley; I never imagined that it was near Southampton. Surely you must have been dreadfully tired.

After all the Drummonds could not lunch on Wednesday. We may see them this afternoon. Mrs Drummond wrote to me that they thought of spending a few days *here* next week, and I am hoping that they will stop at *this* Pavillon.

Yesterday I saw le Père Coubé. I thought it so very kind of him to come and see me. He is going to send me a copy of one of his sermons. He asked much after you. I feel so shy, dear André, of speaking about money, and am so touched at your asking me to do so. I have already spent a little more than half of your last kind present. Expenses here have on the whole been less than they were in Paris. Your promise of further help leaves me too grateful to thank you properly.

How good you are to me, dear André, a brother in fact out of a fairy tale. I really feel more anxious to get well for your sake than for my own.

 Good-bye,

 Ever yours very affectionately AUBREY BEARDSLEY

MS OXFORD

To André Raffalovich
4 July 1897

 The Normandy Hotel, Paris

My dearest Brother,

 Dr Prendergast has just been to see me and has made a very prolonged examination of my lungs. He finds the right in very fair working order, but the left has consolidated generally. He took much the same view of my case as Dr Phillips, but of course as this is the first time he has seen me he could not tell whether I am better or worse than I was when I first came to France. As we thought, my liver has been a great deal the cause of my weakness and depression. It is considerably enlarged. Dr Prendergast thinks that I should be in a more bracing air so that I could take plenty of exercise, without being fatigued, and suggests Trouville as being the nearest and best place for the purpose. We had suggested Boulogne but he thought it unsuitable, and with regard to Dinard and places in that part of the coast, he said they would be too expensive for me. We discussed a little about winter resorts. He does not advise mountain districts, but says that Egypt could not fail to be of the very greatest advantage to me. What do you think of Trouville? I see it is near Havre, and have just got a little guide book which tells me that we shall be able to find moderate hotels.

Yesterday we went to see the Drummonds. They are such charming people. They are coming to see us today and will perhaps go back to S. Germain with us tomorrow. I think they are going to spend a few days at the Pavillon Louis XIV. I shall be so glad to see more of Master Malcolm. I suppose you know that Mrs Drummond is also a Catholic. I assisted at a very beautifully sung Mass at S. Roch this morning.

> With much love,
> Ever yours very affectionately AUBREY BEARDSLEY

MS OXFORD

To André Raffalovich
6 July [*1897*]

S. Germain

My dearest Brother,

Mother saw Dr Prendergast again on Sunday and he reassured her once more as to my chances of improvement in good climates. As to our imminent move, he gave us a great choice of places. Havre, Trouville and Dieppe seemed to be the most suitable. There is something in favour of each.

On the whole perhaps Dieppe would be the wisest choice, as it is not *too* fashionable, and I know from experience that it is amusing and inexpensive. I am a little frightened of Trouville.

The Drummonds come to stay here on Wednesday. I do hope you are going to have nice weather. I am so glad you are finding the country pleasant and restful. I hear you have a camera amongst you; who is the photographer? I shall look forward to seeing you all in miniature and Kingswood from every point of view. Please give my very best remembrances to Cecil Dayer.[1] I hope I am to have the good chance of renewing his acquaintance some day.

Thank you so much for your most kind letter.

> With much love,
> Ever yours very affectionately AUBREY BEARDSLEY

1. Not identified.

To Leonard Smithers[1]
[*circa 8 July 1897*]

S. Germain

My dear Smithers,

I am leaving early on Saturday. Shall probably go to Dieppe. As soon as I know my new address I will send it you. I have not been at all well here.

Best wishes,

Your AUBREY BEARDSLEY

1. Translated from *Briefe Kalendernotizen.*

MS OXFORD

To André Raffalovich
12 July [*1897*]

Hôtel Sandwich, Rue Halle au Blé, Dieppe

My dearest Brother,

We had such dreadful difficulty in coming here by the train of our choice. We had chosen the ten o'clock from S. Lazare, but had no sooner put our hand bags in our carriage than we were told by the Chef de la Gare that we could not possibly be allowed to travel by that train as we were not going on to London. It was only about a minute before the train started that we prevailed on the authorities to break the rule in our favour. Even then we had to leave all the serious luggage behind to be sent on by a later train.

There was quite a scene about it all, but as the next train to Dieppe took nearly seven hours to arrive we stuck to our decision with overwhelming obstinacy. I stood the journey wonderfully well. I am so thankful that we found splendid weather here to greet us. Today again the sun is all powerful and there is such a lovely fresh breeze.

The Drummonds came down to S. Germain on Wednesday. They were enchanted with the place and will be staying there some little time. It was so pleasant for us to have them staying at our Pavillon.

They are such charming people. I was very glad to see more of Malcolm Drummond, he is a really nice fellow.

I am looking rather ill nowadays but am feeling rather better just now than I have been for some time.

Good-bye, dear André.

With much love,

Ever yours very affectionately AUBREY BEARDSLEY

MS OXFORD

To André Raffalovich
[13 July 1897]

Hôtel Sandwich, Dieppe

My dearest Brother,

I was so pleased to get your letter forwarded on to me from the Louis XIV. I hurried away from Paris this time as the weather was so hot and oppressive. Here we are having splendid luck, gentle winds and a constant sun. I get out about half-past eight and have my little breakfast at the Café. It is such a luxury to get the morning air, and quite a new one for me nowadays. In the afternoon I stay at home, and read and write and rest. My room here is really a fine one, the largest I think I have ever slept in, and it also makes a very pleasant sitting-room. I find myself leading almost precisely the same life as I did here two years back, doing the same things at the same time; so the past keeps me a sort of cheerful company.

Dear old Father MacDaniel! I know he is amusing. Mrs Drummond had a great deal to tell me about him.

I and Mother were so grieved to say goodbye to Père Henri. You can't think how perfectly sweet and kind he was all the time we were at S. Germain.

Thursby's attempted suicide must make a stirring group.[1]

With much love. Please thank Cecil Dayer for his kind remembrances and please give him mine.

Good-bye, dear André, with much love.

Always yours very affectionately AUBREY BEARDSLEY

I wonder if you can tell me where I could find some good study of Wolfram von Eschenbach's work?

1. A scene in a play (Gray's note), probably *Broken Fetters* (see p. 350).

MS Oxford

To André Raffalovich
Wednesday [*14 July 1897*]

Hôtel Sandwich, Dieppe

My dearest Brother,

The wire to the Normandy never reached us, as we were staying at the Terminus Hôtel (on account of its nearness to S. Lazare). How jolly it is about Mabel's engagement at the Criterion.[1] Such a good thing for her in every way, especially as relieving her from the fatigues and worries of a tour. Surely she must be in great spirits about it. I wonder if she will be able to come over to Dieppe some weekend.

The weather seems to set fair here, and I ought to prosper. I am beginning to take a tonic Dr Phillips has prescribed, and I am sure it is going to do me a great deal of good. I am so grateful for his advice, and the wonderfully kind interest he has taken in my case.

The Proprietress has just been up to ask Mother to decipher a letter in English which the old lady supposed must be an inquiry for rooms at the Hôtel. We were amused to find that the letter was one of Mabel's for us, but oddly enough the name on the envelope spelt 'Windling' quite as well as 'Beardsley'. Our landlady has left the letter with us, with apologies for having opened it, but with ill-disguised doubts as to our right to possess it.

I think, dear André, if you could send your very very kind present in a note for £10 and a cheque for the rest I should be able to deal with it more easily than in any other way. Thank you again and again for all your marvellous and affectionate concern for my welfare but know that your kindness quite outstrips the chance that my poor words may have to express my thankfulness fully.

With much love,

Always your very affectionate AUBREY BEARDSLEY

1. Mabel Beardsley appeared in *Four Little Girls* by W. S. Craven, which opened at the Criterion Theatre on 17 July 1897.

MS Princeton

To Henry Davray
[*circa 15 July 1897*]

Hôtel Sandwich, Dieppe

My dear Davray,
 I hope by this time all your worries of déménagement are over. Change of residence is I know one of the most painful ordeals in this life.
 Dieppe is adorable just now, such splendid weather. I believe that I am going to flourish here. S. Germain was too dull and wretched for mortal to stay more than twenty-four hours in.
 I was charmed to receive such kind messages from M. Mallarmé.[1] If you think he would care for it I would send him a large-paper copy of my album. You might let me know. I do not, by the way, know his address.
 Is there any chance of your being in Dieppe this summer? It would give us much pleasure if you were able to. With kindest regards from us both.
 Always yours AUBREY BEARDSLEY

1. There is no evidence that Beardsley met Stéphane Mallarmé (1842–98).

To Leonard Smithers[1]
[*circa 15 July 1897*]

Hôtel Sandwich, Dieppe

My dear Smithers,
 Amongst my books you will find a cheap edition of Chapman's *Iliad* (Morley's Library). Send me the book—and I'll bless you.
 The weather is divine here.
 A.B.

1. Translated from *Briefe Kalendernotizen*.

MS OXFORD

To André Raffalovich
Monday [*19 July 1897*]

Hôtel Sandwich, Dieppe

My dearest Brother,

I received your very kind and sympathetic letter yesterday, and had begun to acknowledge it immediately, when I was carried off by a sudden invitation to the Saint-Saëns Festival[1] here and a dinner at Fritz Thaulow's,[2] so had not a moment. Your touchingly generous present I will make use of as wisely as possible, and always with the affectionate remembrance of the giver. My week's bill has just been presented me and is most moderate. Of course it does not quite represent a week's expenses here, as there are always unavoidable little leakages of money outside the hotel.

I dare not say much of my improvement in health at Dieppe, for my returns to strength, alas, seem too often to be only the preludes to fresh troubles. Still last night I could not help being hopeful as well as grateful for the really wonderful way in which I had borne a very tiring day that might well have fatigued much stronger people than myself. It was past eleven when I left Thaulow's. I came home on foot (about ten minutes' walk) and afterwards slept soundly and without any discomfort. Today too I am feeling well.

Father Henri anticipated that I might find some difficulty in choosing a director here, and gave me a word of warning at the same time. Jesuits come here occasionally to preach but there are none in residence. The other orders are also unrepresented. For the moment L'Abbé Georget of S. Rémy will be the successor of the good Père Henri.

In a week or ten days I am going to visit a scholastic house near Dieppe, the aumonier of which I have heard is a most saintly and beautiful character. The school is kept by a layman to whom I am to have an introduction quite soon. From all I have been told I hope to find at the 'school' some very sympathetic friends, a devout counsellor, and a place of retreat. I will tell you a lot more about this soon.

The constant presence of the Blessed Sacrament in the church is indeed the greatest of all privileges, and even the least advanced in the spiritual life find in their devotions before the Blessed Sacrament an extraordinary joy and content.

Good-bye, dear André, and with the greatest love and gratitude,
Yours always most affectionately AUBREY BEARDSLEY

1. Concert held on 18 July followed by an official luncheon in honour
of the composer.
2. Norwegian landscape painter (1847–1906) living in Dieppe.

MS OXFORD

To André Raffalovich
22 July [*1897*]

Hôtel Sandwich, Dieppe

My dearest Brother,
 I was so delighted to hear from Mabel this morning that all has
gone very well with her at the Criterion. I do hope that the pieces
will have a good run. How hard she must have been worked lately,
with her part too to study for Cartwright's matinée.[1]
 I am grateful to say that I still walk and sleep very well and am
beginning to eat better. The weather has not been however lately
all that is best for me. I think I am likely to be alone here for a few
days as Mother may have to pay a visit to England. Her mother is
seriously [ill] at Brighton. Père Henri wrote to us today, he was won-
dering what had become of the Drummonds. I suppose they left
S. Germain almost immediately after us.
 I read in the paper of extreme heat in London. I do hope you
have not suffered from it at Weybridge. I hope too you have quite
recovered from all your town season's fatigues and are really feeling
very well.
 With much love,
 Ever your very affectionate AUBREY BEARDSLEY
The bank has sent me ten pounds. Thank you so very much in-
deed, it was so sweet and good of you to send the money in two
amounts. Again most heartfelt thanks.

1. Charles Cartwright (1855–1916), the producer of *Four Little Girls*,
directed a Catholic Charity Matinée performance of *Broken Fetters*
by Charles Thursby at St George's Hall on 22 July 1897. Mabel
Beardsley and Thursby took the leading parts. Thursby had previously
appeared in *The Blackmailers* by Gray and Raffalovich, 1894.

MS HUNTINGTON

To Leonard Smithers
[Postmark 22 July 1897]

Hôtel Sandwich, Dieppe

My dear Smithers,

A room will be ready for you here on Saturday. So glad you are coming over.

Room 5 *francs* per day.

Pension per head 5½ *francs not* including petit déjeuner which is 75 cents.

Hope you will have a sunny crossing.

So many thanks for Homer and *Parsifal*.

Ever A B

MS OXFORD

To André Raffalovich
26 July *[1897]*

Hôtel Sandwich, Dieppe

My dearest Brother,

So many thanks for your letter. Yes, certainly I received the cheque for £90. My letter of the 19th was in acknowledgement, but how stupid of me if I did not make it clear that it had arrived safely. I am wondering in what foolish and ill-written sentences I must have said 'thank you.' Do forgive me.

Mother will not be leaving me unless the call to Brighton is *very* urgent. Of course I should be a little nervous by myself, though I am grateful to say just now I feel no cause to be apprehensive.

My first confession to Abbé Georget has made me regret more than ever the loss of Père Henri's kindness and beautiful advice. The two churches here, S. Rémy and S. Jacques, are magnificent to look at but I fear neither very well served or attended. What good news about Mabel. I am full of joy and gratitude.

It is just possible I may be leaving this hôtel at once. I will wire you immediately any change of address. Some rather unpleasant people come here.[1] For other reasons too I fear some undesirable

complications may arise if I stay. However I am still uncertain.

Mother has just returned from a search for new quarters, and I am going round with her in a moment to see some rooms which she has looked at and finds prettily situated and comfortable. The Hôtels have let all their best places by now, so the move has been made a little difficult. Good-bye, dear André, with the greatest affection.

AUBREY BEARDSLEY

I look forward so much to the photographs.

1. Almost certainly Wilde, who was living at Berneval-sur-Mer near Dieppe. Beardsley saw him on 24 July. On the 26th Wilde wrote to Ross: 'I saw Aubrey in Dieppe on Saturday; he was looking well and in good spirits. I hope he is coming out here tomorrow to dine.'

On 3 August he wrote to Reginald Turner: 'I have made Aubrey buy a hat more silver than silver. He is quite wonderful in it.'

These letters cast some doubt on the general belief that Beardsley avoided Wilde, though he was at pains to let Raffalovich think he was doing so.

MS BODLEY

To John Lane
Thursday [*Postmark 29 July 1897*]

Hôtel Sandwich, Dieppe

My dear Lane,

I have just heard from Mabel telling me that you are engaged to be married.[1] Please accept my heartiest congratulations and best wishes.

I had hoped to stay here all the summer, but I find the sea air terribly trying. At the end of this week I shall move to Paris, and then into winter quarters as soon as possible.

Ever yours AUBREY BEARDSLEY

1. Lane had become engaged to Annie King. They were married in 1898.

MS HUNTINGTON

To Leonard Smithers
Thursday [*? 29 July 1897*]

Hôtel Sandwich, Dieppe

My dear Smithers,
 1000 thanks for the cheque.
 Initial T will be sumptuous.[1]
 The move from here seems impossible. Every place is full up now. I am to spend the winter in Paris.

Ever A B

1. For *Mademoiselle de Maupin*. Beardsley's drawing *D'Albert* (Gallatin 1085) was originally made as the ornament to this initial.

MS OXFORD

To André Raffalovich
Friday [*30 July 1897*]

Hôtel Sandwich, Dieppe

My dearest Brother,
 As you will see our attempts at a removal have proved fruitless. Mother is leaving for London by the afternoon boat today. I shall not be left quite alone as Mrs Smithers is staying in the Hôtel and will be able to look after me if I fall ill. The weather is gradually improving, and I don't fear any immediate disaster.
 What a charming photograph John Gray sent me; please tell him that I am writing to him.
 Mother will call on Doctor Phillips if he is still in town. She is writing to you.
 With best love from us to all.

Ever most affectionately AUBREY BEARDSLEY

MS Oxford

To André Raffalovich
2 August [*1897*]

Hôtel Sandwich, Dieppe

My dearest Brother,
 Thank you so many times for your very kind and thoughtful letter. I am really getting much stronger and am in perfectly good spirits. I am able to work too, and that keeps me employed the best part of the day. Some agreeable friends are staying here so I am not without company. The unpleasant people come and *go*.
 I should much like Mabel to come over when she has time to spare. Still I am afraid she would get dreadfully bored with me and my ways. Dear Mother I know has been sadly tried these last few months. But Mabel will tell you how impossible I am to get on with. And what can *you* think of me with all my constant grumblings and changes of mind.
 I was expecting a letter from Mother by this morning's post but none has arrived. I had a wire from her on Saturday. I think she must have seen Dr Phillips.
 The weather here is not brilliant just now, but still quite possible for me.
 I do hope you are very well and that your London journeys did not tire you too much. With the utmost gratitude for all your sweet patience and brotherliness.
 Very affectionately AUBREY BEARDSLEY
 Best love to all.

MS Princeton

To H. C. J. Pollitt
[*Postmark 2 August 1897*]

Hôtel Sandwich, Dieppe

My dear good Friend,
 Yes *do* come over here some time soon. I am in vastly better spirits and at work. *Mdlle de Maupin* is the book and is to be printed

in French and eight monthly parts! You may offer up any number
of prayers for the completion of the pictures.

Ever AB.

MS PRINCETON

To H. C. J. Pollitt
[*Postmark 8 August 1897*]

Hôtel Sandwich, Dieppe

Dear wonderful person,

I cannot thank you enough for the photographs. Quite splendid
they were. I am enchanted to have them. When do you arrive on
this side?

Mdlle de Maupin occupies my spirit enormously.

I was delighted to get your letter.

Ever AUBREY

MS OXFORD

To André Raffalovich
Wednesday [*11 August 1897*]

Hôtel Sandwich, Dieppe

My dearest Brother,

I am so unhappy to have had no letter from you. I do hope you
are quite well. I have begun such a number of letters to you since
I wrote last, but strove in vain to make anything more than two
or three lines out of my uneventful life. I have enjoyed a wonderful
stretch of good health, wonderful enough to make me tremble at
moments. Sudden changes in the weather I notice much less than
formerly.

I think Mother will be coming back tomorrow, and Mabel speaks
of the chance of her being able to cross over on Sunday week. It will
be a great pleasure for me to see her again. They both tell me that
London has been the most horrid place imaginable these last few
weeks. I wish Mabel could have spent the rest of the summer with

me here. She must want a really good holiday. I have heard nothing about the new piece at the Criterion.[1]

Do you know Vincent O'Sullivan, a young Catholic writer? He is staying here just now. I had a letter a while ago from Malcolm Drummond who was staying somewhere in Switzerland.

Looking forward very much to a letter from you, dear André.

Ever very affectionately AUBREY BEARDSLEY

Best love to all.

1. *Four Little Girls* closed on 7 August. Mabel Beardsley was not in *The Sleeping Partner*, which opened at the Criterion a week later.

MS OXFORD

To André Raffalovich
[15–16 August 1897]

Hôtel Sandwich, Dieppe

My dearest Brother,

Thank you many times for your kind letter. I was so very grieved at what you tell me of your suffering from fatigue and sad spirits. How I wish I could see you sometimes and have some charming talks. I am sure you would think I have improved a little lately. I feel stronger in many ways.

I was so interested in the criticism of the *Journal of Mental Science*.[1]

Mother came back on Thursday. We spend a great deal of time discussing our winter quarters in Paris. I am all impatience to get there. We have heard of a good hotel in the Avenue d'Antin. However Mother will go to Paris first and make arrangements.

I expect Mabel will spend a week with us soon. The dear child seems to be tired dreadfully with rehearsals at Camberwell.[2] I do hope she is looking well.

Mass was beautiful this morning at S. Rémy. My first celebration of the feast of the Assumption.

Monday.

I have just had a line from Dr Phillips; he tells me that he is going to spend some of his holidays here.

You must not think, dear André, of writing to me when you are tired. I feel so ashamed of myself for having begun my last letter to you so importunately and ungratefully. What could you have thought of me. Do forgive me. You must never trouble either to write me long letters, just a line from you sometimes will always give me so much pleasure and encouragement.

I can't bear to think of you tiring yourself with letter writing. I feel sure you do not spare yourself half enough. I am so glad you find Weybridge restful and peaceful. What charming evenings!

 With the greatest affection AUBREY BEARDSLEY

How awfully good of Gray to promise me some more photos. I don't deserve them. I have not even said 'thank you' for the last.

1. A long and largely favourable review of *Uranisme et Unisexualité* in the issue for July 1897.
2. Where *Four Little Girls* opened on 16 August at the Metropole, Denmark Hill.

MS HUNTINGTON

To Leonard Smithers
[*circa 16 August 1897*]

 Hôtel Sandwich, Dieppe

My dear Smithers,
 The cover[1] will be very pretty!
 I think you will like it.
 I do wish you would send me George Moore's address. I supposed you might have it on your books.
 I hear you may be going to Paris next week. I fancy I shall be there too.

 Ever A B

1. For *The Houses of Sin,* by Vincent O'Sullivan (1897).

MS OXFORD

To André Raffalovich
Wednesday [*18 August 1897*]

Hôtel Sandwich, Dieppe

My dearest Brother,

Thank you very much indeed for your letter. Of course I should send Mabel her ticket, dear child I didn't think she much wanted to come, so I never pressed the invitation. I have sent her today a little cheque. So many thanks, dear André, for writing to me about this.

I am overjoyed that you think Paris a satisfactory winter city. I am more pleased with the plan than I can say. I have written a little note to Dr Phillips.

I sleep well and eat *very* well.

We too have been having splendid weather, and mosquitoes. The wind is from the south, and with the sun has silenced my creaking lung.

How delightful the Thames and its banks must be if you are sharing this warmth. I hear of a wonderful life of Frank Harris that has been published, called I believe *John Johns*.[1] Have you read it?

Again many thanks for your letter which has cheered me very much.

Yes, I feel much more happy now than I did a little time ago.

With greatest love,

Ever most affectionately AUBREY BEARDSLEY

Best love to all.

1. *The Adventures of John Johns*, novel by Frederic Carrel; the chief character is based on Frank Harris (1856–1931), editor of *The Saturday Review*.

MS PRINCETON

To Louis Octave Uzanne
19 August 1897

Hôtel du Casino, Rue Halle au Blé, Dieppe

Dear Monsieur Uzanne,

I am spending the end of the summer in Dieppe, but shall be

returning to Paris in the autumn. I hope I may have the great pleasure of seeing you then again.

I have been working lately quite hard, and have some sketches in hand for the Venetian episodes in Casanova.[1]

I hope to spend a few weeks in Venice before I settle down for the winter in Paris.

My mother joins me in kindest regards.

Most sincerely AUBREY BEARDSLEY

1. These drawings were not made.

MS HUNTINGTON

To Leonard Smithers
[*circa 21 August 1897*]

Hôtel Sandwich, Dieppe

My dear Smithers,

So sorry you could not make your weekly trip, and so grieved to learn the cause. I do hope your leg is getting better with rest.

I am sending tomorrow the cover for O'Sullivan's book. It is to be printed in gold upon black smooth cloth. No other way. Purple however might be an alternative to print upon. You will observe that the design is melodramatic.[1]

Ever A

If the Quatre Parties du Jour is Frenched by the Abbé Bernis[2] I should be interested in it.

1. It was printed in gold on white parchment boards.
2. Presumably *Les Quatre Saisons ou les Géorgiques Français* by Cardinal Bernis, 1763.

MS READING

To John Gray
Monday [*Postmark 23 August 1897*]

Hôtel Sandwich, Dieppe

My dear Gray,

The photographs you have sent me are perfectly charming. So very many thanks for them. A small vague one of Mabel wandering

among the trees is surely quite the prettiest thing the camera has ever done. Your mounts are most successful.

I think I have got a good deal stronger since I have been in Dieppe, in spite of bad weather too. For the last week or so the rain has been pitiless. However it has kept the town delightfully empty.

I am wondering if you are likely to find yourself at the British Museum sometime soon. If you do it would be so very kind of you to make a reference for me in the library. The book I should like to have a slight description of is Guiffrey's *Les Caffiéri* (Morgand and Fatout, Paris, 1877) .[1] I have tried to get it here but Morgand tells me it is out of print, and that I should have great difficulty in finding a copy. Please don't make a journey to the Museum unless you are on a voyage of discovery on your own account.

Mabel arrived yesterday. It's very cheering to have her. With our kindest regards,

Always yours AUBREY BEARDSLEY

1. Account of a family of seventeenth and eighteenth-century sculptors and craftsmen in bronze.

MS OXFORD

To André Raffalovich
Monday [*23 August 1897*]

Hôtel Sandwich, Dieppe

My dearest Brother,

Thank you so very much for your two letters. I keep wonderfully well considering the terribly rainy weather we have been having. When is the pilgrimage to Belgium likely to be made? Your letter seems to promise a chance of our meeting. I do hope the promise may be fulfilled soon.

How interesting about that church in the Campagna.

Mabel came over yesterday. Looking so well I thought. It is such a pleasure to have her with us. I hope she will be able to stay quite a nice time.

I was so amused at all I heard about the Hall Caine criticisms. After all this he ought to be called the Maxman.[1]

I do hope you are getting rested now and that the boisterous and squally weather has not tried you.

I have hopes—faint ones—that September may turn out clement.

I suppose you will be at Weybridge till the end of it. We have just arranged to change our hotel. Our new address is Hôtel des Etrangers, Rue d'Aguado.

It is such a charming hotel, beautifully sheltered from the wind. I have got a very good room there. The meals really became too impossible here.

Again very many thanks indeed for your kindest letters.

With best love from all to all,

Ever your very affectionate AUBREY BEARDSLEY

1. Hall Caine (1853–1931), who had scored a great popular success with *The Manxman* in 1894, published his new novel *The Christian* on 9 August 1897 with immense publicity. Max Beerbohm reviewed it scathingly in the *Daily Mail* on 11 August 1897, and other critics were equally severe.

MS OXFORD

To André Raffalovich
[23 August 1897]

Hôtel des Etrangers, Rue d'Aguado, Dieppe

My dearest Brother,

We moved in here quite successfully this morning. I was getting quite starved lately at the other place. The people staying here are many of them rather charming.

There is a very nice covered terrace to the Hotel so I am able to sit out of doors the best part of the day.

With best love from us to all,

Always your very affectionate AUBREY BEARDSLEY

To Leonard Smithers[1]
[Postmark 23 August 1897]

Hôtel des Etrangers, Dieppe

My dear Smithers,
 This is the new address. Moved in this morning. The food is a great improvement.

Ever A.

1. Text from Walker.

MS PRINCETON

To H. C. J. Pollitt
[Postmark 24 August 1897]

Hôtel des Etrangers, Dieppe

My dear kind friend,
 This is my new address here. I do hope you will be able to come over soon; the third week in September will most probably see me in the South of France. Such rain.

Ever devoted A

MS PRINCETON

To H. C. J. Pollitt
[Postmark 27 August 1897]

Hôtel des Etrangers, Dieppe

Dearest Friend,
 I look forward enormously to Tuesday. Stay here, quite a good hôtel.

Ever and always A.

MS Oxford

To André Raffalovich
Tuesday [*31 August 1897*]

Hôtel des Etrangers, Dieppe

My dearest Brother,

Everyone tells me that I am looking much stronger since I came here and I feel better myself. Mabel's visit has cheered me very much, and I think she too has enjoyed her little visit to Dieppe.

The weather has been tolerably good. Today however is very rough, and is making a havoc of the tricoloured flags hung over the hotel gates in honour of the new alliance.[1]

I am beginning to add to my food with cod liver oil, and am thankful to say that I am able to take it. If I can only manage to continue with it regularly I feel sure it will do great things for me.

How long will you stay at Weybridge? You will be sad I am sure to leave such a beautiful garden, that makes such delicate and tender backgrounds in a camera's pictures. Every one here has been enchanted with Gray's photographs. Would you please tell him that the book I asked him to look at for me at the British Museum has unexpectedly been sent me.

I am hoping always that you are very well and not too tired. How I wish I could see you sometimes.

With much love,

Your most affectionate AUBREY BEARDSLEY

Mabel and mother join me in best love to all.

1. 31 August 1897 was a public holiday in France in honour of the President's return from Russia, where he had signed a treaty of alliance with the Tsar.

MS Princeton

To H. C. J. Pollitt
[*Postmark 2 September 1897*]

Hôtel des Etrangers, Dieppe

Dear friendly person,

Ah, if you could only see the pendant I have made for the

Bathylle. It is *Arbuscula* and beyond all words.[1]

I see now that the reference to Tuesday in your last letter was merely in the letter's date.

I wonder if you could send me some good classical dictionary. I am so in want of one, and don't quite know what to order myself. I fancy I have been told that Smith's large one is good. It would be charming of you to let me know of a nice thing.

Till you come
and for ever

Yours AB.

1. See p. 307.

To Leonard Smithers[1]
[*circa 3 September 1897*]

Casino de Dieppe

My dear Smithers,

So sorry you could not come over this week, hope to see you next and flourishing.

Ever A.B.

1. Text from Walker.

MS OXFORD

To André Raffalovich
Tuesday [*7 September 1897*]

Hôtel des Etrangers, Dieppe

My dearest Brother,

So many thanks for your letter. We have had such a spell of rainy weather and were prepared to make a flight to Paris if it continued. Today however has wrought a splendid change, and we have stayed our packing. I stood the cold damp weather quite wonderfully.

Dr Dupuy who has been staying in this hotel recommends Paris very warmly for at least the first half of the winter. He thinks diet

even more important for me than climate. He will see me as soon as I arrive in Paris and make a thorough examination of me. He spoke very hopefully of such cases as mine.

Everyone has been charming to me here. I am so glad I made up my mind to leave the other hotel. I have made famous progress since I have been at the Etrangers. This afternoon's boat brought over Dr Phillips. He thought me looking quite another person.

I do hope you are very well. Mother joins me in best love to all.

With much love,

Always your very affectionate AUBREY BEARDSLEY

MS OXFORD

To André Raffalovich
Thursday [*9 September 1897*]

Hôtel des Etrangers, Dieppe

My dearest Brother,

Dr Phillips has just put me through a very careful examination. He thinks I have made quite a marvellous improvement since he saw me at the Windsor Hotel, and that if I continue to take care I shall get quite well and have a new life before me. He is certain that Paris is the best place for me for the autumn and at least the early winter.

I cannot tell you what great joy it gives me to be able to send *you* this good report. I wish I could see you soon and speak my gratitude. As I get better I realize more and more the tremendous debt I owe you. Are you likely to be in Paris this autumn?

We leave here on next Tuesday and I think we may stay at Foyot's Hotel—at the corner of the Rue Tournon and the Rue Vaugirard. It is rather a nice situation and I shall be able to get a room facing south. What a relief it is to feel I shall not have a long journey to make.

I am quite sorry to leave Dieppe, it is such a charming little place.

Good-bye, dear André.

With much love,

Always your very affectionate AUBREY BEARDSLEY

Mother joins me in best love to all.

Dr Phillips asks to be remembered to you.

MS Huntington

To Leonard Smithers
[*Postmark 9 September 1897*]

Hôtel des Etrangers, Dieppe

My dear Smithers,

Many thanks for your letter and the portraits of Dubarry. I am keeping one of them and returning the other two. I am so dreadfully sorry to hear you have been unwell again, the weather too must give you the hump. It's been dreadful here. We leave for Paris next week. I hope you will be able to come over to the city beautiful.

Yes I'm at work![1]

Kindest regards from my mother and self,

Ever A B

1. On 2 September Smithers wrote to Wilde: 'I send you back your poem [*The Ballad of Reading Gaol*]. I showed it to Aubrey and he seemed to be much struck by it. He promised at once to do a frontispiece for it—in a manner which immediately convinced me that he will never do it. He has got tired already of *Mademoiselle de Maupin* and talks of Casanova instead. It seems hopeless to try and get any connected work out of him of any kind.'

MS Princeton

To H. C. J. Pollitt
[*Postmark 9 September 1897*]

Hôtel des Etrangers, Dieppe

Dear friend,

A line in haste. *Don't* say anything to Smithers about the *Arbuscula. Heinemann* has it for a book on dancing he is bringing out. Pray be entirely secret about this. A thousand thanks for a long and yet charming letter. I leave here early next week for Paris. Can't you manage a visit to the blessed city?

Ever affectionately AB.

MS Princeton

To Robert Underwood Johnson[1]
12 September [*1897*]

Hôtel des Etrangers, Dieppe

My dear Mr Johnson,

So very many thanks for your letter. It was most kind of you to send us such a royal list of 'pensions.' We are most grateful to have the addresses. Tuesday will see us in grey Paris, and we look forward very much to seeing you again. I am enchanted at the change in the weather and feel much better for it. My London doctor examined me a few days ago and pronounced a *very* satisfactory opinion of my condition.

I shall be able to show you in a few days a new miniature edition of *The Rape of the Lock*.

My mother joins me in kindest regards and best wishes to Mrs Johnson, Miss Johnson and yourself.

Very sincerely yours AUBREY BEARDSLEY

1. American author (1853–1937), at this time associate editor of *The Century Magazine,* which offered to publish Beardsley's work. See p. 385.

MS McGill

To Leonard Smithers
[*Postmark 15 September 1897*]

Hôtel Foyot, Rue Tournon, Paris

My dear Leonardo,

Arrived here last night and am very comfortably installed. So sad to leave Dieppe.

I hope you are well and florissant. Paris is charming just now.

Ever A

To André Raffalovich
Wednesday [*15 September 1897*]

Hôtel Foyot, Paris

My dearest Brother,

So many thanks for your very kind letter so full of encourage-
ment. We arrived in Paris yesterday evening. I have got such a
charming room at this hotel, facing south and the Luxembourg Gar-
dens. Paris is so charming just at this moment and is quite the best
place for me. I shed however bitter invisible tears on leaving Dieppe.
I had so many nice friends there and amusing acquaintances. Par-
ticularly a very charming catholic family, relations of Bishop
Capel's.[1] They live in Paris so I hope I shall see a good deal of them.

I cannot help feeling in good spirits today and pleased that the
move here has tired me so very little.

I shall see Dr Dupuy in a few days when I have settled down.

I hardly like to think now of all the thin ice I must have skated
over since March 31st—a miraculous patinage!

Good-bye, dear André, most kind and most patient of brothers.
 With much love,

Ever very affectionately AUBREY BEARDSLEY

1. Thomas John Capel (1836–1911), appointed Domestic Prelate to the
 Pope in 1873; the original of Monsignor Catesby in Disraeli's *Lothair*
 (1870).

To Robert U. Johnson
Wednesday afternoon [*15 September 1897*]

[*Paris*]

My dear Mr Johnson,

So sorry to find you out. We arrived in Paris last night and have
gone after all to *Foyot's Hotel, Rue Tournon* in the Luxemburg
Quarter.

What charming weather it is just now. I wonder what afternoon you would all be kind enough to take tea with us, say at the "Five o'clock" in the Boulevard Haussmann?

In haste,
Most cordially AUBREY BEARDSLEY

MS PRINCETON

To Leonard Smithers
[*Postmark 16 September 1897*]

Hôtel Foyot, Paris

My dear Smithers,
How provoking that the O'Sullivan should be wandering out of all knowledge of the post. Surely a select jury composed of—say—yourself, and myself to give the casting vote, could settle as to its propriety as a cover for the book.
I am doing some charming work for you.

Ever A.

MS PRINCETON

To H. C. J. Pollitt
Thursday [*16 September 1897*]

Hôtel Foyot, Paris

My dear Friend,
It was a sad moment when I tore myself from Dieppe, the most charming spot on earth. Paris however has points and I am forgetting my sorrow. Of course the Butterfly's picture will not come to an end just yet. His portraits are notoriously Charley's Aunts for running on.[1] Your likeness will probably enter its third year before the master says Finished. After that the frame.
You see the dear old thing loves paint and colour, and delights to hover between palette and canvas as long as possible. How charming he must be. What pictures has Evans made of you?
I should like to see your framed collection of Aubreys. I don't

see my own work half enough. *Bathylle* must and shall be done before long but just now my life is atrociously knotted and I don't settle down readily to pencil and papier. A whole host of people to see here.

I see I must end.

Ever A

1. Brandon Thomas's great success opened in December 1892 and broke all records by running for 1,466 performances.

MS OXFORD

To André Raffalovich
Saturday [*18 September 1897*]

Hôtel Foyot, Paris

My dearest Brother,

I was so glad to get your kind letter. I have felt rather the change from sea air, with the result that I am suffering from a slight cold that keeps me to my room. I had just the same trouble at the Voltaire.

I shall be so glad to see Père Coubé again and shall make my confession to him next week. I hope that Thursday will see you back in town wonderfully refreshed and strengthened after your holiday. As for me I am trying to think of the winter as bravely as possible and encourage myself with the recital of 'if winter comes can spring be far behind?'[1] I count on a glowing October.

I am so pleased that Mabel has found such comfortable rooms at Hyde Park Mansions. Mrs Erskine seems to be very kind and agreeable.

It is a great thing to be in this quarter of Paris, all one wants is just round one, also it seems to me to be a few degrees warmer than nearer the river.

How wonderfully good of you, dear André, to think of making me such a splendid present in October. I shall strive my utmost to make it bear most excellent fruit.

£10 in a note and £90 in a cheque will as you kindly suggest be the most convenient form for me to receive it in.

Good-bye, my dear Brother.
 With much love,
 Ever your most affectionate AUBREY BEARDSLEY

1. Shelley, 'Ode to the West Wind'.

MS GANNON

To Leonard Smithers
Saturday [*18 September 1897*]

Hôtel Foyot, Paris

My dear Smithers,

I am so sorry to have kept the Dubarrys so long; but the worries of packing and unpacking don't seem to have left us no strength for the despatching of parcels. Today however I send you back two out of the three portraits. You will see I have kept the *Drouais en habit de danse.*

I am very glad your leg improves. October I expect will be charming in Paris.

I hope in about a month or six weeks to show you a complete booklet of my writing and illustration.[1]

If O'Sullivan doesn't hurry up over his cover, I should like the pig and the pillar on the back of *my* book.

I hope Sebastian O'Scar will get his poem in the *Chronicle*.[2]

Very many thanks for sending Edmund Gosse the L.P. *Rape.*

Ever AB

1. Probably *The Comedy of the Rhinegold* (see p. 164).
2. i.e. Wilde, who had taken the name Sebastian Melmoth. Smithers had arranged to publish *The Ballad of Reading Gaol* and discouraged Wilde's suggestion of prior newspaper publication.

MS PRINCETON

To Leonard Smithers
[*Postmark 23 September 1897*]

Hôtel Foyot, Paris

My dear Smithers,

I will do the bookplate and have written to Olive Custance.[1]

Vile cold weather.

In haste,

Ever A.

Dent has just published a book by a certain Chamberlain on *Wagner*. Could you get me a copy? I believe it is 25/-.[2]

[On back of envelope] Thanks for *Rape* just arrived.

1. This bookplate (Gallatin 1061) was first published in *Early Work*.
2. *Wagner* by Houston Stewart Chamberlain, first published in German in 1896 and now translated by G. A. Hight.

MS PRINCETON

To H. C. J. Pollitt
Sunday [*26 September 1897*]

Hôtel Foyot, Paris

And how is my dear best Friend? There is one more wonderful book plate in the world. That makes two. Yours and another I have just made for a Miss Custance. You must ask Leonardo for a proof.

I am so glad you rather like my *Rhinegold* drawings.[1] When the Maupin is over I mean to produce a perfectly marvellous set of four for the comedy of the *Daughters of Rhenus*.[2]

I simply adore that work of Wagner's.

My life here is fairly dull, I don't know when I shall get south.

Write me something about yourself whenever you can.

Ever AUBREY BEARDSLEY

1. Pollitt had brought at least two of the *Rheingold* drawings published in *The Savoy*, December 1896.
2. Beardsley made no more drawings of this subject.

MS OXFORD

To André Raffalovich
27 September [*1897*]

Hôtel Foyot, Paris

My dearest Brother,

I have been suffering so from neuralgia for the last few days that I have felt quite incapable. Dr Dupuy came to see me on Thursday

and found that my trouble was in a very advanced state, but still quite curable.

I may not only have several years of life before me, but perhaps even a long life.

The wretched chill I caught when I arrived here, has not quite left me yet. Even these last few scorching days have not set me right.

I wish I had felt better to enjoy this perfectly marvellous summer weather. I thought of you much on Thursday, leaving your pleasant retreat at Weybridge. I do hope the leaving and arriving have not tired you too much.

An artist who is building a grand new house at Auteuil[1] asked me to pay a visit to it and tell him what I think of a certain yellow paint he has used for decorating his salon. If I dislike it I am to write at once to him at Dieppe and tell him so. He will then journey to Paris and make some change in the colour. If I like it the yellow is to stay. I *dis*like the decoration very much.

But what am I to do?

If I bring him up all the way to Paris and he is after all satisfied with the work he will grumble at the trouble I have given him. If I say nothing he will blame me no doubt in the long run as he is sure at some time or other to dislike the yellow of his choice.

 With much love,

 Ever yours very affectionately AUBREY BEARDSLEY

1. Possibly Blanche.

MS HUNTINGTON

To Leonard Smithers
[Postmark 27 September 1897]

 Hôtel Foyot, Paris

My dear Smithers,

Here is (by this post) Olive Custance's bookplate, a most charming design.

It is almost a pencil drawing so for heaven's sake do not allow the reproducer to touch the original; the pencil I used was so soft that the merest touch with the finger will rub it off. Pray drill this

thoroughly well into whoever you give the drawing for block-making. Leave the tissue paper on.

In great haste,

Ever A

Can you possibly send me 30/- or a couple of pounds?
I suppose a tiny photogravure will be the most sensible thing to make of it.

To Leonard Smithers[1]
29 September [*1897*]

Hôtel Foyot, Paris

My dear Leonardo,

So very many thanks for the cheque. J'étais stoné.

Am glad you like the bookplate. *Wagner*—by the way—is not yet arrived.

I am at work this very morning as ever is at the Maupin; and love the book as much as heretofore.

Ever A

1. Text from Walker.

To Leonard Smithers[1]
[*? 30 September 1897*]

My dear S.

The *Wagner* (a handsome volume) has arrived. Many thanks.

Your A.

1. Translated from *Briefe Kalendernotizen*.

MS Princeton

To William Heinemann
[circa *October 1897*]

Hôtel Foyot, Paris

My dear Heinemann,
I shall be pleased to come to lunch with you at 12.30.

Always yours AUBREY BEARDSLEY

MS Oxford

To André Raffalovich
1 October [*1897*]

Hôtel Foyot, Paris

My dearest Brother,
Thank you so very much for your kind letters and splendid present—the cheque for £90—which I received this morning.

How sweet and good of you to send it to me! and how can I ever thank you really for all your wonderful kindness.

Yes, I am doing my best to get better and stronger, and am of course following Dr Dupuy's advice. His medicines are suiting me very well. My obstinate cold has at last left me. We have been having such fine weather, and I am able to be out of doors a great deal. I suppose Symons' remark about freedom in Russia was *intended* for a joke.

I hope you have quite recovered from the fatigues of your return to town, it was so good of you to write to me when you must have been so tired and so busy.

I think Paris is suiting Mother much better this time. Everyone tells us how healthy this quarter is.

Did you see that long article in the *Figaro* yesterday on Cardinal Vaughan à propos of his visit to France as the representative of the Holy Father?

Good-bye, dear André; and again most heartfelt thanks. With the greatest love.

I am, dear Brother,

Your very affectionate AUBREY BEARDSLEY

MS Oxford

To André Raffalovich
3 October [*1897*]

Hôtel Foyot, Paris

My dearest Brother,

I have just received the note for £10 you so sweetly sent me. Thank you very very much. It was so convenient for me to receive your present in a cheque and a note, and how kind of you to trouble to send it me in two instalments. I find my expenses here very moderate indeed. The hotel is in connection with Foyot's restaurant and visitors to the hotel get the benefit of splendid cooking for very reduced rates. The food itself is so good as well as the way it is cooked and I am sure I am profiting greatly by the excellence of the 'beef'.

Dr Dupuy has ordered me to take a turpentine 'bath' night and morning. I have come out in a magnificent rash, but still am greatly comforted. The weather keeps very fine on the whole; and as long as the winds don't blow too roughly, I don't think I shall suffer from cold.

Vincent O'Sullivan has been staying in Paris a few days. I always like to see him as he is one of the few Catholic friends I have, and is admirably read in theological literature. He was talking very interestingly last time on the works of Ste Theresa. He has just had a story accepted by the *Mercure de France*.[1]

I wondered whose life it was of Peter the Great you were reading? I have just finished that great and appalling work *The Memoirs of Casanova*.

I wrote to Father Coubé. I expect he returned at the end of last week.

Good-bye, dear André, and hoping you are very well.

Yours always most affectionately AUBREY BEARDSLEY

1. *Le Scarabée Funèbre* (translated by Davray) published in the issue for January 1898.

MS PRINCETON

To Leonard Smithers
3 October [*1897*]

Hôtel Foyot, Paris

My dear Smithers,

I am glad Olive Custance and V. O'Sullivan were pleased with their respective drawings. I keep well enough and find life moderately agreeable.

How are *you?*

Ever A.

and when do you come to Paris?
O'Sullivan wants the design to be printed on both sides of his book.[1]

1. This was at Wilde's suggestion: 'Nothing looks more vulgar and cheap than a book with an ornament on one side of the cover and the other side blank.' (Quoted by O'Sullivan in *Aspects of Wilde*, 1936).

To Leonard Smithers[1]
[*Postmark 8 October 1897*]

Hôtel Foyot, Paris

My dear Smithers,

I continue to live, and hope you flourish still. Can you send me *Savoys* containing 'The Three Musicians', 'The Ballad of a Barber' and 'Catullus'? Or are they entirely out of print? I look forward to seeing proofs of the O'Sullivan cover.

Ever A

I do hope the leg mends and that the month's end will see you in Paris.

1. Text from Walker.

MS OXFORD

To André Raffalovich
Tuesday [*12 October 1897*]

Hôtel Foyot, Paris

My dearest Brother,

So very many thanks for your kind letter.

My neuralgia has scarcely troubled me at all lately, and I am waiting for a letter from my English dentist before I venture to place myself at the mercies of a stranger. The weather gives me continued cause for gratitude. Père Coubé thought I was looking much better and stronger than when he saw me last. He has just returned from Biarritz and advises me very warmly to go there if I have to leave Paris. He says it is so amusing and invigorating.

I saw the dear Father at the Rue de Sèvres again this afternoon. He was so kind and encouraging. He asked often after you and John Gray and sent remembrances.

The drawings of classic cities have not been engraved yet. A photogravure has been made of Carthage, but does not satisfy the artist.[1]

How interesting to have met the head of the Bollandists.[2]

I was dreadfully sorry to hear of your sudden indisposition at Mass. I do pray that it was really nothing serious that causes your failure of strength. I cannot bear to think of your getting over-fatigued. I am sure you overwork yourself, and do not think of yourself nearly enough.

Please remember us most kindly to the Drummonds. Is Malcolm to become a priest?

I shall try to be at St Sulpice next Sunday. Cardinal Vaughan seems to have made a great impression at Arles.[3]

Vincent O'Sullivan left Paris a few days ago. I don't see many people. I am so frightened of getting overtired.

My reading has come to a standstill. I wish you could tell me of some happy and inspiring book.

With much love,

Always very affectionately AUBREY BEARDSLEY

1. This reference has not been traced.
2. An association of ecclesiastical scholars editing the *Acta Sanctorum* in Brussels.
3. He preached there on 10 October.

To Leonard Smithers[1]
[*circa 18 October 1897*]

[*Paris*]

I send you by this post 3 full page illustrations for Part I of the *Maupin.*[2] Four drawings would establish a pretty stiff precedent. So let us say *three* for each part.

1. Text from Walker.
2. i.e. *D'Albert in Search of his Ideals, The Lady at the Dressing Table* and *The Lady with the Rose* (Gallatin 1086–1088) .

MS Oxford

To André Raffalovich
Thursday [*21 October 1897*]

Hôtel Foyot, Paris

My dearest Brother,

I was glad to get your letter.

I saw Dr Dupuy today who found a slight improvement in me. I spoke to him about Biarritz. He thought it might be a good place but that I should run the risk there of suffering from Atlantic gales later in the winter.

We have had the most astonishing weather here, but today alas, there is a change—a sharp cold wind that has tried me a little.

I was at St Sulpice on Sunday. The church was crowded. Cardinal Vaughan was the celebrant. He looked magnificent and was admired greatly by everybody. I noticed Father Bampton was in his suite.

I heard nothing of his sermon in French. Was it ever preached?

It was so sweet of you to promise to look after my reading. I amuse myself most with picture books nowadays. A German firm have been publishing such wonderful little illustrated biographies of artists, a most valuable series. Their *Mantegna* is so good. I mean to spend some afternoons next week at the Chalcographical department of the Louvre. I am told they have a very large collection of engravings there for sale at a few francs apiece. Do you want some *Saint Sebastians*?

I am so glad that Mabel is looking well.

My nights are quite good now, and my appetite never fails me. With much love, and hoping you are very well yourself,

Yours very affectionately AUBREY BEARDSLEY

MS HUNTINGTON

To Leonard Smithers
22 October [*1897*]

Hôtel Foyot, Paris

My dear Smithers,

I send you by this another picture.[1] A very good one I think. I note all you say about the *Maupin*. Thanks for your letter.

Albert we need not trouble about placing yet awhile.

How *could* you have told Doré that I was in Paris? I am worried to death over the whole business and quite put off my work. Will you please sell all the books of mine you have *except*

J. Gray's spiritual poems
2 vols of *Lives of the Saints* in French (Folio)
Works of Ste Thérèse (3 vols)
Prose works of R. Wagner (4 vols)

I am utterly wretched again nowadays with only the ghost of hope to keep me going.

Always A.

There is pencil work on the lady's face and a little on the hand, so threaten Swan with eternal punishment if they touch the drawing.

1. *The Lady with the Monkey* (Gallatin 1089).

MS HUNTINGTON

To Leonard Smithers
24 October [*1897*]

Hôtel Foyot, Paris

My dear Smithers,

A line in haste to acknowledge the letter and cheque for which

many thanks. I am writing to you this evening about the *Maupin*. I suppose by this time the fourth drawing has reached you. It was posted at the same time with my last letter.

<div align="right">Always A.</div>

MS Princeton

To Leonard Smithers
Monday [*? 25 October 1897*]

<div align="right">Hôtel Foyot, Paris</div>

My dear Smithers,

The question of the *Mdlle de Maupin* now becomes pressing. I shall soon be more than ready for you. You have quite made up your mind I hope to print in French. Can you not find an English printer to do the work? A French printer, having no one near to see after him, is sure to delay the parts horribly. What can you arrange? I am longing to hear of your decision, and am impatient to see you over here. You will be pleased I am sure with what I have done. Do you, by the way, still care to do the book?! Would you get the drawings put in hand at once? Swan of course should do them. Just drop me a line.

I keep well and enjoy Paris. We have good weather. Hoping you are vastly well.

<div align="right">Ever A</div>

There are four full page drawings for Part 1. I have dropped the idea of initial letters. The T must be taken off the Albert drawing and a small block be made of the picture that might be printed in sanguine on a gray cover???? P.T.O.

Could you have this block made at once 1/3 *reduction* say, and let me see a proof.

<div align="right">A</div>

The initial should be painted out in white paint. Of course they mustn't rake out lights.

MS D'Offay

To John Gray
[*Postmark 27 October 1897*]

Hôtel Foyot, Paris

My dear Gray,
　This reproduction from the Pope's presentation album has just appeared in a French Paper. I thought perhaps you might not have seen it.[1]

Always yours AUBREY BEARDSLEY

1. See p. 383.

MS Huntington

To Leonard Smithers
[*Postmark: 27 October 1897*]

Hôtel Foyot, Paris

My dear Smithers,
　I am utterly cast down and wretched. I have asked my sister to come and see you and have a talk with you. I must leave Paris. Heaven only knows how things are to be managed.

A.

To Leonard Smithers[1]
28 October [*1897*]

Paris

I am glad No. 4 has arrived . . . I am beginning to wonder whether the *Maupin can* be illustrated without being either insufficient or indecent . . . I would tell you all about Doré only I cannot write letters nowadays.

[Discusses terms]

A.

1. Text from catalogue No 15, Myers and Co.

MS OXFORD

To André Raffalovich
31 October [*1897*]

Hôtel Foyot, Paris

My dearest Brother,

I have been so worried and upset this last week that I have not been able to write. If there had not been such splendid weather in my favour I should have really got terribly depressed. My room is littered with guide books to Mentone, Cannes, Biarritz, etc., etc. We have been hearing very good things of Arcachon. Dr Dupuy speaks well of it and I have heard of a good and cheap hotel there. Did you not stay once at Arcachon? Though if I recollect rightly it was in the summer. I wish you would advise me about the place. I know consumptives go there in the winter. It seems that the changes in temperature and weather are less frequent and less sudden than in the Riviera. Still I suppose in the south of France one would get more sun. I dread repeating the grey skies of Bournemouth.

Every fresh person one meets has fresh places to suggest and fresh objections to the places we have already thought of. Yet I dare not linger late in Paris; but what a pity that I have to leave!

Mother has just had given her a bottle of water from Lourdes for me from the sisters of the Sacré Coeur. They were so sweet and kind.

How are you in London? I hear of bad fogs and am all gratitude as I sun myself in the streets here. I keep wonderfully well and at times don't look ill at all. Everyone has noticed my improvement. Yet all the same I get dreadfully nervous, and stupidly worried about little things.

Will you please tell John Gray that the *St Sebastian* I sent him is from a fresco by Pinturicchio in the newly opened Borgia apartments at the Vatican. I believe the frescoes have not been seen since the time of Alexander VI. The present Pope had an album of photogravures made from them and sent presentation copies to most of the crowned heads and Chefs d'Etat in the world.

Last week Mgr Clari brought Félix Faure[1] his copy.

With much love,

Always yours very affectionately AUBREY BEARDSLEY

1. The President of the Republic.

MS OxFORD

To André Raffalovich
2 November [*1897*]

Hôtel Foyot, Paris

My dearest Brother,
 Thank you so much for your very kind letter. I was cheered so much by it. I will indeed make that prayer.
 Mother saw Dr Dupuy yesterday. He is in no hurry for me to leave Paris so long as this wonderful weather lasts, and says the South of France is not fit for me just yet. I am so grateful for your advice about Arcachon. I must confess I was a little frightened by the Bournemouth pictures of the place in the guide book.
 All Saints' Day was brilliant here, such crowds in the churches.
 Good-bye, dear André, and again thank you for your letter.
 With much love,
 Yours always very affectionately AUBREY BEARDSLEY
Mother joins me in best love to all.

MS PRINCETON

To Leonard Smithers
2 November 1897

Hôtel Foyot, Paris

My dear Smithers,
 Very many thanks for your letters. I will try and collect my brains and write you a less silly reply than usual. I have been thinking a great deal about the *Maupin* and the reproduction of the drawings. I quite understand what a burden the expense of block making will be to you in such a large undertaking, and just now you are not over anxious to be burdened with expenses? Is not that so? Next year perhaps the difficulty will be less. In the meantime would it not be better for me to let you have a small series of line drawings for which you could find immediate use? You have now four wash drawings of mine, and a little one, for the *Maupin*, three of which are eminently saleable and in part payment of which you have already

paid me £15. According to our contract for *Mdlle de Maupin* about £15 more would be owing for this work.

I should suggest that any further payments from you should be for fresh drawings of mine for some smaller work that could appear complete in the immediate future, and which would mean far less outlay. Of course if you should sell the wash drawings you would let me have a share in the profits.

The question then is what work shall we choose? I am most anxious to produce something soon, so the book must be fairly short and not demand more than five or six pictures. Also it must be possibly popular. I have a very fine line drawing in hand and half-way through for the legend of Tannhäuser.[1] May I finish it and send it you to look at? If you liked it I should propose that you get some-one to translate the old ballad of Tannhäuser into English, or else print a translation of Wagner's libretto. Either would be attractive. The legend would be best, and should be translated into prose. It would make a very pretty little large picture book, and should sell.

The *Century* is the magazine that has made overtures to me about work. I have of course settled nothing with them. The *Century* by the way never sell original drawings, so whatever I might do for them would not get into the market. However I would much rather work exclusively for you as long as you care to take my drawings and publish them.

I hope you are much better nowadays. I keep well, the weather is marvellous here. Joined in kindest regards,

Always AUBREY BEARDSLEY

When does O'Sullivan's book appear?

1. This drawing is not recorded.

MS PRINCETON

To H. C. J. Pollitt
3 November [*1897*]

Hôtel Foyot, Paris

My dear good Friend,

So glad to get your last letter. I stick on here but then the sun shines every day just now and there's nothing to drive me South. What is happening to you?

I am making a few pictures for Tannhäuser, —————— I can't write a word. I'm at a Café and Mr and Mrs Hall Caine are seated opposite me, we glare and stare at one another. In the dim past we have been introduced somewhere I believe, but am not sure. Anyhow his presence gives me the jumps. I'm dreadfully tired too, after trailing about the blessed Louvre for three mortal hours.

Paris is beastly dull, nothing to see or do, Kendal[1] is I am sure far less primitive. Can you tell me of some adorable book or other? I have come to a full stop with my reading.

<div align="right">Yours AUBREY</div>

I have just found your letter in an unexpected pocket, it reminds me that you were hopping about between the ancestral mansion and the goods station on the lookout for your belongings. I hope all your treasures are housed now.

Do you care for music?

1. Where Pollitt lived.

MS PRINCETON

To Mabel Beardsley
[circa 5 November 1897]

<div align="right">Hôtel Foyot, Paris</div>

Dearest Mabel,

I have got into a chronic state of worry—so that's nothing. Really nothing but work amuses me at all. I am at work again and I hope on some very good drawings. I can't help feeling Smithers has honourable intentions, I don't think it would be to his advantage to ill-treat me. Unless he is possessed by the devil. I expect we shall be in Cannes quite soon now. I dread the experience. Paris I see will be impossible for me any longer; the density of the cold air troubles my lungs very much. I keep fairly well however, and till this wintry change was hardly distressed at all.

Yalouse[1] seems to be a very second rate sort of piece.

A play called *Les Corbeaux*[2] has just been started at the Odéon; it is a great success and accounts of it read brilliantly. However it is gloomy and risqué. If you care to look at it I will send you a copy,

that is if you are still thinking of adapting some modern French piece.

Strangman[3] dined with us last night. He is quite a pleasant person and I am sure will help us over our move.

With lots of love,

Loving A

1. By M. A. Bisson at the Vaudeville.
2. By Henri Becque, first produced in 1882.
3. Edward Strangman, an Irishman (*b.* 1866), a friend of Rothenstein and later an associate of Smithers.

MS PRINCETON

To H. C. J. Pollitt
[Postmark 6 November 1897]

Hôtel Foyot, Paris

My dear Politiano,

I am in a writing mood. I congratulate you on your candlesticks. As for Rome, get there as soon as possible.

I fear Cannes is to be my fate. How terrible it must be there.

I am hunting Paris today for a fine picture of a fox. Of this more anon. Do you know anything of Swinburne's study of Ben Jonson?[1] I want to get it if it is good.

Paris contains nothing that an English gentleman really wants. Of course it never gets asked for anything by Frenchmen, and therefore keeps nothing in stock. I get almost all my French books from Soho Square.[2]

I study the Louvre a good deal. There are still things left to [be] said.

Have you a photograph of your seat at Kendal? I should like enormously to have one. When I am South occasional letters from you will even if possible be more welcome than ever, and I may as well confess at once that the reception of some stray Chandos Classic, or ill-bound volume from some ninepenny library of reprints, fills me with joy.

Put by for me a shilling a month, and I will make mental cartoons for you hourly.

With many thanks for your letter AUBREY

1. Published in 1889. This is the first hint of Beardsley's last work, the unfinished set of illustrations to *Volpone*.
2. Where Smithers and Nichols had their shop. Both had now moved, but kept these premises probably as a warehouse.

MS HUNTINGTON

To Leonard Smithers
[Postmark 6 November 1897]

Hôtel Foyot, Paris

My dear Smithers,

Very many thanks for your letter. I ask for nothing better than to send you chefs d'oeuvres, to have them published soon, printed well, and to *toucher* as often as can be a modest cheque or two. I will send you without fail (DV) within the next two months six drawings for some small and quite possible work. I by no means shelve the *Maupin*. Can you very kindly by return send me my volume of Ben Jonson containing *The Alchemist* and *The Fox* (Mermaid).

The weather here has got much colder and a little foggy. We may be driven to Cannes any day—

Always yours,

In haste A B

MS PRINCETON

To Mabel Beardsley
[circa 10 November 1897]

Hôtel Foyot, Paris

Dearest Mabel,

Many thanks for your letter. It isn't money so much, by the way, that frets me, but being away from England and having to arrange everything by letter. It's the annoyance of sitting down to a drawing and not knowing if it will ever get published or paid for. I fancy that not only does Smithers find it almost impossible to pay me for work, but also that he cannot meet the expenses of block making, printing

and binding. Which means that my drawings will hang about hidden in his shop till Doomsday perhaps. I *have* got into a mess over it all. If I only dared offer my drawings straight off to someone else. I don't even trust Smithers to bring out books nicely even if he does bring them out.

About Ainslie,[1] he had better buy from Smithers one of the *Maupin* drawings if he cares for them.

If I *could only* be a few days in town.

We go to Bordighera in about a week. Of course I shan't be able to see Smithers now at all.

I can't help feeling that my most sensible plan is to get a good set of pictures finished for some respectable English book and to keep them by me for the moment.

How hard-worked you must be. Don't bother to go round to Smithers.

Lots of love A.

1. Douglas Ainslie (1865–1948), poet and later diplomatist, who had met Beardsley at Dieppe in the summer.

To Leonard Smithers[1]
[*circa 11 November 1897*]

All right, *Ali Baba* be it. I am within an ace of having finished a really splendid cover for it, which I will send you in twenty-four hours or so.[2] Have you had a block made of the other?[3] If so, will you send me a proof? I should like to see if it is at all suitable for the prospectus, but I recollect that there is too much black in it. Just got cheque for £5. Many thanks indeed. My move South costs a deuce of a lot. I should advise you undoubtedly to print it in black or red upon yellow, as a posterette card for shops. We leave on ? Thursday next.

1. Text from Walker.
2. This cover design (Gallatin 1090) was used for *Volpone,* published by Smithers in 1898.
3. Gallatin 1057 (see p. 320).

MS Oxford

To André Raffalovich
[*circa 12 November 1897*]

Hôtel Foyot, Paris

My dearest Brother,

I am so grateful to you for a so kind and beautiful letter.

We shall descend at Mentone and stay there unless we find Bordighera very tempting indeed. Thursday next is our day of departure. In the meantime Paris is as warm as in June, perfectly bewildering weather. However fine weather is as necessary for travelling (in my state) as a railway ticket. I should dread a night journey in the cold.

We had very chilly weather and a little fog here about a week ago and I suffered a good deal.

How glad I am to have such good news of Mabel. Her engagement at the Royalty is capital,[1] above all it allows her to stay in London. I am so happy about it all.

My nights are quite undisturbed now. I am so ashamed of myself for grumbling so much. In so many ways I am better and stronger than I have ever been since my schooldays.

Thank you more than I can say for what you wrote to me about prayers for health.

I have just been interrupted in the middle of this by the visit of a M Saunier,[2] such a funny little man who has quite lost his heart to London.

With much love,

Always yours very affectionately AUBREY BEARDSLEY

Mother joins me in best love to all.

1. Mabel Beardsley joined the cast of *Oh! Susannah* at the Royalty Theatre on 30 November.
2. Not identified.

MS Huntington

To Leonard Smithers
[*Postmark 14 November 1897*]

Hôtel Foyot, Paris

My dear Leonardo,

Many thanks for your letter. I got the proof and *Ali Baba* and the

Jonson last night. Thanks. The proof is *capital* and after all will make the best cover. The design I told you of is nearly finished now and looks wonderful but is not specially suitable for *Ali Baba*. I have therefore written another name on it. It will make the cover for a well-considered trifle I have on hand.

Chefs d'oeuvre by all means. I expect I shall settle down comfortably at Mentone and work famously in front of open windows and the Mediterranean. How much I should have liked to say good-bye to you before I started. To make up I am sending you these two French prints you liked as a farewell gift—

In haste,

Ever a

My mother sends kindest regards.

MS Oxford

To André Raffalovich
Thursday [*18 November 1897*]

Hôtel Foyot, Paris

My dearest Brother,

At the last moment Dr Dupuy has forbidden me to make the journey at night and moreover insists on my breaking the journey at Marseilles. So we had to return our wagon lits, and put off the departure till tomorrow morning. It is quite cold and foggy again here, and I get very good accounts of the weather in the south. If I don't take a decided turn for the better now I am afraid I shall go down the hill rather quickly.

I had quite sad news from Père Coubé yesterday; it was of the death of dear old Père Henri. He died in Paris very peacefully. I don't think you ever saw him. He was so kind and so saintly.

With much love,

Always yours very affectionately AUBREY BEARDSLEY

MS PRINCETON

To H. C. J. Pollitt
[Postmark 18 November 1897]

[*Paris*]

My dear Politiano,

Today sees my departure from this. I am making things for Ben Jonson's *Volpone.* Such a stunning book it will be. I think I shall stay at Mentone, but may go on to Bordighera.

I have suffered a good deal from fog and cold here this last week or so, and long for the escape.

Always A.

MS HUNTINGTON

To Leonard Smithers
[18 November 1897]

Hôtel Foyot, Paris
Till tomorrow morning

My dear Smithers,

The doctor has forbidden me to travel at night so our journey does not begin till Friday morn. I shall spend the night at Marseilles. We get to Mentone about four o'clock on Saturday afternoon. Will send you my address as soon as I have a settled one.

Always A.

Part V

1897-1898

ON 20 November 1897 Beardsley and his mother reached Menton. It was nearly a month since the scheme to illustrate *Mademoiselle de Maupin* had been abandoned and Beardsley had now begun to design pictures for *Volpone*. His intention at first was to do the work secretly, but he soon told Smithers, who hailed the idea with his usual enthusiasm and trumped Beardsley's suggestion of a set of small pen-and-ink drawings (easily reproduced by means of line blocks) by proposing the most ambitious scheme they had yet adopted, twenty-four large full and half-page drawings in line, with frontispiece and initial letters in pencil (which involved the much more expensive method of half-tone reproduction). Dowson was to edit the text and O'Sullivan to write the introduction. The whole book was to be produced even more luxuriously than *The Rape of the Lock*.

Of all this work Beardsley completed only the cover-design, frontispiece (in the pen-and-ink version originally intended for the prospectus) and five initial letters. The frontispiece is almost without question the most spectacular and finely detailed of all his drawings, while the initial letters reveal a strength and breadth of scope new in Beardsley's work, and a mastery of the medium that make it safe to guess that the book, if completed, would have been his greatest achievement.

Meanwhile financial anxieties were less pressing. Smithers was paying regularly again and Raffalovich's quarterly allowance of £100 kept Beardsley and his mother in comfort. All might have been well but for the climate of Menton. The damp winter brought on another attack of congestion of the lungs, and after 26 January 1898 Beardsley did not leave his room. Bravely he explained to his friends in London that he was kept from working by rheumatism in his right arm and did his best to sound cheerful, but on 6 March he suffered a haemorrhage so violent that it was clear that the disease had reached an artery and there could no longer be any hope. The following day he wrote to Smithers his last letter of repentance. Shortly afterwards

Mabel Beardsley arrived to see him for the last time, and on 16 March, in her words, 'he died as a saint.' He was buried at Menton and a Requiem Mass was held at Farm Street on 12 May.

Smithers, so far from destroying Beardsley's *Lysistrata* and Juvenal drawings as he had been implored to do in that last letter, kept them safe and sold copies to collectors at every opportunity. He even sold facsimiles of the letter itself. After his bankruptcy in 1900, when all his rights in Beardsley's work were bought by Lane, he continued to issue occasional sets of drawings, usually those for Juvenal, under various fictitious imprints, and in 1907 he published for the first time the unexpurgated text of *The Story of Venus and Tannhäuser*. His pirated editions of works by Wilde continued to appear, to the fury of Robert Ross, who had become Wilde's literary executor. When Smithers was hard up, he sold batches of letters from his carefully preserved correspondence with Beardsley, Wilde and Dowson, but by the end of 1907 his resources were exhausted and he died of drink, drugs and exposure combined on 19 December, his forty-sixth birthday.

André Raffalovich did not follow Gray into the priesthood but, like him, withdrew from London society and published no book after *Self-Seekers* in 1897. When Gray was appointed to the parish of St Peter in Edinburgh in 1905 Raffalovich settled in a house near the new church, which he had financed, and there resumed the lavish—though always decorous—hospitality which in his London days had prompted Wilde's gibe. In Edinburgh he was a success, and for the next twenty-five years he received at his luncheon and dinner parties almost every distinguished resident and visitor to the city. His death in 1934 was followed a few weeks later by Gray's. In the last few years of his life Gray had begun to publish poetry again, but it received little attention, and, as happened with Raffalovich, his death passed almost unnoticed outside Edinburgh.

Mabel Beardsley continued to act after Aubrey's death and achieved a mild notoriety for her exotic and flamboyant appearance. For years she received the homage of W. B. Yeats, whose sequence of poems *Upon a Dying Lady* is addressed to her. In 1902 she married George Bealby Wright but remained on the stage until illness forced her to retire. She died of cancer in 1916. Ellen Beardsley survived both her children and lived till 1932. In her last years she was poor and became dependent on help from John Lane and other admirers of her son's work. Self-effacing, modest, loyal and completely devoted to her gifted children, she deserved better.

MS HUNTINGTON

To Leonard Smithers
[*20 November 1897*]

Hôtel Cosmopolitain, Menton

My dear Smithers,

At last. The journey nearly did for me (a little blood at Dijon).
We spent the night at Marseilles. Such a jolly place. Here we are
charmingly installed, a good hotel in its own grounds. My room is
quite palatial. *Such* sun. I must prosper. Will write again. Am
resting.

Always A.

Menton less loathsome than I expected.

MS OXFORD

To André Raffalovich
Monday [*22 November 1897*]

Hôtel Cosmopolitain, Menton

My dearest Brother,

I was very tired after the journey and did not seem able to write
at all. We are staying here as I feel sure the place will suit me. The
air is lovely and there is so much sun. I do hope I may get a little
better.

Today I saw the town, it is pretty and not at all dull. I have had
no more haemorrhage and think I shall avoid it if I take care.

Please forgive a very short letter, I shall look forward to hearing
from you.

With much love,

Yours very affectionately AUBREY BEARDSLEY

Mother joins me in best love to all.

MS Princeton

To H. C. J. Pollitt
Monday [*22 November 1897*]

Hôtel Cosmopolitain, Menton

My dear Politian,

I was nearly dead when I got here. It turns out to be a sweet place and to suit me. I am abominably ill; I ran down at Paris quite alarmingly. In the train I got a sight of my own blood which terrified me for the rest of the journey. A punishment I believe for taking Gibbon with me to read. In the future I won't travel without the *Imitation*, or St Thérèse at least.

I have a very charming room at this hotel, with sun all the livelong day. At night mosquitoes make a havoc of one's face despite all nets and curtains.

Juice of citrons I believe will prevent and cure all that.

I am utterly done up!

Always A

MS Princeton

To Mabel Beardsley
24 November [*1897*]

Hôtel Cosmopolitain, Menton

Dearest Mabel,

Quite forgotten what the date is of your first night at the Royalty. Your part in the lever de rideau[1] must be trying, but I suppose the piece is not sufficiently well written to demand a very finished study of the London tart. I wish I was at your side to give you some grandly realistic tips. However I have no doubt that Brookfield[2] can throw great light on the role. Why not invite him to coach you. With his vast knowledge of the subject—

Menton is quite delicious—marvellous sunshine and perfect air. I am already clearing up a little, but alas ran down sadly in Paris. It was unfortunate that I stayed so long there.

My room is charming, Mother has made it look so pretty. I am

at work on *Volpone* and pray I may have strength of mind and op-
portunity to get all the drawings done before I despatch any. If A.[3]
is all right in January I need not get rid of them in any indecent
haste. I shall be grateful to you indeed for keeping an occasional
eye on the Arcade.[4] I wonder when O W's poem comes out. By the
way he has gone back to his old name.[5]

I am longing to hear all about the Royalty appearance, you are
sure to be a great success.

Lots of love A

So sorry to hear about Aggie.[6]

1. *A New Leaf* by Herbert Darnley, first performed on 30 November.
2. Charles Brookfield, actor and playwright (1857–1913), later Licenser
 of plays in the Lord Chamberlain's Office. He had played an impor-
 tant part in Wilde's downfall by discovering evidence against him,
 including that of a prostitute who blamed the decline in her business
 on his activities.
3. i.e. Raffalovich.
4. Smithers's shop.
5. Wilde wrote to Dowson *circa* 26 October 1897: 'I have taken my own
 name, as my incognito was absurd.' Nonetheless he continued to be
 known as Sebastian Melmoth by everyone except close friends.
6. Not identified.

To Leonard Smithers[1]
[*circa 24 November 1897*]

[*Hôtel Cosmopolitain, Menton*]

I progress. The weather is quite model. Menton also is charm-
ing and makes me feel gay. Will you send me, as soon as may be,
Swinburne's *Study of Ben Jonson?* I shall be all gratitude. How
are you, and what is happening in London? I am going to develop
a new style. My mother sends her kindest regards.

1. Text from Walker.

MS OXFORD

To André Raffalovich
29 November [*1897*]

Hôtel Cosmopolitain, Menton

My dearest Brother,

I have quite recovered from my fatigue, and am prospering in this wonderful sunshine. I can't tell you how grateful I feel to have got better again. The pains in my lungs have left me and my cough is much less troublesome. I sleep without any distress and eat quite heartily. Even in this short time the people here have noticed an improvement in me.

I am able to be out almost all day, and there are such beautifully sheltered spots in the grounds of this hotel where I can sit all the morning if I am too tired to get down to the sea.

The little town here is so gay and amusing.

There are several churches. The old Cathedral of S. Michel, the Pénitents Blancs and Pénitents Noirs and quite near me a little chapel which I shall always attend. Père Calixte is in charge of it. He seems very kind and serious. I shall make my confessions to him. You would like the chapel so much, it is dedicated to S. Roch. The Quête is made in a shell.

I am much happier and more peaceful than when I wrote to you last. I do hope I shall be able to send you more and more satisfactory accounts of myself.

The mistral has not blown yet.

With much love,

Always your very affectionate AUBREY BEARDSLEY
Mother joins me in best love to all.

MS O'CONNELL

To Leonard Smithers
29 November [*1897*]

Hôtel Cosmopolitain, Menton

My dear Smithers,

Very many thanks for your letters and enclosures which arrived

all at once by this morning's post. Menton suits me splendidly, and we have been having wonderfully warm and sunny weather. I get out all the morning and work and rest in the afternoon.

I have to take my time over things rather, but I face pen, ink and whatman paper regularly.

You will be pleased I am sure with my present drawings. In pure line, they are even stronger than the *Rape*. I hope they will all be really forcible and contain some ideas. The cover I told you of looks fine, and the first picture, *Volpone Adoring his Treasure*, is one of the strongest things I have ever done. I want all the drawings to be full of force both in conception and treatment.

As to the Forty Thieves, would you like them all in a row on one sheet? It would be a huge but amusing task to put them all into one picture.[1]

I shall look forward to the Swinburne.

Are you by the way on terms with Arthur Symons?

The *Maupin* drawing comes out well. How pretty it is. I don't remember the original well enough to correct the proof intelligently. Yes that mark is a smear and should come out.

I wish you were here with us, you would be enchanted with the South and Monte Carlo at your elbow as it were. I hope you keep well. Joined by my Ma in kindest regards.

Always A

Did the French prints ever reach you?

1. This drawing was not made.

MS PRINCETON

To Leonard Smithers
Friday [*3 December 1897*]

Hôtel Cosmopolitain, Menton

My dear Leonardo,

Many thanks for your letter. I am hard at work and full of enthusiasm and desire to produce some great and compelling [work]. I know you will bring it out in grand style.

I am delighted to hear from Mabel this morning that her appearance at the Royalty went off very well.

Our mountains are snow capped and look lovely to-day.

Like you I long for the new year. 'Ninety-eight will either see my death or chefs d'oeuvre. Be it the latter.

Thanks for forwarding on my letters.

I am all excitement over my picture making. Some to print with the text and some out of it. I will send you the first, first.

The town is being searched for something to add to your pigstye.

Always your most esteeming A

My mother sends her kindest regards.

I hope you keep well. But London must be vile. What a time the letters take coming and going.

MS PRINCETON

To Mabel Beardsley
Friday [*3 December 1897*]

Hôtel Cosmopolitain, Menton

Dearest Mabel,

I was so delighted to get your letter this morning. I knew you would be a great success. But what a pity your parts are not more amusing and better written. Our dear little Menton is obscured to-day with the most unbecoming clouds, and it is raining too.

I had myself and my room photographed a few days ago. They tell me that it has come out splendidly. We are to see proofs on Saturday. I will send you the picture but don't show it to anyone as I shouldn't like it to get round to André that I had been photoed.[1]

Smithers has sent me £5 and promises encore in a few days.

Volpone will be splendid.

Such a dear old German novelist (Ludwig Habicht)[2] has been staying here. We became quite friends. He knew naught of my modest fame, but presaged a brilliant future and success for me. He was sure I should be heard of one day.

I wish you would order for me at any French bookshop volumes 1 and 3 of Taine's *English Literature*.[3] No hurry about it. I will send you the money. If they won't let you have the separate volumes, don't bother about it. I have got volume 2 and don't want volume 4.

How sweet of the Grib[4] to give you a frock.

Lots of love,

Always A.

1. This photograph was published in *The Academy,* 10 December 1898, and subsequently in Lane's edition of *Under the Hill,* 1904. Why Raffalovich should object is incomprehensible.
2. 1830–1908.
3. Published in 1863.
4. Miss Gribbell.

To Leonard Smithers[1]
Saturday [*4 December 1897*]

Hôtel Cosmopolitain, Menton

My dear Leonardo,

I send you on the other side a complete list of drawings for the *Volpone.* You will make it I suppose a companion volume to the *Rape.*

I wish you would announce in the *Athenaeum* that Mr Aubrey Beardsley is engaged on a series of drawings for Ben Jonson's famous comedy of *Volpone,* which edition will be a companion volume to the *Rape of the Lock* and published from

4

the

ARCADE

!

For ever and aye AUBREY B.

VOLPONE

Cover (scroll and Title)

1.	F'piece Volpone and his treasure	(Line and wash)
2.	Mosca's masque (half page)	Line
3.	Voltore's gift (Full page)	,,
4.	Corbaccio (half page)	,,
5.	Volpone as the quack doctor (FP)	,,
6.	Mosca and Corvino (HP)	,,
7.	Mosca (HP)	,,
8.	Lady Politick and Volpone (HP)	,,
9.	Celia and Volpone (FP)	,,
10.	Finale for Act 3?	,,
11.	Ben Jonson (an interlude) (FP)	,,
12. 13.	In the Scrutineo (FP and HP)	,,

14.	Castrone and Nano publish Volpone's death (FP)	Line
15.	Mosca and the will (FP)	Line
16.	Sir Politick and the Tortoise-shell (FP)	Line
17.	Mosca and Volpone disguised (HP)	Line
18.	Volpone mocks Corbaccio and Corvino (HP)	Line
19.	Volpone and his servants (HP)	Line
20.	⎫	
21.	⎬ The Scrutineo again (FP and HP[s])	,,
22.	⎭	
23.	Finale (FP)	,,
24.	Tail piece and Epilogue	,,

I can let you have a line drawing for a prospectus in a few days. It will be a less elaborate and line version of the F'piece and not to appear in the book.[2] Will therefore be precious and worth having.

1. Facsimile in *Unknown Drawings*.
2. This is the version used in the book. The other was not made.

MS OxFORD

To André Raffalovich
6 December [*1897*]

Hôtel Cosmopolitain, Menton

My dearest Brother,

Your very kind letter was sent on to me from the Continental. I was so glad to get it. You have said so many beautiful and helpful things in it.

Menton suits me splendidly. Our hotel stands high, so I have the benefit of mountain air as well as sea, a very improving combination.

I am gradually throwing off my languor and depression, and am particularly grateful to be less troubled with the latter as depression seems to unfit me more for resistance to all sorts of temptations than even thoughtlessness or positive weakness.

I am so glad that Mabel's appearance at the Royalty went off so well. Dear child, she does deserve to succeed. What a pity the first piece is not going to run much longer.

I have just been reading a Port Royalist version of Saint Augus-tine's *Confessions*.¹ I am quite astonished at what he says about beauty and the use of the eyes.

With much love,

Always your most affectionate AUBREY BEARDSLEY

Mother joins me in best love to all.

1. Translation by R. Arnauld d'Andilly, 1675.

MS HUNTINGTON

To Leonard Smithers
8 December [*1897*]

Hôtel Cosmopolitain, Menton

I send you, my dear Smithers, today, the *cover*,¹ and *design for prospectus* of *Volpone*. Especially of the latter let me have proofs on various papers at once. I am nervous to see the result. Let Hentschel make the block? But command and conjure him to take the uttermost care. Make the prospectus as handsome as possible. I know you will like both of these drawings very much.

Always AUBREY BEARDSLEY

I think a *very tiny* reproduction of the cover design would look pretty on the back of the prospectus. But of course have black and white reversed. White design on black background. It can be done.²

The wording of the prospectus had better be a compound of the *Rape of the Lock* and *Mlle de Maupin* prospectuses. I have nearly finished a good introductory note to *Volpone*.³

1. Gallatin 1090.
2. This idea was later given up.
3. Beardsley made several drafts of this. One is reproduced in *Miscellany*.

*To Leonard Smithers*¹
[*circa 9 December 1897*]

Hôtel Cosmopolitain, Menton

My dear Leonardo,

I enclose a rough idea for wording of prospectus, which please

improve, amplify and glorify to any extent. The drawing for it will be full page, and will be in your hands very shortly.

Always A.

1. Text from *Miscellany*.

MS HUNTINGTON

To Leonard Smithers
10 December [*1897*]

Hôtel Cosmopolitain, Menton

My dear Smithers,

Very many thanks for your letter and enclosure of £5—I wrote to you this morning, sending off the two chefs d'oeuvre.[1] Yes, I will keep alive and well and patient over the whole blessed twenty-four drawings if you will but cheer me with proofs of them as I send them to you.

Once blocks are made I don't worry any longer about possible loss of or accident to drawings. It will also leave you free to dispose of them at any moment. I beg of you to do this. I quite understand your delay in announcing the immortal fact of my working on *Volpone*. After Christmas will be more sensible and you can send a prospectus with the announcement. Have it all over the place.

I should think that such paper as you used for the letter-press of the first edition of the *Rape* would print the sort of drawings I am sending you best. You will see. If possible I shall avoid the expense of half-tone or photogravure frontispiece, and make an ordinary line drawing, which will be in keeping with the rest of the book.[2] I will write final titles on the backs of each drawing and their place in the play.

With kindest regards from us,

Always A.

How unpleasant about Conder.[3] *The Houses of Sin* looks capital. Quite O'Sullivan's best book.

1. Presumably the letter of 8 December delayed.
2. This was done.
3. Conder was now drinking heavily.

To H. C. J. Pollitt
11 December [*1897*]

Hôtel Cosmopolitain, Menton

My dearest Friend,

A thousand thanks for your thrice kind telegram and letter. It would be delightful beyond Archangels' dreams to have you down here. Do come. How charming to see you the livelong day, my sympathique and amusing collector. I carry *Volpone* about with me from dawn to dawn, and dream of nothing else. The pictures for prospectus and cover are now with Smithers. The thing will be announced in January; and be ready for publication in May or June, I hope and pray.

Twenty-four drawings! The first of them, an initial to grace ACT I is in train, and without beastly vanity is adorable! An elephant bearing on its well-dressed back a basket of fruit and flowers. Round about it all a scroll and the letter V over everything. AB in the corner.[1]

Your Cambridge bard must indeed be decorated and issued from the Arcade. I will protect him with the finest cover.[2]

I suffer horrible things here in the way of dullness and silence. Alas I am not nearly well enough to work more than three or four hours a day. Still I try to make up by regularity what I lose by resting.

If you have a Catholic church in your part of the world do put up a candle or two for a successful illustration of the *Fox*.

Eternally yours and affectionately AUBREY B

1. Gallatin 1093.
2. Probably Aleister Crowley (1875–1947). His volume of poems *White Stains* was privately printed by Smithers in 1898. Beardsley did not make any illustrations.

To F. H. Evans
11 December [*1897*]

Hôtel Cosmopolitain, Menton

My dear Evans,

As a long letter would only most probably bore you I will not

attempt to give you any account of myself and all I have been doing and suffering since you heard from me last. What a life! and how wonderful that one has lived through it all. At last I have got into sunshine and a possible atmosphere and have settled down to steady work again. I am making pictures for Ben Jonson's adorable and astonishing *Volpone*, and this is to ask you to wish me good luck in my work.

Always yours affectionately AUBREY BEARDSLEY

MS PRINCETON

To Mabel Beardsley[1]
[*circa 12 December 1897*]

Hôtel Cosmopolitain, Menton

. . . dreadfully sorry . . . had got so overtired . . . I do hope you . . . rest and are much . . . now. Don't bother about Arcade. Smithers has just wired 'Drawings splendid', and so they are. I can think of nothing but *Volpone* and have set my heart on doing it finely. You can put up prayers and candles whenever you like to its success. I have kind letters from André.

Always A.

1. Several words are missing because the top left hand corner of the sheet is torn off.

MS OXFORD

To André Raffalovich
13 December [*1897*]

Hôtel Cosmopolitain, Menton

My dearest Brother,
 Winter is wonderful down here; we have not had a single cold day since we arrived. Only for a couple of hours at sundown do I have to close my windows. What a splendid salesman you must be or what a cunning purchaser to get rid of any book with so small

a loss. I should probably have got shillings instead of pounds for the Behmen.[1]

Do you know anything of a German novelist named Ludwig Habicht? He has been staying at this hotel and is such a dear old thing. This week I am sorry to say he has gone away, also some other very charming people, Americans, have left. I am hoping that Christmas will bring me some companionable folk.

Every one in Menton is on a bicycle and bursting with health. I believe I am the only invalid in the place.

My other grievance is mosquitoes. They have attacked me atrociously. So many thanks for your kind letter. How interesting Ward's book must be.[2]

With much love,

Always your very affectionate AUBREY BEARDSLEY

Mother joins me in best love to all.

1. German mystic (1575–1624). His works were first published in 1675.
2. *The Life of Cardinal Wiseman* by Wilfrid Ward, 1897.

MS PRINCETON

To Leonard Smithers
14 December 1897

Hôtel Cosmopolitain, Menton

My dear Smithers,

I was glad to get your kind wire and letter. I am most pleased that the book will be larger than the *Rape*. By all means print the cover in *gold on blue*, it will look much the best that way.[1]

As to the prospectus. Please send me a rough draft of the wording. In speaking of the drawings I should say '24 drawings, illustrative and decorative'.

Please let me have the exact size of the page. I am making elaborate initial letters which will be finished soon, and which I should like to be reproduced as large as the page will admit without their looking clumsy. They are in pure outline without masses of black.

V	Acts 1 and 5	The only other drawing
M	Act 3	in the text will be a small
S	Acts 2 and 4[2]	tailpiece

On the subject of full pages I will write you at monstrous length in a day or so.

The statue to yourself in Bedford Square must be put in hand soon, a regular garden god. The pedestal to be adorned with the choicest things out of the Priapeia.

Always A B

Yes, certainly the scroll design with *Volpone* in the middle is for the cover.

By the way, have you noticed (with your fine poetic insight I am sure you have) that *Volpone* rhymes to Mentone? 'Stony' should of course be the last line of the limerick.

1. This was the colour-scheme adopted.
2. These initials, together with the V for the Argument (Gallatin 1092–1096), were the last drawings Beardsley completed. The S for Act IV is repeated from Act II, though Beardsley's initial sketch for a different design is preserved in the Gallatin Collection at Princeton.

MS O'CONNELL

To Leonard Smithers
[Postmark 17 December 1897]

Hôtel Cosmopolitain, Menton

My dear L S (d?),

Just got your letter. What you say about half-tone and art paper upsets my plans—for the better. Now the initials will be stupendous.[1]

Please send me *by return* the drawing you have of mine of a Lady and a monkey at a window,[2] I shall certainly press it into the service of *Volpone* as an initial for the Rhymed argument. *Volpone childless rich etc etc* which you will of course print on a page by itself. Today I start a diary so give me a chance of saying the most charming things about you in it.[3]

Yes, let Naumann make the prospectus blocks if he can properly.
In haste

A

I send you today my photo.

1. The initials were originally outline drawings. Smithers's decision to use the more expensive method of half-tone reproduction enabled Beardsley to add pencil shading.

2. One of the drawings for *Mademoiselle de Maupin* (Gallatin 1089).
Beardsley did not use it in *Volpone*.
3. This has not survived.

To Leonard Smithers[1]
19 December [*1897*]

Hôtel Cosmopolitain, Menton

My dear Smithers,

Just got your letter. By all means bring forth the *Peacock*. I will contribute cover and what you will, and also be Editor, that is if it is *quite agreed that Oscar Wilde contributes nothing to the magazine anonymously, pseudonymously or otherwise.*[2] I will make you a resplendent peacock in black and white, and you have already some fine wash drawings of mine from which you can choose for contributions to No. 1. If you will let me I should like to publish a short article I have in hand on *Volpone* in the first number.

Now as to *Volpone*. I fear with all the work necessary to bringing out a magazine that you will give it second place in your plans. I beg of you not to allow it to be delayed. It will be an *important book* as you will see from the drawings I am soon sending you. Its marked departure as illustrative and decorative work from any other arty book published for many years *must create some attention*. I have definitely left behind me all my former methods. Please write to me clearly about all this. I want *Volpone* to appear well this side of 1 June 1898. You shall have all work done in time to make this possible. The drawings to be printed in the text will be with you the first week in January. As for the editing, *Gifford's text (1816) with his short introduction and notes can be reprinted.*

If I can only be spared from worry I shall send you good work, the best I have ever done, and I know it will be worth your while to bring it out.

Looking forward to your answer and also the *Volpone* proof.

Always yours AUBREY BEARDSLEY

1. Text from Walker.
2. This projected successor to *The Savoy* was not published. Beardsley's refusal to be associated with Wilde resulted probably from Raffalovich's hostility. Wilde in fact wrote nothing after *The Ballad of Reading Gaol*, though Smithers issued the first editions of his last

two plays, *The Importance of Being Earnest* and *An Ideal Husband*, in 1898 and 1899.

MS READING

To John Gray
22 December [*1897*]

Hôtel Cosmopolitain, Menton

My dear Gray,
I must write you a few lines to send you my best wishes for Christmas.
Contrary to all my expectations I have found Menton a charming place, and it was a most good Providence that led us to this particular hotel. It is well out of the town and on the hill, but with my renewed vigour the ascent gives me very little trouble. I had run down terribly before I came here and was quite shattered by the journey. I shall be curious to see how I progress in the wonderfully favourable conditions that Menton affords. I am at this moment feeling about as well as I did before Dr Phillips saw me at Dieppe. A gradual improvement, however slight, will encourage me a good deal. I was weighed at a medical institute here at the beginning of the month and await nervously the verdict of the bascule on 2 January. The terrible accuracy of this machine will not leave me in any charming doubts such as the penny-in-the-slot ones might allow. I shall know my loss to a gramme.
My mother joins me in kindest regards and sends you her best wishes for Christmas.

Always yours AUBREY BEARDSLEY

MS HUNTINGTON

To Leonard Smithers
22 December [*1897*]

Hôtel Cosmopolitain, Menton

My dear Smithers,
Very many thanks for your letter and for cheque, both of which

I received with great joy and profound gratitude. I will put the initial on The Lady and the Monkey in pencil; on return of drawing and block being made you can take out the letter or leave it as you please.

Your 'In Arcadia ego' as a motto for your show[1] is capital. I will put it in the middle of a design if you like for an imprint! The limerick is inspired, and when you publish it in your volume of collected verse I will *not* write to the papers to claim the rhymes.[2]

Many thanks in advance for your photo.

I look forward much to the rough draft of prospectus. I will send you tomorrow a page or so of remarks on *Volpone* you can stick into the body of your foreword. They are unconnected utterly. I am very glad that V. O'Sullivan is making the preface for the book.[3] *Please keep him up to the mark.* He may as well do the editing and all. I was delighted at the story of your opening the suppository box at Mabel's.

I am still engaged on the initials for *Volpone* but they will be fine. My first large picture will be a group of the *Legacy Hunters*. The second *Volpone as Antinous.*

Teetotal except at feeding hours is a noble resolve.

My mother's best wishes etc etc and mine for Noël, the filthy season!

<div align="right">Always A.</div>

[On back of envelope] Just got your photo. Many thanks.

1. A proposed exhibition of work by Beardsley. He never designed the suggested trade-mark.
2. See p. 408.
3. O'Sullivan's critical essay on Jonson was included in the book together with a eulogy of Beardsley by Robert Ross.

MS OXFORD

To André Raffalovich
23 December [*1897*]

<div align="right">Hôtel Cosmopolitain, Menton</div>

My dearest Brother,

How much I shall think of you this Christmas and how gratefully. But my gratitude can never equal your goodness and kindness.

Mabel tells me that she will be with you on Christmas evening; I am so glad for I shall feel that her presence gives me a sort of place amongst you on Saturday.

I do hope the most encouraging of all the Feasts will bring you the fullest joy and happiness.

With the utmost affection AUBREY BEARDSLEY

Mother joins me in best love and Christmas wishes to all.

MS PRINCETON

To H. C. J. Pollitt
[Postmark 23 December 1897]

Hôtel Cosmopolitain, Menton

Dear and only Friend,

There is a horrid pseudo-Christmas gaiety spread over this our French town, that has depressed me utterly for the moment. *Volpone* goes beautifully and will be scrumptious and amusing. I long for you to have a copy. I suppose the end of March will see my part of the work completed, the end of May the publication.

It will be a large book, as big as the album of fifty. All the pictures in half-tone; initial letters, tail pieces and heaven knows what.

Lovingly and in haste A.

MS PRINCETON

To Leonard Smithers
26 December *[1897]*

Hôtel Cosmopolitain, Menton

My dear Smithers,

Very many thanks for your letters and cheque for £5. The Racines surprised and delighted me, I sit and muse [over] that lovely *maroquin*. How charming of you to send me such a lovely gift. Thank you, by the way, very much for having given the little Rapelets to Mabel. She was most grateful for them.

Proof of *Volpone* drawings arrived.[1] Both blocks are quite good,

that is supposing that a few faintnesses in the large picture are owing to printing only. (The hair in places, and the lines about the shoulder have suffered a little in my proof). The whole thing of course looks beastly grey and cold on Naumann's shiny paper. For the prospectus I want you to use a *soft paper with plenty of warmth in it so that the drawing may look as rich and velvety as possible.* The drawing is a trifle cold in the original, so please let printer's ink on warm paper correct this fault. Something similar to that used for the *Morte Darthur* would do. As to the little reproduction of cover, 'tis a failure. The masses of white look empty and meaningless and the whole gives a bad idea of the cover. Please don't use it in the *prospectus.*[2] You could use it for the catalogue and it would be useful later in an inevitable tiny edition of *Volpone.*

I see that 11 inches by 8½ inches are the dimensions of the large block. You gave me the same measurements for size of page of the book. I suppose however you are making the sheet of prospectus a good deal larger than sheet of book. That of course matters not. I yearn for a sight of the wording. I wonder if you were able to make any use of my glowing periods.

If you have not already sent me the lady and the monkey do not do so as it will be quite out of keeping with the rest of the initials.

As to the *Peacock* do you not think that the question of who *shall* write for it is far more important than the question of who shall *not* unless you have piles of stuff up your editorial sleeves? No. 1 could never be got ready by April 1st. But of this more anon. The thing must be edited with a savage strictness, and very definite ideas about everything get aired in it. Let us give birth to no more little backboneless babies. A little well-directed talent is in a periodical infinitely more effective than any amount of sporadic and desultory genius (especially when there is no genius to be got).

On the art side I suggest that it should attack *untiringly and unflinchingly* the Burne-Jones and Morrisian medieval business, and set up a wholesome seventeenth and eighteenth-century standard of what picture making should be.

On the literary side, impressionistic criticism and poetry, and cheap short storyness should be gone for. I think the critical element should be paramount. Let verse be printed very sparingly. I am anxious to see what O'Sullivan is made of in the prefatory line. He tells me he is at work on *Volpone.* I should advise you to let Gilbert Burgess[3] do occasional things for us. Try to get together a staff. Oh for a Jeffreys[4] or a Gifford,[5] or anybody with something to say.

Have you settled definitely on calling it the *Peacock?*

As a title I rather fancy *Books & Pictures.*
In haste,

Always AUBREY BEARDSLEY

1. Of the cover design and frontispiece.
2. The prospectus was illustrated with the frontispiece drawing enlarged to 15 x 11 inches.
3. Editor of James Hackman's *Love Letters of Mr H and Miss R,* 1895, and a friend of Wilde's.
4. He means Francis Jeffrey (1773–1850), editor of *The Edinburgh Review,* 1803–9.
5. William Gifford (1756–1826), the first editor of *The Quarterly Review,* 1809–24.

MS HUNTINGTON

To Leonard Smithers
[*Postmark 27 December 1897*]

Hôtel Cosmopolitain, Menton

My dear Smithers,
 I have strengthened this part of the drawing a little I think by filling with black blot.[1] Can the alteration possibly be made in the block? It should be quite easy to do. I have marked in pencil on the back the places I have filled in with ink.

Always AUBREY BEARDSLEY

1. In the frontispiece.

MS HUNTINGTON

To Leonard Smithers
28 December [*1897*]

Hôtel Cosmopolitain, Menton

Dear good friend,
 The safety pin is a duck, a 1000 thanks. Menton yields nothing

in the way of possible gifts, but I send you today a poor little maroquin cigarette case just to blunt the pin's point.

Longing for further news of *Volpone* and much engaged thereon.

Always AUBREY BEARDSLEY

MS PRINCETON

To André Raffalovich
29 December [*1897*]

Hôtel Cosmopolitain, Menton

My dearest Brother,

How much I thought of you this Christmas. What you said in your last letter of some pious hopes you had gave me a subject for many prayers on your behalf. May your hopes be fully and perfectly realized. Menton continues to give me nothing but cause of gratitude and great expectations. It is a dear little place and I have got quite fond of it. An Abbé Luzzani who has a villa here brought me the Blessed Sacrament and will do so regularly for me. He is a good priest and a kind and accomplished man.

How glad I am that Mabel recovered as speedily as she did from her over-fatigues, and I do hope she is taking more rest and care of herself now. I had a kind note from John Gray telling me that he was going into retreat for a week with the Jesuit fathers.[1] So many thanks for your letter and news. I hear you have been having quite good weather in town. Here it is a *temps* for boating flannels and panama hats.

With the greatest affection AUBREY BEARDSLEY

Mother joins me in best love to all.

1. It was probably at this time that Gray made the decision to resign from the Foreign Office and study for the priesthood. He entered the Scots College in Rome in October 1898.

MS OXFORD

To André Raffalovich
30 December [*1897*]

Hôtel Cosmopolitain, Menton

My dearest Brother,

I have just received your marvellously kind present, the cheque for £100. Dear André, how can I thank you? Among many things your goodness has taught me is a greater care and wisdom in the spending of money. How hot my face gets when I think how wildly and uselessly one scattered one's money once. I am glad to say life is comparatively cheap here, much cheaper for instance than at such a place as Dieppe.

I am delighted at your success with the works of Symonds.[1] There is much to be said for a writer who may be sold profitably at second-hand.

Yes there is a library here but not a very good one. However I belong to it as I found a dozen books or so in the catalogue that I was anxious to read, and were worth the expenditure of six francs.

Oh how good of you to think of sending me some scraps from Archbishop Ullathorne's life,[2] but have you really the time to copy them out?

For the last twenty-four hours we have had a pitiless drench of rain, and the Mentonese are rejoicing for the sake of their oranges and lemons. But I am grumbling dreadfully at being kept indoors.

With the greatest affection and gratitude for your brotherly care and love. AUBREY BEARDSLEY
Mother joins me in best love to all.

1. John Addington Symonds had issued several of his works on homo-sexuality in privately printed editions.
2. His *Autobiography with Selections from his Letters,* 1891–2.

MS PRINCETON

To Leonard Smithers
1 January 1898!

Hôtel Cosmopolitain, Menton

My dear Smithers,

I send by this two initials V and M.[1] They are (as all my draw-

ings will be) in pencil. Please implore and conjure the blockist to treat them with the utmost care as the least touch will make a smudge, and the least smudge will spoil the picture. Imagine a smudge for instance *on the white of the initial,* or *across the cupid's fingers.* Yet it could get there easily enough unless *great care is taken.* Initial S[2] is well in hand.

Just got your letter. So sorry your Christmas was so dismal. Mine was not gay. I did not leave my room all day, and the day was wet and beastly. Your Racines and pin were all I had to cheer me.

I am awfully sorry that the reversing of the black and white turned out so unfortunately.[3] I expect it will look all right the other way. *The Lady and the Monkey* I shall not need.

Vincent O'Sullivan has arrived here and is staying for a few days. He has caught a horrid chill. The weather is too awful.

It's good of you to send me the books. Many thanks.

May the New Year bring you great luck and prosperity and may the early months of it be made glorious by the publication of a certain English drama divinely well got up.

Always A

My mother's kindest regards.

[On back of envelope] Just got proof of prospectus and am writing to you.

1. The initials to Acts I and III.
2. For Act II.
3. See p. 413.

To Leonard Smithers[1]
1 January 1898

Hôtel Cosmopolitain, Menton

My dear Smithers,

Just got your note of the 30th.

As all the drawings will be processed in half-tone I imagine we have no choice but art paper for printing upon.

The price of the book you should hit upon more safely than I, but I suppose S.P. 10/6, L.P. £2.2.0. as in the case of the *Rape.* Certainly it should not appear in parts. If you have not a copy of *Volpone* get volume I of Ben Jonson's *Works* (Chatto and Windus) 3/6.

Don't get the Mermaid Series as that does not print the Epistle Dedicatory.

As to number of drawings. The list of twenty-four I sent you was made when I intended having several half-page illustrations in the book, and doing all the work in pure line. As you will see from the initials I have sent you the work will be far more elaborate, and as I do not want to be longer than twelve weeks at the utmost on *Volpone* the number of pictures must necessarily be reduced from twenty-four to something considerably less. I should say fifteen (including initials).

These details by the way interest me I assure you quite as much as they may interest the public who as you say clamour for them. If I let you have *all* the work in hand by last week in March, I suppose the book could be out first week in May?

<div style="text-align: right;">In haste,</div>

<div style="text-align: right;">And always A</div>

If I find I have time I mean to avoid any repetition of initial letters.

1. Text from Walker.

<div style="text-align: center;">MS P<small>RINCETON</small></div>

To Leonard Smithers
7 January 1898

<div style="text-align: right;">Hôtel Cosmopolitain, Menton</div>

My dear Smithers,

I am glad you are getting the drawings fixed.[1] You say you are not reducing the initials much, but, good lord, unless the book is to be as big as an atlas! I am beside myself to see proofs and discover how my new work reproduces. Insist on the greatest care being taken, if the blocks are really good I think it only fair to publish the name of the reproducer.

The S is grand and the second V goes beautifully.

Twelve and six is a good and quite possible price. Give my best love to Dowson and tell him how pleased I am that he is editing.[2] Gifford's notes are fair but not quite adequate. I like notes to a book and should be glad if Dowson would look after them. Don't

let him forget to print all commendatory verses. I wonder what O'Sullivan will have to say.

How goes the prospectus?

Davray has just written to me to say *L'Ermitage* is about to blossom out into a large magazine[3] and he wants to know if I will lend him something of mine occasionally for it. I shall promise him a *Volpone* drawing, and shall ask him to review it grandly when it comes out.

In haste A.

1. Sprayed with fixative.
2. Dowson wrote to William Theodore Peters *circa* 20 January 1898: 'For the moment I am busy at the Museum collating the editions of Ben Jonson's *Volpone* for the text which Smithers is to publish with Aubrey Beardsley's illustrations.' Dowson is not named as editor in the published text.
3. The new *Série Illustrée* began with the issue for January 1898.

MS PRINCETON

To Henry Davray
7 January 1898

Hôtel Cosmopolitain, Menton

My dear Friend,

I was glad to hear from you. Certainly I shall be only too pleased to let you have something for the new *Ermitage*. I am bringing out an *édition de luxe* of Ben Jonson's *Volpone* and when I get some proofs (in a month or six weeks) I will send you them to choose from. The book will be out in June if you care to wait till then when we will of course send it you for review.

I will send you the prospectus quite soon. There is a simple line drawing on the front of it if you care to use it, but it gives no idea of my present work which is a great advance on anything I have yet done.

Let me know how soon you would care to have a drawing of mine and I will see that Smithers lends you something good. I was so sorry not to see you before I left Paris; but I was so ill, hardly well enough to travel at all. I am much better now and am working hard.

Please accept a thousand good wishes for the new year, and also for the great success of the enlarged *Ermitage.*

Always yours AUBREY BEARDSLEY

MS PRINCETON

To Leonard Smithers
8 January [*1898*]

Hôtel Cosmopolitain, Menton

My dear L S,

An awful thought has just come to me, it is that the blockmaker may be contemplating 'raking out lights' in the drawings just sent you. *Don't let him touch them,* but make him leave screen over *initials and white spaces anywhere and everywhere* in these *and all drawings for Volpone.* Shout it at him *'Don't rake out lights.'* I don't want V's and M's etc to jump out of the book as if they wanted to escape from their backgrounds.

Always and in haste A.

[On the envelope] Urgent and Pressing.

MS PRINCETON

To Leonard Smithers
9 January 1898

Hôtel Cosmopolitain, Menton

Cover, my dear L S is *simply ravishing!* Yes print it both sides, it will look gorgeous![1]

Blue and gold *great success.*

Yours AUBREY B.

1. This suggestion was not adopted.

To Leonard Smithers
10 January 1898

Hôtel Cosmopolitain, Menton

My dear Smithers,

The initials will be all the better and firmer for reduction. I am most curious to see how the M comes out; if you have not already had a block made I should like the trial proof to be of the *Venus and Cupid*.[1] I have already written you on the subject of raking out lights.

The books you kindly sent off have just arrived, and the agent has had the cheek to charge me over 11 francs for carriage. Is there any reason why such a huge price should be charged? I enclose receipt, which please return, as unless the agent (in Paris) can explain the enormity of his offence I am going to make a complaint to the Consul here. Many thanks for the books. I am sending you back the prospectus. How good the blue and gold look.

Always and in haste A.

Am sending off first S and second V this evening or tomorrow morning.[2]

1. i.e. the initial to Act III.
2. The initials to Acts II and V.

To Mabel Beardsley
10 January 1898

Hôtel Cosmopolitain, Menton

Dearest Mabel,

I do hope you are getting quite well again, and do rest. But I know how trying it is to give up things. I am a thousand times better now I have set to work. The *Volpone* gets better and better with each drawing. Smithers has just sent me the cover (gold and blue) and it looks gorgeous. When he has got plenty of work to show you,

I will ask him to invite you to a private view. Don't go round on spec as the work is sure to be 'reproducing'.

In a weak moment, and little dreaming he would do it, I asked O'Sullivan to write me a preface. He is going to do it. Dowson is editing and making the notes. The book will be quite big, larger than the *Rape* considerably.

Campbell[1] says I may go to Dieppe this summer. I hope it can be managed as it will mean a chance of seeing you. Unless Smithers is willing to make the new quarterly a Catholic magazine it don't interest me much. Do think of it, and tell me if you feel that there is any chance of a Catholic quarterly having any buyers, and, what is as important, any staff.

Today I was to have lunched at Monte Carlo with the Tylers[2] etc. but the rain prevented.

When I am not frightfully depressed and wondering whether my masterpieces are getting lost or spoilt in the post, I keep in good spirits, and know not what languor and laziness feel like. Do light candles for me and offer up prayers.

<div align="right">Your ever loving AUBREY</div>

1. His doctor at Menton.
2. Joseph John Tyler (1851–1901), engineer and Egyptologist, whose *Wall Drawings and Monuments of El Kab* appeared 1895–1900.

<div align="center">MS PRINCETON</div>

To H. C. J. Pollitt
10 January 1898

<div align="right">Hôtel Cosmopolitain, Menton</div>

My dear pretty Pollitt,

I will make you the most adorable Bambino[1] as soon as ever I can say 'finished' of *Volpone*. Continue to light candles for my safe delivery. I wax greatly in gifts of the pencil, someone must be praying for me. Nowadays I adore my own drawings, but really they are becoming capital.

A thousand affectionate good wishes.

<div align="right">Ever A.</div>

1. This drawing was not made.

MS HUNTINGTON

To Leonard Smithers
11 January [*1898*]

Hôtel Cosmopolitain, Menton

My dear Smithers,
 I have been thinking of your ET IN ARCADIA EGO trade
mark.[1] I will make an elaborate affair of it in pencil to appear on
the title of *Volpone*. Let me know if you want to use it on all your
books etc and catalogues perhaps. If so I must make a pen and ink
version or could you get the pencil cut on wood? Where could one
get a good *illustrated* handbook on alchemy?

Always A

Initials S and V just sent off.

1. See p. 411.

MS OXFORD

To André Raffalovich
11 January [*1898*]

Hôtel Cosmopolitain, Menton

My dearest Brother,
 Thank you so much for your kind letter. Yes, I am in a land of
sunshine again, and the spell of wet weather does not seem to have
done me the least hurt. Menton is a truly sociable little place, and
the strong English contingent here furnishes me with quite a num-
ber of people to talk to. There is a famous Egyptologist here, one
Tyler, who looks like a corpse, has looked like one for fourteen years,
who is much worse than I am, and yet lives on and does things. My
spirits have gone up immensely since I have known him.
 Both the priests who visit me here have been invalids like myself
and are so kind and sympathetic. Neither of them is French. The
Abbé Luzzani is German and Italian, and Father Orchmans is Belge.
The curé of Menton is an old dear but I see very little of him.
 I think so much of Mabel nowadays, I do hope she is really

keeping well and happy, and I do so look forward to seeing her again this summer at Dieppe.

Your year's waiting will surely be attended with the greatest graces, as are even the least acts of obedience.[1]

With our best love to all,

Yours always most affectionately AUBREY BEARDSLEY

1. This may refer to Raffalovich's admission to the Third Order of the Dominicans in May 1898.

MS HUNTINGTON

To Leonard Smithers
14 January [*1898*]

Hôtel Cosmopolitain, Menton

My dear Smithers,

Many thanks for letters. I am *very glad* that *Swan* is making the blocks. I have for the moment a little V,[1] a little N and a large S on hand.

Fifteen pounds is well worth saving, and I am not especially keen on having the design both sides. *Don't* print the little block. If you particularly want something on the other side I will make a new design, but I don't think it at all necessary.

I'm afraid good books on the wall paintings of Pompeii are costly and beyond my balance. Still, if you hear of anything at all possible let me know. But ye gods how in want of art books I am. A good, clear and inexpensive handbook of perspective, and a ditto of anatomy would soothe me much just now and should not run away with more than a few shillings. Evans might know of something good on these subjects.

In haste A

1. Initial to Act V. The other drawings were not completed.

To Leonard Smithers[1]
[*Postmark 15 January 1898*]

Hôtel Cosmopolitain, Menton

My dear Smithers,

I find it rather difficult to give you really precise details of my work to come. But I'll do my best.

1	*Initials*	?	(O'Sullivan's preface)
2	Large	N	Epistle dedicatory
3	Little	V	Argument (acrostic)
4	"	N	Prologue
5	Large	V	Act 1
6	"	S	" 2
7	"	M	" 3
8	"	S	" 4
9	"	V	" 5

Full Page
1 Volpone and treasure
2 The legacy hunters
3 Mosca's masque
4 Volpone as the quack doctor
5 " as Antinous
6 The Fox (this should come 3rd really)
7 Volpone's descent into the prisons
Half-page—well, about half a dozen of them.

I must try and boil the book down but it's so rich and full of chances that skimping would be a sin.

I don't see quite that you can say much about them in the prospectus, even if they were all finished now.

Of course you can say that they will be half-tone reproductions from pencil drawings (*all* will be in pencil) and that they will be quite my best work.

About price.

I have already had £25 for *Volpone*, or was £5 of that for O'Sullivan's book cover? If so, then £20.

In return I have sent you

a cover design ⎫
prospectus ⎬ Average for drawing
4 initials ⎭ about £4.

Now would you care to go back to an old arrangement of weekly payments? Of course it would suit me best.

I will let you have all drawings to go in text right away if that means that you will begin to put the book in hand immediately you have them. It will save a lot of time in getting the thing out.

I don't see my way to dividing out my drawings into acts.

'*Interest*' was the word instead of '*virulence.*'[2]

I beg of you to keep all pictures well within bounds. One thing, the breadth—base line—of both half and full page should be identical

comme ça

As you are giving plenty of reduction to the initials you must surely do the same by the other drawings or the pencil work will not look the same right away through the book. Reduction pulls a drawing together and strengthens it in every way.

Always in haste AUBREY BEARDSLEY

1. Text from Walker.
2. Probably in Beardsley's draft for the prospectus.

MS PRINCETON

To Mabel Beardsley
16 January [*1898*]

Hôtel Cosmopolitain, Menton

Dearest Mabel,

So glad to get your letter. I don't like referring to my work in my letters to A. He will only scold me. But of course I must if it is really necessary. When I was in Paris I told him I drew a little.

I believe firmly a well-conducted Catholic quarterly review (*quite serious*) would have buyers. The pictures should be few. Illustrations to such poems as the 'Burning Babe',[1] events from lives of the saints, designs for Church decoration etc. could appear occasionally. The reviews must deal not only with English Catholic work and works, but with all that goes on of importance all over the world. The staff would have to be vastly competent to do the thing properly. But Smithers will want a lot of talking to before he will take it up.

The set of initials for *Volpone* (10) will be capital. The illustrations will be both full and half page. Swan is making the blocks. I have just had a charming letter from them, and I am sure they will take especial care of my work.

The exhibition can wait a bit. It's such a bother to arrange one.

I haven't sent the photo to Father Bearne yet, but will soon. Letter writing humps me dreadfully.

<div style="text-align: right">Lots of love A</div>

1. By Robert Southwell (1561–95).

MS Huntington

To Leonard Smithers
[*21 and*] 22 January 1898

<div style="text-align: right">Hôtel Cosmopolitain, Menton</div>

My Dear Ls,

I suppose you got my wire. Since sending it I have spent twenty-four hours or so looking at that elephant. Really *this* block is quite good and I pass it. But I am anxious to see how the *large unbroken masses in the S* and details of *human figure in the M* will reproduce. Please speak to Swan thoroughly about it all; I am sure they wouldn't take up the work unless they could do it fairly adequately. I know pencil is very hard to work from.

Saturday

Heaven only knows why I wired you such a foolish wire. It was just the opposite I meant, for really nothing now can really be settled about *Volpone* until the method of reproduction is put

beyond a second choice. Give Swan the bird[1] to do next. Blow Nichols.[2]

Always yours AUBREY BEARDSLEY

1. The initial S to Act II.
2. Probably for refusing financial backing for *Volpone*.

MS PRINCETON

To Leonard Smithers
22 January [*1898*]

Hôtel Cosmopolitain, Menton

My dear L S,

I have had such a beastly attack of rheumatism[1] in my right arm, and had to rest a few days, hence delay in the final initials. But now they go on merrily.

Thanks so much for the books. The anatomy is very good indeed and I shall find it most useful.

In haste,

Always A.

1. Actually another tubercular attack. See p. 436.

MS OXFORD

To André Raffalovich
24 January [*1898*]

Hôtel Cosmopolitain, Menton

My dearest Brother,

I was so glad to get your letter which I would have answered before, but I have had to rest my arm a little owing to rather a painful attack of rheumatism. We have just got over some very treacherous weather, made up of a cold north-east wind and a really summer sun. All that though has given way at last to a

delicious spring mildness. You would be delighted with the flowering shrubs here; and trees like the mimosa literally sing with bees.

Today Father Orchmans who was lunching with us told me that Monsieur de Chaptal[1] is now a Vicaire. He was so interested to hear that I had met him, and that I knew Father Coubé.

I have found the Egyptologist an amusing person. This morning he gave me such an interesting account of a convent of the Holy Child Jesus at Mayfield. He has introduced a number of pupils to their school, most of whom have ended by becoming nuns. He is himself a Quaker, but I am sure will be drawn to the Church sooner or later.

I was so glad to hear of Raymond Roze being so devoted.

No, I have never heard of the preservative girdles you speak of, and I am curious to know something about them.

 With our best love to all,

 Always yours most affectionately AUBREY BEARDSLEY

1. Raffalovich's cousin, the Vicomte de Chaptal, later auxiliary bishop in the diocese of Paris.

MS PRINCETON

To Mabel Beardsley
Monday [*? 31 January 1898*]

[*Hôtel Cosmopolitain, Menton*]

Dearest Mabel,

I feel dreadfully incapable and couldn't be sparkling to save my life. Does the *Idler* expect you to be funny?[1]

Browning has some rather charming things about Gypsies and Bohemians at the beginning of 'Fifine at the Fair', so you might refer airily to his surmises as to the charms of a life freed from the ordinary social restraints.

The more society relaxes the less charm and point there is in Bohemianism. Flourishes in France because society is so rigid. Will never quite die in England as it is the refuge and consolation of the unsuccessful. Young writers, painters, etc. in England are in such a hurry to *épater* the bourgeois and to 'arrive', to separate

themselves from one another rather than to herd together, and to appear quite '*sérieux*'.

They've come for the post. A

1. Mabel Beardsley contributed to a discussion *Is Bohemianism Extinct?* published in *The Idler,* April 1898.

MS Huntington

To Leonard Smithers
1 February [*1898*]

Hôtel Cosmopolitain, Menton

My dear L.S.,

Many thanks for letters. The rheumatics have been at me again and I have kept my bed for a few days. I look forward much to proofs of the bird, bless its bony beak! I think about the *Menus et Programmes*[1] that there are many other books etc that would be more useful to me just now; so please forgive me if I return it. Many thanks for giving me a sight of it. It is very attractive and will soon be off your hands. I wish you would sell some of my books for me and put the results of sale to the credit of my account with you. You might catalogue the following:

Ricketts' Vale publications	6	vols[2]	
Voltaire	30	"	
Racine	6	"	
Balzac	20	"	
All French novels			
Bourdaloue's sermons	6	"	[in his *Oeuvres Complètes,* 1830]

Acajou et Zirphile.[3]

I can't think of any others but if you know of some more amongst all my trash that would fetch something more than a shilling you might recall it to my memory.

Just had a note from Evans who hasn't yet seen the *Volpone* pictures.

Blessed weather here at last today, quite warm and springlike. How disgusting of Nichols.

Always A.

1. Untraced.
2. Charles Ricketts (1866–1931) issued some fifty finely produced books from the Vale Press, Chelsea, which he ran with his friend C. H. Shannon.
3. A fairy tale by C. Pineau Duclos, published anonymously in Paris, 1744.

MS OXFORD

To André Raffalovich
2 February [1898]

Hôtel Cosmopolitain, Menton

My dearest Brother,

I have had a slight return of rheumatism, and a touch of congestion, so have had to keep my bed for a few days and am alas still there.

How glad I was to get your letters, and that precious little book on St Thomas. It was very charming of you to think of the stamps; Father Cavanagh[1] has them by this. The girdle I look forward to exceedingly.

I got such a kind letter last night from dear Father Bearne. I am sorry to say he has been unwell. He is convalescent now. He gave me such an interesting account of Wardour Castle where he is now staying.[2]

Please forgive such a scanty letter but I feel rather incapable after the fatigues of enforced rest, and a diet from which solid foods have almost entirely been excluded.

Joined in best love to all,

Yours always very affectionately AUBREY BEARDSLEY

I have not told Mabel anything about this little trouble of mine. It would only worry her and she would be sure to fancy I am worse than I really am.

1. Father Pius Cavanagh O. P., who later received both Gray and Raffalovich into the Dominican Third Order.

2. In Dorset, home of Lord Arundell of Wardour, head of one of the old English Catholic families.

MS HUNTINGTON

To Leonard Smithers
[*Postmark 4 February 1898*]

[*Hôtel Cosmopolitain, Menton*]
Bed

My dear LS,

I quite forgot that a volume of Gray's poems was amongst the Vale publications. Please don't sell the *Spiritual Poems*. En revanche get rid of the three-volume *Rabelais*.

The *Spiritual Poems* you might get Zaensdorff or someone to put into a scarlet maroquin cover for me. Don't by *any mischance* sell *The Lives of the Saints* (2 folio volumes, green maroquin). I still linger in bed. Weary work.

Always affectionately AUBREY B

Charming of you to promise me a pull of the *Volpone* on rice paper.
[On envelope] Parcel was sent by Railway Co.[1]

1. See p. 421.

MS OXFORD

To André Raffalovich
9 February [*1898*]

Hôtel Cosmopolitain, Menton

My dearest Brother,

I am still bedridden. We have had a sad spell of mistral which has kept my poor chest in a menacing state. Everyone has been so kind and sympathetic. Father Orchmans and the Abbé Luzzani come often to see me, and cheer me much, and help to chase away Maître Pathelin's papillons noirs.[1]

Thank you very much for your letter. I am so grieved that you

have not been very well. I too have known something of weariness this last week or two. For a traveller, weariness is the good angel that keeps him in mind of the end of his journey.

Both Mother and myself have relished the little book on St Thomas very greatly. She says she wishes she had a copy herself, and I wonder if you still have one you could send her. She would be so grateful.

Good-bye, my dearest Brother.

I am always most affectionately AUBREY BEARDSLEY

I am joined in best love to all.

1. A reference to the early French *Farce de Maistre Pierre Pathelin.*

MS OXFORD

To André Raffalovich
16 February [*1898*]

Hôtel Cosmopolitain, Menton

My dearest Brother,

I have been able to get up for a short time today, but look very disconsolate with a beard and in an extremely composite costume.

It was so sweet of you to send me the little book of Faber's,[1] I liked it so much. Mother asks me to thank you for the maxims of St Thomas. Father Cavanagh sent me a blessed card. Yes, it is beautifully designed.

There has been a great deal of illness here the last few weeks. The Egyptologist has kept me company.

I do hope, dear André, that you are quite well.

Joined in best love to all.

Ever very affectionately AUBREY BEARDSLEY

1. Probably *Heavenly Promises,* 1898, a selection from the religious poems of F. W. Faber (1814–63).

MS HUNTINGTON

To Leonard Smithers
Thursday [*? 17 February 1898*]

Hôtel Cosmopolitain, Menton

My dear Smithers,

Very many thanks for the pull of *Volpone* which looks very handsome. The Swan blocks are much the best and they had better continue with the work. The bird comes out *very well indeed*. I am up a little today, but it is a slow job. O'Sullivan's preface is admirable, is it not? Mother would have written to you long ago to have thanked you for the *Rape* but the poor dear lady has suffered horribly with toothache. Two have just been taken out.

Praying that you are vastly well.

Always A.

MS OXFORD

To André Raffalovich
21 February [*1898*]

Hôtel Cosmopolitain, Menton

My dearest Brother,

I hope you are much less worried now, or rather not worried at all. Thank you so much for your letter.

I am glad to say I have not been sent to bed again. My first few days of convalescence were blessed with the most perfect weather and I made good progress.

Today alas there is a downpour and I am miserably depressed. There is hardly any trace left of the congestion, but the rheumatism as might be expected is most obstinate; when I get stronger Dr Campbell will order me massage.

My copy of *La Cathédrale* has not arrived yet. I read a short extract from it in some paper which made me curious to get the book, but I don't expect to like it as I never like Huysmans.

Do you know a picture of Benozzo Gozzoli's (at the Louvre) called *Le Triomphe de S. Thomas d' Aquin*? I saw a photograph of it the other day. It is quite the most brilliant and attractive thing.

I was indeed delighted with Fr Rickaby's text for his sermon on the conversion of England. I am by the way just having a book of his sent me.[1]

Fathers Orchmans and Luzzani are deeply interested in the doings at St Ethelburga's, full accounts of which have appeared in *La Croix*.[2]

The country house of the dear Oratorians must I am sure be a delightful retreat. I wish you would remember me very affectionately to Fr S. Bowden when you see him next.

I should like to have written you a much nicer letter but I cannot overcome my downcast feelings. It has all been such a terrible disappointment for me.

With the greatest affection AUBREY BEARDSLEY

Mother joins me in best love to all. Poor dear lady she has been a martyr to toothache these last few days, but this afternoon it is to come out.

1. Probably *Cambridge Conferences*, 1898, talks delivered to Catholic undergraduates in the chapel of St Edmund's House.
2. A protracted dispute over the ceremonial in use in the Anglican Church of St Ethelburga, Bishopsgate. Three parishioners were creating disturbances at services in protest against the alleged Romish practices of the curate.

MS PRINCETON

To Mabel Beardsley
[*circa 21 February 1898*]

Hôtel Cosmopolitain, Menton

Dearest Mabel,

I was so glad to hear all about the Garrick,[1] but how hard worked you must be. I do hope you have a nice part in the first piece. The photograph in *St. Paul's*[2] looked so good, I am glad you have had such a successful one taken. Poor dear André seems to have been having worries lately, I wonder what has been the matter.

Did Mother ask you if you would care for St Térèse? Her books are quite wonderful. I should like so much to send you something, so make your own choice.

My rheumatism is really a serious bother as I can't draw as long

as it continues. Dr Campbell is going to have my arm and shoulder massaged if I don't get better.

At the end of this month Menton will begin to empty, how I long to have the Cosmopolitain to myself. However everyone is pleasant enough.

I dare not think of coming to London this year. But I should love to. Lucerne will be I think my next move. I shall stay here as long as possible. I believe the sun is quite bearable up to the middle of May.

Lots of love A.

1. Mabel Beardsley was rehearsing *22A Curzon Street* by Brandon Thomas and J. Edwards, which opened at the Garrick Theatre on 2 March with *The Nettle* by Ernest Warren as curtain-raiser.
2. In the issue for 5 February 1898, with a short account of her career

MS Princeton

To H. C. J. Pollitt
[*Postmark 22 February 1898*]

Hôtel Cosmopolitain, Menton

My dear Friend,

So pleased to get a letter from you. I have had a vile attack of congestion of the lungs, and spent three weeks in bed. It has left me an utter wreck and quite incapable of work. I am simply in an agony of mind over it. Heaven only knows when I shall be able to work again. Pray breathe not a word of this *to anyone*, I have told people in town that I have had a touch of rheumatism. However I shall set to work and get something written whilst I am in this state of exile from design.

Such splendid things I had planned out too. The dear saints are my only comfort, and give me patience.

Always AUBREY BEARDSLEY

MS PRINCETON

To Mabel Beardsley[1]
Thursday [*24 February 1898*]

Hôtel Cosmopolitain, Menton

Dearest Mabel,

We are longing to hear all about the pieces. It will be rather nice playing Kitty Clive in *Masks and Faces*[2] . . . the Triplet?

I'm still indoors so can't attend any Lenten[3] services. Carême is being preached here by a Jesuit from Nancy, I wish I could have heard him. I envy your being able to get about and see things and people, and especially having a nice cosy little church near to pop in and out of.

I hope you have got S. Térèse by now. Dear S. Alphonse Liguori is my great love just at present, when I get my arm again I am going to make a picture of him which shall find its way to you.

I suppose you have seen the new Catholic monthly *St Peter's*.[4] What an awful production.

I had rather a charming order from the *Revue Illustrée* last week to make an 'illustration' for a story they are going to publish; 'Les Quatre Pages d'armes de Marlborough'. It was not a bad tale. Of course I had to refuse. Such a pity as the *Revue Illustrée* is very *répandu* all over Europe, and . . .

. . . says he is doing . . . Have you read . . . *Volpone;* I expect . . . have finished it by the end . . . this month! My luck . . . out. I don't . . . if you are ever near Burns and Oates. If so I wish you would ask them to send me

> *The Rosary, its history etc* (3d) by Fr Lescher O.P.
> *Clock of the Passion* (6d) Liguori.

But don't bother . . .

1. Part of the text is illegible because of worn folds.
2. Comedy by Charles Reade and Tom Taylor, first produced in 1852 and often revived, though there is no record of a London production at this time.
3. Lent began on 23 February.
4. An illustrated review which ran from 1898 to 1900.

MS Princeton

To Mabel Beardsley
[*circa 26 February 1898*]

[*Hôtel Cosmopolitain, Menton*]

Dearest Mabel,

Hachette or Dulau will easily get the Teresa for you. Don't let them try and get you the more expensive edition. This one 12 francs for the three volumes is very well printed etc.

Lots of love A.

S. Térèse. *Oeuvres 3 vols* (in 12°) containing *Vie de S. T écrite par elle-même, Livre des Fondations etc, Chemin de la Perfection etc.*
Traduit par Marcel Bouix
Published by Victor Lecoffre, 90 Rue Bonaparte, Paris
Price 12 francs

MS Oxford

To André Raffalovich
27 February [*1898*]

Hôtel Cosmopolitain, Menton

My dearest Brother,

Thank you very much for your letter, and the little book for the month of St Joseph which I will read with you day by day through March. I am not able to get out yet so I have a lot of time for reading.

I am in better spirits, indeed very happy at times, for I have really great cause to be thankful for this latest trouble. I have been reading a good deal of St Alphonsus Liguori; no one dispels depressions more effectually than he. Reading his loving exclamations so lovingly reiterated it is impossible to remain dull and sullen. I believe it is often mere physical exhaustion more than hardness of heart that leaves me so apathetic and uninterested.

It is just possible that I may be able to come to England this summer, say to stay at Hindhead, Reigate, Guildford or some such place near London. But it is very uncertain. This hotel closes early in May.

Poor dear Mabel seems to have been very hardworked lately. I do hope she is keeping well. Mother's visit to the dentist ended with the loss of two teeth. She was marvellously brave over it all, and wonderfully well after it. All the ladies here do not know what to make of such Spartan behaviour.

She joins me in best love to all.

I am, dear André,

Your very affectionate AUBREY BEARDSLEY

MS HUNTINGTON

To Leonard Smithers[1]
[Postmark 7 March 1898]

Hôtel Cosmopolitain, Menton

Jesus is our Lord and Judge

Dear Friend,

I implore you to destroy *all* copies of *Lysistrata* and bad drawings. Show this to Pollitt and conjure him to do same. By all that is holy *all* obscene drawings.

AUBREY BEARDSLEY

In my death agony.

1. The envelope is addressed by Ellen Beardsley.

MS ROSS

Mabel Beardsley to Robert Ross
12 March *[1898]*

Hôtel Cosmopolitain, Menton

My dear Mr Ross,

Dear Aubrey is very very ill, we fear he cannot live many hours. He is touchingly patient and resigned and longs for eternal rest. He holds always his crucifix and rosary. Thank God for some time past he has become more and more fervent.

Pray for him and for us.

Mother is very worn though we have two nurses.

Yours very sincerely MABEL BEARDSLEY

MS ROSS

Mabel Beardsley to Robert Ross
Wednesday [*16 March 1898*]

Hôtel Cosmopolitain, Menton

My dear Mr Ross,

Our dear one passed away this morning very early. He looks so beautiful. He died as a saint. Pray for him and for us. The funeral is tomorrow at nine. We are broken-hearted, I cannot write more. He sent sweet messages to all his friends. He was so full of love and patience and repentance.

Yours sincerely MABEL BEARDSLEY

MS PRINCETON

Ellen Beardsley to Robert U. Johnson
15 May [*1898*]

24 Wellington Square, Chelsea, S.W.

Dear Mr Johnson,

I thank you from my heart for your most kind letter of sympathy. It is difficult for me yet to speak of my terrible loss, I am inconsolable and in thought I live over and over again those sad sad months and the cruel suffering of the end. My darling never left his room or dressed completely after the 26 January when he had a slight haemorrhage. He used to be better some days and able to move about his room a little, and read a little, and then the haemorrhage would recur. But it was more slight oozing from one lung and then the other than any one bad attack till ten days before his death when there was a very dreadful attack, the disease had touched an artery and it was tragic. Nothing could be done to save him though the

doctor still would not quite give up hope. But I wired for Mabel as I felt nothing short of a miracle could restore him.

Of those last sad days I cannot bear to write, save just to say that his marvellous patience and courage amid very great sufferings from frequent severe haemorrhages and the agony of breathing touched all who were near him to the heart. Morphia had frequently to be administered and at last he passed away, I thank God, while under the influence of it without suffering the last agony of all, suffocation under an attack, which the doctor, and we who were watching the struggle, momentarily feared. He had won the love of all who knew him in Menton, every waiter and servant in the hotel was absolutely devoted to him, and the proprietor and his wife loved him as if he had been their own. They told me over and over again that he was 'a benediction in the house' and at the last I found in them both the tenderest care and support. They did everything for me and together with the good priest, who also loved my darling tenderly, arranged the last sad rites. We had a Solemn Requiem Mass in the Cathedral and then under a blue cloudless sky the solemn procession (for nearly all in the hotel followed) mounted the hill to the lovely cemetery, in very truth a Via Dolorosa, and then he was laid to rest in just such a lovely spot as he would have chosen. Dear beautiful soul 'of whom the world was not worthy'!

Last Thursday, May 12th, a Solemn Mass of Requiem was held at the Jesuit Church, Farm Street, London, with glorious music, and though it was a terrible ordeal for us yet I am thankful it was held as it gave an opportunity for the many friends who could not be present at his funeral to show their love and respect by attending. The church was full. The beautiful Funeral March of Chopin was played at the conclusion of the Service.

This is the first letter I have written and indeed when I began it I did not think I should write so much. But the remembrance of the affection both you and Mrs Johnson showed for him has carried me on, and you will, I know, care to hear what I have told you.

With very kindest regards to Mrs Johnson and yourself,

Yours very sincerely ELLEN A. BEARDSLEY

Manuscript Locations and Sources

Anderson	Mr Alan Anderson
Berg	Henry W. and Albert A. Berg Collection, New York Public Library
Bodley	Bodleian Library, Oxford
Booth	Mr Robert L. Booth
Brighton	Brighton Grammar School
Clark	William Andrews Clark Memorial Library, University of California
Davis	Mr A. R. Davis
d'Offay	Mr Anthony d'Offay[1]
Easton	Dr Malcolm Easton
Gannon	Don Patricio Gannon
Good	Mr W. G. Good
Harvard	Harvard University Library
Huntington	Henry E. Huntington Library, San Marino, California
Lambart	Mrs Enid Lambart
Leeds	Brotherton Collection, Leeds Public Library
London	University College Library, London
McGill	McGill University Library
Mix	Mrs Katherine Lyon Mix
O'Connell	The late J. Harlin O'Connell
Oxford	Blackfriars, Oxford[2]
Princeton	Princeton University Library
Reading	Reading University Library
Reichmann	Mrs Eva Reichmann
Revington	Mr S. M. Revington
Rosenwald	Rosenwald Collection, National Gallery of Art, Washington
Ross	Mr J.-P. B. Ross
Thomas	Mr Alan G. Thomas
Texas	University of Texas Library
Wilson	The late A. E. Wilson[3]

1. Offered for sale in his catalogue 1 July 1961.
2. Now in the University of Texas Library.
3. Offered for sale by Mr H. T. Jantzen in his catalogue 79, 1968.

Index of Recipients

General Index

Notes

1. 'AB' means Aubrey Beardsley.
2. Figures in **bold** type refer to biographical footnotes.
3. Streets and other addresses will be found under the names of their towns.

Academy, The (periodical), 401 *n* (1)
Acajou et Zirphile (Duclos), 430
Acta Sanctorum, 378 *n* (2)
Actors and Singers (Wagner), 335
Adey, William More, 60, **60 n(2)**
Adolphe (Constant), 207, 210, 211, 214 *bis,* 218, 225, 233, 261
Adulterer, The (AB), 264 *n*
Adventures of John Johns, The (novel by Carrel), 358 *n*
Affaire Oscar Wilde, L' (Raffalovich), 85 *n,* 110 *n*
'Aggie' (not identified), 397
Ainslie, Douglas (poet), 389, **389 n(1)**
Albani, Madame (operatic soprano), 90
Albemarle Review, The, 223 n (4)
Alberich (AB), 172 *n,* 177
Alchemist, The (Ben Jonson), 388
Alciphron (letters of), 216 *n,* 264, 265, 267
Alexander VI, Pope, 383
Alexander, (Sir) George (actor-manager), 63, **64 n(2)**
Ali Baba (and the Forty Thieves): AB's illustrations for, 96, 141 *n,* 142–5 *passim,* 147, 315, 324, 327, 329, 389, 399; his cover design, 319, 389 *&* n (2), 390, 391
All Men Seek Thee (Stephens), 27
Alte Pinakothek (Munich), 217 *n*
Alvary, Max (operatic tenor), 72 *n* (2)

Ambassadors, The (Holbein), 25, 29
Ambler (unidentified), 30
Ambrose, Father, 270
Ambush of Young Days, The (play by Raffalovich and Gray), 85 *n*
Amoris Victima (Symons), 218, 279 *n* (1)
Andilly, R. Arnauld d', 403 *n*
'Anglican Orders, Papal Bull on' (sermon by Father Bampton), 196 *n*
'Annales de l'Unisexualité' (article by Raffalovich), 179 *n,* 250 *n*
Annan and Swan (block-makers, *see also* Swan), 66
Antoine Watteau (Rosenberg) 232 *n*
Aphrodite (Louÿs), 195
Aquinas, St Thomas: book on, 431, 433; Church of (Paris), 299, 302, 304, 336; *Life of,* 304; maxims of, 433; *Triomphe* of, 434
Arabian Nights, The (trs. Burton, ed. Smithers), 143 *n;* (trs. Galland), 315
Arbuscula (AB), 307, 364, 366
Arcachon (France), 383, 384
Architect, The, 27
Archives de l'Anthropologie Criminelle, 179 *n* (3), 181 *n* (3), 249, 250 *n* (1)
Aristophanes, *see* Lysistrata
Arles (France), 378
Armance (Stendhal), 207

© Cassell and Co. Ltd. 1970